SUPERMAN

THE WAR YEARS
1938–1945

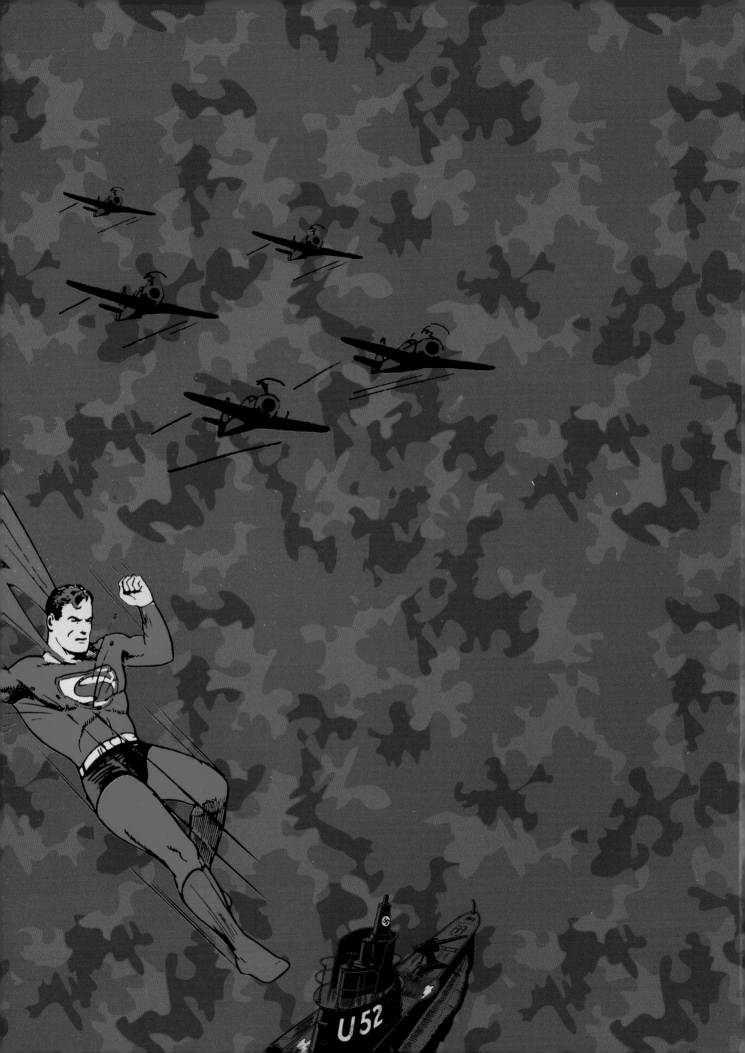

SUPERMAN

THE WAR YEARS
1938 – 1945

By Roy Thomas

CHARTWELL
BOOKS

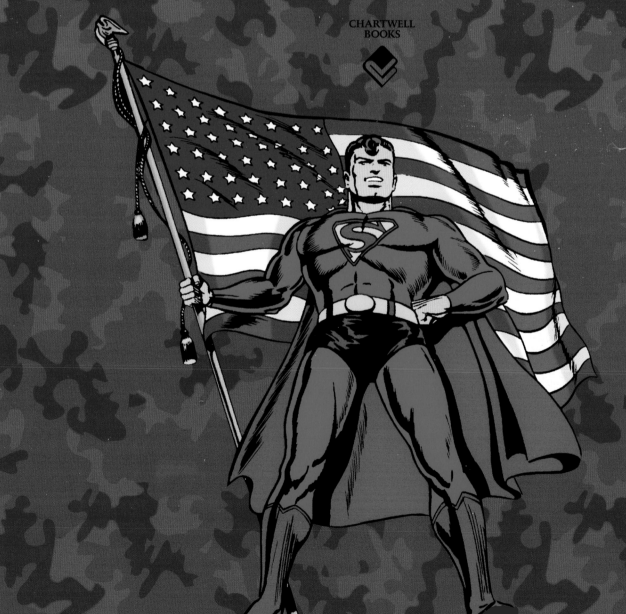

EDITORS

Michelle Faulkner

Frank Oppel

EDITORIAL ASSISTANT

Jason Chappell

DESIGNER

Maria P. Cabardo

DESIGN ASSISTANT

Cheryl Smith

COVER DESIGNER

Rachael Cronin

This edition published in 2015 by Chartwell Books , an imprint of Book Sales, a division of Quarto Publishing Group USA Inc.
142 West 36th Street, 4th Floor, New York, New York 10018 USA

This edition published with permission of and by arrangement with DC Entertainment
4000 Warner Boulevard, Burbank, CA 91505 USA
A Warner Bros. Entertainment Company.

ISBN-13: 978-0-7858-3282-9 Printed in China 2 4 6 8 10 9 7 5 3 www.quartous.com

All identification of writers and artists made in this book utilized information provided by the Online Grand Comics Database.

Some of the vintage images and text reprinted in this volume were produced in a time when racial and societal caricatures
played a larger role in society and pop culture. They are reprinted without alteration for historical reference.

*Dedicated to the memory of
Jerry Siegel & Joe Shuster,
two men who launched a hero–
a legend–and an industry.*

*With special thanks to
Joe Desris, Dean Mullaney,
and Eddy Zeno.*

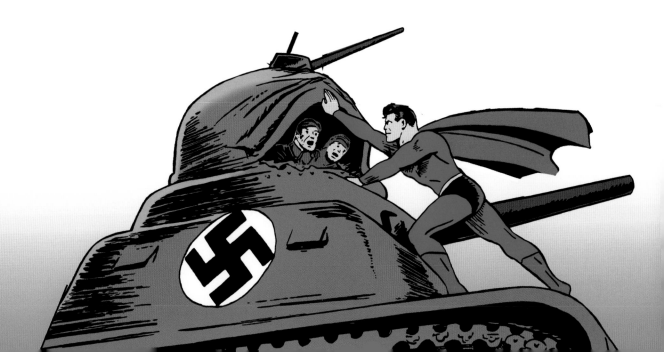

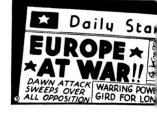

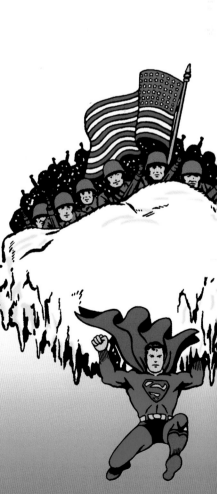

Introduction

BY ROY THOMAS

Superman.

The first glimpse America got of Superman, he was committing what looked like an act of rampant, albeit impressive, vandalism: holding a late-model green automobile over his head as he smashed its grill into a huge boulder, while innocent bystanders fled or lay sprawled on the ground, gaping in horror.

That was circa April of 1938, the late-Depression year when Detective Comics, Inc. (forerunner of today's DC Comics), published the first issue of its third title, *Action Comics #1*. The official date on the cover was June, a ploy to try to convince retailers to leave the comic book on their shelves a bit longer. You wouldn't think it could've worked out, though, because *Action* was a monthly from the get-go, which meant that, by May, a *second* issue would arrive to replace the remaining copies of the first.

Be that as it may: behind that lurid cover scene, on the first interior color page, the reader was deluged with a compressed backstory for the flivver-tosser: a "distant planet" had been destroyed by "old age"—whatever *that's* supposed to mean—and one of its scientists sent his "infant son" to Earth in "a hastily devised space-ship." On our world, that diaper-wearing nipper was able to lift an overstuffed easy chair with one tiny hand; and by the time he'd become a young adult, he could leap an eighth of a mile (that's 660 feet, undoubtedly an Olympic record), lift a steel girder with one now slightly larger hand, and outrace a speeding bullet train. His name was Superman, a "champion of the oppressed" and "physical marvel" whose powers were explained in shorthand by noting that an ant can lift many times its own weight and a grasshopper can hop tremendous distances.

After that single page, the reader was plunged into an adventure already in progress, as if one just walked in on the third reel of a movie at the local Bijou. But, to the mostly young audience that eagerly grabbed copies of *Action #1* off dime-store shelves, the story hardly mattered. What counted was seeing Superman smash his way through a steel door—repel bullets from his mighty chest—throw a burly wife-beater into a splintering wall—smash that green car all over again (turned out those "innocent bystanders" were actually criminals who'd just kidnapped a lonely-hearts journalist named Lois Lane)—and carry off one of the hoodlums into the sky.

All the above, including the cover, comprised only the first 14 pages of comics you'll find in this explosive volume.

"Superman," it'll probably not surprise you to learn, was an instant hit with the small fry (and no doubt with a number of older readers, as well). Copies of *Action Comics* were flying off the stands. However, because readers didn't generally write letters to comics in 1938, it was hard to tell precisely *which* feature in Action was selling all those magazines. Was it Superman? Was it Zatara, Master Magician,

who resembled the popular comic strip hero Mandrake the Magician? Was it the cowboy Chuck Dawson—or "Pep" Morgan, the "versatile young athlete" who becomes a boxing champ in his first published story—or maybe Scoop Scanlon, Five Star Reporter—or even Tex Thomson, a Western adventurer off on a world tour? Hard to say.

Superman, despite being on the cover, was just one more hero among many. His creators, young Jerry Siegel and Joe Shuster, had been mailing in stories to the company's mags for the past year from their homes in Cleveland, Ohio—including spy stories, federal agent stories, and something called "Dr. Occult," about a detective who fought supernatural menaces—and none of *those* had set the world on fire. While legends vary about precisely how Superman came to DC's attention, editor Vince Sullivan liked this Superman, this extra-terrestrial who had super-human powers, and even wore a blue-and-red circus acrobat's outfit just to make sure nobody thought he was just a normal guy!

It had been an easy story to plop into *Action* #1, since some of the hero's first 13-page story already existed. Siegel and Shuster prepared a number of weeks of continuity for a "Superman" *comic strip,* which they tried to sell to newspaper syndicates without success. After the rejection letters saying Superman was too far-fetched a character for a newspaper comic strip, the pair were content to see the feature in a *comic book* instead. The existing strips were cut

up, re-pasted in the format of comic book pages, and colored (in Photostat form)—a cover was drawn depicting one of the yarn's key moments—and the whole thing was shipped off to the printer.

Still, because no one was certain what sold *Action Comics* #1 (and because at least the next couple of covers had to be prepared even before it went on sale), different types of subject matter was utilized on the following several covers. Those of *Action* #2 through #6 spotlighted a man parachuting from a biplane with a pistol in one hand and a blonde in the other; a sword-wielding soldier surrounded by dark-skinned "natives;" a Canadian Mountie getting his man; a lone adventurer beset by desert Arabs; even a snarling gorilla sneaking up on an unwary hunter. But not a man in a blue-and-red trapeze outfit.

Even so, the mag kept increasing in sales . . . and before long, it became clear that it was Superman who was selling the magazine. After that, Superman began to appear first on one cover out of every three . . . then on every second cover . . . until, at last, with *Action* #12, he began to be featured on *every* cover.

9

The rest of the story of Superman is well-known, at least in its general outlines. With Superman's popularity known, DC threw together an all-*Superman* comic book that reprinted stories from the earliest issues of *Action* (this quickly became a regular series with all-new stories). The McClure

Newspaper Syndicate launched "Superman" as a daily comic strip—and, soon afterward, plans were in the works for an *Adventures of Superman* radio program.

So Siegel and Shuster had made it into the newspaper funnies after all . . . What's more, other worlds—toys, a fan club, Halloween costumes, movie cartoons, a live-action series in the newfangled medium called television, eventually even blockbuster theatrical films that would make audiences "believe a man can fly"—lay in the future, which was just waiting to be met and conquered.

Superman was, from the very first tales, a "champion of the oppressed." He battled gun-toting criminals, ruthless mine-owners, dishonest sports promoters and anybody else who was out to take advantage of the so-called Common Man, there at the tail-end of the Great Depression. People needed a hero, someone to stand up for them, even if only on a four-color page—and Superman was it. He was going to make justice count for something in this world. He was, as he was called at the time, the "Man of Tomorrow."

But then, amid all the home-grown bad guys, there slowly arose a new challenge—one that Superman would have to meet head-on, with canny intelligence rather than hammering fists.

It was called World War II.

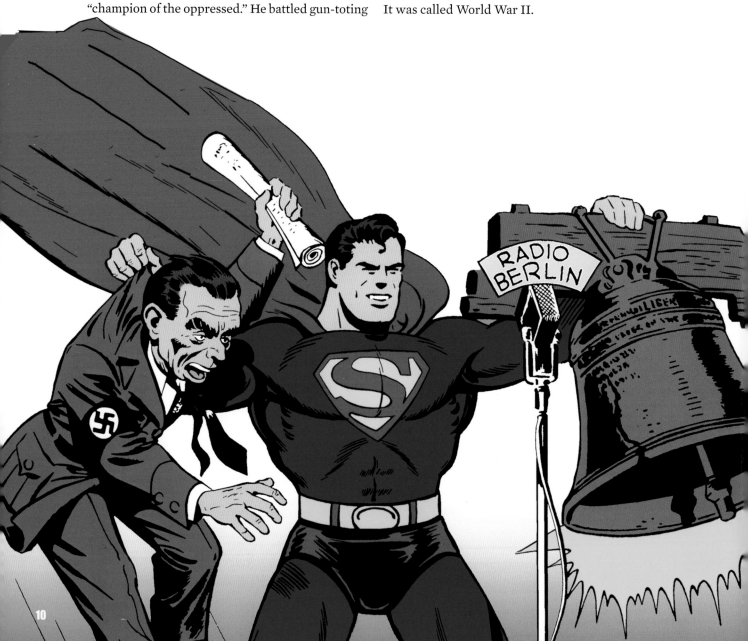

Part One

The Second World War was a surprise that nearly everyone expected . . . at least as the 1930s wore on.

THE ROAD TO WAR

From an American (and European) viewpoint, there were plenty of signposts, years before war actually broke out. The Soviet Union, composed of Russia and the countries it had absorbed since its 1917 Revolution, preached a radical social theory—Communism—but its dictator, Joseph Stalin (whose name *also* meant "Man of Steel"), concerned himself mostly with home-grown enemies and victims, for the time being.

Benito Mussolini had been "Il Duce" ("the Leader") of a Fascist Italy since the early 1920s and had vowed to forge a new "Roman Empire." The only question was which country he would attack first.

The increasingly militaristic Japanese Empire had designs on all of China, gobbling up Manchuria in 1931 before launching a full-scale invasion of China in 1937.

In 1933, Adolf Hitler became "Der Führer" (again, "the Leader") of a resurgent Germany, determined to use his National Socialist ("Nazi") Party and a revitalized military to gain revenge on Britain and France, who had humiliated the Fatherland in the Great War of 1914–18.

Meanwhile, America and the rest of Europe, for much of the decade, paid as little attention as they could afford to the four totalitarian regimes, because they had troubles of their own, mainly the Great Depression. Beginning in 1929, the Depression reached a nadir in 1932, with millions unemployed, economies stagnant, even fears of possible anti-democratic revolutions. Franklin D. Roosevelt, elected President of the United States

that November, promised a "New Deal" to get the nation and its people back on their feet. But it would be a long hard slog, with at least one step backward for every two steps forward.

By 1939, the New Deal appeared to have run out of steam at home, even while things were collapsing abroad: millions of troops of Imperial Japan rampaged through China; Fascist Italy subjugated Ethiopia in 1935 and was eager for new conquests; Hitler's Nazis annexed Austria in 1938 and then seized Czechoslovakia, while Britain and France adhered to appeasement, giving him other people's territory; and the Germans and the Soviets were engaged in a proxy battle in Spain, fighting on opposite sides in its civil war. Britain and France, belatedly realizing that Hitler's ambitions were boundless, finally told Der Führer that if he invaded endangered Poland as well, a state of war would exist between them and his Third Reich.

This was the world that Superman inhabited—and tried to ignore, just like his adopted country did—in stories during his first year of adventures on his adopted planet.

In the earliest tales, he functions mainly as what he was called in *Action Comics* #1: a "champion of the oppressed," at a time when that meant oppressed by the Depression... by harsh economic realities and hard times, not by foreign aggressors. He combats bank robbers, yes, but he also takes on ruthless mine owners, crooked football coaches, and natural disasters. Still, the story in *Action* #2 has a definite war theme. Not the threats from Nazism, Fascism, Japanese imperialism, but a civil war raging in San

11

Monte, "a small South American republic." In a time when many Americans were isolationists and proud of it, the tale's main concern is to drive home the horror and uselessness of war, rather than any danger posed by ambitious dictatorships across the seas.

All the same, war images from China and Spain and of the new technologies of war which Hitler and Mussolini and General Tojo were employing in their modern-day saber-rattling, were omnipresent in the magazines, newspapers, and newsreels of the day. So it was all but inevitable that several covers of *Action Comics* and the quarterly *Superman* title that debuted in the spring of 1939 would depict the Man of Tomorrow smashing an airplane or tank—even if the alleged "enemy" was coyly unidentified.

Then, in the Fall 1939 issue of *Superman*—written and drawn by spring, on sale that summer—Siegel and Shuster (and the studio-full of artists they'd recently hired to help meet the demand for an increasing number of "Superman" pages) ratcheted things up a notch. In that double-length yarn, our hero starts out trying to prevent war profiteers from selling a deadly new gas to a fictitious nation called Boravia; but that quest soon takes him to that country, where yet another "civil war" is going on.

This time, at least, the nation involved has a definitely European-sounding name. And when (SPOILER ALERT!) Superman causes a giant dirigible to "fall to its doom," even many of the younger readers surely recalled the *Hindenburg* disaster of just two years earlier, when a hydrogen-filled German dirigible exploded while attempting to land in New Jersey.

This civil war, too, ends in a truce being forced on the two sides by Superman. But the days when peace alone was the sole objective worth pursuing were swiftly coming to an end, even in DC's comic books.

Abroad, the drums of war were beating ever more loudly, and Superman—like his creators, editors, and publishers—had very keen hearing.

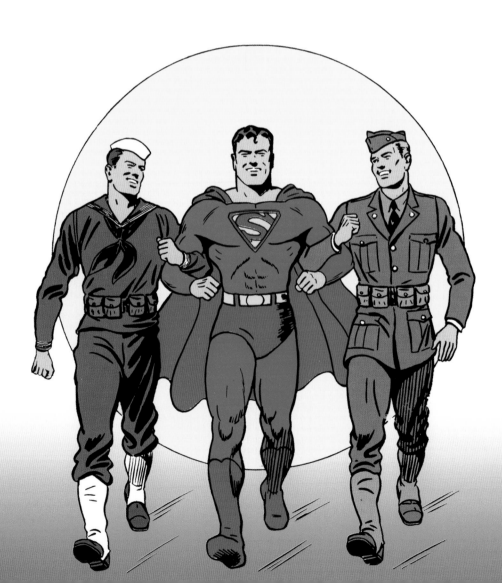

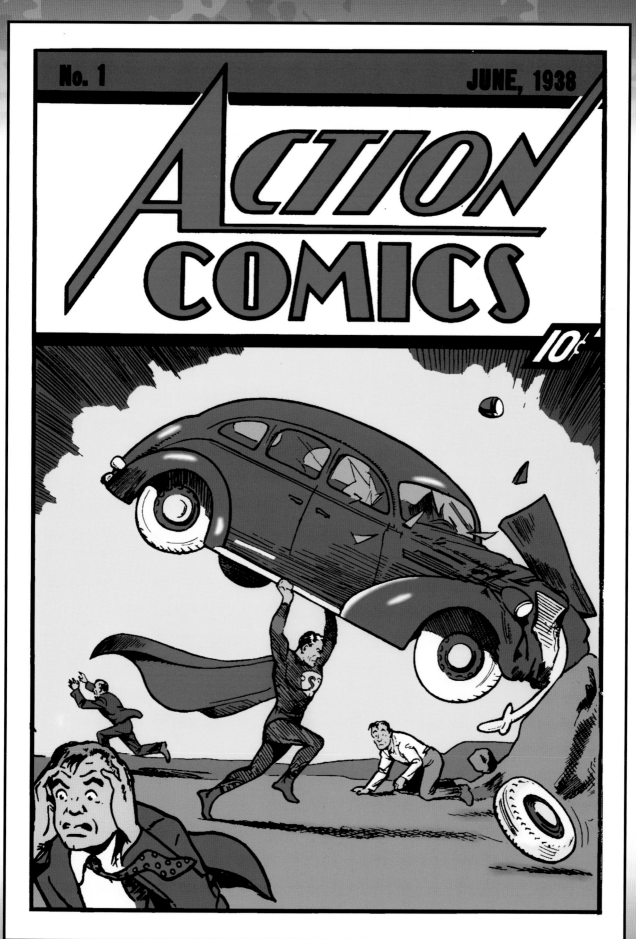

Action Comics #1 (June 1938) - cover art: Joe Shuster

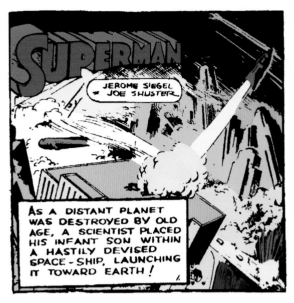
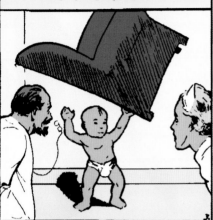

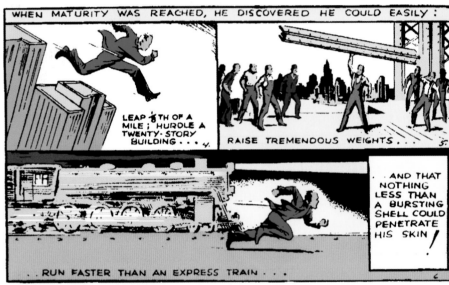
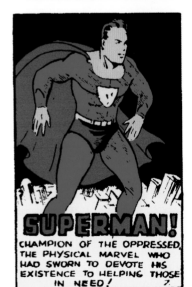

Action Comics #1 (June 1938) - script: Jerry Siegel - art: Joe Shuster

A TIRELESS FIGURE RACES THRU THE NIGHT.. SECONDS COUNT.. DELAY MEANS FORFEIT OF AN INNOCENT LIFE

THE GOVERNOR'S ESTATE FINALLY IS REACHED

MAKE YOURSELF COMFORTABLE! I HAVEN'T TIME TO ATTEND TO IT

WHAT DO YOU MEAN BY KNOCKING THIS HOUR OF THE NIGHT?

I MUST SEE THE GOVERNOR. IT'S A MATTER OF LIFE AND DEATH!

SEE HIM IN THE MORNING!

CLICK

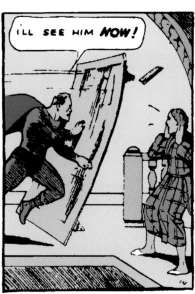

I'LL SEE HIM NOW!

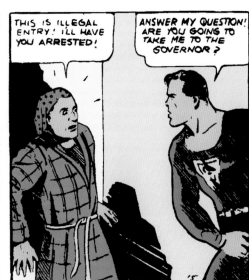

THIS IS ILLEGAL ENTRY! I'LL HAVE YOU ARRESTED!

ANSWER MY QUESTION! ARE YOU GOING TO TAKE ME TO THE GOVERNOR?

15

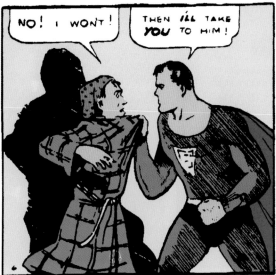

NO! I WON'T!

THEN I'LL TAKE YOU TO HIM!

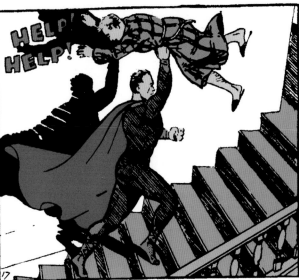

HELP! HELP!

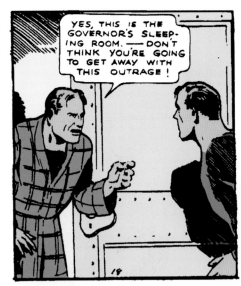

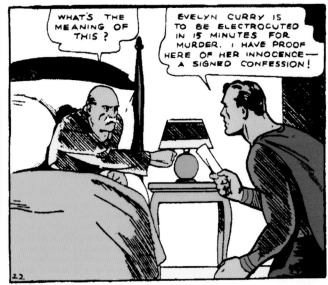

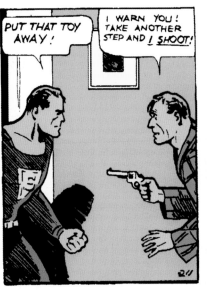

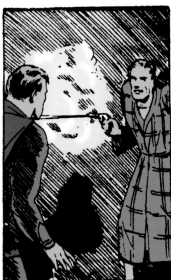

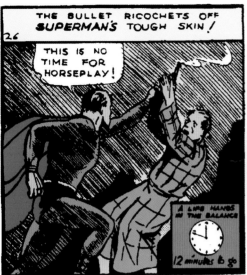
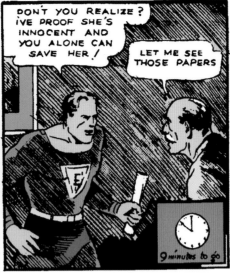
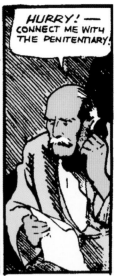

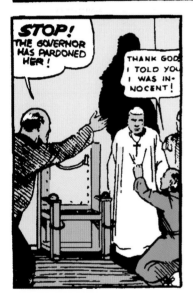

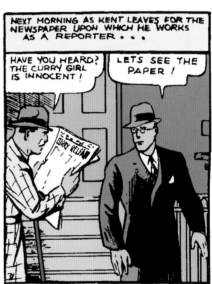

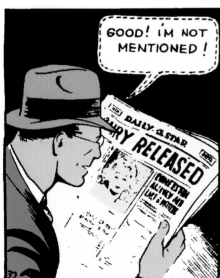

17

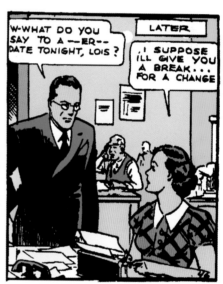

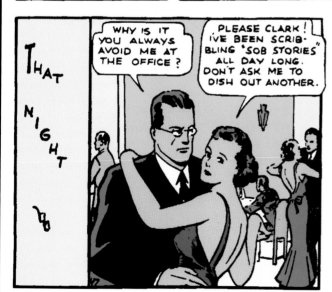

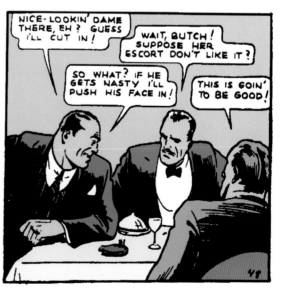

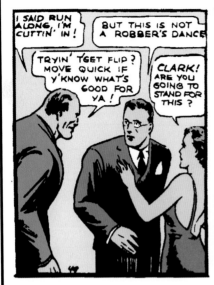

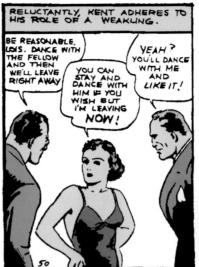

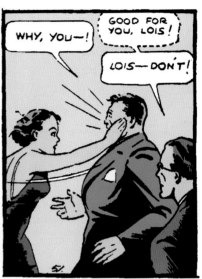

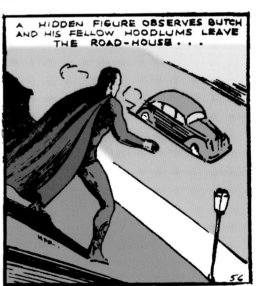

20

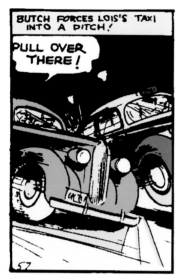

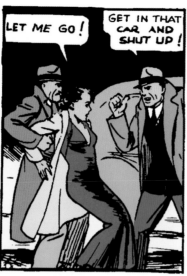

21

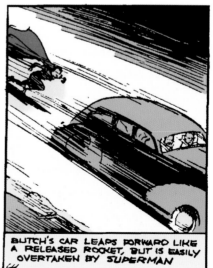

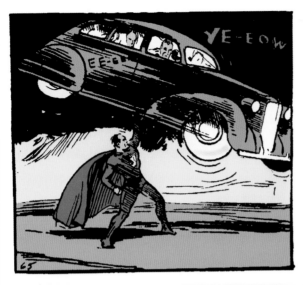

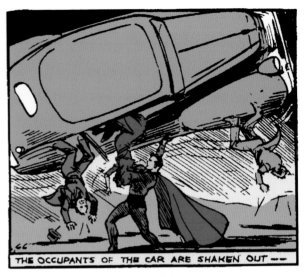

THE OCCUPANTS OF THE CAR ARE SHAKEN OUT ――

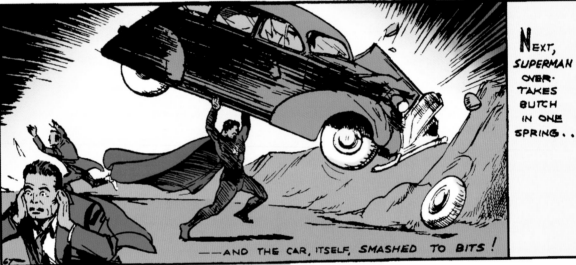

NEXT, SUPERMAN OVER-TAKES BUTCH IN ONE SPRING..

――AND THE CAR, ITSELF, SMASHED TO BITS !

JUST A MINUTE, BUTCH !

DO YOU MIND ?

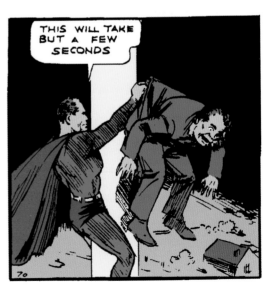

THIS WILL TAKE BUT A FEW SECONDS

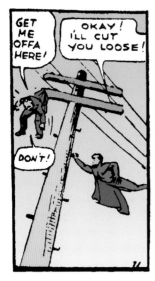

GET ME OFFA HERE!

OKAY! I'LL CUT YOU LOOSE!

DON'T!

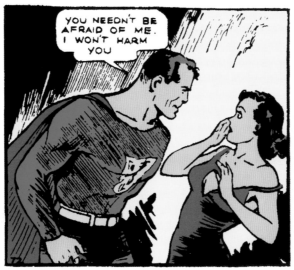

YOU NEEDN'T BE AFRAID OF ME. I WON'T HARM YOU

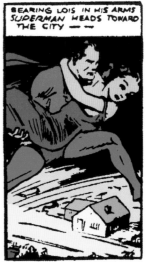

BEARING LOIS IN HIS ARMS SUPERMAN HEADS TOWARD THE CITY — —

— — DEPOSITING HER UPON ITS OUTSKIRTS

I'D ADVISE YOU NOT TO PRINT THIS LITTLE EPISODE

NEXT MORNING

BUT I TELL YOU I SAW SUPERMAN LAST NIGHT!

ARE YOU SURE IT WASN'T PINK ELEPHANTS YOU SAW?

EDITOR

LOIS TREATS CLARK COLDER THAN EVER

I'M SORRY ABOUT LAST NIGHT — PLEASE DON'T BE ANGRY WITH ME

23

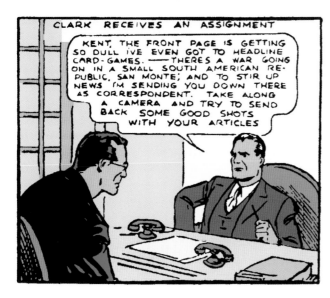

CLARK RECEIVES AN ASSIGNMENT

KENT, THE FRONT PAGE IS GETTING SO DULL I'VE EVEN GOT TO HEADLINE CARD-GAMES. — THERE'S A WAR GOING ON IN A SMALL SOUTH AMERICAN RE-PUBLIC, SAN MONTE; AND TO STIR UP NEWS I'M SENDING YOU DOWN THERE AS CORRESPONDENT. TAKE ALONG A CAMERA AND TRY TO SEND BACK SOME GOOD SHOTS WITH YOUR ARTICLES

KENT TAKES A TRAIN, NOT TO-WARD SAN MONTE, BUT TO WASHINGTON D.C.

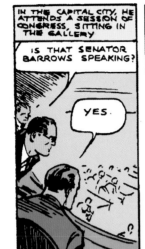

IN THE CAPITAL CITY, HE ATTENDS A SESSION OF CONGRESS, SITTING IN THE GALLERY

IS THAT SENATOR BARROWS SPEAKING?

YES.

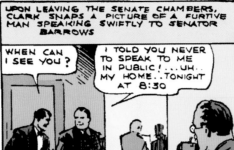

UPON LEAVING THE SENATE CHAMBERS, CLARK SNAPS A PICTURE OF A FURTIVE MAN SPEAKING SWIFTLY TO SENATOR BARROWS

WHEN CAN I SEE YOU?

I TOLD YOU NEVER TO SPEAK TO ME IN PUBLIC!...UH.. MY HOME..TONIGHT AT 8:30

AT THE "MORGUE" OF A LOCAL NEWSPAPER....

WHO'S THE CHAP SPEAKING TO SENATOR BARROWS?

WHY, THAT'S ALEX GREER, THE SLICKEST LOBBYIST IN WASHINGTON. NO ONE KNOWS WHAT INTERESTS BACK HIM.

EIGHT-THIRTY P.M.! OUTSIDE SENATOR BARROWS' RESIDENCE...
AN EAVESDROPPER LISTENS IN ON AN INTERESTING CONVERSATION!

I'VE TOLD YOU TO AVOID ME IN PUBLIC. WHAT WOULD PEOPLE THINK IF THEY KNEW I HAD ANYTHING TO DO WITH YOU?

QUIT SPUTTERING! I HAD TO SEE YOU. TELL ME: DO YOU THINK YOU'LL SUCCEED IN PUSHING THE BILL THRU?

THERE'S NO DOUBT ABOUT IT! THE BILL WILL BE PASSED BEFORE ITS FULL IMPLICATIONS ARE REALIZED. BEFORE ANY REMEDIAL STEPS CAN BE TAKEN, OUR COUNTRY WILL BE EMBROILED WITH EUROPE.

FINE! WE'LL TAKE CARE OF YOU FINAN-CIALLY FOR THIS!

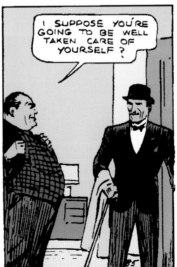

I SUPPOSE YOU'RE GOING TO BE WELL TAKEN CARE OF YOURSELF?

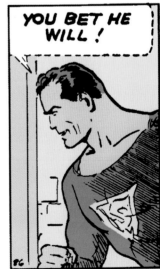

YOU BET HE WILL!

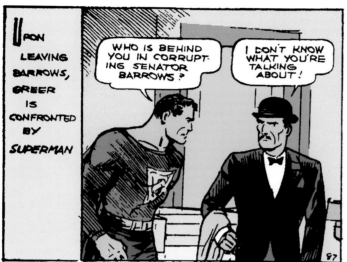

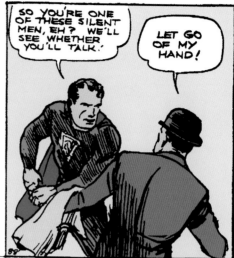

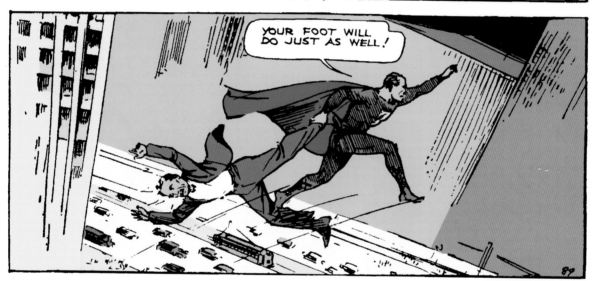

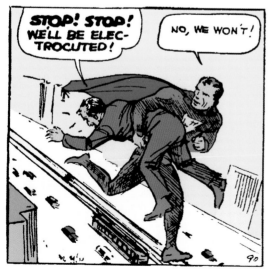

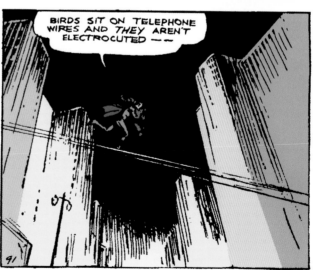

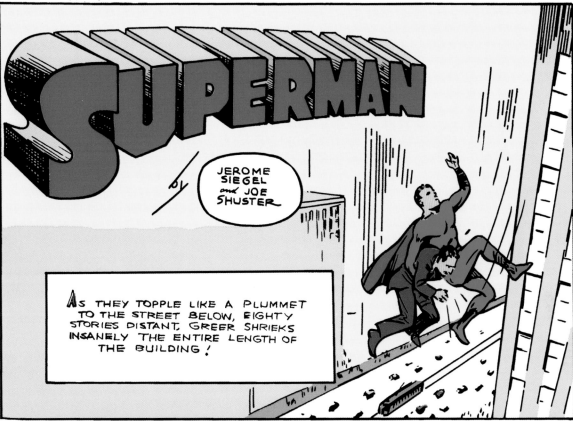

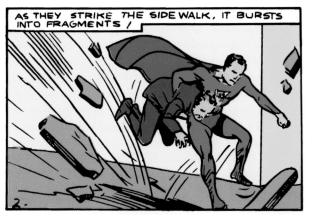

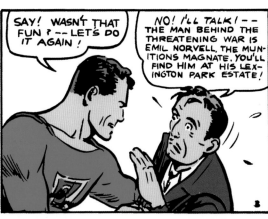

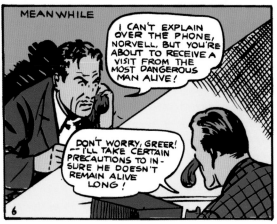

Action Comics #2 (July 1938) - script: Jerry Siegel - art: Joe Shuster

FIVE MINUTES ELAPSE -- THEN...
...SUPERMAN STEPS THRU THE WINDOW OF EMIL NORVELL'S STUDY AND CALMLY CONFRONTS HIM...

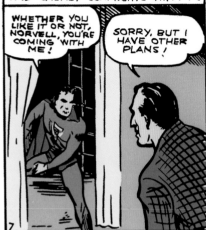

WHETHER YOU LIKE IT OR NOT, NORVELL, YOU'RE COMING WITH ME!

SORRY, BUT I HAVE OTHER PLANS!

AS HE SPEAKS, THE MUNITIONS MANUFACTURER SURREPTITIOUSLY REACHES BEHIND HIM TO PRESS A BUTTON ON HIS DESK.

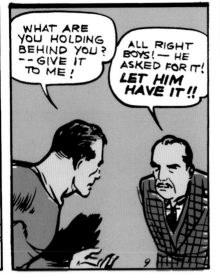

WHAT ARE YOU HOLDING BEHIND YOU? --GIVE IT TO ME!

ALL RIGHT BOYS!-- HE ASKED FOR IT! *LET HIM HAVE IT!!*

INSTANTLY SEVERAL PANELS ABOUT THE ROOM SLIDE ASIDE AND OUT STEP A NUMBER OF ARMED GUARDS!

NEXT MOMENT SUPERMAN IS THE CENTER OF A DEAFENING MACHINE-GUN BARRAGE!

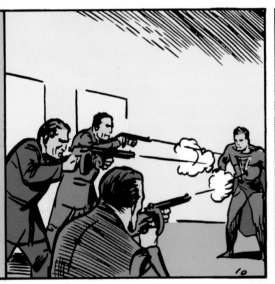

UNHARMED BY THE RAIN OF MACHINE-GUN BULLETS, *SUPERMAN* STREAKS TOWARD HIS WOULD-BE MURDERERS!

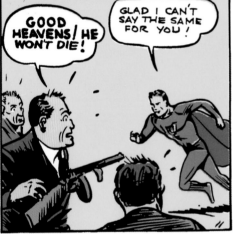

GOOD HEAVENS! HE WON'T DIE!

GLAD I CAN'T SAY THE SAME FOR YOU!

A MOMENT LATER A DOZEN BODIES FLY HEADLONG OUT THE WINDOW INTO THE NIGHT, THE MACHINE-GUNS WRAPPED FIRMLY ABOUT THEIR NECKS!

YOU SEE HOW EFFORTLESSLY I CRUSH THIS BAR OF IRON IN MY HAND? --THAT BAR COULD JUST AS EASILY BE YOUR NECK!... NOW, FOR THE LAST TIME: ARE YOU COMING WITH ME?

YES! YES! IMMEDIATELY!

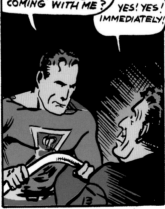

SEVERAL MINUTES LATER...

YOU SEE THAT STEAMER? IT'S THE BARONTA. TOMORROW, IT LEAVES FOR SAN MONTE. UNLESS I FIND YOU ABOARD IT WHEN IT SAILS, I SWEAR I'LL FOLLOW YOU TO WHATEVER HOLE YOU HIDE IN, AND TEAR OUT YOUR CRUEL HEART WITH MY BARE HANDS!

I-- I'LL BE ON IT!

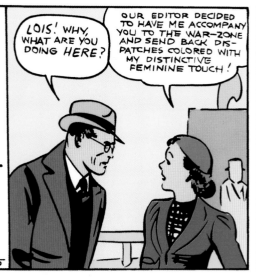

NEXT DAY AN ODD VARIETY OF PASSENGERS BOARD THE SAN MONTE' BOUND STEAMER BARONTA... CLARK KENT AND LOIS LANE...

LOIS! WHY, WHAT ARE YOU DOING *HERE*?

OUR EDITOR DECIDED TO HAVE ME ACCOMPANY YOU TO THE WAR-ZONE AND SEND BACK DISPATCHES COLORED WITH MY DISTINCTIVE FEMININE TOUCH!

15

...A GROUP OF SULLEN-FACED TOUGHS WHO POSSIBLY INTEND TO ENLIST WITH ONE OF THE ARMIES AS PAID MERCENARIES...

16

...LOLA CORTEZ, WOMAN OF MYSTERY, AN EXOTIC BEAUTY WHO FAIRLY RADIATES DANGER AND INTRIGUE...

..AND EMIL NORVELL, WHO HURRIES PASTY-FACED UP THE GANG-PLANK AND QUICKLY CONFINES HIMSELF TO HIS CABIN.

HALF AN HOUR LATER THE *BARONTA* HOISTS ITS ANCHOR AND SLIPS OUT TO SEA, DESTINED FOR ONE OF THE STRANGEST VOYAGES THE WORLD HAS EVER KNOWN.

29

IT IS THE FIRST NIGHT OUT...

AS NORVELL NERVOUSLY PACES HIS CABIN, THERE COMES A KNOCK AT THE DOOR...

HE ANSWERS IT....

20

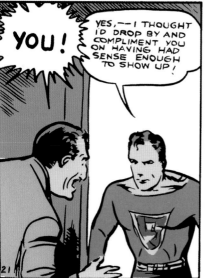

YOU!

YES,-- I THOUGHT I'D DROP BY AND COMPLIMENT YOU ON HAVING HAD SENSE ENOUGH TO SHOW UP!

21

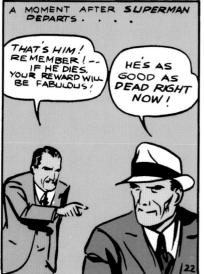

A MOMENT AFTER *SUPERMAN* DEPARTS...

THAT'S HIM! REMEMBER!-- IF HE DIES, YOUR REWARD WILL BE FABULOUS!

HE'S AS GOOD AS DEAD RIGHT NOW!

22

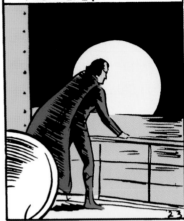

AS SUPERMAN STANDS SILENTLY AT THE SHIP'S RAIL, ADMIRING THE MOONLIGHT, HE WHIRLS SUDDENLY AT THE SOUND OF FOOTSTEPS!

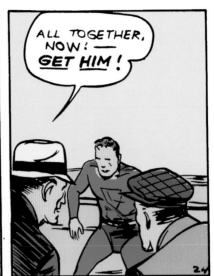

ALL TOGETHER, NOW! — GET HIM!

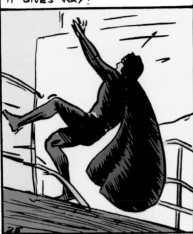

FOR AN INSTANT SUPERMAN BRACES HIMSELF AGAINST THE RAIL -- AND IN THAT SECOND IT GIVES WAY!

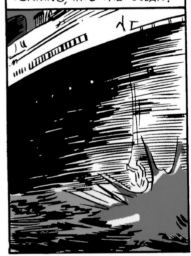

HE IS FLUNG, TWISTING AND TURNING, INTO THE OCEAN!

THE THUGS REPORT BACK TO NORVELL...

IT WAS SIMPLE! A LITTLE SHOVE AND HE TOPPLED OVERBOARD! -- NOW HOW ABOUT THAT DOUGH YOU PROMISED US!

YOU'LL GET NOTHING! GET OUT OF HERE, YOU TRUSTING FOOLS, AND BE GLAD I DON'T TURN YOU OVER TO THE POLICE!

MEANWHILE -- AT THAT VERY INSTANT SUPERMAN, SWIMMING VIGOROUSLY, HAS CAUGHT UP WITH THE STEAMER . . .

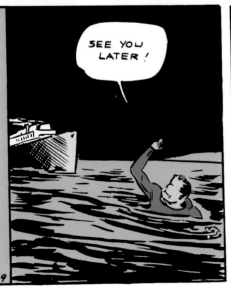

. . BUT INSTEAD OF CLIMBING ABOARD HE CONTINUES ONWARD UNTIL THE BARONTA IS OUTDISTANCED FAR BEHIND!

SEE YOU LATER!

NEXT EVENING, A FEW MINUTES AFTER THE STEAMER LANDS . . NORVELL IS ATTACKED BY HIS DOUBLE-CROSSED HENCHMEN.

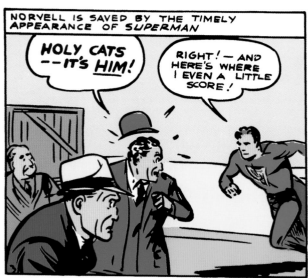

NORVELL IS SAVED BY THE TIMELY APPEARANCE OF *SUPERMAN*

HOLY CATS -- IT'S *HIM!*

RIGHT! -- AND HERE'S WHERE I EVEN A LITTLE SCORE!

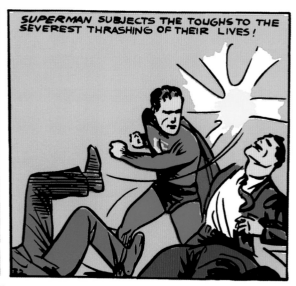

SUPERMAN SUBJECTS THE TOUGHS TO THE SEVEREST THRASHING OF THEIR LIVES!

THE THUGS FLEE BEFORE HIS FURY!

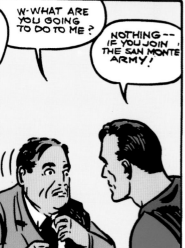

YOU SAVED ME! -- BUT WHY?

BECAUSE THE FATE YOU ESCAPED IS PLEASANT INDEED COMPARED TO THE ONE I HAVE IN STORE FOR YOU!

W-WHAT ARE YOU GOING TO DO TO ME?

NOTHING -- IF YOU JOIN THE SAN MONTE ARMY!

33

35

31

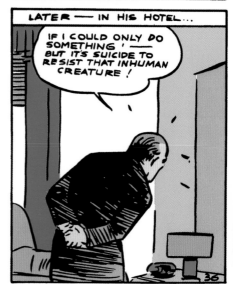

LATER -- IN HIS HOTEL...

IF I COULD ONLY DO SOMETHING! -- BUT IT'S SUICIDE TO RESIST THAT INHUMAN CREATURE!

36

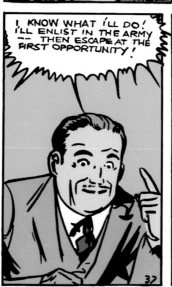

I KNOW WHAT I'LL DO! I'LL ENLIST IN THE ARMY -- THEN ESCAPE AT THE FIRST OPPORTUNITY!

37

AFTER NORVELL ENLISTS --

YOU!

YES, I JOINED TOO-- I COULDN'T BEAR BEING PARTED FROM YOU!

38

ORDERS FROM HEADQUARTERS, SIR WE'RE TO MOVE TO THE FRONT.

THE NEW DETACHMENT MOVES IN TOWARD THE BATTLE-LINE.

WHAT ARE YOU TRYING TO DO? — KILL US BOTH?

YOU'LL SEE!

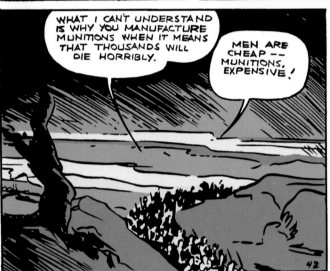

WHAT I CAN'T UNDERSTAND IS WHY YOU MANUFACTURE MUNITIONS WHEN IT MEANS THAT THOUSANDS WILL DIE HORRIBLY.

MEN ARE CHEAP -- MUNITIONS, EXPENSIVE!

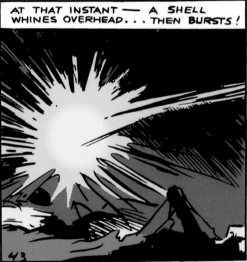

AT THAT INSTANT — A SHELL WHINES OVERHEAD... THEN BURSTS!

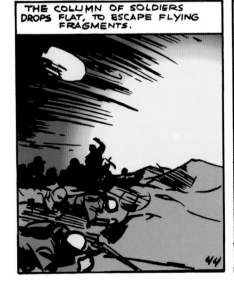

THE COLUMN OF SOLDIERS DROPS FLAT, TO ESCAPE FLYING FRAGMENTS.

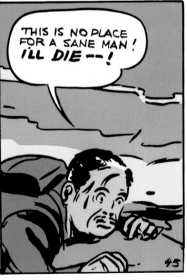

THIS IS NO PLACE FOR A SANE MAN! I'LL DIE --!

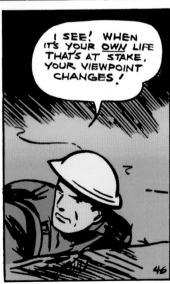

I SEE! WHEN IT'S YOUR OWN LIFE THAT'S AT STAKE, YOUR VIEWPOINT CHANGES!

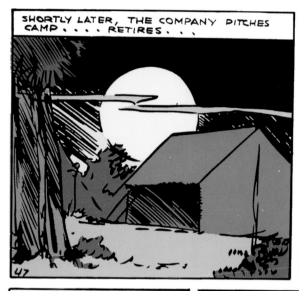

SHORTLY LATER, THE COMPANY PITCHES CAMP.... RETIRES...

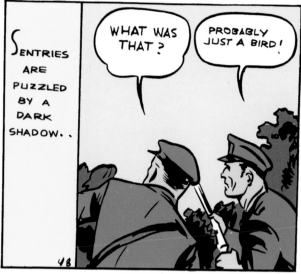

SENTRIES ARE PUZZLED BY A DARK SHADOW..

WHAT WAS THAT?

PROBABLY JUST A BIRD!

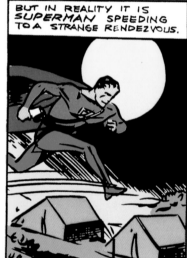

BUT IN REALITY IT IS SUPERMAN SPEEDING TO A STRANGE RENDEZVOUS.

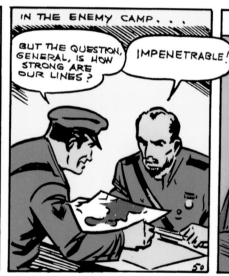

IN THE ENEMY CAMP...

BUT THE QUESTION, GENERAL, IS HOW STRONG ARE OUR LINES?

IMPENETRABLE!

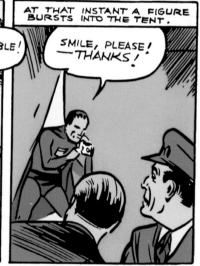

AT THAT INSTANT A FIGURE BURSTS INTO THE TENT.

SMILE, PLEASE! —THANKS!

33

A FEW MOMENTS LATER —

GONE!— BUT HE WON'T ESCAPE!

GUARDS!

LATER THAT EVENING, CLARK KENT MAILS A PACKAGE...

WHERE TO?

THE EVENING NEWS... CLEVELAND, OHIO

THE EVENING NEWS PRINTS A PICTURE-SCOOP...

EVENING NEWS

AMAZING WAR PICTURES!!

GENERALS CONFER

MEANWHILE, LOIS LANE AND LOLA CORTEZ HAVE REGISTERED AT THE SAME HOTEL.

I'M A REPORTER DOWN HERE ON A NEWS ASSIGNMENT, AND YOU?

-- A WEALTHY TRAVELER.

AT THAT INSTANT, ARMY OFFICERS ENTERS THE HOTEL --

WHAT'S THE TROUBLE?

OFFICIAL BUSINESS.

SUDDENLY PANICKY, LOLA DARTS INTO AN ELEVATOR . . .

. . . AND HIDES A CERTAIN DOCUMENT IN LOIS'S ROOM!

AN IMPORTANT DOCUMENT HAS BEEN STOLEN. MAY WE SEARCH THE GUESTS' ROOMS?

YOU HAVE MY PERMISSION.

SORRY, MADAM!

I TOLD YOU THAT YOU WERE WASTING TIME SEARCHING MY ROOM!

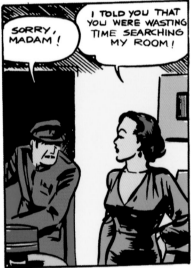

THE PLANTED DOCUMENT IS DISCOVERED IN LOIS' ROOM!

SORRY, WE MUST PLACE YOU UNDER MILITARY ARREST!

BUT I KNOW NOTHING OF THIS!

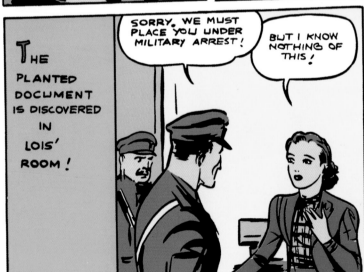

SENTENCE IS PASSED --

BUT I'M INNOCENT!

IT IS THE JUDGEMENT OF THIS COURT THAT YOU SHALL BE EXECUTED AT DAWN FOR ESPIONAGE!

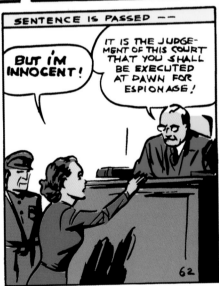

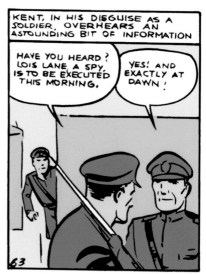

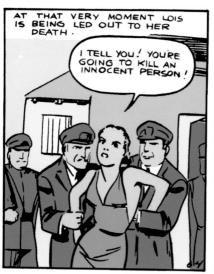

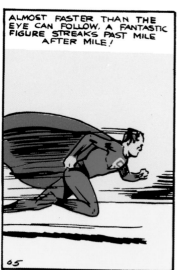

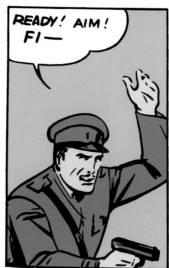

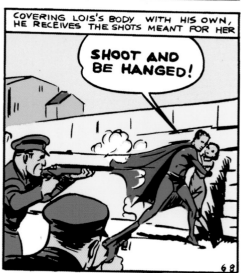

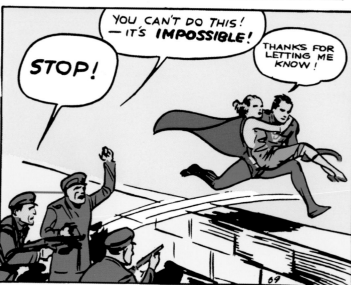

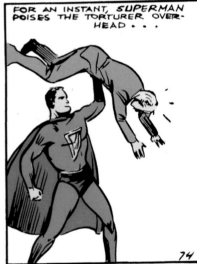

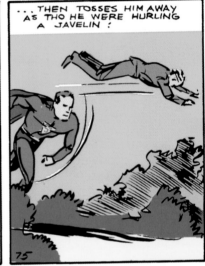

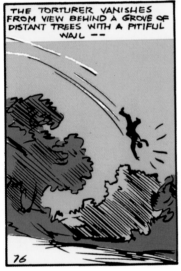

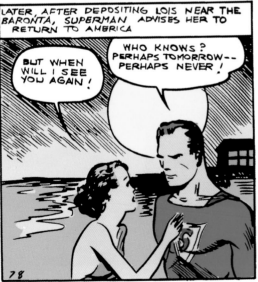

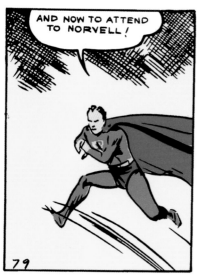

AND NOW TO ATTEND TO NORVELL!

79

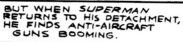
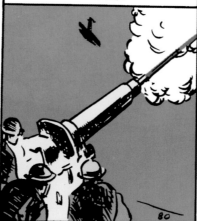

BUT WHEN *SUPERMAN* RETURNS TO HIS DETACHMENT, HE FINDS ANTI-AIRCRAFT GUNS BOOMING.

80

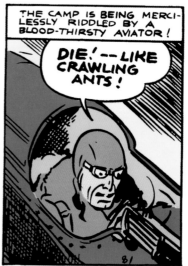

THE CAMP IS BEING MERCILESSLY RIDDLED BY A BLOOD-THIRSTY AVIATOR!

DIE! -- LIKE CRAWLING ANTS!

81

SUPERMAN LEAPS TO THE ATTACK! FOR THE FIRST TIME IN ALL HISTORY, A MAN BATTLES AN AIRPLANE SINGLE-HANDED!

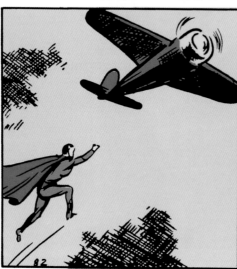

82

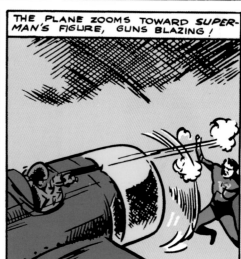

THE PLANE ZOOMS TOWARD *SUPERMAN'S* FIGURE, GUNS BLAZING!

83

37

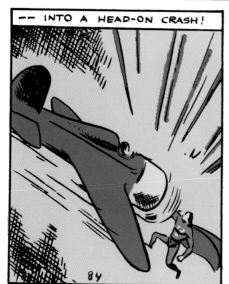

-- INTO A HEAD-ON CRASH!

84

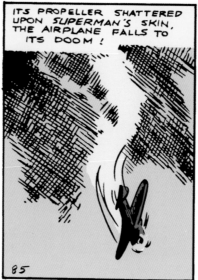

ITS PROPELLER SHATTERED UPON *SUPERMAN'S* SKIN, THE AIRPLANE FALLS TO ITS DOOM!

85

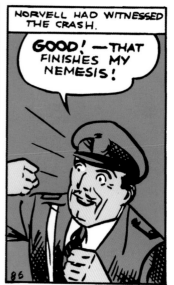

NORVELL HAD WITNESSED THE CRASH.

GOOD! -- THAT FINISHES MY NEMESIS!

86

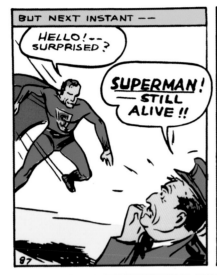

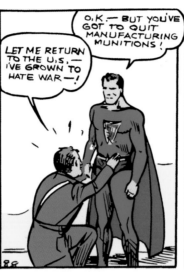

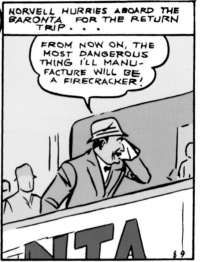

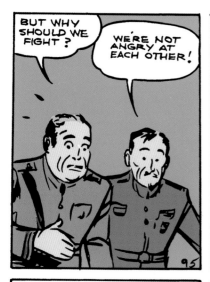

BUT WHY SHOULD WE FIGHT?

WE'RE NOT ANGRY AT EACH OTHER!

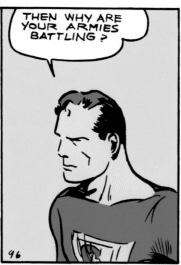

THEN WHY ARE YOUR ARMIES BATTLING?

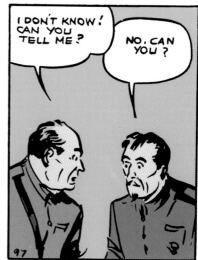

I DON'T KNOW! CAN YOU TELL ME?

NO, CAN YOU?

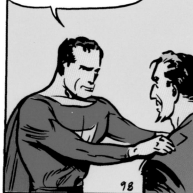

GENTLEMEN, IT'S OBVIOUS YOU'VE BEEN FIGHTING ONLY TO PROMOTE THE SALE OF MUNITIONS! — WHY NOT SHAKE HANDS AND MAKE UP?

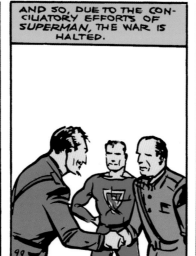

AND SO, DUE TO THE CONCILIATORY EFFORTS OF SUPERMAN, THE WAR IS HALTED.

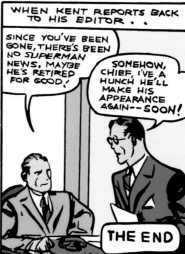

WHEN KENT REPORTS BACK TO HIS EDITOR..

SINCE YOU'VE BEEN GONE, THERE'S BEEN NO SUPERMAN NEWS. MAYBE HE'S RETIRED FOR GOOD!

SOMEHOW, CHIEF, I'VE A HUNCH HE'LL MAKE HIS APPEARANCE AGAIN--SOON!

THE END

39

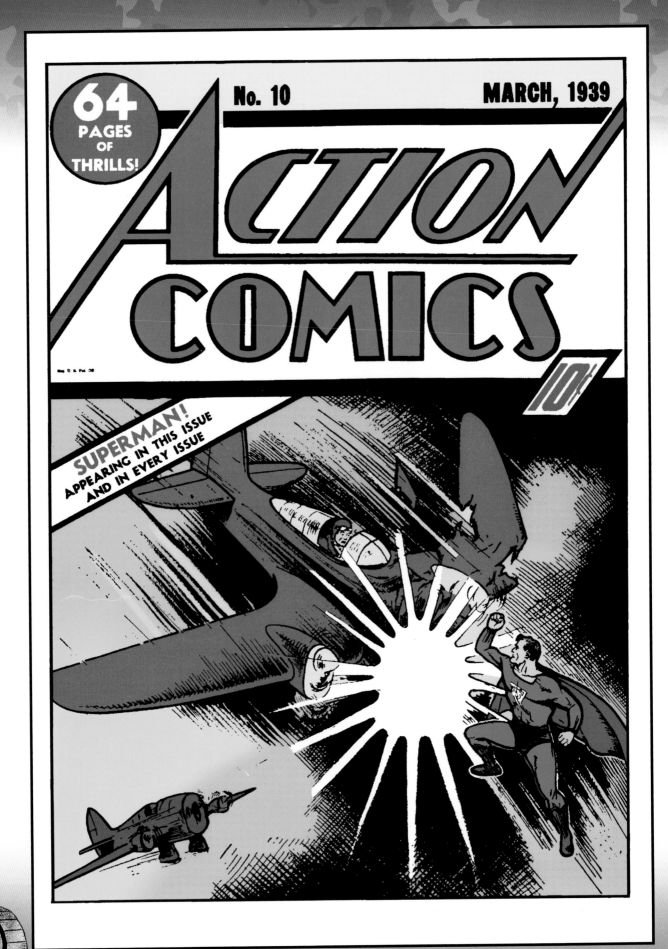

Action Comics #10 (March 1939) - cover art: Joe Shuster

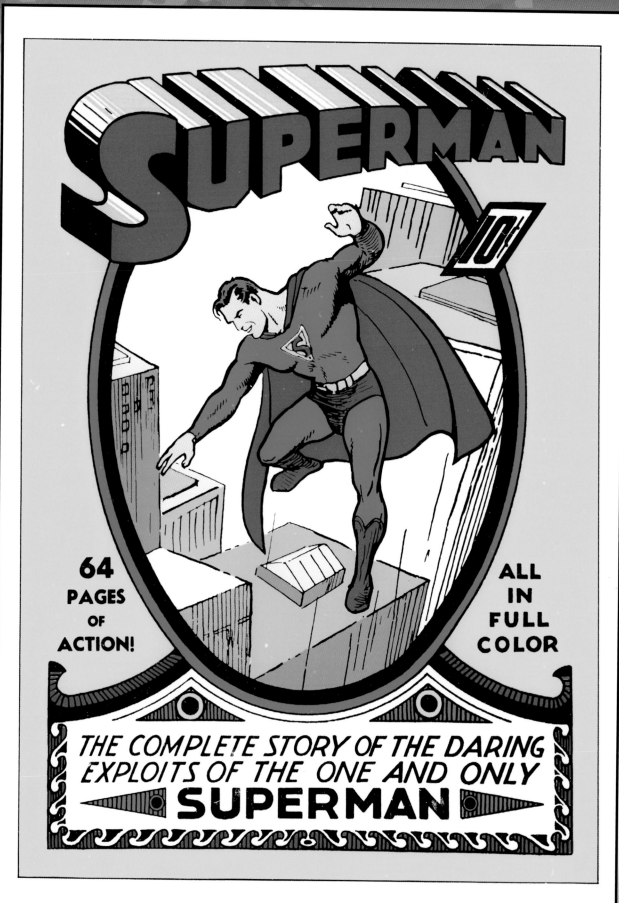

Superman #1 (Summer 1939) - cover art: Joe Shuster

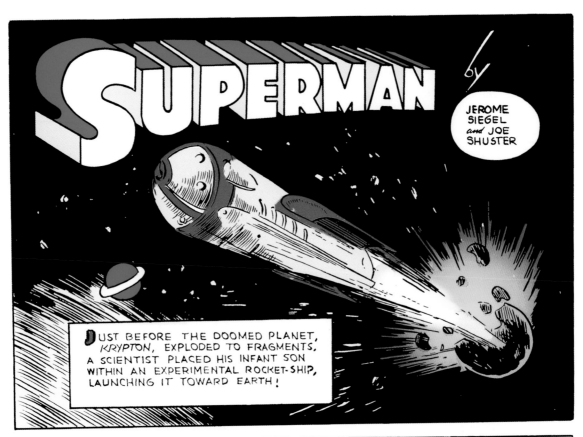

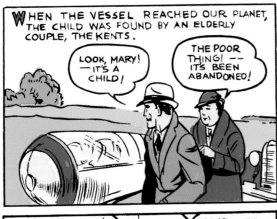

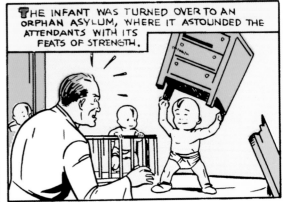

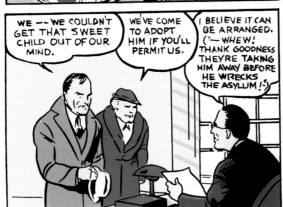

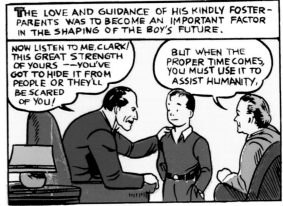

Superman #1 (Summer 1939) - script: Jerry Siegel - art: Joe Shuster

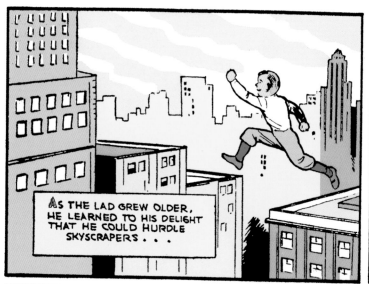

As the lad grew older, he learned to his delight that he could hurdle skyscrapers . . .

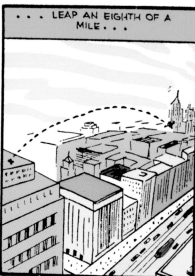

. . . Leap an eighth of a mile . . .

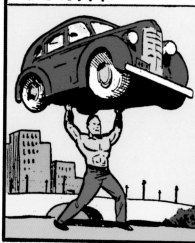

. . . Raise tremendous weights . . .

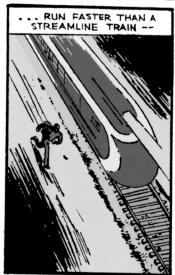

. . . Run faster than a streamline train --

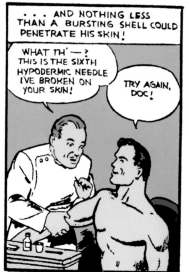

. . . And nothing less than a bursting shell could penetrate his skin!

WHAT TH' —? THIS IS THE SIXTH HYPODERMIC NEEDLE I'VE BROKEN ON YOUR SKIN!

TRY AGAIN, DOC!

43

The passing away of his foster-parents greatly grieved Clark Kent. But it strengthened a determination that had been growing in his mind.

Clark decided he must turn his titanic strength into channels that would benefit mankind.

And so was created--

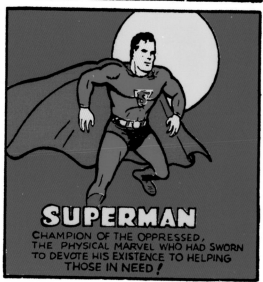

SUPERMAN

CHAMPION OF THE OPPRESSED, THE PHYSICAL MARVEL WHO HAD SWORN TO DEVOTE HIS EXISTENCE TO HELPING THOSE IN NEED!

Ad for Superman of America Club, *Superman* #1 (Summer 1939) - art: Joe Shuster

44

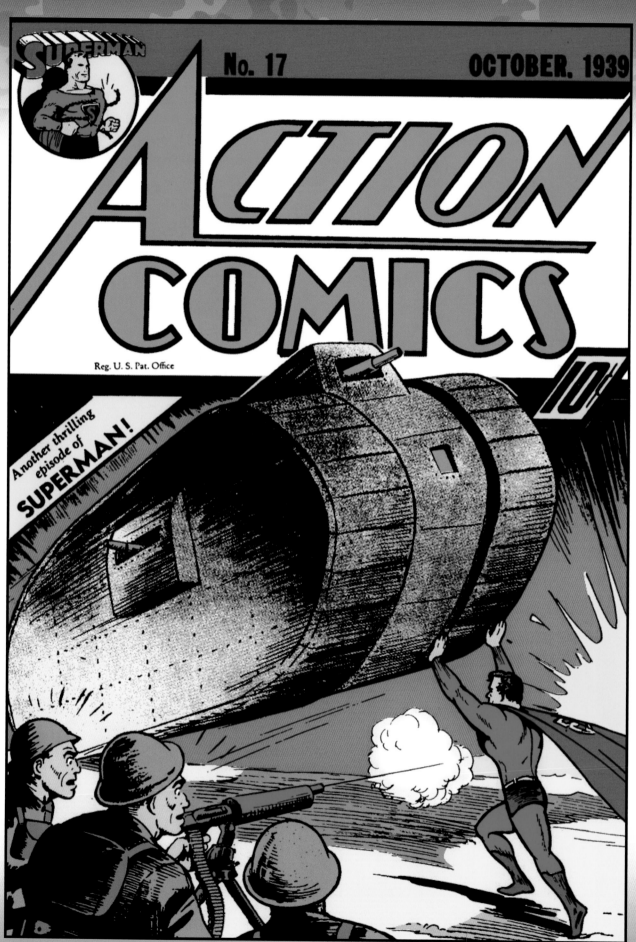

Action Comics #17 (Oct. 1939) - cover art: Joe Shuster

SUPERMAN
CHAMPIONS
UNIVERSAL PEACE!

By Jerry Siegel and Joe Shuster

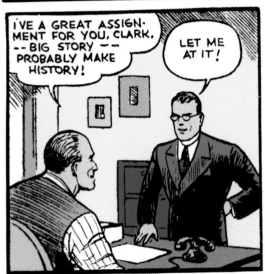

I'VE A GREAT ASSIGN-MENT FOR YOU, CLARK. --BIG STORY -- PROBABLY MAKE HISTORY!

LET ME AT IT!

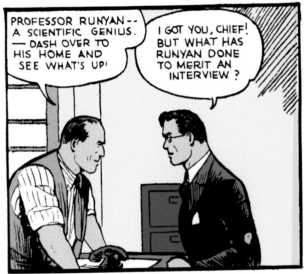

PROFESSOR RUNYAN-- A SCIENTIFIC GENIUS. -- DASH OVER TO HIS HOME AND SEE WHAT'S UP!

I GOT YOU, CHIEF! BUT WHAT HAS RUNYAN DONE TO MERIT AN INTERVIEW?

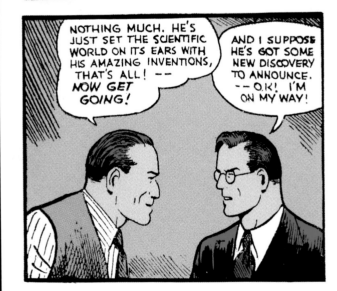

NOTHING MUCH. HE'S JUST SET THE SCIENTIFIC WORLD ON ITS EARS WITH HIS AMAZING INVENTIONS, THAT'S ALL! -- NOW GET GOING!

AND I SUPPOSE HE'S GOT SOME NEW DISCOVERY TO ANNOUNCE. -- O.K! I'M ON MY WAY!

LATER

YOU'RE PROFESSOR RUNYAN, AREN'T YOU?

YES! AND YOU MUST BE THE REPORTER FROM THE DAILY STAR! -- STEP IN, YOUNG MAN! I'VE A STORY TO TELL THAT SHOULD MAKE YOUR FRONT PAGE!

Superman #2 (Fall 1939) - script: Jerry Siegel - art: Joe Shuster

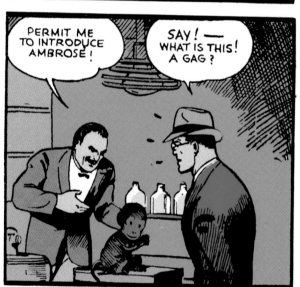

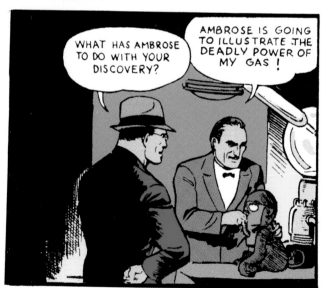

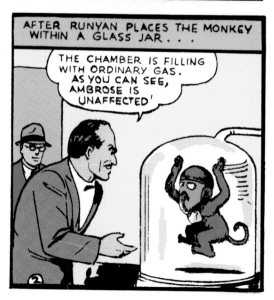

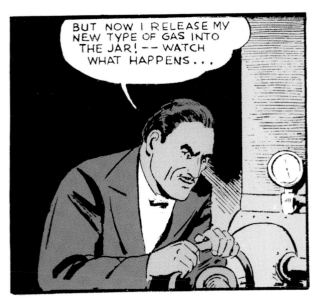

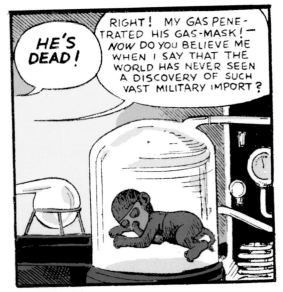

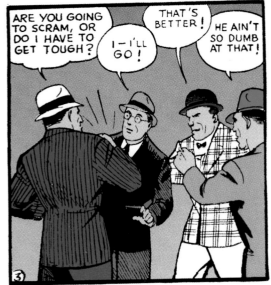

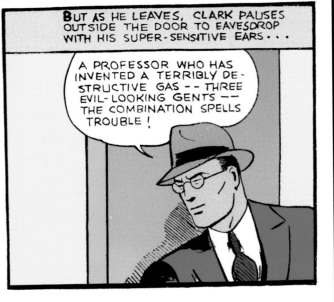

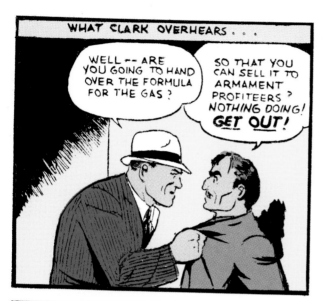

WHAT CLARK OVERHEARS . . .

WELL -- ARE YOU GOING TO HAND OVER THE FORMULA FOR THE GAS?

SO THAT YOU CAN SELL IT TO ARMAMENT PROFITEERS? NOTHING DOING! GET OUT!

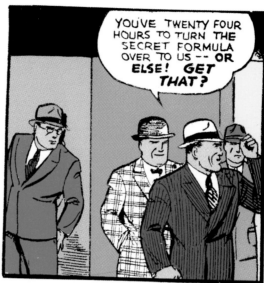

YOU'VE TWENTY FOUR HOURS TO TURN THE SECRET FORMULA OVER TO US -- OR ELSE! GET THAT?

CLARK TRAILS THE INTERNATIONAL RACKETEERS TAXI . . .

. . . TO A BUNGALOW BESIDE A PRIVATE FLYING FIELD.

SO THERE'S WHERE THEY HANG OUT! HM-M! I'LL JUST KEEP THAT IN MIND!

49

AFTER CLARK RETURNS TO THE NEWS-PAPER OFFICE . . .

I'LL DASH OFF THIS WRITE-UP OF RUNYAN, THEN RETURN TO BARTOW AND HIS FRIENDS FOR A LITTLE "TALK"!

4

HERE IT IS, CHIEF . . . THE INTERVIEW WITH PROFESSOR RUNYAN. — SOME STORY.

JUST A MOMENT WHILE I ANSWER THIS CALL!

WHAT'S THAT? SAY IT AGAIN!— WELL, I'LL BE BLOWED!

WHAT IS IT, CHIEF?

RUNYAN'S JUST BEEN FOUND --MURDERED!

RUNYAN -- MURDERED! ...THOSE THREE MEN WHO THREATENED HIM ARE HIS SLAYERS -- NO DOUBT OF IT!

← EDITOR

LATER... WITHIN THE PRIVACY OF HIS APARTMENT, CLARK KENT REMOVES CIVILIAN CLOTHES...

...REVEALING HIS SUPERMAN COSTUME BENEATH!

NOW FOR THEIR HIDEOUT!

THOSE MURDERERS ARE SLATED TO RECEIVE A VISIT FROM SUPERMAN ...AND JUSTICE!

DOWN TOWARDS BARTOW'S BUNGALOW HURTLES A FANTASTIC FIGURE...

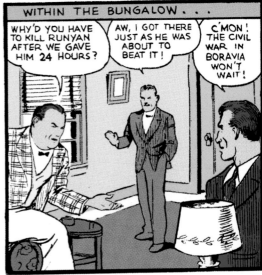

WITHIN THE BUNGALOW...

WHY'D YOU HAVE TO KILL RUNYAN AFTER WE GAVE HIM 24 HOURS?

AW, I GOT THERE JUST AS HE WAS ABOUT TO BEAT IT!

C'MON! THE CIVIL WAR IN BORAVIA WON'T WAIT!

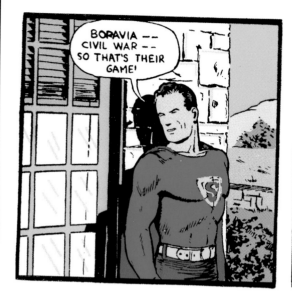

BORAVIA -- CIVIL WAR -- SO THAT'S THEIR GAME!

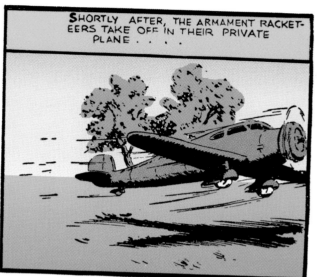

SHORTLY AFTER, THE ARMAMENT RACKETEERS TAKE OFF IN THEIR PRIVATE PLANE

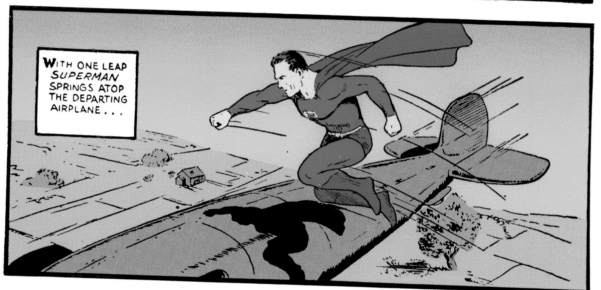

WITH ONE LEAP SUPERMAN SPRINGS ATOP THE DEPARTING AIRPLANE . . .

51

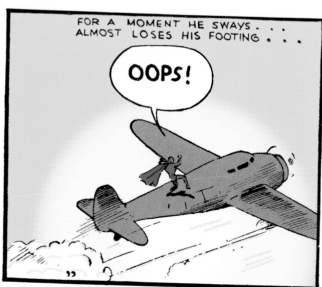

FOR A MOMENT HE SWAYS . . . ALMOST LOSES HIS FOOTING

OOPS!

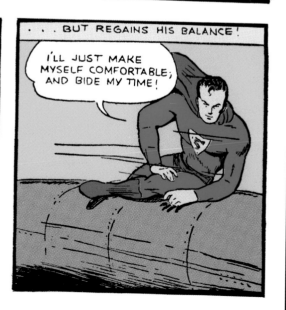

. . . BUT REGAINS HIS BALANCE!

I'LL JUST MAKE MYSELF COMFORTABLE, AND BIDE MY TIME!

FOR HOURS THE INTERNATIONAL ARMAMENT CROOKS' PLANE CONTINUES ITS FLIGHT, WITH THE *MAN OF STEEL* CLINGING TIRELESSLY ATOP IT...

ARE WE NEAR BORAVIA?

WE'LL REACH IT IN A FEW MOMENTS!

AND THEN, TO CASH IN ON THAT FORMULA!

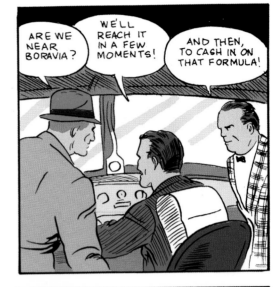

SEVERAL MINUTES LATER THE AIRPLANE WINGS SWIFTLY OVER BORAVIA, A SMALL COUNTRY EXHAUSTING ITS LIFE BLOOD IN SENSELESS CIVIL WAR....!

SUPERMAN ACTS! — TEARING AT THE PLANE'S METAL SIDES, *HE RIPS IT OPEN!*

IT'S TIME I HAD A LITTLE TALK WITH BARTOW!

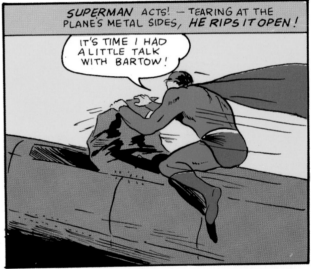

WHAT IN--? HOW DID YOU GET HERE?

NEVER MIND! WHAT YOU SHOULD BE CONCERNED WITH IS-- WHAT I'LL DO NOW THAT I'M HERE!

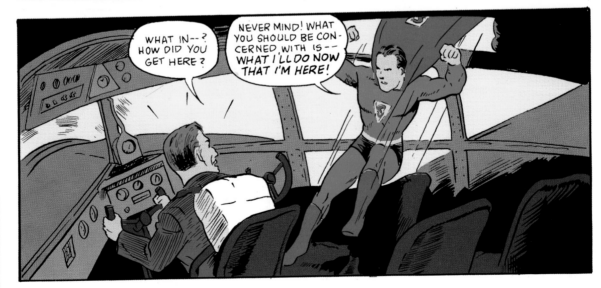

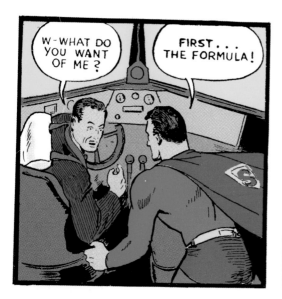

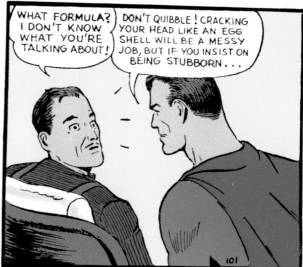

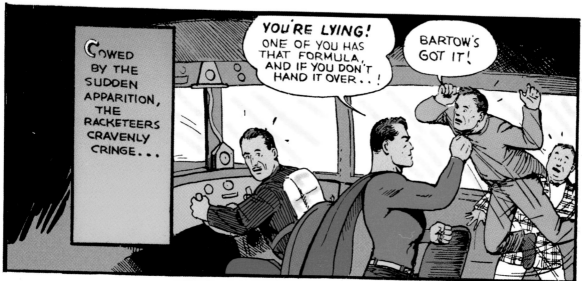

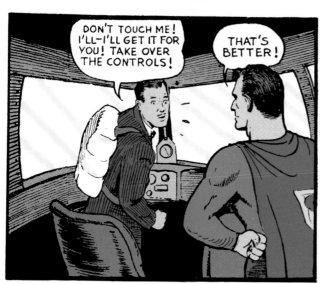

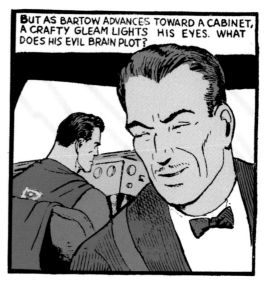

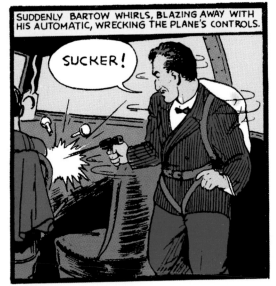

SUDDENLY BARTOW WHIRLS, BLAZING AWAY WITH HIS AUTOMATIC, WRECKING THE PLANE'S CONTROLS.

SUCKER!

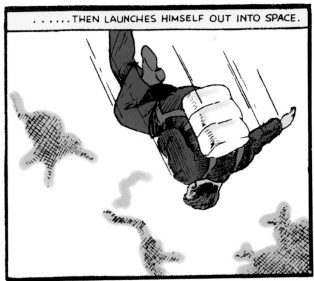

......THEN LAUNCHES HIMSELF OUT INTO SPACE.

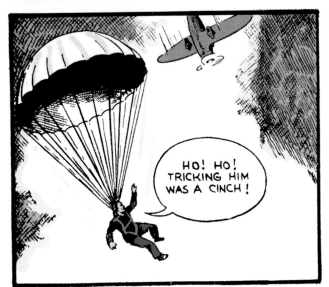

HO! HO! TRICKING HIM WAS A CINCH!

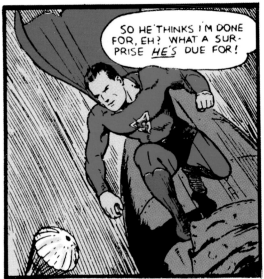

SO HE THINKS I'M DONE FOR, EH? WHAT A SURPRISE HE'S DUE FOR!

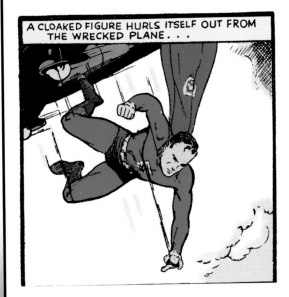

A CLOAKED FIGURE HURLS ITSELF OUT FROM THE WRECKED PLANE...

... DOWN IT SPEEDS IN A BREATHTAKING PLUNGE......

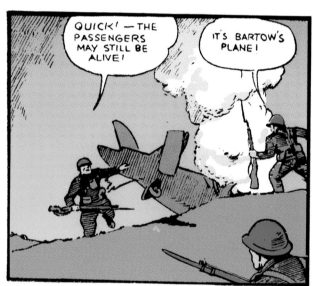

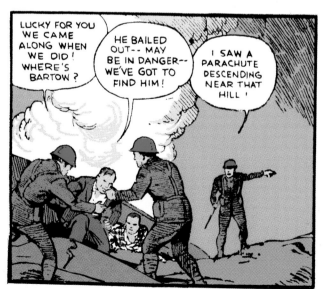

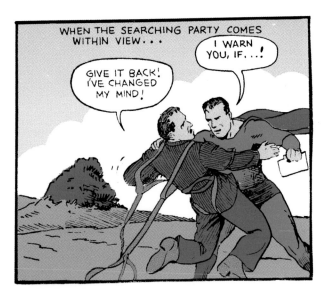

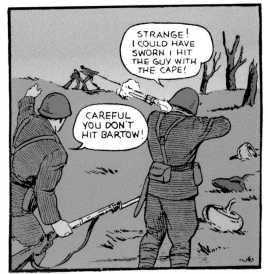

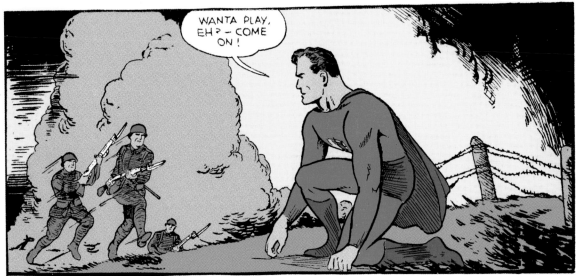

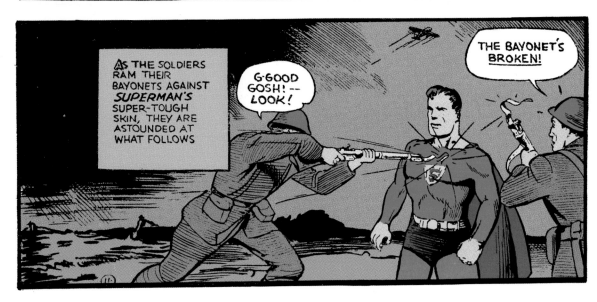

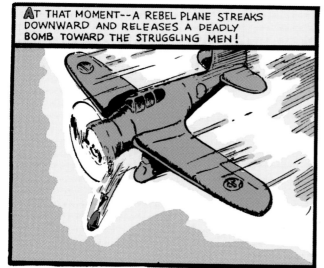

AT THAT MOMENT--A REBEL PLANE STREAKS DOWNWARD AND RELEASES A DEADLY BOMB TOWARD THE STRUGGLING MEN!

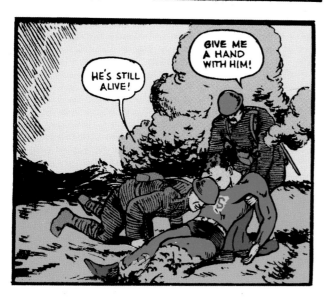

HE'S STILL ALIVE!

GIVE ME A HAND WITH HIM!

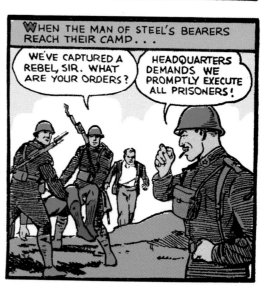

WHEN THE MAN OF STEEL'S BEARERS REACH THEIR CAMP...

WE'VE CAPTURED A REBEL, SIR. WHAT ARE YOUR ORDERS?

HEADQUARTERS DEMANDS WE PROMPTLY EXECUTE ALL PRISONERS!

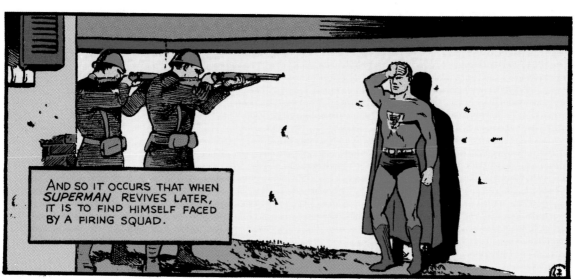

AND SO IT OCCURS THAT WHEN *SUPERMAN* REVIVES LATER, IT IS TO FIND HIMSELF FACED BY A FIRING SQUAD.

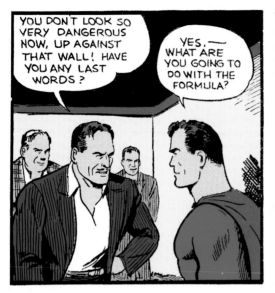

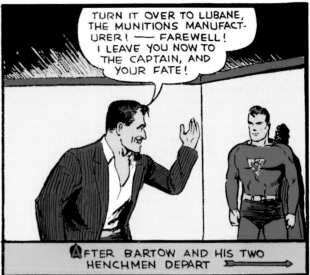

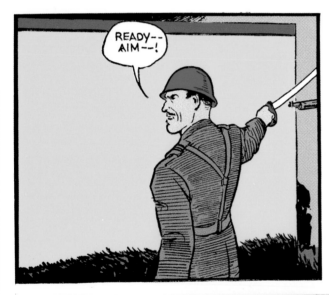

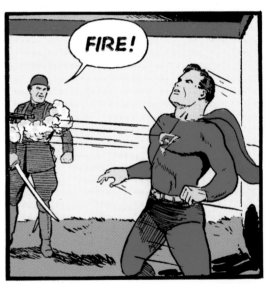

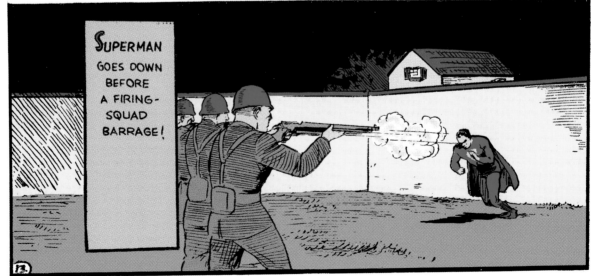

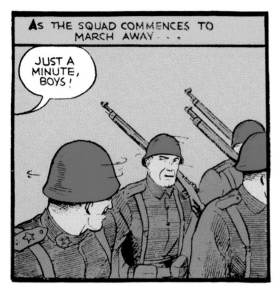

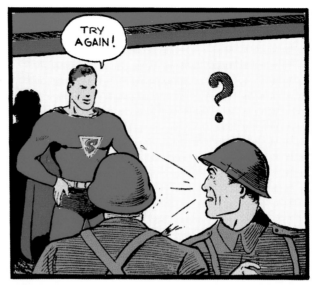

59

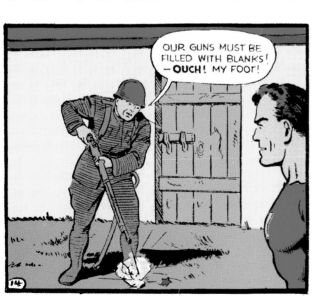

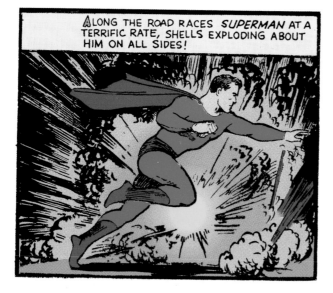

ALONG THE ROAD RACES *SUPERMAN* AT A TERRIFIC RATE, SHELLS EXPLODING ABOUT HIM ON ALL SIDES!

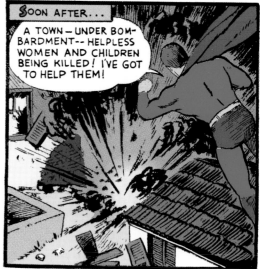

SOON AFTER...

A TOWN—UNDER BOMBARDMENT-- HELPLESS WOMEN AND CHILDREN BEING KILLED! I'VE GOT TO HELP THEM!

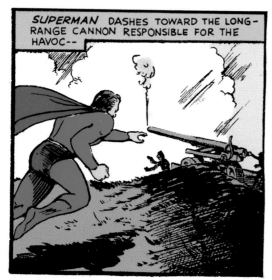

SUPERMAN DASHES TOWARD THE LONG-RANGE CANNON RESPONSIBLE FOR THE HAVOC--

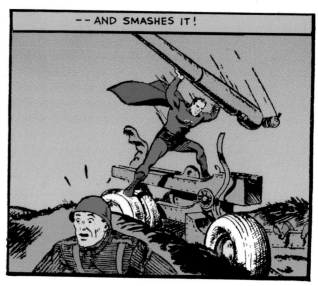

-- AND SMASHES IT!

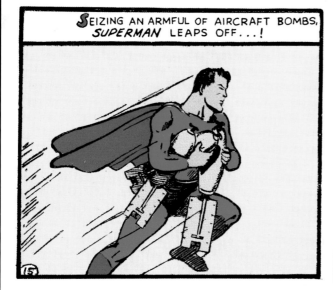

SEIZING AN ARMFUL OF AIRCRAFT BOMBS, *SUPERMAN* LEAPS OFF...!

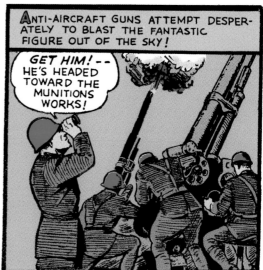

ANTI-AIRCRAFT GUNS ATTEMPT DESPERATELY TO BLAST THE FANTASTIC FIGURE OUT OF THE SKY!

GET HIM! -- HE'S HEADED TOWARD THE MUNITIONS WORKS!

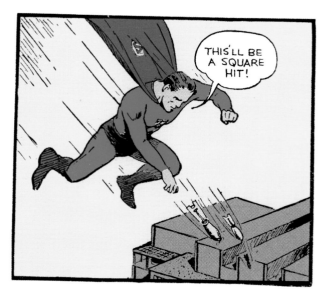

THIS'LL BE A SQUARE HIT!

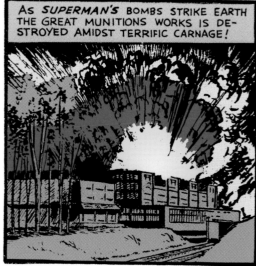

AS *SUPERMAN'S* BOMBS STRIKE EARTH THE GREAT MUNITIONS WORKS IS DE-STROYED AMIDST TERRIFIC CARNAGE!

A DIRIGIBLE SWERVES TOWARD *SUPERMAN* DETERMINED TO BLOT HIM OUT BEFORE HE CAN CONTINUE WITH FURTHER DESTRUCTION.

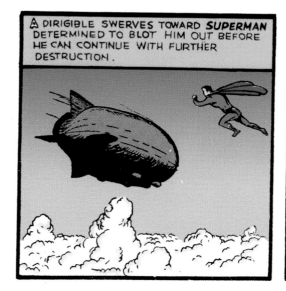

A FANTASTIC BATTLE WAGES HIGH ABOVE THE EARTH...THE *MAN OF TOMORROW* SCRAMBLES ATOP THE SKY-VESSEL...

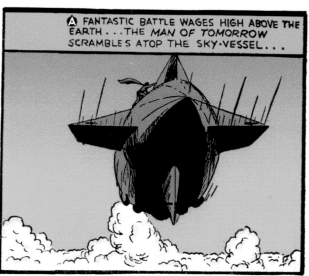

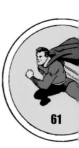

61

AS *SUPERMAN* TEARS THE GREAT BALLOON APART, IT FALLS TO ITS DOOM!

16.

MEANWHILE -- A FEW MINUTES PREVIOUS TO *SUPERMAN'S* AIR-RAID...

BARTOW! -- YOU'RE SOONER THAN I EXPECTED!

YES, LUBANE! AND WE'VE HAD SEVERAL HAIR-RAISING EXPERIENCES!

NEVER MIND ABOUT THAT! IF YOU'VE GOT THE FORMULA, GIVE IT TO ME!

HERE IT IS! -- WE WERE FORCED TO USE -- ER -- DRASTIC METHODS TO SECURE IT!

TAKE THIS FORMULA TO THE LABORATORY AND HURRY IT BACK WITH A SAMPLE OF THE GAS!

YES, SIR!

AFTER THE ASSISTANT DEPARTS -- ABRUPTLY -- THE ROOM IS ROCKED BY A SERIES OF EXPLOSIONS!

WH-WHAT'S *THAT*?

WE'RE BEING BOMBED!

THOSE EXPLOSIONS! WHAT'S HAPPENING -- *WHAT DO THEY MEAN?*

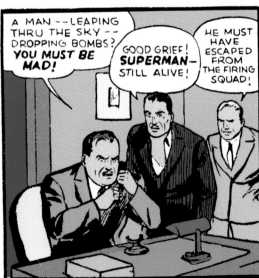

A MAN -- LEAPING THRU THE SKY -- DROPPING BOMBS? *YOU MUST BE MAD!*

GOOD GRIEF! *SUPERMAN* -- STILL ALIVE!

HE MUST HAVE ESCAPED FROM THE FIRING SQUAD!

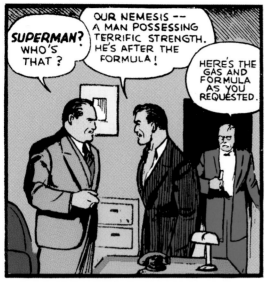

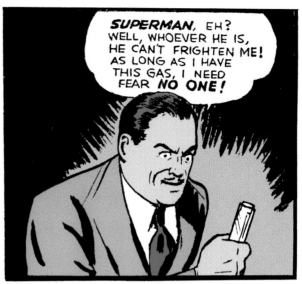

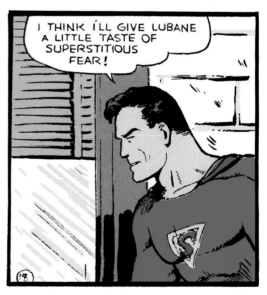

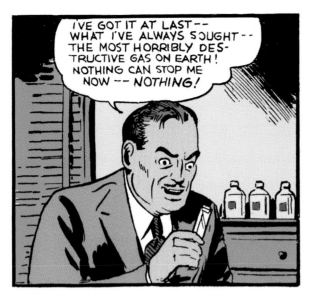

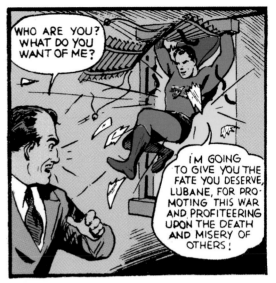

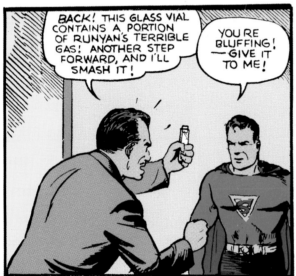

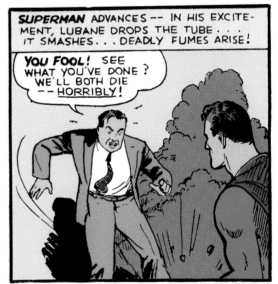

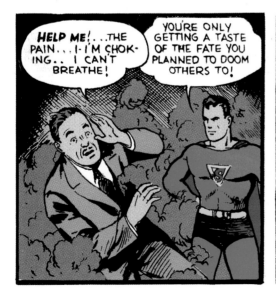

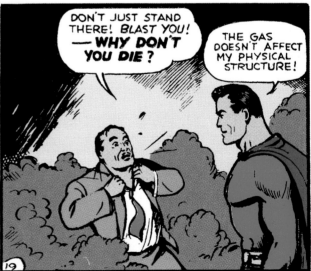

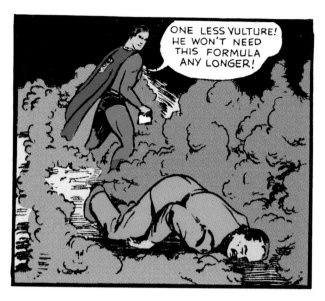

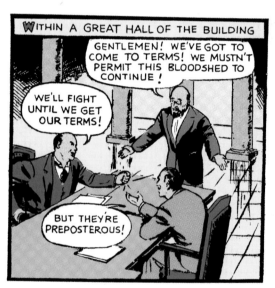

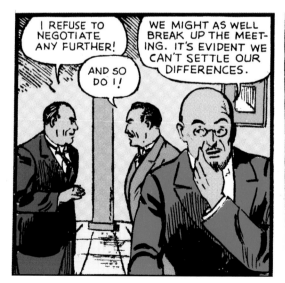

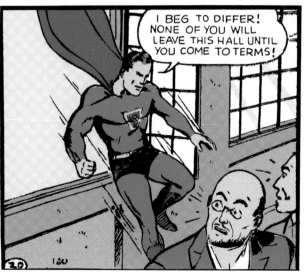

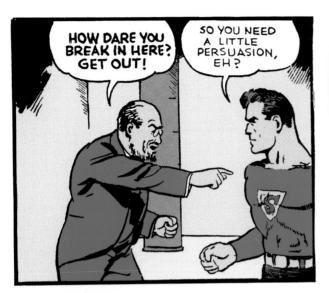

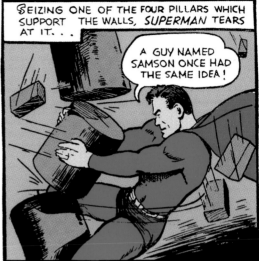

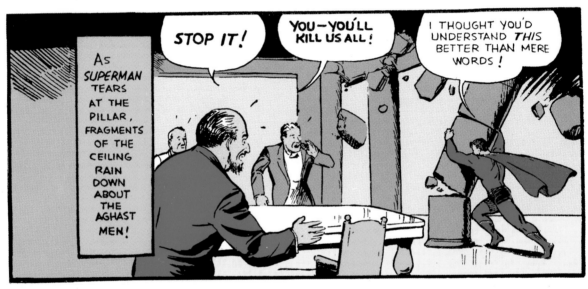

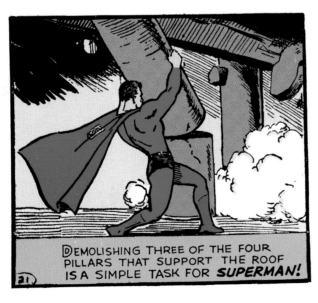

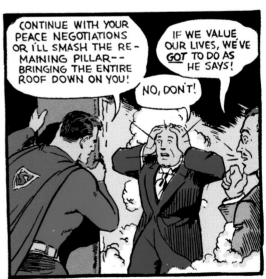

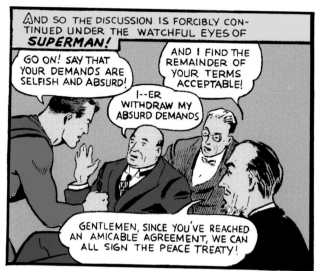

AND SO THE DISCUSSION IS FORCIBLY CONTINUED UNDER THE WATCHFUL EYES OF *SUPERMAN!*

GO ON! SAY THAT YOUR DEMANDS ARE SELFISH AND ABSURD!

AND I FIND THE REMAINDER OF YOUR TERMS ACCEPTABLE!

I--ER WITHDRAW MY ABSURD DEMANDS

GENTLEMEN, SINCE YOU'VE REACHED AN AMICABLE AGREEMENT, WE CAN ALL SIGN THE PEACE TREATY!

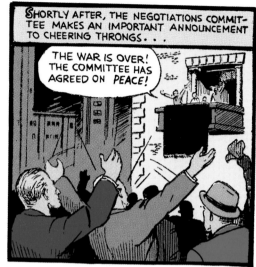

SHORTLY AFTER, THE NEGOTIATIONS COMMITTEE MAKES AN IMPORTANT ANNOUNCEMENT TO CHEERING THRONGS . . .

THE WAR IS OVER! THE COMMITTEE HAS AGREED ON *PEACE!*

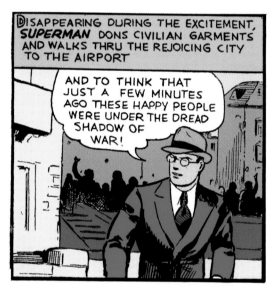

DISAPPEARING DURING THE EXCITEMENT, *SUPERMAN* DONS CIVILIAN GARMENTS AND WALKS THRU THE REJOICING CITY TO THE AIRPORT

AND TO THINK THAT JUST A FEW MINUTES AGO THESE HAPPY PEOPLE WERE UNDER THE DREAD SHADOW OF WAR!

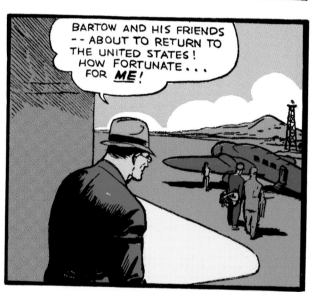

BARTOW AND HIS FRIENDS -- ABOUT TO RETURN TO THE UNITED STATES! HOW FORTUNATE . . . FOR *ME!*

67

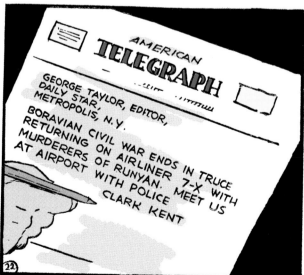

AMERICAN
TELEGRAPH

GEORGE TAYLOR, EDITOR,
DAILY STAR,
METROPOLIS, N.Y.

BORAVIAN CIVIL WAR ENDS IN TRUCE
RETURNING ON AIRLINER 7-X WITH
MURDERERS OF RUNYAN. MEET US
AT AIRPORT WITH POLICE
CLARK KENT

22

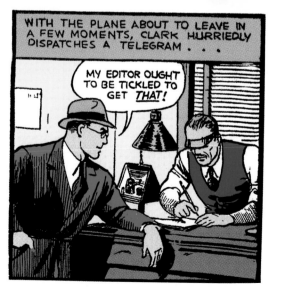

WITH THE PLANE ABOUT TO LEAVE IN A FEW MOMENTS, CLARK HURRIEDLY DISPATCHES A TELEGRAM . . .

MY EDITOR OUGHT TO BE TICKLED TO GET *THAT!*

TOWARD THE U.S. WINGS THE GREAT BORAVIAN AIRLINER

WITHIN IT, THRU THE LONG HOURS OF THE VOYAGE, CLARK KEEPS BARTOW'S MEN UNDER SURVEILLANCE

WHAT'S THE MATTER WITH YOU? WE'VE A FORTUNE IN CASH ON US AND YOU PERSIST IN ACTING JITTERY!

I CAN'T HELP IT-- WHEN I THINK OF *SUPERMAN* STILL BEING ALIVE.

OH, SNAP OUT OF IT!

AS *METROPOLIS* IS REACHED . . .

YOU'RE UNDER ARREST FOR THE MURDER OF ADOLPHUS RUNYAN!

BUT-- BUT THERE MUST BE SOME MISTAKE! WHO MAKES THIS RIDICULOUS CHARGE?

I DO! -- AND YOU WON'T THINK IT SO RIDICULOUS WHEN A COURT OF LAW MAKES YOU PAY FOR YOUR CRIME!

NICE GOING, CLARK! NOW GET DOWN TO THE OFFICE AND TURN OUT THE STORY BEFORE ANOTHER PAPER SCOOPS US!

RIGHTO!

DAYS LATER -- KENT TAKES THE WITNESS STAND . . .

AND I DISTINCTLY OVERHEARD BARTOW THREATENING RUNYAN'S LIFE!

THE RACKETEERS FRENZIEDLY SEEK TO PIN THE RAP ON EACH OTHER...

HE DID IT! -- I SAW HIM SHOOT RUNYAN!

THAT'S A LIE! YOU DID IT YOURSELF!

...AND AS A RESULT, RECEIVE A SEVERE PENALTY

I HEREBY SENTENCE ALL THREE OF YOU TO DIE IN THE ELECTRIC CHAIR!

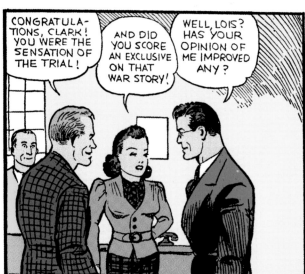

CONGRATULATIONS, CLARK! YOU WERE THE SENSATION OF THE TRIAL!

AND DID YOU SCORE AN EXCLUSIVE ON THAT WAR STORY!

WELL, LOIS? HAS YOUR OPINION OF ME IMPROVED ANY?

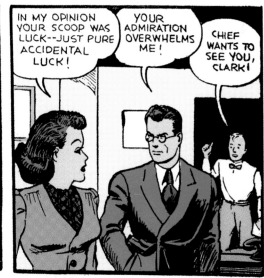

IN MY OPINION YOUR SCOOP WAS LUCK--JUST PURE ACCIDENTAL LUCK!

YOUR ADMIRATION OVERWHELMS ME!

CHIEF WANTS TO SEE YOU, CLARK!

69

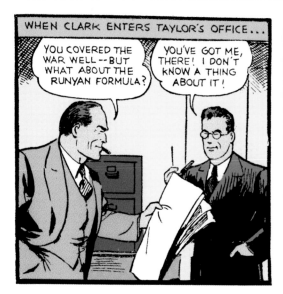

WHEN CLARK ENTERS TAYLOR'S OFFICE...

YOU COVERED THE WAR WELL -- BUT WHAT ABOUT THE RUNYAN FORMULA?

YOU'VE GOT ME, THERE! I DON'T KNOW A THING ABOUT IT!

24

LATER...

AND THAT'S THE END OF THE FORMULA! IT'S TOO DEADLY TO BE PERMITTED TO EXIST!

Part Two

WAR COMES TO EUROPE

In August 1939, two scorpions in a bottle—Nazi Germany and the Soviet Union—suddenly signed a peace pact despite their mutual hatred.

A week later, German troops invaded Poland, and Britain and France found themselves at war with a Germany that was now poised to get much-needed natural resources from the USSR (which carved a piece out of Poland for itself). For the rest of '39 into early '40, though, the Western powers and the Third Reich mostly glared at each other. France felt safe behind its border fortresses, but neither France nor Britain could give any real help to Poland, which quickly ceased to exist as a country.

Back in the world of comic books, Superman's creators and editors were mostly content to have their hero battle nondescript criminals. But someone had a different idea.

The weekly picture-magazine *Look* (the chief rival of the even more popular *Life*) contracted with DC to feature a special two-page "Superman" comic story in its Feb. 27, 1940, issue. Therein, the Man of Tomorrow scoops up first Hitler, then Stalin, and brings them to trial before the League of Nations, the post-World War I forerunner of today's United Nations. Exactly what *Look* hoped to accomplish with this fable about how Superman would end the war is hard to fathom.

Its editors didn't even bother to color the hero's costume correctly. The story has been reprinted, *re-colored*, once or twice since. Still, the appearance of a "Superman" tale in a mass-market publication produced for adults showed the impact the character made in the nearly two years since its debut.

By the time that edition of *Look* hit the nation's mailboxes and newsstands, the comic book Superman had at least gotten involved in a non-civil war for a change, in a two-part story spread over *Action Comics #22–23*. This time, "the armed battalions of *Toran* unexpectedly swoop down upon a lesser nation, *Galonia*," surely Siegel and Shuster's take on Germany's assault on Poland. "EUROPE AT WAR!" declares the headline of the *Daily Star*, the newspaper that employs reporters Clark Kent and Lois Lane. The paper's name would soon be changed to the familiar *Daily Planet*, because there were many newspapers with the word "*Star*" in their name, but nobody had ever heard of one with "*Planet*" on its masthead.

That yarn let the writer and artists show what Superman could do against the kind of war-weaponry Nazi Germany had employed first in Spain, now in Poland, without DC Comics appearing to choose sides at a time when America was not at war with anybody. In the end, however, the creators cop out; the comic book war turns out to be the scheme of a criminal mastermind intent on plunging the European continent into war. (Said mastermind's name? Luthor. No first name yet—and he has red hair in this first appearance.) The two countries come to their senses and make peace, just as in earlier stories. Superman even destroys Luthor's dirigible—a *second* echo of the *Hindenburg* tragedy. History was starting to repeat itself.

A standoff existed in Europe from autumn 1940 until the following April, when Britain and Germany suddenly found themselves battling over neutral Norway. Germany won. Then, in May, Nazi troops, tanks, and aircraft attacked France, conquering it in mere weeks. Mussolini got into the

fray by having Italian troops invade from the east as the French were reeling. At this point, Britain—albeit with the aid of its far-flung Empire and Commonwealth, which included Canada, Australia, and New Zealand—stood alone against the German juggernaut, shielded only by its Navy, the Royal Air Force, and the all-important English Channel.

The United States was still officially neutral, although President Roosevelt, and increasingly the American public, favored the British cause. It wasn't hard to root against the Nazis. On covers, Superman's battles against military hardware became more frequent, but the enemy was still unidentified . . . even though, during the same period, the cover of upstart Timely Comics's *Captain America* #1 depicted its star-spangled hero slugging Hitler in the jaw.

Gradually, though, the people behind Superman were edging toward calling a spade a shovel. An espionage-centered story in *Superman* #8 (Jan.–Feb. 1941) featured a South American sailor who in some panels resembles Hitler. In *Superman* #10 (May-June 1941), the consul of an unfriendly and rather Germanic nation called Dukalia also has a somewhat Hitlerian mustache, in a tale whose "Dukalia-American Sports Festival" echoed the 1936 Olympics, which had been held in Berlin and presided over by Hitler. In *Superman* #12 (Sept-Oct. 1941), a foreign power schemes to gain control of a jungle island not far from the U.S., at the same time Roosevelt was promoting "Hemispheric solidarity" to keep the Nazis out of Latin America and the Caribbean; but in this episode there was nothing identifiable about the country behind the plot. Two steps forward led to one step back.

Meanwhile, at least the *covers* of Superman's comics began to take sides in the struggle being waged in Europe. On the cover of the 12th issue of his own now-bimonthly magazine, Superman marches arm-in-arm with an American soldier and a sailor, while on the cover of *Action Comics* #43 (Dec. 1941), he flies toward a parachuting soldier with a swastika armband. On the next cover he's bending the barrel of swastika-branded artillery. In addition, around the same time, on the cover of *Superman* #13, he's depicted attacking a gunboat decorated with a symbol that resembled a German "Iron Cross." At last, some sort of corner had been rounded—even though nothing matching the cover scenes could be found inside those three issues.

Superman was moving slowly toward a more openly hostile attitude toward Nazi Germany, even as President Roosevelt, using mostly executive authority, was giving so much aid to the embattled British Navy and merchant ships that he was virtually fighting an undeclared Naval war with German submarines in the Atlantic. Roosevelt knew he couldn't get a divided Congress to declare war on the Nazis. In June 1941, Hitler launched a sneak attack on his erstwhile ally, the Soviet Union, but the German dictator was still too canny to declare war on America and bring yet another powerful nation into hostilities against him.

The observant reader may notice that there's no mention at all in these comics, or on their covers, even in a veiled way, of the Japanese assault on China, now in its fourth year.

But all that would change, one bright Sunday morning in Honolulu, Hawaii . . .

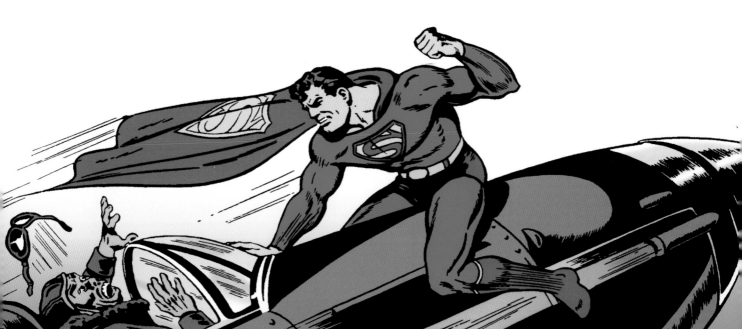

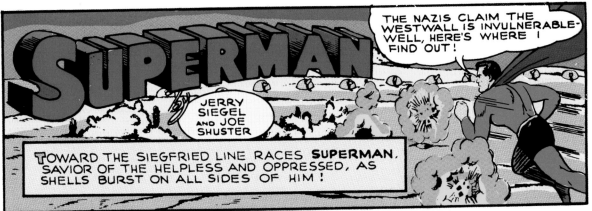

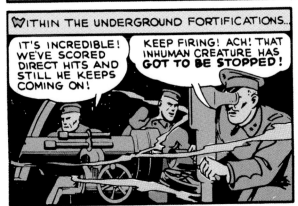

Look Magazine (Feb. 27, 1940) - script: Jerry Siegel - art: Joe Shuster and The Shuster Shop

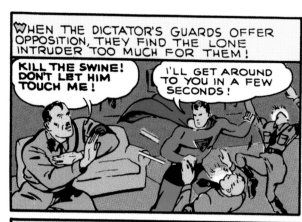

WHEN THE DICTATOR'S GUARDS OFFER OPPOSITION, THEY FIND THE LONE INTRUDER TOO MUCH FOR THEM!

KILL THE SWINE! DON'T LET HIM TOUCH ME!

I'LL GET AROUND TO YOU IN A FEW SECONDS!

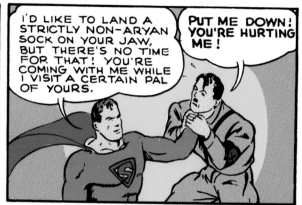

I'D LIKE TO LAND A STRICTLY NON-ARYAN SOCK ON YOUR JAW, BUT THERE'S NO TIME FOR THAT! YOU'RE COMING WITH ME WHILE I VISIT A CERTAIN PAL OF YOURS.

PUT ME DOWN! YOU'RE HURTING ME!

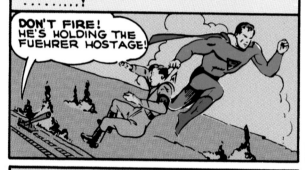

EASTWARD RACES SUPERMAN WITH HIS UNWILLING BURDEN, AT A CLIP THAT WOULD OUTDISTANCE THE FASTEST PLANE!

DON'T FIRE! HE'S HOLDING THE FUEHRER HOSTAGE!

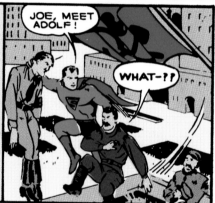

MOSCOW, RUSSIA— AS STALIN REVIEWS HIS TROOPS FROM ATOP A BALCONY, THE MAN OF STEEL'S FIGURE PLUMMETS FROM THE SKY PLUCKING HIM FROM HIS PERCH...

JOE, MEET ADOLF!

WHAT—??

AS SUPERMAN RACES INTO THE MASSED MARCHERS, THE TROOPS SCATTER IN CONFUSION!

THAT'S RIGHT! CLEAR THE WAY!

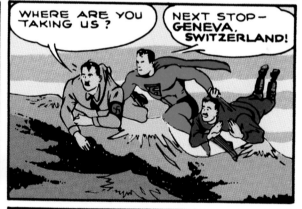

WHERE ARE YOU TAKING US?

NEXT STOP— GENEVA, SWITZERLAND!

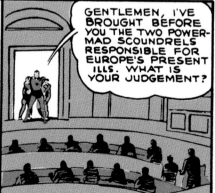

LATER— SUPERMAN DROPS IN ON A MEETING OF THE LEAGUE OF NATIONS...

GENTLEMEN, I'VE BROUGHT BEFORE YOU THE TWO POWER-MAD SCOUNDRELS RESPONSIBLE FOR EUROPE'S PRESENT ILLS. WHAT IS YOUR JUDGEMENT?

ADOLF HITLER AND JOSEF STALIN— WE PRONOUNCE YOU GUILTY OF MODERN HISTORY'S GREATEST CRIME — UNPROVOKED AGGRESSION AGAINST DEFENSELESS COUNTRIES.

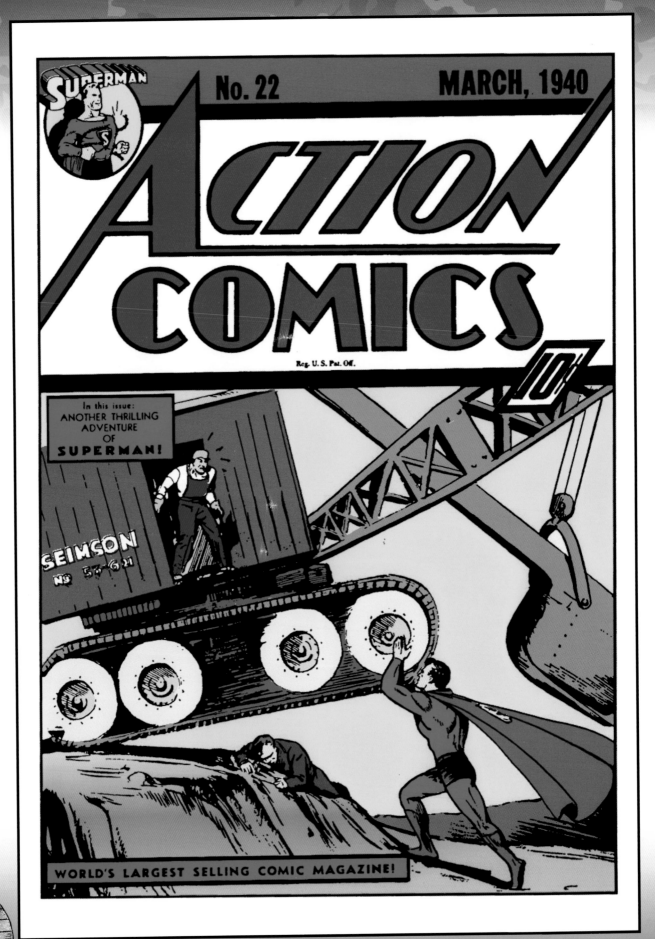

Action Comics #22 (March 1940) - cover art - Joe Shuster (pencils) & Paul Cassidy (inks)

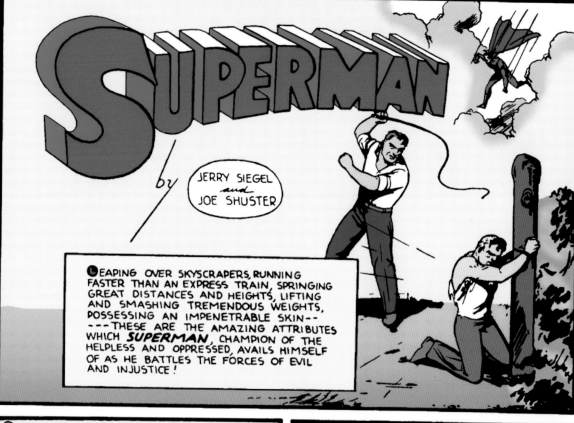

Leaping over skyscrapers, running faster than an express train, springing great distances and heights, lifting and smashing tremendous weights, possessing an impenetrable skin -- ---THESE ARE THE AMAZING ATTRIBUTES WHICH *SUPERMAN*, CHAMPION OF THE HELPLESS AND OPPRESSED, AVAILS HIMSELF OF AS HE BATTLES THE FORCES OF EVIL AND INJUSTICE!

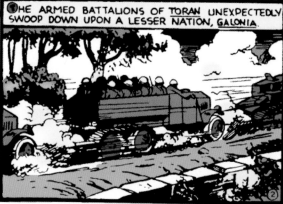

THE ARMED BATTALIONS OF TORAN UNEXPECTEDLY SWOOP DOWN UPON A LESSER NATION, GALONIA.

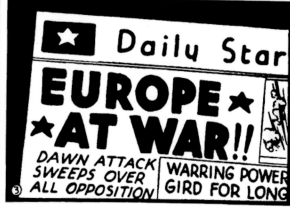

Daily Star

EUROPE ★ ★AT WAR!!

DAWN ATTACK SWEEPS OVER ALL OPPOSITION

WARRING POWER GIRD FOR LONG

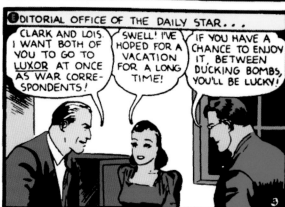

EDITORIAL OFFICE OF THE DAILY STAR...

CLARK AND LOIS. I WANT BOTH OF YOU TO GO TO LUXOR AT ONCE AS WAR CORRESPONDENTS!

SWELL! I'VE HOPED FOR A VACATION FOR A LONG TIME!

IF YOU HAVE A CHANCE TO ENJOY IT, BETWEEN DUCKING BOMBS, YOU'LL BE LUCKY!

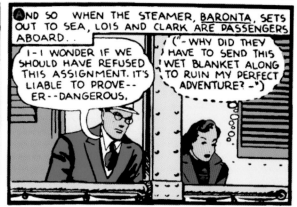

AND SO WHEN THE STEAMER, BARONTA, SETS OUT TO SEA, LOIS AND CLARK ARE PASSENGERS ABOARD..

I-I WONDER IF WE SHOULD HAVE REFUSED THIS ASSIGNMENT. IT'S LIABLE TO PROVE-- ER--DANGEROUS.

("-WHY DID THEY HAVE TO SEND THIS WET BLANKET ALONG TO RUIN MY PERFECT ADVENTURE? -")

Action Comics #22 (March 1940) - script: Jerry Siegel - art: Joe Shuster & Paul Cassidy (pencils) & Paul Cassidy (inks)

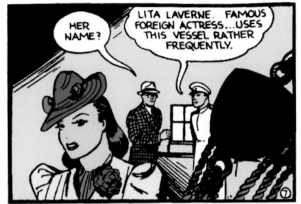

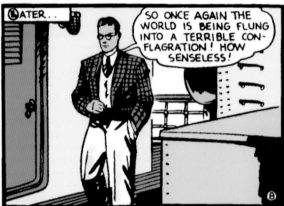

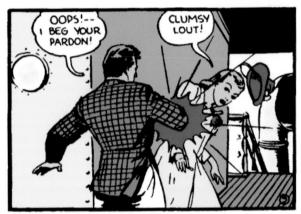

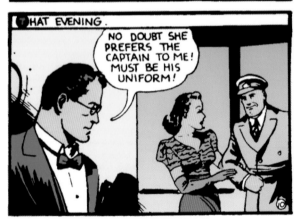

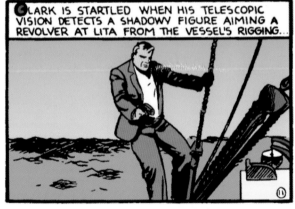

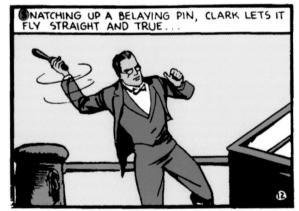

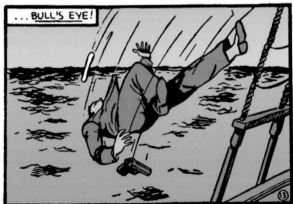

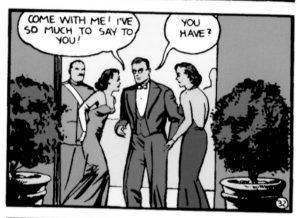

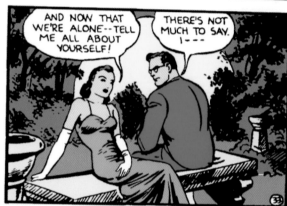

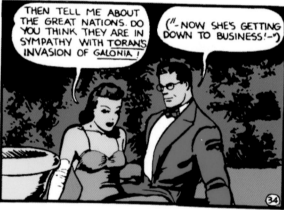

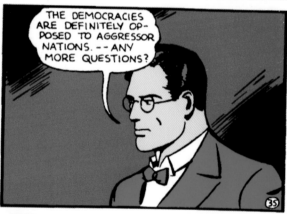

79

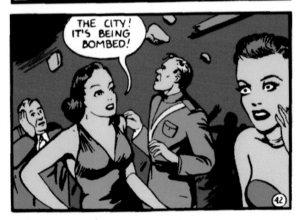

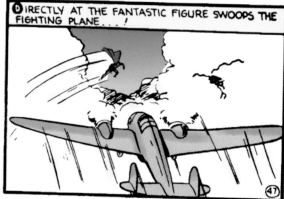

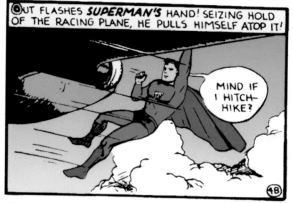

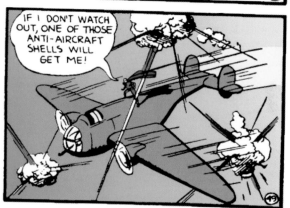

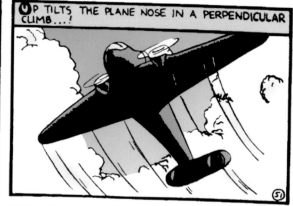

81

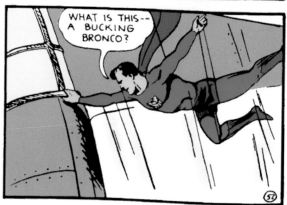

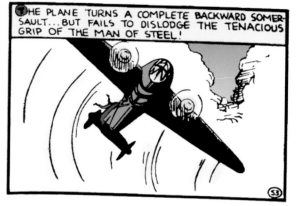

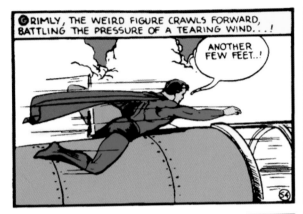

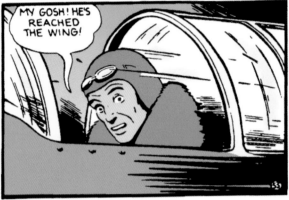

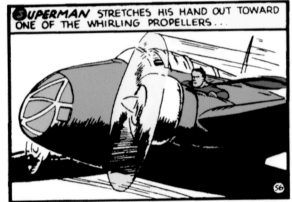

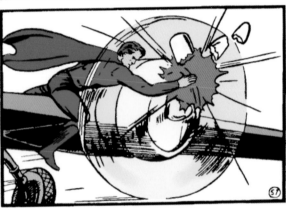

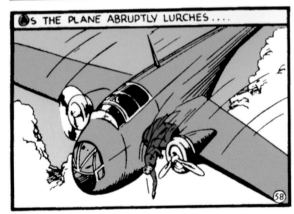

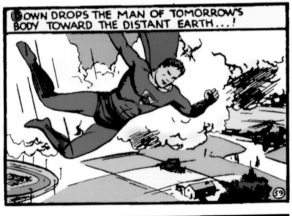

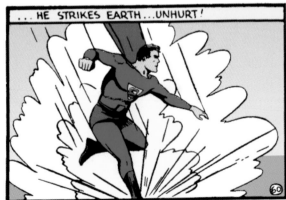

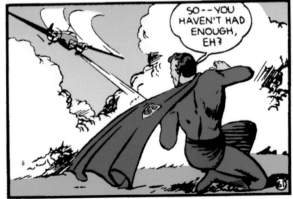

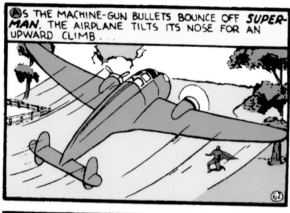

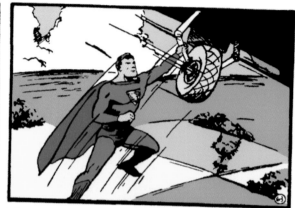

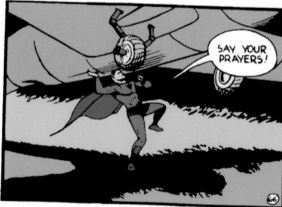

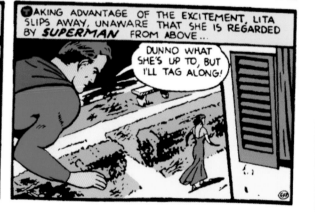

83

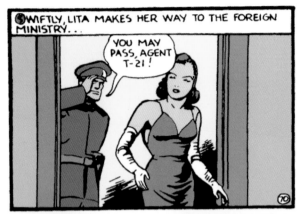

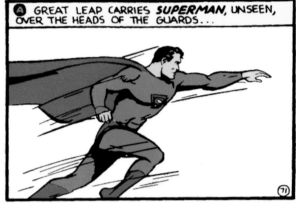

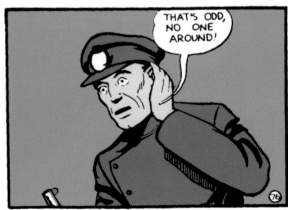

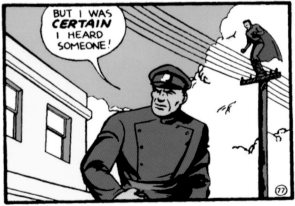

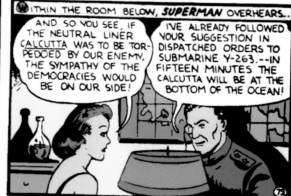

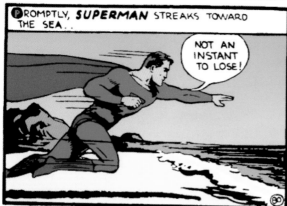

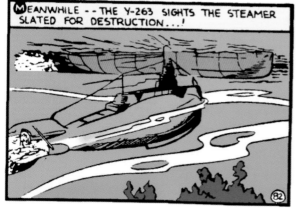

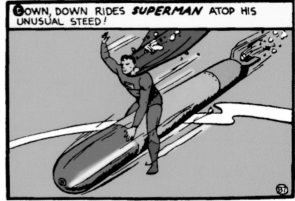

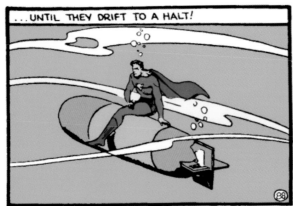

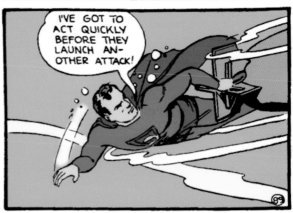

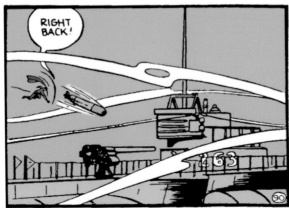

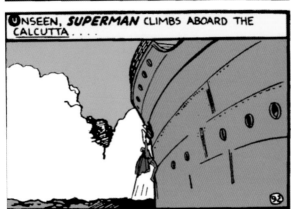

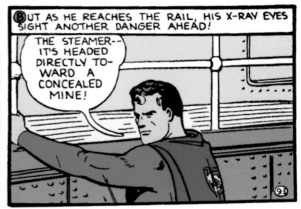

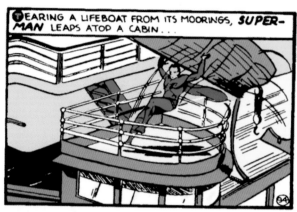

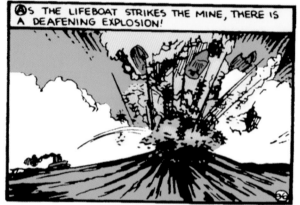

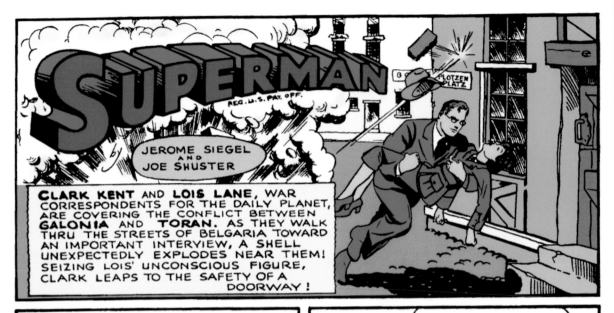

Action Comics #23 (April 1940) - script: Jerry Siegel - art: Joe Shuster (pencils) & Paul Cassidy (inks)

STREAKING DOWN TO EARTH, **SUPERMAN** SWIFTLY DONS HIS CIVILIAN GARMENTS....

IF THERE'S ANYTHING I PARTICULARLY DESPISE, IT'S THE DESTRUCTION OF HELPLESS CIVILIANS.

AS LOIS REVIVES....

WHILE YOU WERE UNCONSCIOUS, **SUPERMAN** APPEARED AND STOPPED TH' BOMBARDMENT SINGLE-HANDED!

JUST MY LUCK! I'VE BEEN PRAYING I'D SEE HIM AGAIN, AND WHEN HE FINALLY SHOWS UP, I HAVE TO BE DEAD TO THE WORLD!

CONTINUING ON TO ARMY HEADQUARTERS, CLARK AND LOIS CONFRONT GENERAL LUPO, WHOM THEY HAVE AN APPOINTMENT TO INTERVIEW...

HOW MUCH LONGER DO YOU EXPECT THE WAR TO LAST?

WE HOPE TO END IT SOON THRU NEGOTIATION.

IN FACT, TWO HOURS FROM NOW ALL FIRING WILL CEASE, AND A PARTY OF TORAN OFFICIALS WILL DRIVE INTO BELGARIA UNDER A FLAG OF TRUCE TO DISCUSS PEACE TERMS.

89

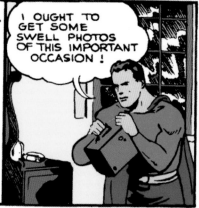

LATER-

ALONE IN HIS HOTEL ROOM, CLARK CHANGES INTO HIS SUPERMAN COSTUME...

I OUGHT TO GET SOME SWELL PHOTOS OF THIS IMPORTANT OCCASION!

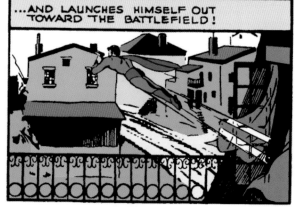

...AND LAUNCHES HIMSELF OUT TOWARD THE BATTLEFIELD!

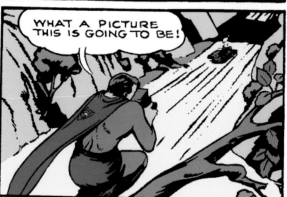

WHAT A PICTURE THIS IS GOING TO BE!

BUT AS SUPERMAN SNAPS THE LENS OF HIS CAMERA!

2

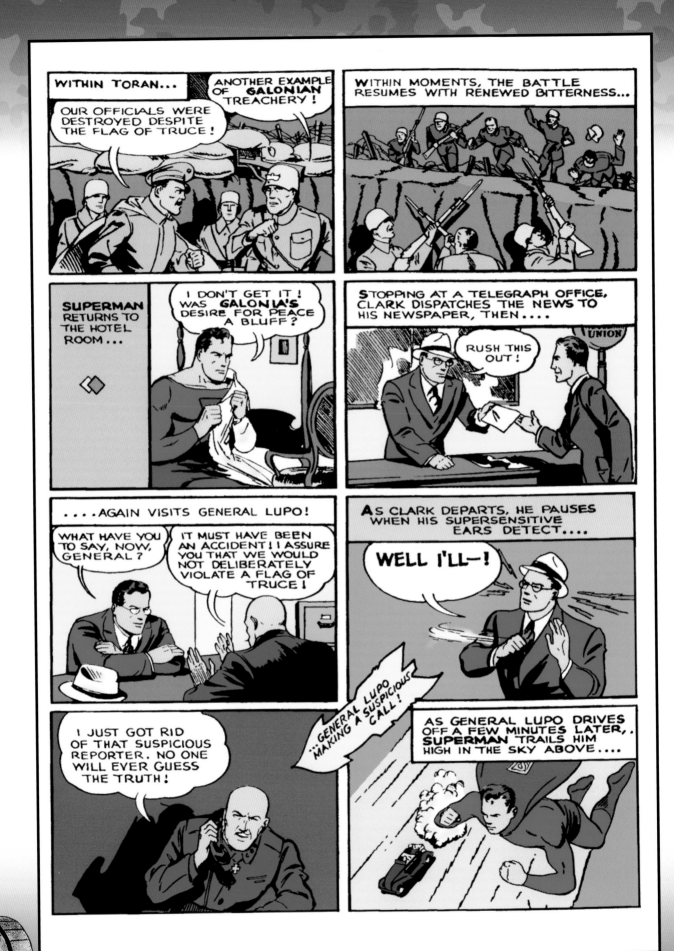

PARKING NEAR A MOUNTAIN, LUPO WALKS UP TO IT...... *AND* ABRUPTLY VANISHES...!

NO ENTRANCE ANY—WHERE! WHAT HAPPENED TO HIM IS BEYOND ME!

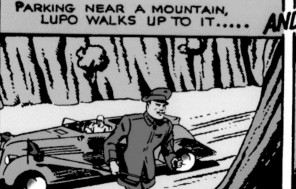

WITH HIS BARE HANDS **SUPERMAN** TEARS APART A SECTION OF THE ROCK, EXPOSING A PASSAGEWAY....

STEALING CAUTIOUSLY WITHIN, **SUPERMAN** WALKS ALONG UNTIL AN UNEXPECTED VISION MAKES HIM CONCEAL HIMSELF....

("—WHAT CAN THIS POSSIBLY MEAN—?")

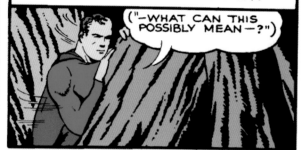

FROM CONCEALMENT, **SUPERMAN** SEES GENERAL LUPO STANDING AT ATTENTION BEFORE A HUGE SLAB OF ROCK....

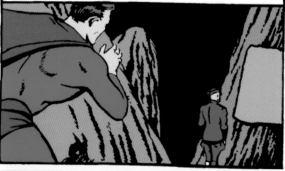

AS LUPO RIGIDLY STARES AT THE SLAB, AS THO IN A HYPNOTIC TRANCE, LIGHTS APPEAR, COMMENCE TO WHIRL AND BRIGHTEN UPON IT....

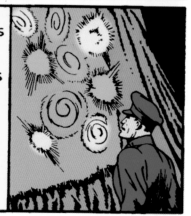

91

SPEAK! HAVE YOU WHAT TO REPORT?

YOUR PLANS HAVE BEEN CARRIED OUT. THE WAR WILL BE PROLONGED!

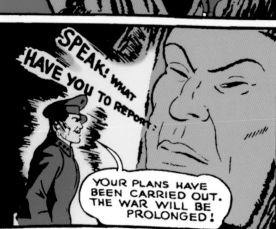

THE INCREDIBLY UGLY VISION VANISHES AS LUPO TURNS TO DEPART. **SUPERMAN** SPRINGS FROM HIDING AND CONFRONTS HIM!

NOT SO FAST!

HOW DID **YOU** GET IN HERE?

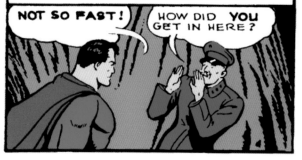

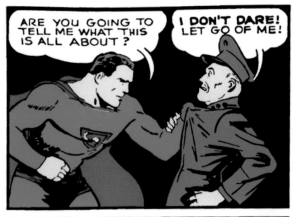

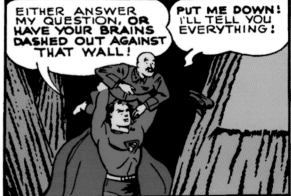

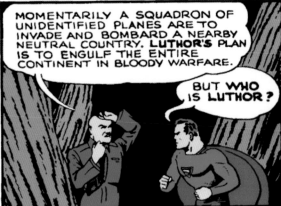

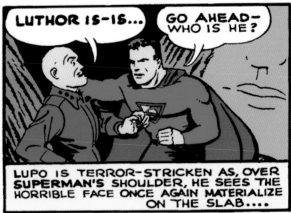

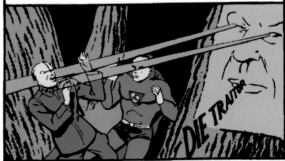

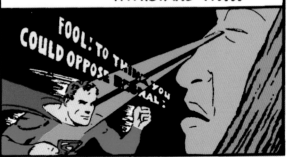

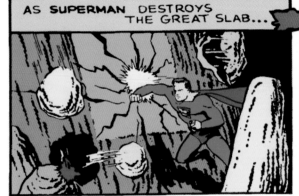

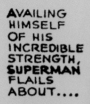

AVAILING HIMSELF OF HIS INCREDIBLE STRENGTH, **SUPERMAN** FLAILS ABOUT....

WHAM! SMASH!

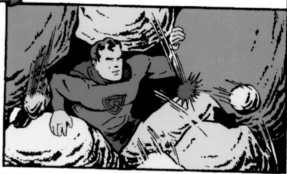

...AND SUCCEEDS IN BURROWING HIS WAY OUT INTO THE SUNLIGHT!

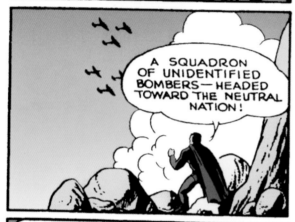

A SQUADRON OF UNIDENTIFIED BOMBERS—HEADED TOWARD THE NEUTRAL NATION!

AS THE HINDMOST BOMBER SIGHTS **SUPERMAN'S** FIGURE SUSPENDED IN THE EMPTY AIR BEFORE HIM, THE GUNNER FRANTICALLY ATTEMPTS TO SHOOT HIM DOWN...

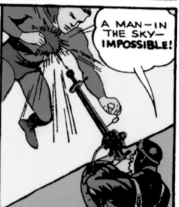

A MAN—IN THE SKY— IMPOSSIBLE!

93

OUT YOU GO! ODD— YOUR UNIFORM IS ENTIRELY UNFAMILIAR!

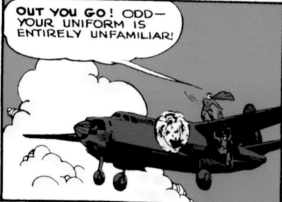

AS THE REMAINDER OF THE SQUADRON SWOOPS AT HIM, **SUPERMAN** SHOOTS DOWN TWO OF THEM....

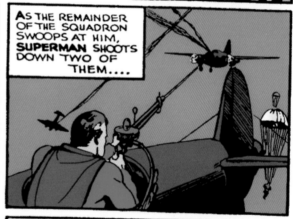

OUT OF AMMUNITION! NOW TO SET THE CONTROLS...

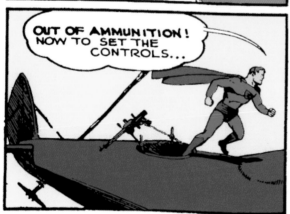

CLIMBING OUT UPON THE PLANE'S WING, **SUPERMAN** PLUCKS TWO OF THE PLANES OUT OF THE AIR AND SMASHES THEM TOGETHER...!

JUST ONE MORE ENEMY PLANE TO GO!

CRASH!

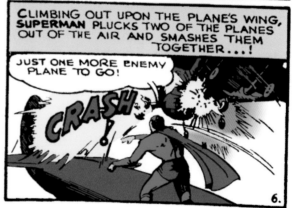

6.

CLIMBING BACK INTO THE PILOT'S SEAT, **SUPERMAN** DIVES STRAIGHT TOWARD THE REMAINING ENEMY PLANE...

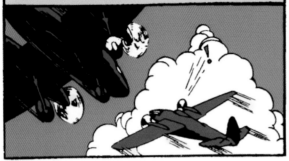

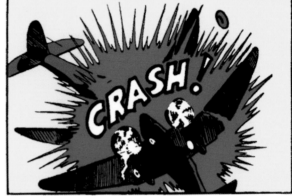

CRASH!

LEAPING FREE FROM THE WRECKAGE, **SUPERMAN** DESCENDS TO THE EARTH UNHURT....

AND THAT ATTENDS TO LUTHOR'S PLAN TO DRAW ANOTHER COUNTRY INTO THE WAR!

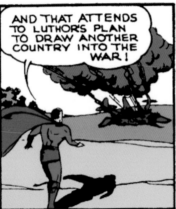

LATER— IN HIS IDENTITY AS CLARK KENT, THE **MAN OF STEEL** SEEKS TO WARN THE TWO WARRING COUNTRIES OF THE GREATER MENACE THAT FACES THEM....

I CAN'T REVEAL MY SOURCE OF INFORMATION, BUT I DEFINITELY KNOW THAT THIS WAR IS BEING PROMOTED BY A MADMAN WHO WISHES TO DESTROY BOTH WARRING NATIONS!

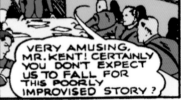

VERY AMUSING, MR. KENT! CERTAINLY YOU DON'T EXPECT US TO FALL FOR THIS POORLY IMPROVISED STORY?

WITHIN **LUTHOR'S** SECRET LAIR...

THIS REPORTER KNOWS TOO MUCH— HE MUST BE ELIMINATED!

AS YOU COMMAND, OH MIGHTY LUTHOR!

AS LOIS GOES TO CLARK'S HOTEL ROOM IN SEARCH OF HIM, SHE IS SEIZED....

THIS IS NOT THE REPORTER!

NEVERTHELESS, LET US TAKE HER TO THE MASTER, HE MAY WANT TO QUESTION HER.

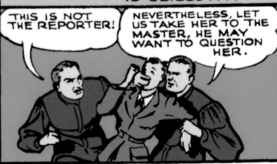

PRISONER WITHIN A STRANGE PLANE, LOIS IS FLOWN TO THE LANDING PLATFORM OF A GIGANTIC DIRIGIBLE SUSPENDED HIGH ABOVE EARTH IN THE STRATOSPHERE

WHEN SHE IS USHERED INTO **LUTHOR'S** PRESENCE...

WHY HAVE YOU BROUGHT THIS GIRL TO ME?

SHE IS AN ASSOCIATE OF THE REPORTER. PERHAPS SHE CAN BE OF USE TO YOU.

A TREMENDOUS DIRIGIBLE—THIS HORRIBLE CREATURE— I MUST BE GOING MAD.

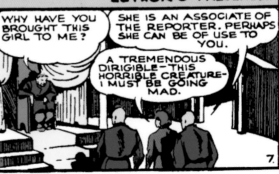

7.

95

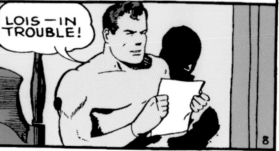

8

MINUTES LATER, **SUPERMAN** LEAPS FROM THE HOTEL IN PURSUIT OF THE FLEEING GUARD...

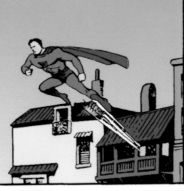

HE'S FLYING DIRECTLY UP INTO THE SKY AT A STRAIGHT ANGLE, AND OUT OF VIEW!

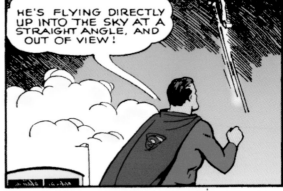

SUPERMAN CROUCHES AND TENSES HIS MUSCLES FOR A GIGANTIC EFFORT...

MY GUESS IS THAT FOLLOWING THAT PLANE WILL LEAD ME DIRECTLY TO LOIS!

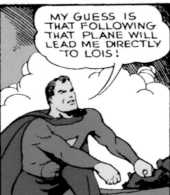

...STEELY MUSCLES PROPEL **SUPERMAN** UP—UP—INTO THE STRATO-SPHERE...

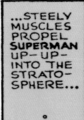

A COLOSSAL DIRIGIBLE!

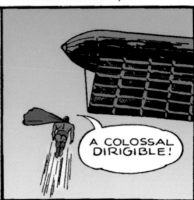

CATCHING ONTO THE LANDING PLATFORM'S EDGE WITH ONE HAND, **SUPERMAN** DRAWS HIMSELF UP...

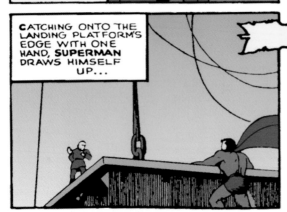

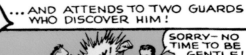

...AND ATTENDS TO TWO GUARDS WHO DISCOVER HIM!

RACK!

SORRY—NO TIME TO BE GENTLE!

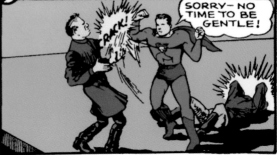

MEANWHILE—LOIS IS BEING TORTURED BY HER GUARD....

LUTHOR WANTS THE TRUTH FROM YOU!

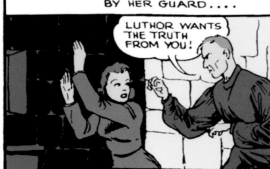

BUT I'VE ALREADY TOLD YOU ALL I KNOW!

C'MON! TALK FAST!

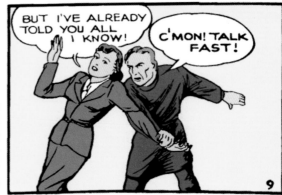

9

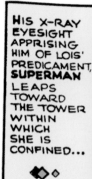

HIS X-RAY EYESIGHT APPRISING HIM OF LOIS' PREDICAMENT, **SUPERMAN** LEAPS TOWARD THE TOWER WITHIN WHICH SHE IS CONFINED...

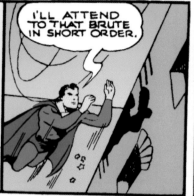

I'LL ATTEND TO THAT BRUTE IN SHORT ORDER.

SUPERMAN!

HOW'S THAT!

QUICK! TAKE MY ARM—WE'VE GOT TO GET OUT OF HERE!

I'D ADVISE YOU NOT TO LEAVE!

I DON'T FEAR YOU— YOU CAN'T HARM ME!

BUT THE GIRL— SHE IS NOT INVULNERABLE! EITHER SUBMIT OR SHE DIES!

FOR LOIS' SAKE, **SUPERMAN** PERMITS THE GIRL AND HIMSELF TO BE ESCORTED BY GUARDS INTO LUTHOR'S PRESENCE...

KEEP YOUR CHIN UP!

WITH YOU NEARBY, I'VE NOTHING TO FEAR!

WHAT SORT OF CREATURE ARE YOU?

JUST AN ORDINARY MAN— BUT WITH TH' BRAIN OF A SUPER-GENIUS! WITH SCIENTIFIC MIRACLES AT MY FINGERTIPS, I'M PREPARING TO MAKE MYSELF SUPREME MASTER OF TH' WORLD!

MY PLAN? TO SEND THE NATIONS OF THE EARTH AT EACH OTHER'S THROATS, SO THAT WHEN THEY ARE SUFFICIENTLY WEAKENED, I CAN STEP IN AND ASSUME CHARGE!

THE ONLY THING YOU SHOULD STEP INTO IS A STRAIGHT-JACKET!

ACCEDING TO LUTHOR'S DEMANDS, **SUPERMAN** PERMITS HIMSELF TO BE CHAINED TO THE WALL WHILE FOUR GREEN RAYS BORE STEADILY AT HIM....

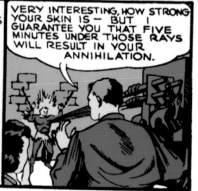

VERY INTERESTING, HOW STRONG YOUR SKIN IS — BUT I GUARANTEE YOU THAT FIVE MINUTES UNDER THOSE RAYS WILL RESULT IN YOUR ANNIHILATION.

10

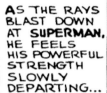

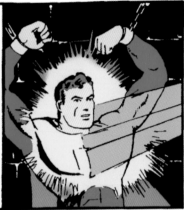
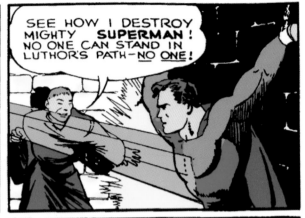

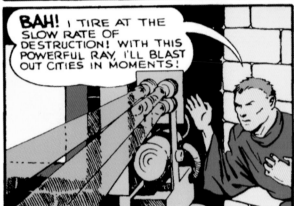
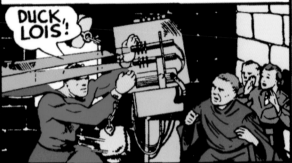
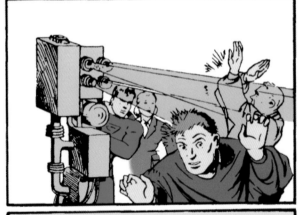
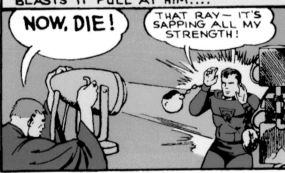
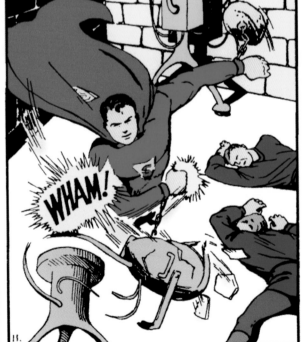

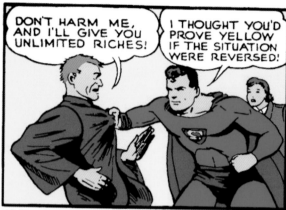

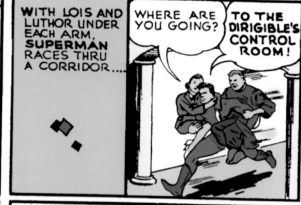

99

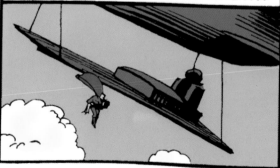

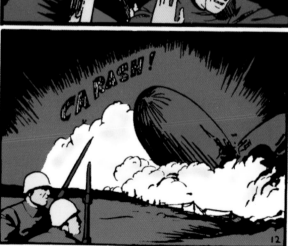

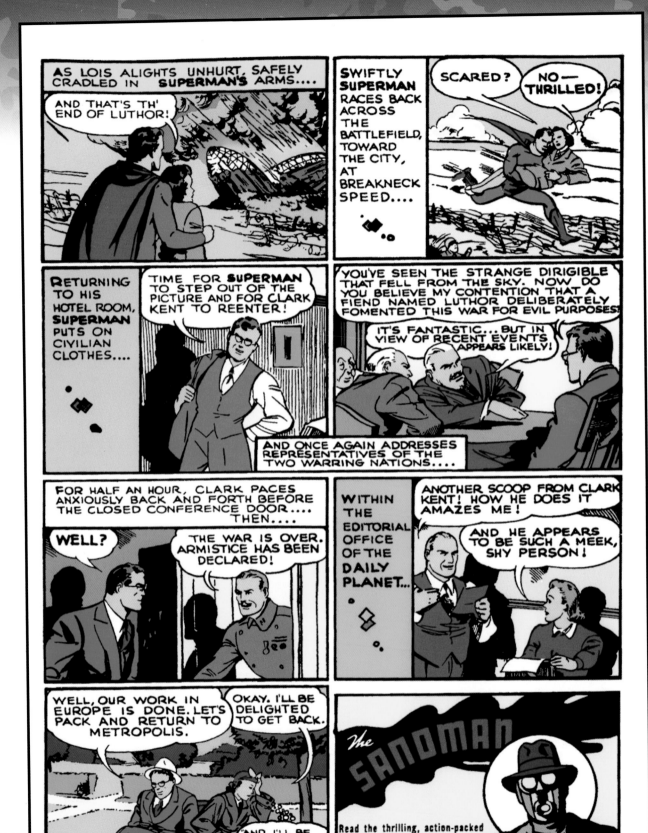

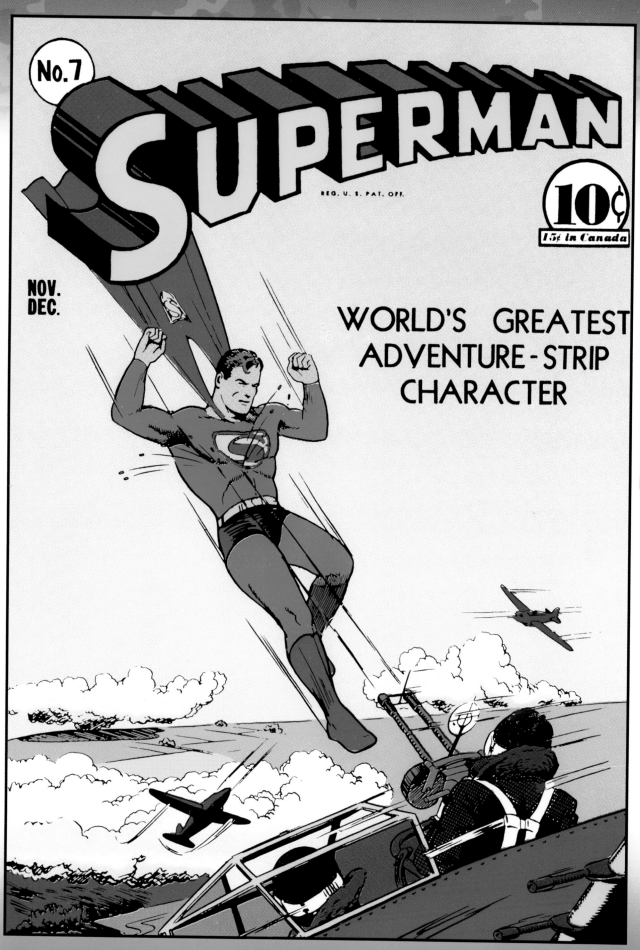

Superman #7 (Nov.–Dec. 1940) - cover art: unknown (pencils) & Wayne Boring (inks)

LISTEN TO THE SUPERMAN RADIO PROGRAM FOR "The Return Of The Yellow Mask!"

BEGINNING DECEMBER

The most thrilling story ever heard on the Superman adventure serial comes to the air over your local station beginning October 7th when THE YELLOW MASK RETURNS!

A crazed scientist whose twisted brain invents amazing machines and devises diabolically clever schemes to aid him in achieving POWER, the YELLOW MASK, once banished by SUPERMAN, returns!

Don't fail to listen to every one of the thrilling, exciting episodes of the Superman Radio Serial beginning October 7th when THE YELLOW MASK RETURNS! Hear how Superman, Champion of Truth and Justice, alone fights to save the world from domination by the most vicious criminal who ever lived!

If you cannot hear the Superman Radio Program where you live, write to your local radio station immediately and ask them to put it on the air.

The SUPERMAN Radio Program is heard **now** on the following stations:

WOR	NEW YORK CITY	WBZ	BOSTON, MASS.
WHAM	ROCHESTER, N. Y.	WJAR	PROVIDENCE, R. I.
WFIL	PHILADELPHIA, PA.	KOY	PHOENIX, ARIZ.
WGY	SCHENECTADY, N. Y.	KZRM	MANILA, Philippine Islands

Ad for "Adventures of Superman" radio program, *Superman* #7 (Nov.–Dec. 1940) - art: Joe Shuster

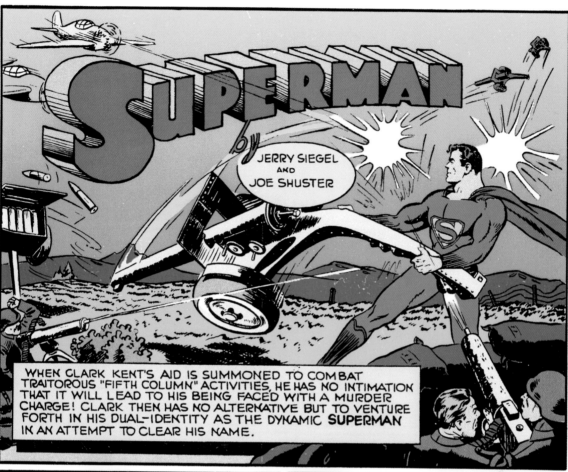

SUPERMAN

JERRY SIEGEL AND JOE SHUSTER

WHEN CLARK KENT'S AID IS SUMMONED TO COMBAT TRAITOROUS "FIFTH COLUMN" ACTIVITIES, HE HAS NO INTIMATION THAT IT WILL LEAD TO HIS BEING FACED WITH A MURDER CHARGE! CLARK THEN HAS NO ALTERNATIVE BUT TO VENTURE FORTH IN HIS DUAL-IDENTITY AS THE DYNAMIC **SUPERMAN** IN AN ATTEMPT TO CLEAR HIS NAME.

103

IN THE PRIVACY OF HIS MIDTOWN APARTMENT, CLARK KENT SURREPTITIOUSLY PEERS THRU A! WINDOW!

ACROSS THE STREET... A MAN... HIS EYES TRAINED UPON THIS WINDOW!

 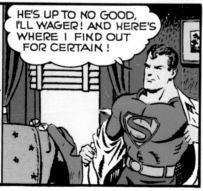

SWIFTLY THE <u>DAILY PLANET</u> REPORTER REMOVES HIS OUTER GARMENTS, TRANSFORMING HIMSELF TO SUPERMAN..!

HE'S UP TO NO GOOD, I'LL WAGER! AND HERE'S WHERE I FIND OUT FOR CERTAIN!

BUT AS **THE MAN OF STEEL** IS ABOUT TO CATAPULT HIMSELF THRU THE OPEN WINDOW...

SOMEONE KNOCKING AT THE DOOR...

Superman #8 (Jan.–Feb. 1941) - script: Jerry Siegel - art: Wayne Boring (pencils) & unknown (inks)

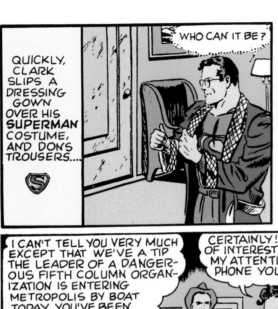
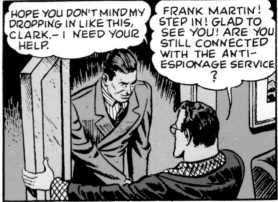
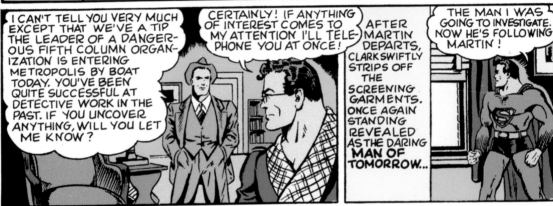
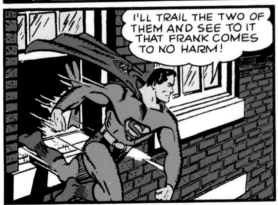
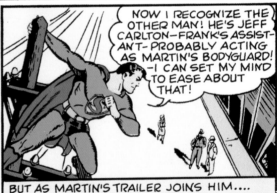
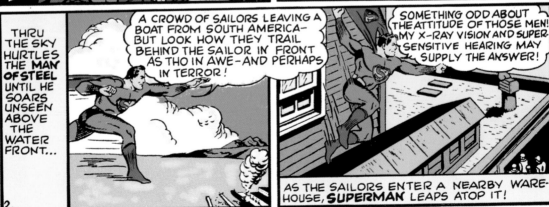

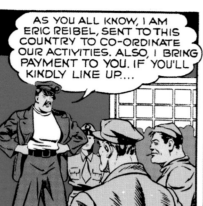
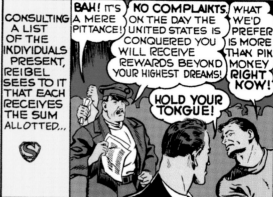
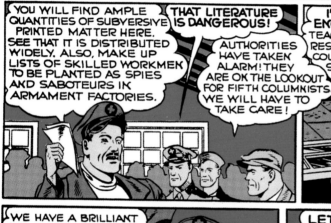
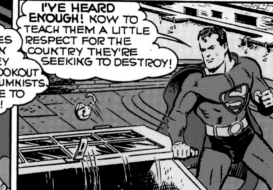
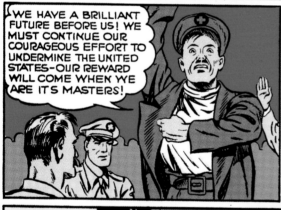
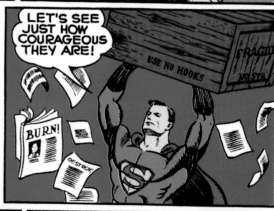

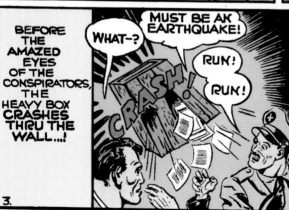

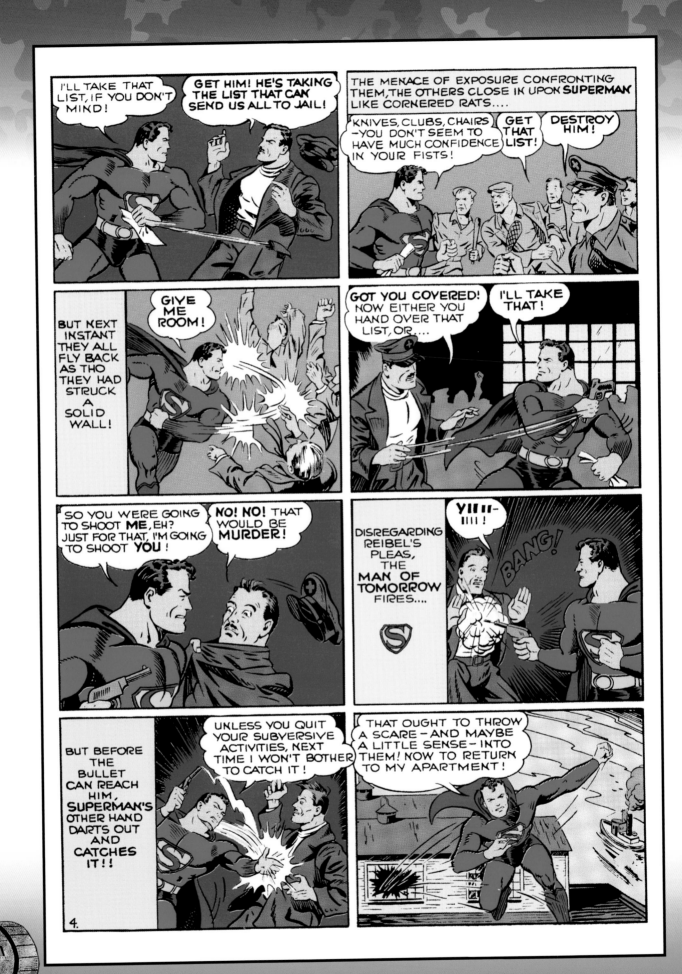

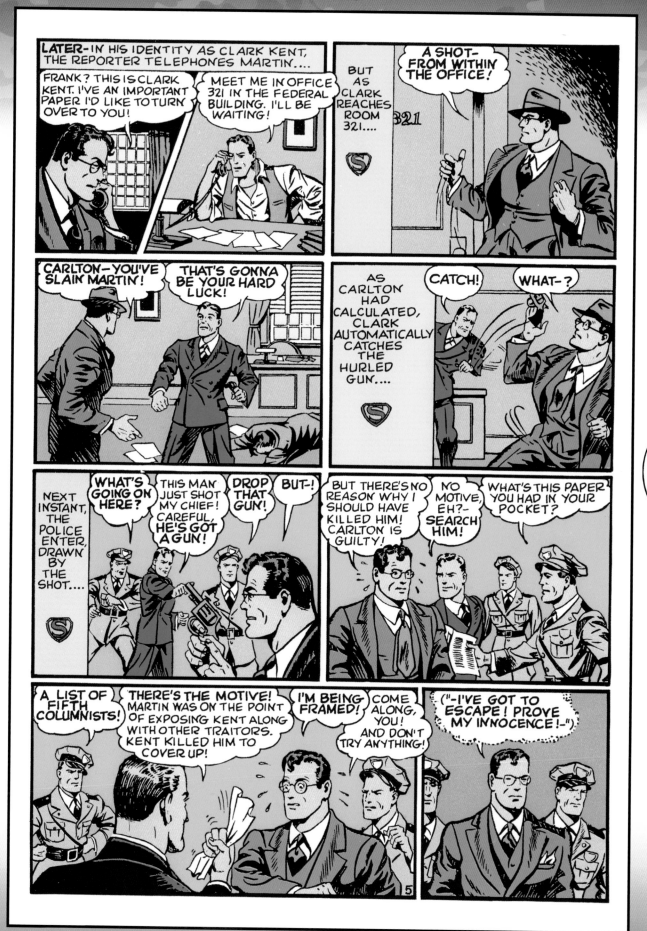

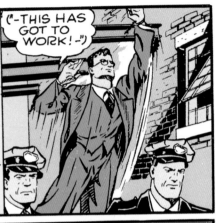
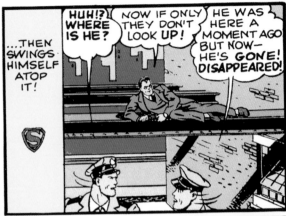
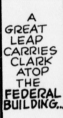
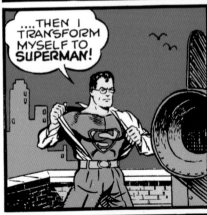

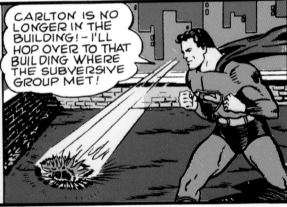
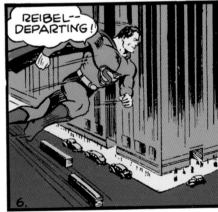
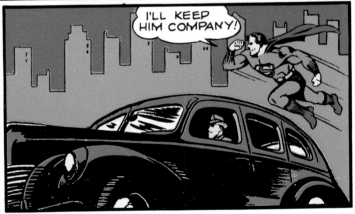

THE AUTO DRIVES TO THE METROPOLIS AIRPORT. FROM HIS VANTAGE POINT, SUPERMAN OBSERVES REIBEL ENTER A HUGE PRIVATE PLANE ALONG WITH OTHER PROMINENT FIFTH COLUMNISTS....

("-LOOKS LIKE A MASS FLIGHT!-")

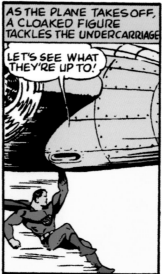

AS THE PLANE TAKES OFF, A CLOAKED FIGURE TACKLES THE UNDERCARRIAGE

LET'S SEE WHAT THEY'RE UP TO!

BUT I DON'T WANT TO GO! MY FAMILY... MY BUSINESS...

YOU'VE GOT TO FLEE WITH US! THE MOMENT THAT LIST BECOMES PUBLIC, WE'RE ALL MARKED MEN!

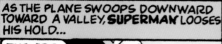

AS THE PLANE SWOOPS DOWNWARD TOWARD A VALLEY, SUPERMAN LOOSES HIS HOLD...

THEY'RE GOING TO LAND!

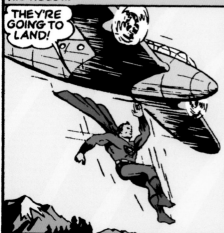

ALIGHTING ATOP A MOUNTAIN RANGE, THE MAN OF STEEL IS AMAZED AT THE SIGHT THAT GREETS HIS EYES....

WHAT-!!

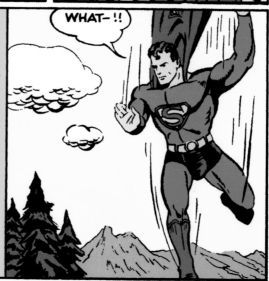

109

IN THE VALLEY BELOW, A SCENE THAT MIGHT WELL BE LAID IN EUROPE...!

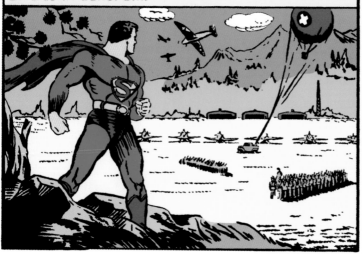

FROM THIS SECRET BASE - A SUBVERSIVE ARMY THAT CAN STRIKE TERROR AND DESTRUCTION FROM THE REAR WHEN THE MILITARY FORCES OF THE U.S. ARE ATTEMPTING TO DEFEND THE COAST AGAINST FOREIGN INVASION!

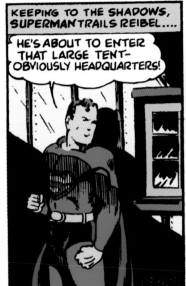

KEEPING TO THE SHADOWS, SUPERMAN TRAILS REIBEL....

HE'S ABOUT TO ENTER THAT LARGE TENT-OBVIOUSLY HEADQUARTERS!

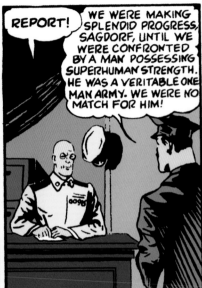

REPORT!

WE WERE MAKING SPLENDID PROGRESS, SAGDORF, UNTIL WE WERE CONFRONTED BY A MAN POSSESSING SUPERHUMAN STRENGTH. HE WAS A VERITABLE ONE MAN ARMY. WE WERE NO MATCH FOR HIM!

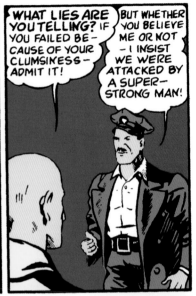

WHAT LIES ARE YOU TELLING? IF YOU FAILED BE-CAUSE OF YOUR CLUMSINESS—ADMIT IT!

BUT WHETHER YOU BELIEVE ME OR NOT — I INSIST WE WERE ATTACKED BY A SUPER-STRONG MAN!

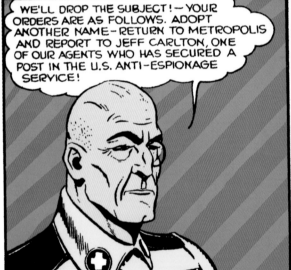

WE'LL DROP THE SUBJECT! — YOUR ORDERS ARE AS FOLLOWS. ADOPT ANOTHER NAME—RETURN TO METROPOLIS AND REPORT TO JEFF CARLTON, ONE OF OUR AGENTS WHO HAS SECURED A POST IN THE U.S. ANTI-ESPIONAGE SERVICE!

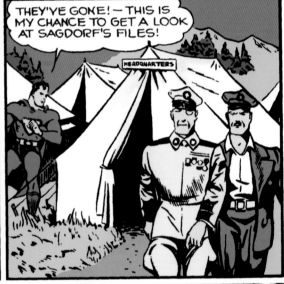

THEY'VE GONE! — THIS IS MY CHANCE TO GET A LOOK AT SAGDORF'S FILES!

HEADQUARTERS

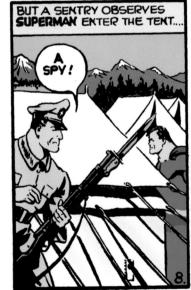

BUT A SENTRY OBSERVES **SUPERMAN** ENTER THE TENT....

A SPY!

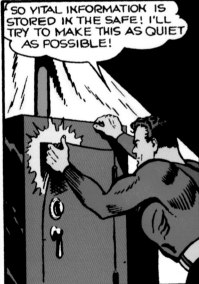

SO VITAL INFORMATION IS STORED IN THE SAFE! I'LL TRY TO MAKE THIS AS QUIET AS POSSIBLE!

8.

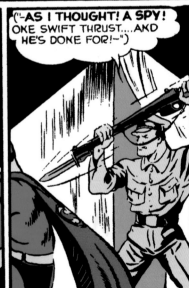

("–AS I THOUGHT! A SPY! ONE SWIFT THRUST.....AND HE'S DONE FOR!~")

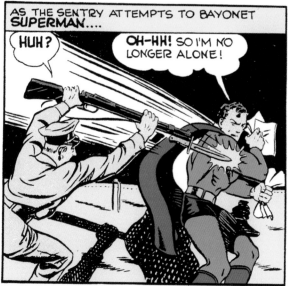

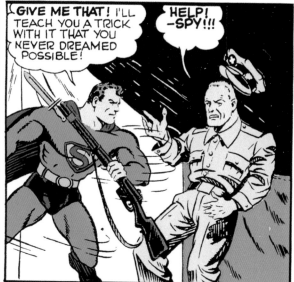

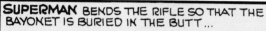

111

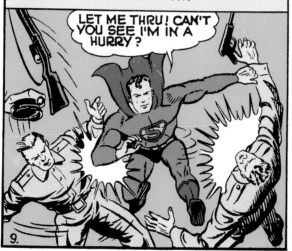

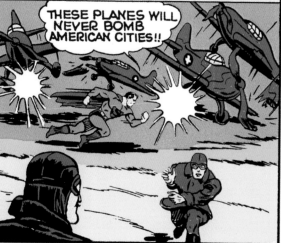

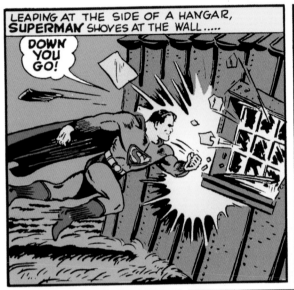
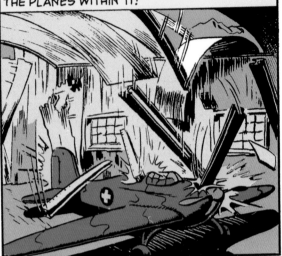
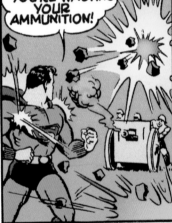
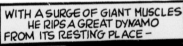
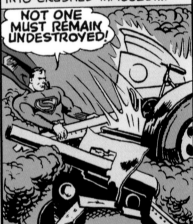
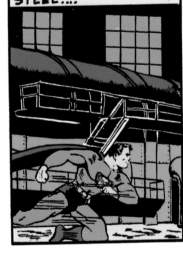
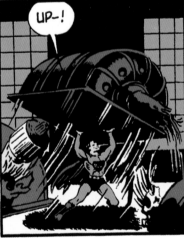
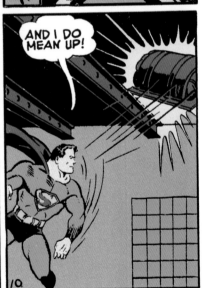

112

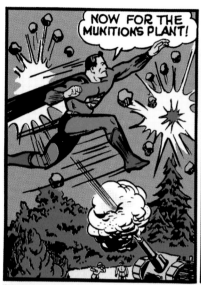

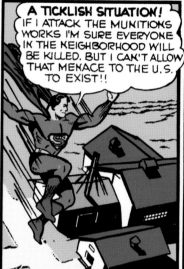

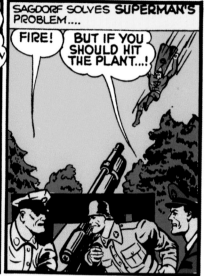

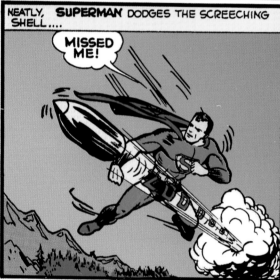

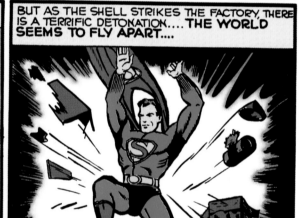

113

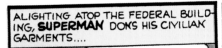

ALIGHTING ATOP THE FEDERAL BUILDING, **SUPERMAN** DONS HIS CIVILIAN GARMENTS....

CLARK DESCENDS TO ROOM 321...

OPENING THE DOOR SLIGHTLY, CLARK SIGHTS....

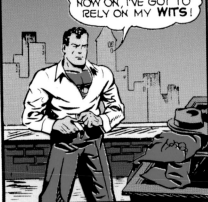

NO MORE SUPER-STRENGTH TODAY! FROM NOW ON, I'VE GOT TO RELY ON MY **WITS!**

SOMEONE IS IN THE ROOM!

IT'S POSSIBLE I MAY HAVE MISSED SOMETHING IMPORTANT!

STEPPING CAUTIOUSLY IN, KENT REMOVES A REVOLVER FROM A DESK DRAWER....

TURN!

WHAT–?

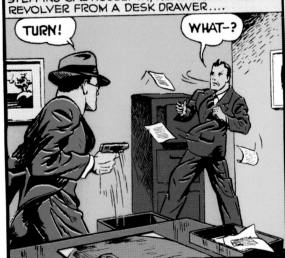

IT'S KENT!

YES. AND I'M HERE TO SEE THAT YOU CONFESS TO YOUR CRIME!

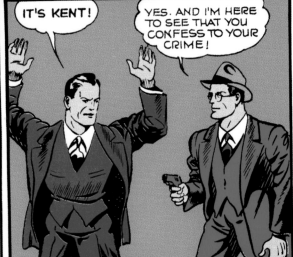

I KNOW THAT YOU'RE NOT RESPONSIBLE – BUT TRY AND GET ME TO REPEAT IT IN PUBLIC!

THAT'S JUST WHAT I'M GOING TO DO! – GET MOVING!

IN A TAXI BOUND FOR THE DAILY PLANET BUILDING.

YOU CAN'T GET AWAY WITH THIS!

THAT REMAINS TO BE SEEN!

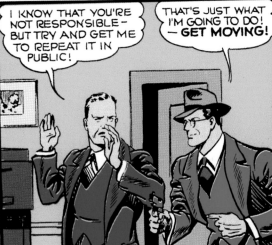

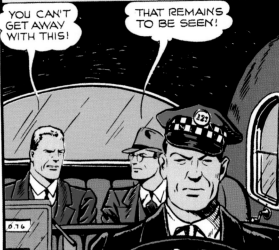

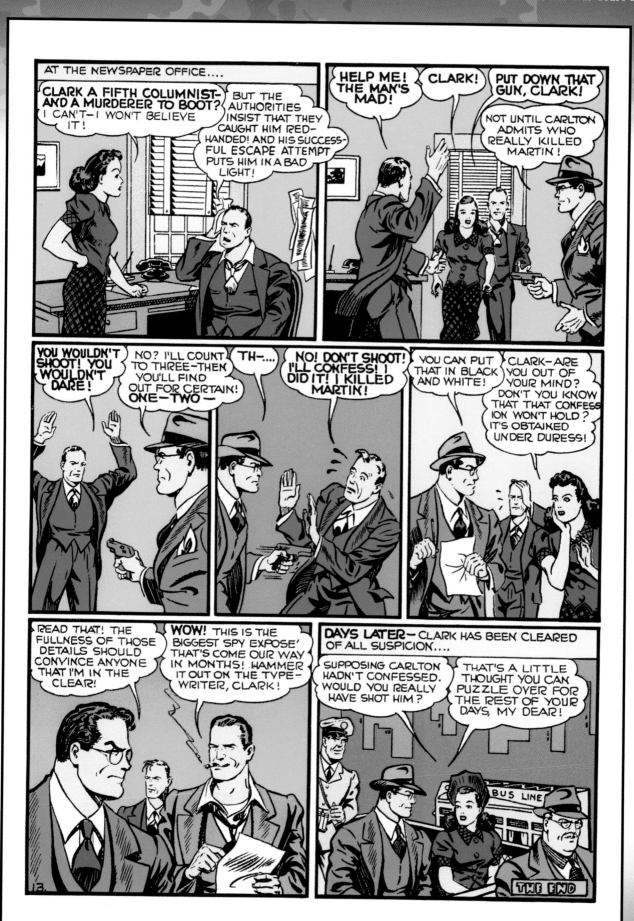

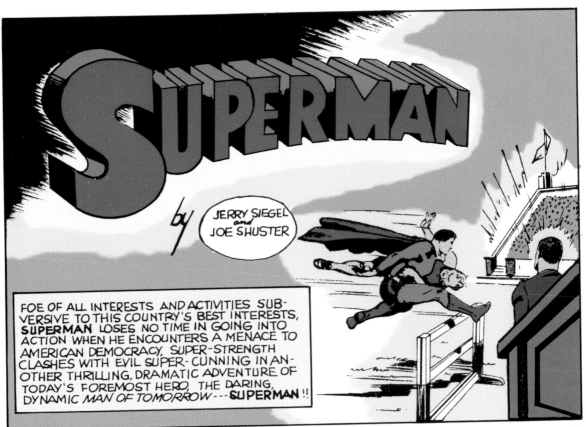

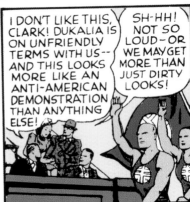
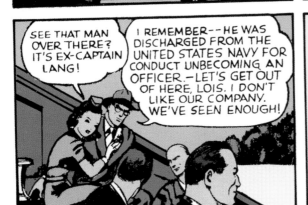
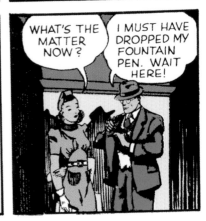

Superman #10 (May–June 1941) - script: Jerry Siegel - art: Wayne Boring (pencils) & The Shuster Shop (inks)

AS SOON AS HE IS OUT OF LOIS' SIGHT, CLARK WHIPS OFF HIS CIVILIAN GARMENTS, STANDING REVEALED AS THE MIGHTY **SUPERMAN . . . !**

I'M CONVINCED THIS SPORTS FESTIVAL IS BUT THE FRONT FOR AN ORGANIZATION FOMENTING UNAMERICAN ACTIVITIES. THE DUKALIAN CONSUL IS ABOUT TO SPEAK—I'LL LEND AN EAR. AND IF I DON'T LIKE WHAT HE SAYS...

DUKALIAN CONSUL KARL WOLFF HOLDS HIS AUDIENCE SPELLBOUND

PRESENT HERE IS THE FLOWER OF DUKALIAN YOUTH! YOU HAVE SEEN THEM PERFORM PHYSICAL FEATS WHICH NO OTHER HUMAN BEINGS CAN. PROOF, I TELL YOU, THAT WE DUKALIANS ARE SUPERIOR TO ANY OTHER RACE OR NATION! PROOF THAT WE ARE ENTITLED TO BE THE MASTERS OF AMERICA!

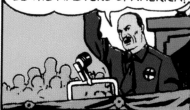

STREAKING DOWN ONTO THE FIELD, INTERRUPTING THE CONSUL'S SPIEL—SUPERMAN!

LET'S SEE JUST HOW SUPERIOR YOU **REALLY** ARE!

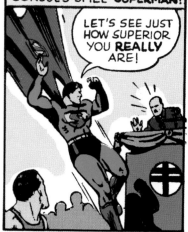

SO YOU'RE THE SHOT-PUTTER, EH? LET'S SEE IF WE CAN BREAK YOUR RECORD—OR YOUR NECK!

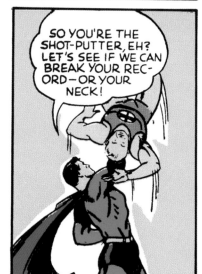

A HEAVE OF THE *MAN OF STEEL'S* MIGHTY ARM AND THE ATHLETE LANDS A DISTANCE AHEAD OF HIS SHOT-PUT....

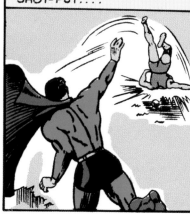

NEXT, **SUPERMAN** SNATCHES THE POLE VAULT CHAMP....

SO THAT'S YOUR RECORD HEIGHT, EH?

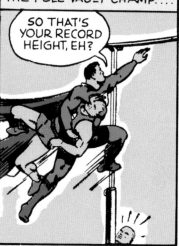

117

NOW YOU CAN SAY YOU BEAT YOUR OWN RECORD—*WITHOUT* THE AID OF THE POLE!

SEIZING ANOTHER ATHLETE BY THE NECK AND SEAT OF HIS PANTS, **SUPERMAN** PUSHES HIM BEFORE HIM IN THE FASTEST HUNDRED YARD DASH THAT HAS EVER BEEN RUN!

TWO SECONDS FLAT!

TAKING THE HURDLE CHAMPION UNDER HIS ARM, **SUPERMAN** CARRIES HIM OVER ALL THE HURDLES IN ONE GREAT LEAP....

HOW'S *THAT*?

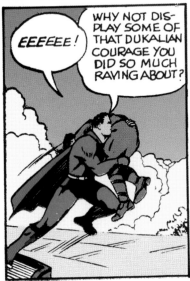

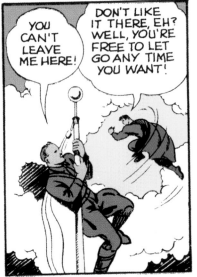

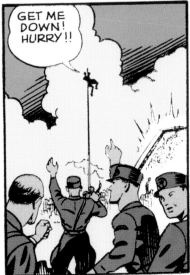

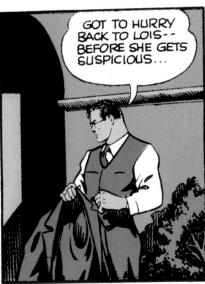

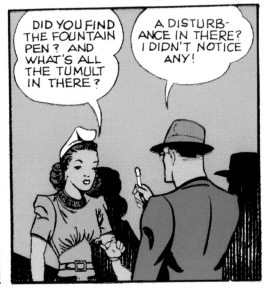

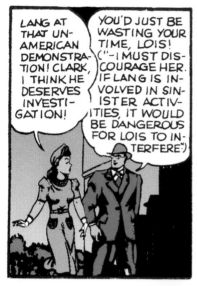

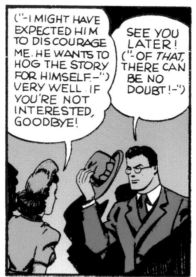

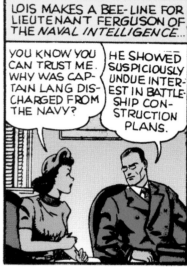

119

OOPS! -- ALMOST LOST MY GRIP THAT TIME!

WHAT--! SOMEONE INSERTING A KEY IN THE DOOR!

CAUTIOUSLY ENTERING THE DARKENED ROOM, THE MAN PLACES A PACKAGE IN THE TOP DRAWER OF THE DRESSER.

("--IT'S ONE OF THE PRIZE-WINNING ATHLETES WHO ATTENDED THE SPORTS FESTIVAL!--")

AFTER THE ATHLETE DEPARTS, LOIS EMERGES FROM HER HIDING PLACE AND OPENS THE PACKAGE...

WHEW! BILLS OF HIGH DENOMINATION -- THEY MUST TOTAL AT LEAST FIFTY THOUSAND DOLLARS!

ABRUPTLY, STRONG FINGERS ENCIRCLE LOIS' NECK FROM BEHIND....

LOIS KICKS BACK SHARPLY, STRIKING HER ASSAILANT'S KNEE. AS THE GRIP ON HER THROAT QUICKLY RELAXES, SHE TEARS FREE AND DASHES TOWARD THE DOOR...

⑤

I'VE GOT TO GET OUT OF HERE!

BUT AS SHE OPENS THE DOOR--!

L-LANG!

WELL...I SEE I'VE COME NOT A MOMENT TOO EARLY!

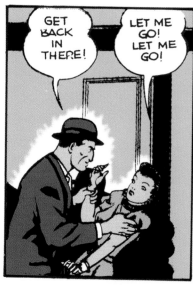

GET BACK IN THERE!

LET ME GO! LET ME GO!

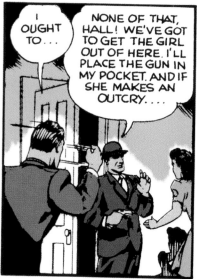

I OUGHT TO...

NONE OF THAT, HALL! WE'VE GOT TO GET THE GIRL OUT OF HERE. I'LL PLACE THE GUN IN MY POCKET. AND IF SHE MAKES AN OUTCRY....

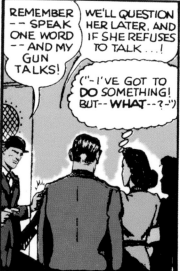

REMEMBER -- SPEAK ONE WORD -- AND MY GUN TALKS!

WE'LL QUESTION HER LATER, AND IF SHE REFUSES TO TALK...!

("--I'VE GOT TO DO SOMETHING! BUT-- WHAT--?-")

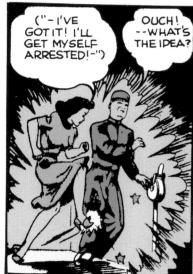

("--I'VE GOT IT! I'LL GET MYSELF ARRESTED!-")

OUCH! --WHAT'S THE IDEA?

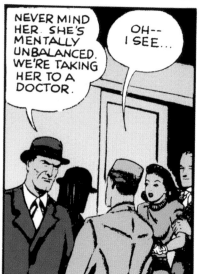

NEVER MIND HER. SHE'S MENTALLY UNBALANCED. WE'RE TAKING HER TO A DOCTOR.

OH-- I SEE...

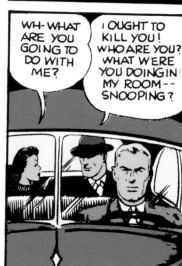

WH- WHAT ARE YOU GOING TO DO WITH ME?

I OUGHT TO KILL YOU! WHO ARE YOU? WHAT WERE YOU DOING IN MY ROOM-- SNOOPING?

121

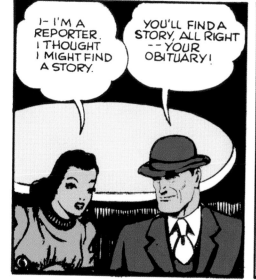

I- I'M A REPORTER. I THOUGHT I MIGHT FIND A STORY.

YOU'LL FIND A STORY, ALL RIGHT -- YOUR OBITUARY!

LATER-- AS THEY REACH A PIER, THEY ARE JOINED BY WOLFF, THE DUKALIAN CONSUL...

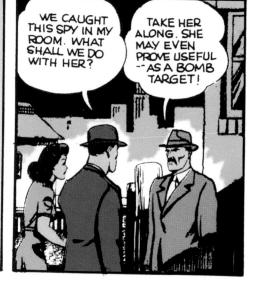

WE CAUGHT THIS SPY IN MY ROOM. WHAT SHALL WE DO WITH HER?

TAKE HER ALONG. SHE MAY EVEN PROVE USEFUL -- AS A BOMB TARGET!

REMEMBER-- THE FIFTY THOUSAND DOLLARS WAS JUST FOR A DEMONSTRATION RIDE ON MY STARTLING INVENTION....

TRUE! AN ADDITIONAL TWO MILLION DOLLARS WILL BE PAID FOR THE INVENTION IF IT MEETS WITH MY COMPLETE SATISFACTION!

IF YOU HAVE MADE A GREAT MILITARY DISCOVERY, DON'T YOU THINK YOUR OWN COUNTRY IS ENTITLED TO IT?

I SWORE THIS COUNTRY WOULD PAY FOR DISMISSING ME FROM THE NAVY! I HAVE WOLFF'S ASSURANCE THAT WHEN DUKALIA CONQUERS AMERICA, I WILL RECEIVE AN IMPORTANT POST!

DUKALIA APPRECIATES GENIUS... AND LOYALTY!

WHEN LOIS HAD DEPARTED, CLARK REMOVED HIS OUTER GARMENTS AND TUCKED THEM BENEATH HIS **SUPERMAN** CLOAK.....

SO LOIS THINKS LANG COULD STAND INVESTIGATING! HM-MM! DOESN'T SOUND LIKE A BAD IDEA, AT THAT!

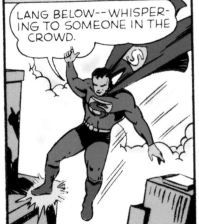

A GREAT LEAP LAUNCHES THE *MAN OF STEEL* TO A POSITION ATOP THE STADIUM...

LANG BELOW-- WHISPERING TO SOMEONE IN THE CROWD.

WHAT **SUPERMAN'S** AMAZING SUPER-SENSITIVE HEARING ENABLES HIM TO OVERHEAR...

I ACCEPT YOUR TERMS!

SPLENDID!

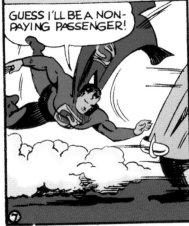

AS EX-CAPTAIN LANG DRIVES OFF, **SUPERMAN** STREAKS DOWN AND SWINGS HIMSELF BENEATH THE CAR.....

GUESS I'LL BE A NON-PAYING PASSENGER!

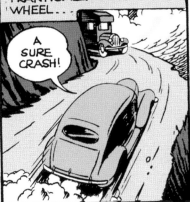

AS LANG SWIFTLY ROUNDS A CURVE ON A MOUNTAIN ROAD, A HUGE TRUCK UNEXPECTEDLY LOOMS BEFORE HIM... THE DISCHARGED NAVAL OFFICER FRANTICALLY TWISTS THE WHEEL...

A SURE CRASH!

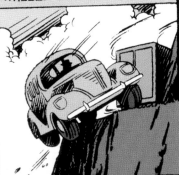

A COLLISION IS NARROWLY AVOIDED! BUT-- THE CAR'S WHEELS SLIP OFF THE ROAD!

THE AUTO COMMENCES TIPPING OVER, PREPARATORY TO BEGINNING THE TERRIBLE DOWNWARD PLUNGE!

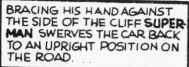

BRACING HIS HAND AGAINST THE SIDE OF THE CLIFF **SUPERMAN** SWERVES THE CAR BACK TO AN UPRIGHT POSITION ON THE ROAD...

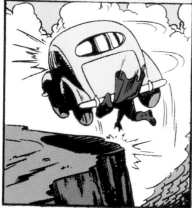

WHEW! I'VE NEVER COME CLOSER TO DEATH! I CAN THANK MY LUCKY STARS!

NO, LANG, YOU CAN THANK SUPERMAN!

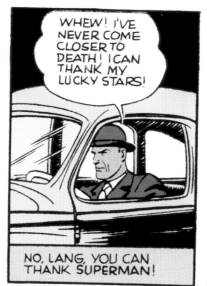

LATER--PARKING NEAR THE WATERFRONT, LANG CAUTIOUSLY OPENS A HIGH GATE, THEN LOCKS IT AFTER HIMSELF...

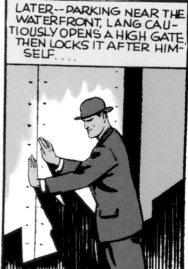

AN INSTANT LATER, THE *MAN OF STEEL* EASILY VAULTS OVER THE BARRIER...

THEY'LL HAVE TO BUILD THIS MUCH HIGHER IF THEY HOPE TO KEEP ME OUT!

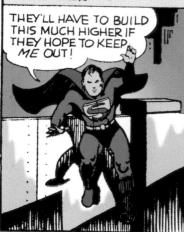

TAKE IT OUT FOR A TRIAL SPIN!

AS YOU DIRECT, SIR!

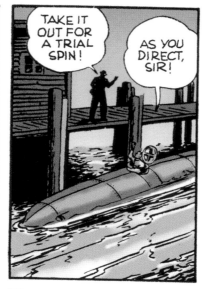

SLOWLY, THE CRAFT MOVES SEAWARD, THEN COMMENCES TO SUBMERGE...

123

PROVIDING YOU DELIVER THE MONEY AS PROMISED, I'M READY TO TAKE YOU ON A DEMONSTRATION VOYAGE AT ONCE!

NO NAME HAS BEEN MENTIONED BUT I COULD RECOGNIZE THAT VOICE ANYWHERE! LANG IS SPEAKING TO WOLFF!

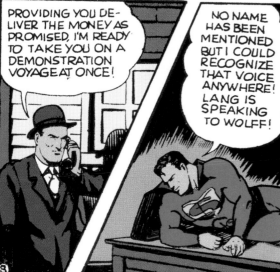

AN INSTANT LATER SUPERMAN IS AMAZED TO DISCOVER THAT THO HE MAKES USE OF HIS TELESCOPIC VISION....

THAT STRANGE VESSEL--COMPLETELY DISAPPEARED-- NO LONGER TO BE SEEN!

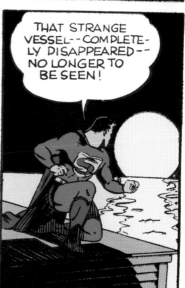

THIS CALLS FOR A MORE THOROUGH SEARCH!

BUT THO **SUPERMAN** RAPIDLY SWIMS UNDERWATER, EXPLORING THE VICINITY, HE FINDS...

--NOT A TRACE OF IT!

ON LAND ONCE AGAIN, **SUPERMAN** STREAKS OFF THRU THE NIGHT....

THIS GROWS MORE MYSTERIOUS--AND SINISTER--EVERY MOMENT! WOLFF IS THE MAN I WANT TO SEE RIGHT NOW!

SUPERMAN FINDS THE WINDOWS OF THE DUKALIAN CONSULATE BARRED, BUT...

THAT'S NO OBSTACLE TO ME!

AS HE ENTERS THE ROOM....

GAS!-- DEADLY HYDROCYANIC GAS!

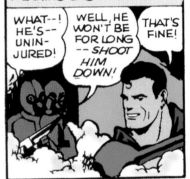

DUE TO HIS GREAT POWERS OF RESISTANCE, THE *MAN OF TOMORROW* IS UNHARMED. AS POWERFUL VENTILATORS CLEAR THE ROOM OF THE GAS, ARMED MEN WEARING GAS-MASKS ENTER.

WHAT--! HE'S-- UNINJURED!

WELL, HE WON'T BE FOR LONG --SHOOT HIM DOWN!

THAT'S FINE!

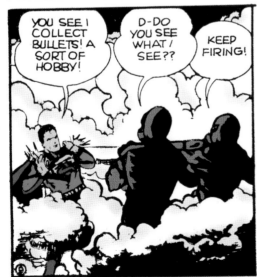

YOU SEE I COLLECT BULLETS! A SORT OF HOBBY!

D-DO YOU SEE WHAT I SEE??

KEEP FIRING!

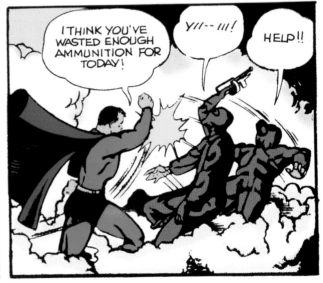

I THINK YOU'VE WASTED ENOUGH AMMUNITION FOR TODAY!

Y//-- ///!

HELP!!

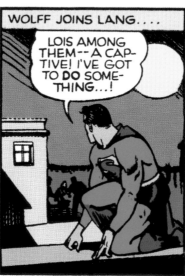

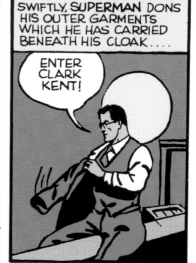

125

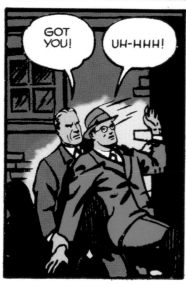

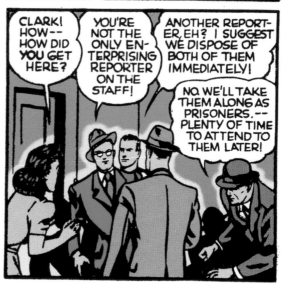

CAPTORS AND PRISONERS ENTER THE UNUSUAL VESSEL, AND AS THEY DO SO, THE HATCH CLOSES....

THE SIDES --MADE OF A TRANSPARENT PLASTIC! WE SEEM TO BE MOVING AT TERRIFIC SPEED!

YOU ARE VERY OBSERVANT... TOO MUCH SO FOR YOUR OWN GOOD!

YOU THINK THAT ASTONISHING? WATCH THIS!

AS LANG PULLS THE LEVER, THE VESSEL SLANTS SHARPLY UP INTO THE AIR!

THEN--AS IT DIVES BENEATH THE WATER'S SURFACE ONCE AGAIN

YOU SEE...MY SHIP CAN TRAVEL *ABOVE* WATER AS WELL AS *BENEATH* IT!-- QUITE AN IMPORTANT DISCOVERY FOR MODERN WARFARE, EH? AND ANYONE CAN OPERATE IT WITH THIS SIMPLE LEVER!

THAT'S ALL I WANT TO KNOW! HEAD FOR THE PANAMA CANAL-- AND FORGET ABOUT THE TWO MILLION... YOU'LL NEVER LIVE TO SEE IT!

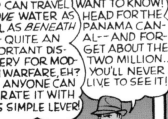

YOU CAN PUT DOWN THAT GUN! THIS SIGNAL SUMMONS MY MEN!

AH--BUT I'VE ANTICIPATED YOU. HALL HAS ALREADY ATTENDED TO THEM ...*SPY!* YOU CAN DROP THE POSE. I HAPPEN TO HAVE KNOWN ALL ALONG YOU STILL SERVE THE U.S. NAVY AND HAVE USED THIS NEW INVENTION TO SNARE FOREIGN SPYS!

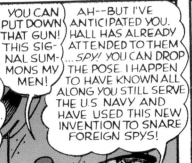

YOU MUST BE COMPLETELY MAD! THIS CRAFT HASN'T THE SLIGHTEST CHANCE OF PENETRATING THE PANAMA CANAL DEFENSES!

YOU UNDERESTIMATE MY INGENUITY!

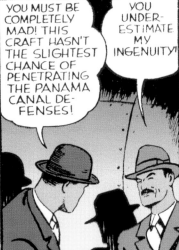

AS WOLFF HAD-PRE-ARRANGED, THE SKY-SUB IS MANEUVERED SO THAT IT IS ATTACHED TO A HOOK BENEATH A LARGE FREIGHTER...

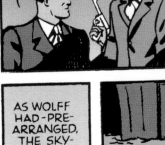

⑪

WITH THE AID OF SPECIAL APPARATUS, TORPEDOES AND BOMBS ARE TRANSFERED FROM THE FREIGHTER TO THE SUB ...

WHEN THE FREIGHTER APPROACHES THE PANAMA CANAL, IT WILL BE INSPECTED AND PASSED. NO ONE WILL KNOW THAT HIDDEN BENEATH IT IS A CRAFT THAT WILL BE RELEASED AT A VITAL SPOT TO BLOW UP THE CANAL!

YOU WON'T GET AWAY WITH IT!

BUT IT APPEARS HE IS!

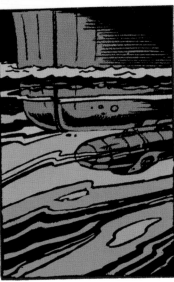

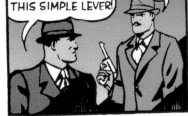

AT THE CONSUL'S ORDERS, CLARK IS PLACED WITHIN AN EMPTY TORPEDO-TUBE....

PLEASE DON'T! THIS IS MURDER!

YOU'LL ONLY BE IN THE WAY NOW. YOU FIRST--THEN... THE OTHERS SHARE YOUR FATE!

YOU --YOU BUTCHER!

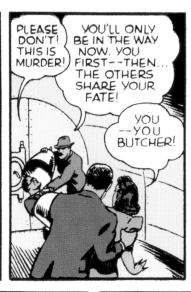

BUT DESPITE LOIS' PLEAS, THE TORPEDO BEARING CLARK IS SHOT INTO THE WATER...

THE SIDES OF THE TORPEDO SPLIT OPEN AS CLARK SMASHES HIS WAY OUT...

HERE'S WHERE I EXIT!

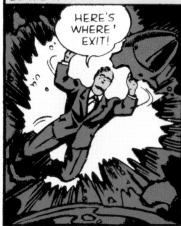

SWIFTLY CHANGING HIS GARMENTS, **SUPERMAN** HIDES HIS CIVILIAN GARMENTS BENEATH HIS CLOAK...

GOT TO GET BACK --BEFORE HE HARMS LOIS--!

SO HERE GOES!

127

SEIZING THE VESSEL, **SUPERMAN** FORCES IT UP TOWARD THE SURFACE...

GET MOVING!

LET THE GIRL AND LANG ALONE. OPEN THE HATCH WHEN WE REACH THE SURFACE AND SEE WHAT THE TROUBLE IS!

WHAT CAN IT BE?

IT'S THAT IN-FERNALLY STRONG MEDDLER -- GET HIM!

THIS BOMB OUGHT TO TAKE CARE OF HIM!

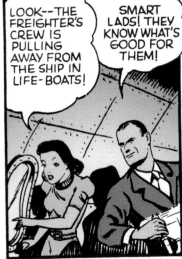

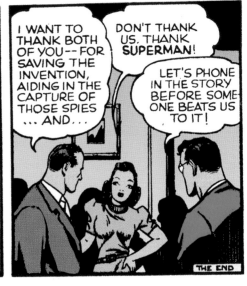

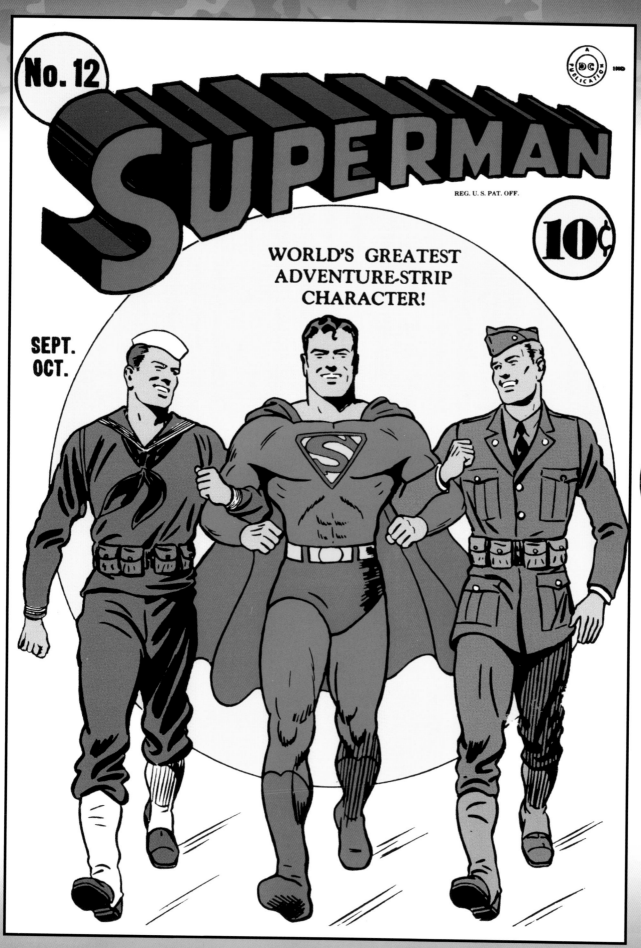

Superman #12 (Sept.–Oct. 1941) - cover art: Fred Ray

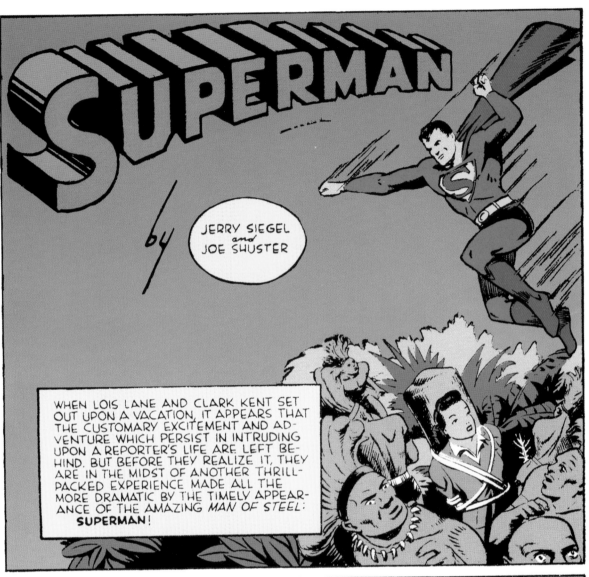

SUPERMAN

by

JERRY SIEGEL *and* JOE SHUSTER

WHEN LOIS LANE AND CLARK KENT SET OUT UPON A VACATION, IT APPEARS THAT THE CUSTOMARY EXCITEMENT AND ADVENTURE WHICH PERSIST IN INTRUDING UPON A REPORTER'S LIFE ARE LEFT BEHIND. BUT BEFORE THEY REALIZE IT, THEY ARE IN THE MIDST OF ANOTHER THRILL-PACKED EXPERIENCE MADE ALL THE MORE DRAMATIC BY THE TIMELY APPEARANCE OF THE AMAZING *MAN OF STEEL:* **SUPERMAN!**

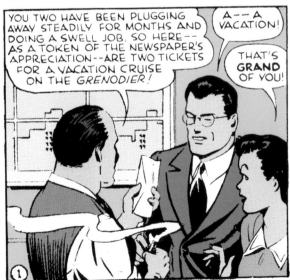

YOU TWO HAVE BEEN PLUGGING AWAY STEADILY FOR MONTHS AND DOING A SWELL JOB, SO HERE-- AS A TOKEN OF THE NEWSPAPER'S APPRECIATION--ARE TWO TICKETS FOR A VACATION CRUISE ON THE *GRENODIER!*

A-- A VACATION!

THAT'S **GRAND** OF YOU!

①

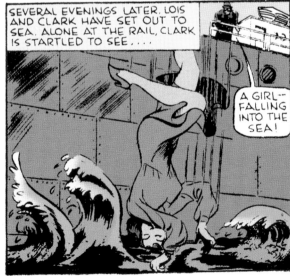

SEVERAL EVENINGS LATER, LOIS AND CLARK HAVE SET OUT TO SEA. ALONE AT THE RAIL, CLARK IS STARTLED TO SEE....

A GIRL-- FALLING INTO THE SEA!

Superman #12 (Sept.–Oct. 1941) - script: Jerry Siegel - art: Joe Shuster (pencil layouts) & Leo Nowak (finished pencils & inks)

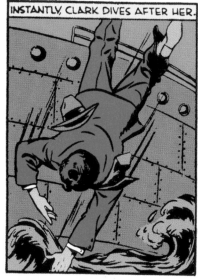

INSTANTLY, CLARK DIVES AFTER HER.

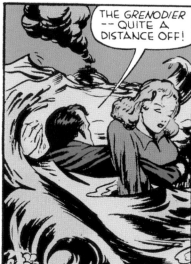

THE *GRENODIER* -- QUITE A DISTANCE OFF!

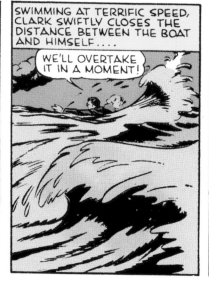

SWIMMING AT TERRIFIC SPEED, CLARK SWIFTLY CLOSES THE DISTANCE BETWEEN THE BOAT AND HIMSELF....

WE'LL OVERTAKE IT IN A MOMENT!

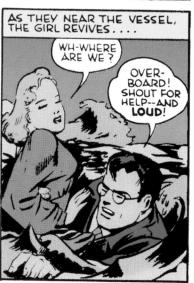

AS THEY NEAR THE VESSEL, THE GIRL REVIVES....

WH-WHERE ARE WE?

OVERBOARD! SHOUT FOR HELP--AND *LOUD!*

131

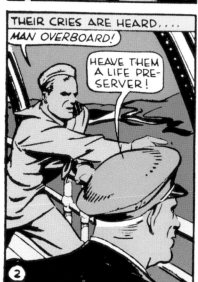

THEIR CRIES ARE HEARD....
MAN OVERBOARD!

HEAVE THEM A LIFE PRESERVER!

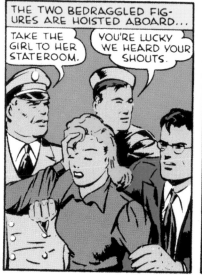

THE TWO BEDRAGGLED FIGURES ARE HOISTED ABOARD...

TAKE THE GIRL TO HER STATEROOM.

YOU'RE LUCKY WE HEARD YOUR SHOUTS.

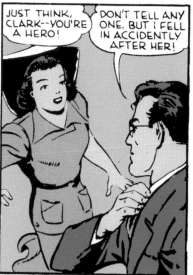

JUST THINK, CLARK--YOU'RE A HERO!

DON'T TELL ANY ONE, BUT I FELL IN ACCIDENTLY AFTER HER!

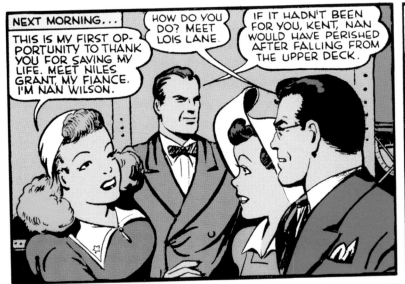

NEXT MORNING...

THIS IS MY FIRST OP-PORTUNITY TO THANK YOU FOR SAVING MY LIFE. MEET NILES GRANT, MY FIANCE. I'M NAN WILSON.

HOW DO YOU DO? MEET LOIS LANE.

IF IT HADN'T BEEN FOR YOU, KENT, NAN WOULD HAVE PERISHED AFTER FALLING FROM THE UPPER DECK.

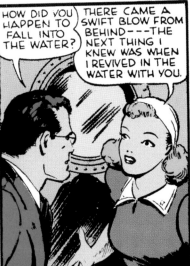

HOW DID YOU HAPPEN TO FALL INTO THE WATER?

THERE CAME A SWIFT BLOW FROM BEHIND---THE NEXT THING I KNEW WAS WHEN I REVIVED IN THE WATER WITH YOU.

DURING THE ENSUING DAYS, CLARK, LOIS AND NAN AND NILES BECOME GREAT FRIENDS

YOU SAY YOU'RE STOPPING OFF AT AN ISLAND YOU'VE INHERITED?

YES. POGO ISLAND. I INHERITED IT YEARS AGO, BUT THIS WILL BE MY FIRST VISIT TO IT

I TRIED TO TALK NAN OUT OF THIS VISIT-- BUT SHE HAS HER MIND SET ON IT!

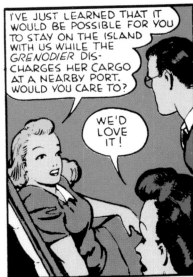

I'VE JUST LEARNED THAT IT WOULD BE POSSIBLE FOR YOU TO STAY ON THE ISLAND WITH US WHILE THE GRENODIER DIS-CHARGES HER CARGO AT A NEARBY PORT. WOULD YOU CARE TO?

WE'D LOVE IT!

NEXT DAY, AS THE SMALL PARTY GETS OFF AT POGO ISLAND....

MEET CARL BOGART, FORE-MAN OF MY PLANTATION.

GLAD TO SEE YOU I HOPE YOU ENJOY YOUR STAY HERE!

③

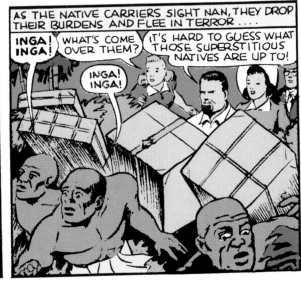

AS THE NATIVE CARRIERS SIGHT NAN, THEY DROP THEIR BURDENS AND FLEE IN TERROR....

INGA! INGA!

WHAT'S COME OVER THEM?

IT'S HARD TO GUESS WHAT THOSE SUPERSTITIOUS NATIVES ARE UP TO!

INGA! INGA!

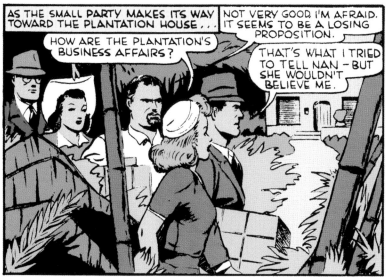

AS THE SMALL PARTY MAKES ITS WAY TOWARD THE PLANTATION HOUSE...

HOW ARE THE PLANTATION'S BUSINESS AFFAIRS?

NOT VERY GOOD I'M AFRAID. IT SEEMS TO BE A LOSING PROPOSITION.

THAT'S WHAT I TRIED TO TELL NAN - BUT SHE WOULDN'T BELIEVE ME.

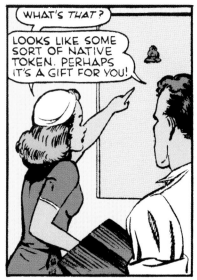

WHAT'S *THAT*?

LOOKS LIKE SOME SORT OF NATIVE TOKEN. PERHAPS IT'S A GIFT FOR YOU!

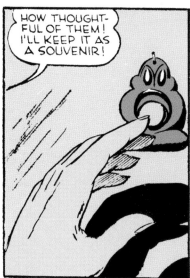

HOW THOUGHT-FUL OF THEM! I'LL KEEP IT AS A SOUVENIR!

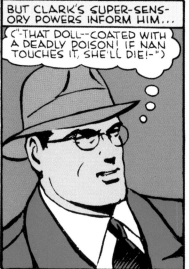

BUT CLARK'S SUPER-SENSORY POWERS INFORM HIM...

("-THAT DOLL--COATED WITH A DEADLY POISON! IF NAN TOUCHES IT, SHE'LL DIE!-")

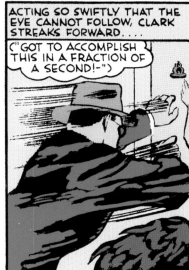

ACTING SO SWIFTLY THAT THE EYE CANNOT FOLLOW, CLARK STREAKS FORWARD....

("GOT TO ACCOMPLISH THIS IN A FRACTION OF A SECOND!-")

SWIFTLY HE RIPS THE FIGURE FROM THE DOOR, HURLS IT AWAY, THEN RETURNS TO HIS FORMER POSITION!

④

THAT'S ODD! --THAT FIGURE-- GONE!

BUT IT WAS THERE A MOMENT AGO!-- PERHAPS IT'S SOME SORT OF NATIVE MAGIC!

("-WHEW! THAT WAS A CLOSE CALL FOR NAN!")

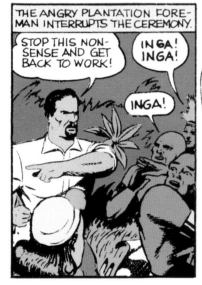
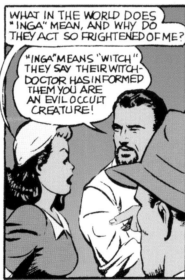

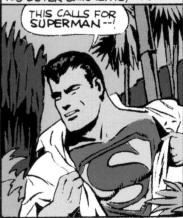

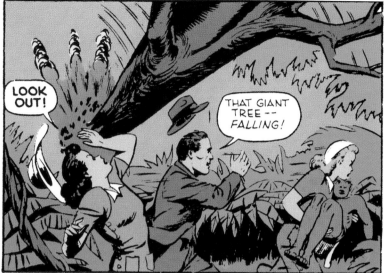

LOOK OUT!

THAT GIANT TREE -- FALLING!

LEAPING IN, THE *MAN OF STEEL* CATCHES, THEN LOWERS THE TREE TO THE GROUND BEFORE IT CAN HARM THE INTENDED VICTIMS...

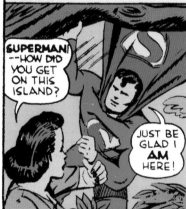

SUPERMAN! --HOW DID YOU GET ON THIS ISLAND?

JUST BE GLAD I **AM** HERE!

I'VE HEARD OF YOU--AND OF YOUR INCREDIBLE STRENGTH!

BUT I ALWAYS THOUGHT YOU WERE A LEGENDARY CHARACTER!

YOU'D BETTER HURRY BACK TO THE PLANTATION!

HE'S RIGHT-- *RUN!*

AS THE OTHERS HURRY ON, AMAZED NATIVES STEP FROM CONCEALMENT AND BOMBARD THE PARTY WITH POISONED DARTS!

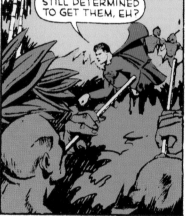

STILL DETERMINED TO GET THEM, EH?

135

RAPIDLY, **SUPERMAN** SNATCHES THE DARTS FROM THE AIR AS FAST AS THE NATIVES SEND THEM.

THESE OUGHT TO MAKE INTEREST-ING ADDITIONS TO MY COLLECTION!

⑥

WHEN THE FUGITIVES REACH THE PLANTATION HOUSE....

WHAT'S HAPPENED TO CLARK?

HE'S **GONE!**

I'LL GO AFTER HIM! HE HASN'T A CHANCE FACING THOSE NATIVES ALONE!

ATOP A HILL ABOVE THE PLANTATION HOUSE..!

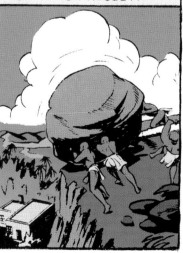

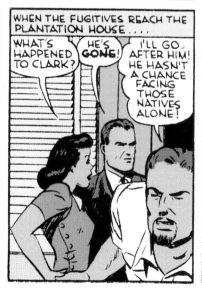

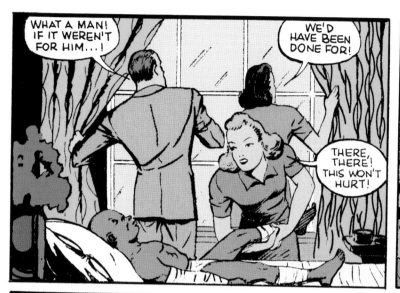

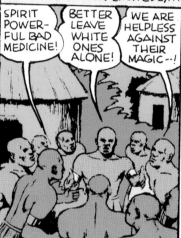

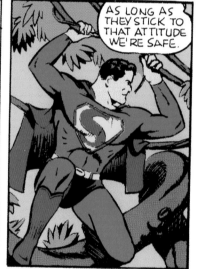

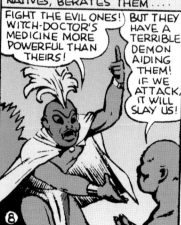

137

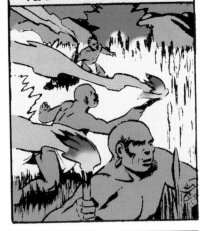

WITH FIENDISH THOROUGHNESS, THE ATTACKERS START A SERIES OF FIRES ABOUT THE PLANTATION HOUSE...!

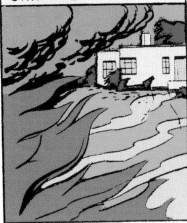

A POWERFUL BREEZE FANS THE FLAMES SO THAT THEY SWEEP HUNGRILY TOWARD THE STRUCTURE...!

MUST ACT QUICKLY-- BEFORE THE FLAMES REACH THE HOUSE!

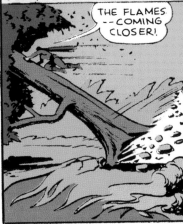

SUPERMAN RACES ABOUT THE PLANTATION AT A GREAT SPEED, USING THE GREAT TREE AS A PLOW, FURROWING A DITCH...

THE FLAMES --COMING CLOSER!

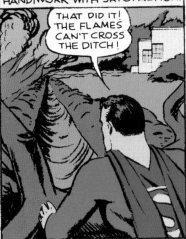

HIS TASK COMPLETED, THE MAN OF TOMORROW SURVEYS HIS HANDIWORK WITH SATISFACTION.

THAT DID IT! THE FLAMES CAN'T CROSS THE DITCH!

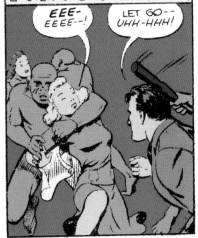

BUT NATIVES CRASH IN THRU THE REAR OF THE HOUSE AND QUICKLY OVERCOME ITS OCCUPANTS...

EEE- EEEE--!

LET GO-- UHH-HHH!

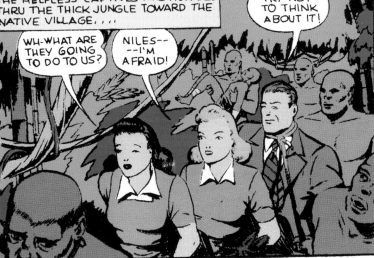

THE HELPLESS CAPTIVES ARE HURRIED THRU THE THICK JUNGLE TOWARD THE NATIVE VILLAGE...

WH-WHAT ARE THEY GOING TO DO TO US?

NILES-- --I'M AFRAID!

TRY NOT TO THINK ABOUT IT!

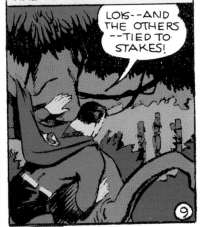

FINDING THE PLANTATION HOUSE EMPTY, SUPERMAN SPEEDS TO THE VILLAGE IN TIME TO SEE....

LOIS--AND THE OTHERS --TIED TO STAKES!

⑨

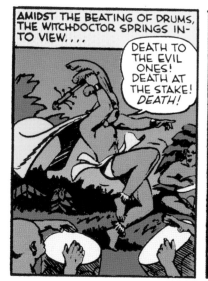
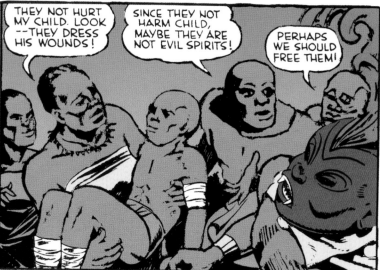
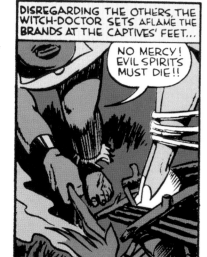
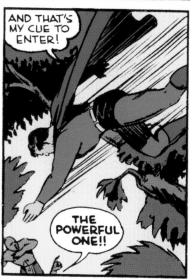
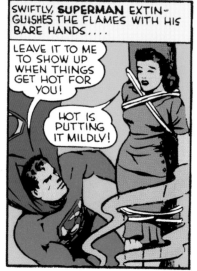

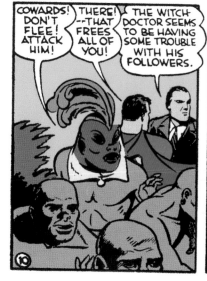
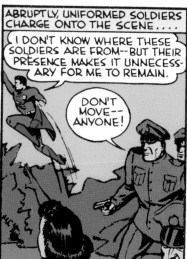
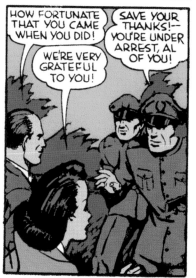

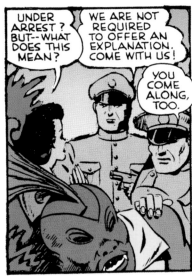
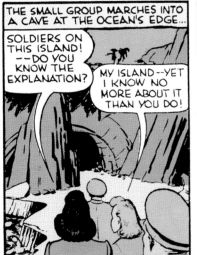

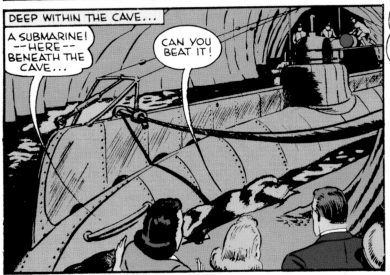

141

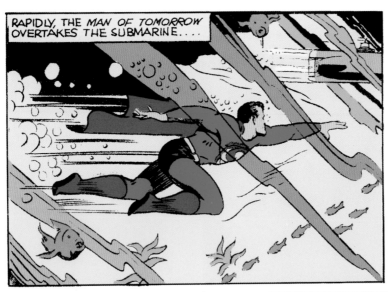

RAPIDLY, THE *MAN OF TOMORROW* OVERTAKES THE SUBMARINE....

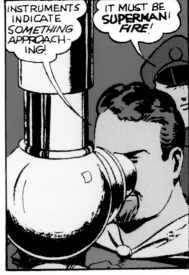

INSTRUMENTS INDICATE SOMETHING APPROACHING!

IT MUST BE *SUPERMAN! FIRE!*

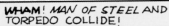

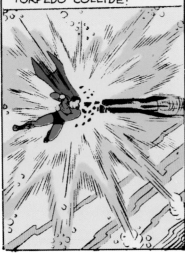

WHAM! *MAN OF STEEL* AND TORPEDO COLLIDE!

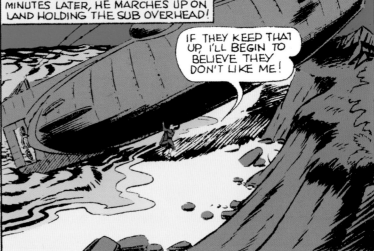

BUT *SUPERMAN* IS UNHARMED! MINUTES LATER, HE MARCHES UP ON LAND HOLDING THE SUB OVERHEAD!

IF THEY KEEP THAT UP, I'LL BEGIN TO BELIEVE THEY DON'T LIKE ME!

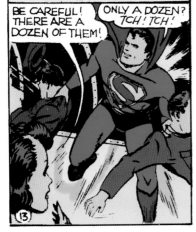

CRASHING THRU THE SIDE OF THE SUB, *SUPERMAN* OVERPOWERS THE FOREIGN SOLDIERS SINGLE-HANDED ..!

BE CAREFUL! THERE ARE A DOZEN OF THEM!

ONLY A DOZEN? TCH! TCH!

⑬

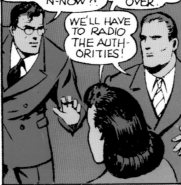

SUPERMAN SPRINGS AWAY -- LEAVING HIS FOES HELPLESSLY TIED. LATER, HE RETURNS AS CLARK KENT...

IS-- IS IT SAFE FOR ME TO COME OUT OF HIDING N-NOW??

PERFECTLY SAFE...NOW THAT THE EXCITEMENT'S OVER.

WE'LL HAVE TO RADIO THE AUTHORITIES!

A DAY LATER--AS CLARK AND LOIS ONCE AGAIN BOARD THE *GRENADIER*...

THANKS A LOT FOR YOUR HOSPITALITY. WE HAD A THRILLING TIME!--AND GOT A SWELL STORY!

WE PROMISE NOT TO HAVE ANY INTERNATIONAL PLOTTERS DISTURB YOUR REST NEXT TIME!

PLEASE COME AGAIN NEXT TIME!

THE END

142

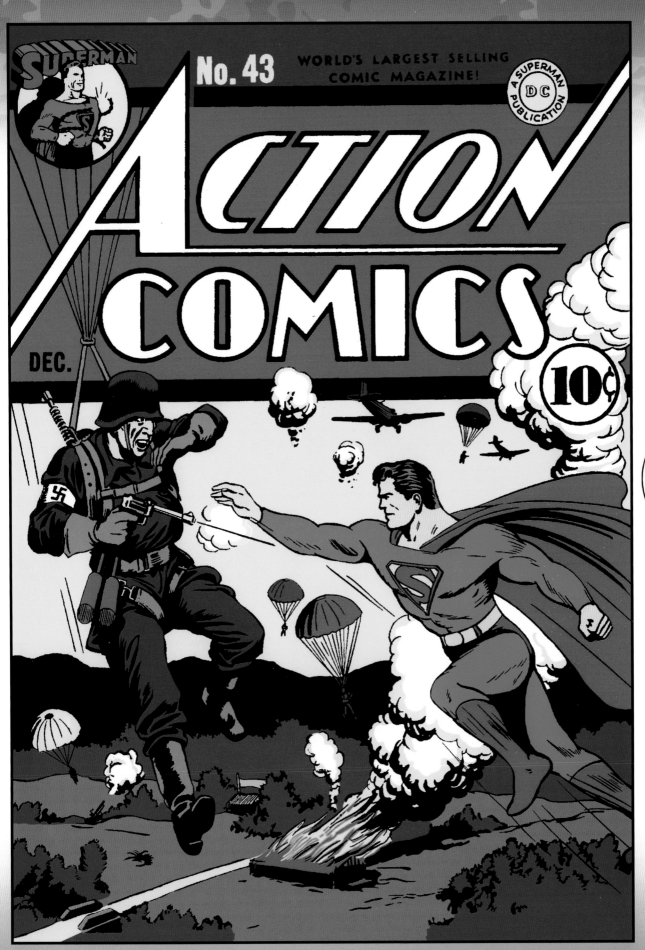

143

Action Comics #43 (Dec. 1941) - cover art: Fred Ray

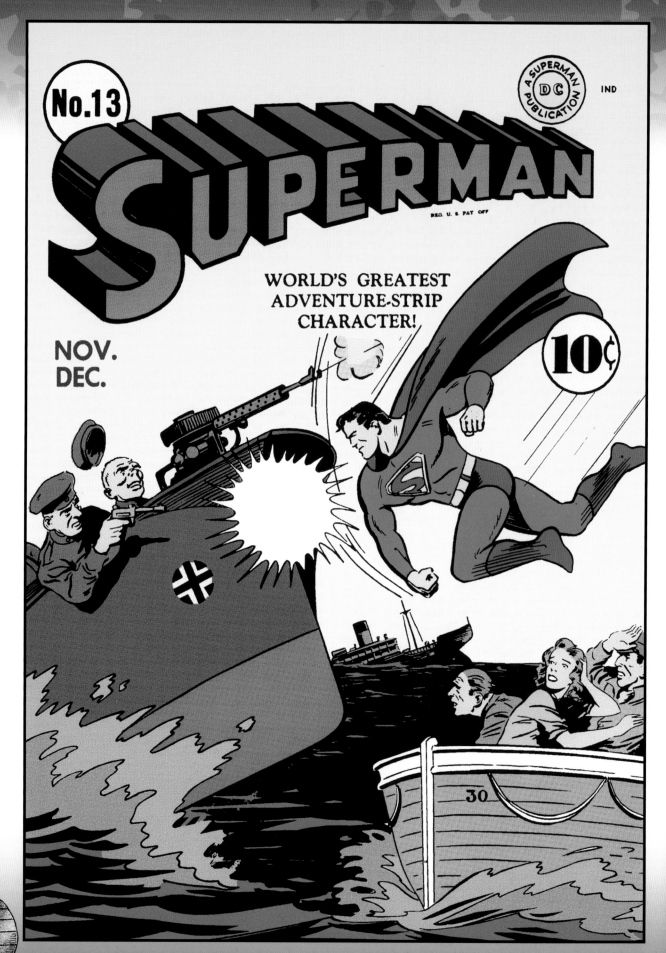

NO.13

SUPERMAN

REG. U. S. PAT OFF

A SUPERMAN PUBLICATION

IND

WORLD'S GREATEST
ADVENTURE-STRIP
CHARACTER!

NOV.
DEC.

10¢

30

Superman #13 (Nov.–Dec. 1942) - cover art: Fred Ray

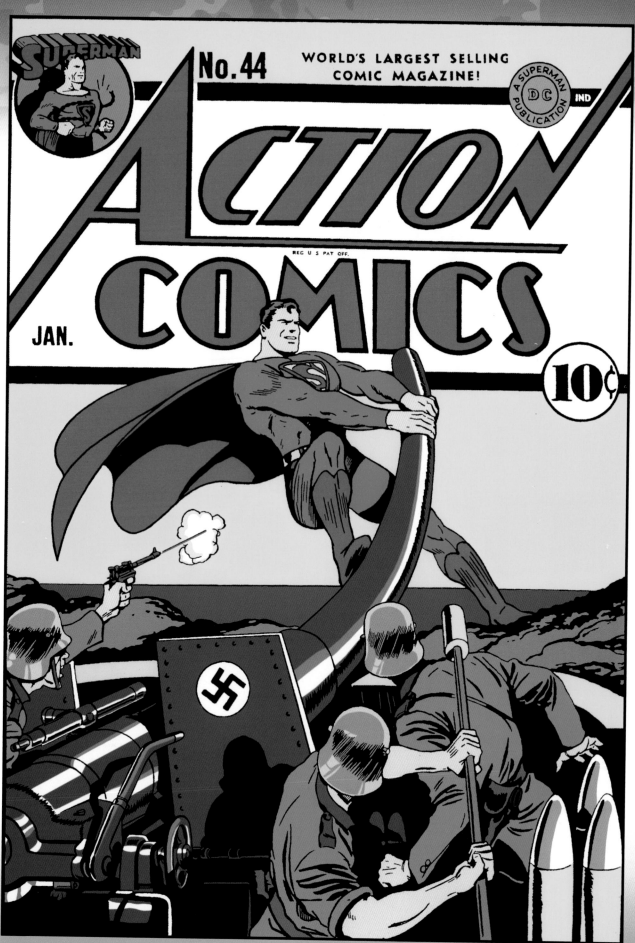

145

Action Comics #44 (Jan. 1942) - cover art: Fred Ray

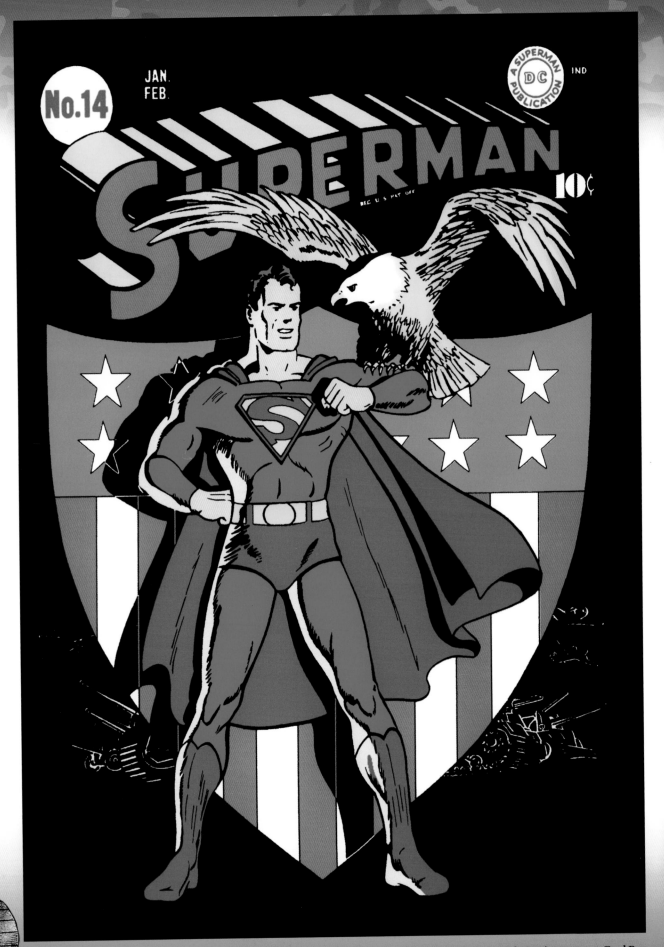

Superman #14 (Jan.–Feb. 1942) - cover art: Fred Ray

Part Three

On December 7, 1941, when the Japanese bullets and bombs stopped falling, many of the U.S. Navy ships docked in Pearl Harbor had been sunk or damaged and 2,000 Americans had died.

AMERICA GOES TO WAR

The next day, President Roosevelt and Congress declared that a state of war existed between the U.S. and Japan. Nazi Germany and Fascist Italy, the other two Axis powers, were not mentioned.

A few days later, Hitler and Mussolini declared war on the United States. What had been two separate wars, on opposite sides of the planet, was now one gigantic Second World War.

The first evidence of this in a Superman story came not in comic books but in newspapers, when, in February 1942, Clark Kent took his draft physical—and flunked it. (For how he did so, see the first story page of this section.) That event was never pictured in the comic books, but was referenced in a story months later.

The first *Superman* "war cover" was that of #17 (July 1942), out in May. In that symbolic illustration, the Man of Tomorrow holds up a startled Hitler and Emperor Hirohito (or is it General Tojo?). This cover appears to have been drawn for the comic at the last minute; there's no reference to the war in any story inside.

Two months later, however, behind a cover on which Superman rides a hurtling bomb down toward what a caption calls "the Japanazis" (a portmanteau word used perhaps *three times* anywhere on Earth), the 18th issue featured a story wherein the enemy tries to use a simulated Nazi invasion of Metropolis as a cover for the real thing! Two issues later, Hitler employed sea monsters, no less, against America's oceangoing craft.

But, after that . . . practically nothing!

There were still militaristic *covers*, with Superman transporting an airplane engine, bending a U-boat's periscope, or intercepting a Nazi shell. On a cover for *World's Finest Comics*, the oversize title he shared with Batman and Robin, the trio were shown selling War Bonds, accompanied by the *second* published use of the word "Japanazis."

However, now that war had been declared, Superman's editorial team had a problem: What kind of stories can you do starring a hero so powerful that, if he truly existed, could have ended the war single-handedly? Much as in that 1940 *Look* story, he could've flown to Berlin and Tokyo and dragged Hitler and Tojo back to America. At the very least, he could've wreaked havoc on the war fronts so that World War II could have been ended in the space of a single issue of *Superman*—maybe even in the 13 pages allotted to him in one edition of *Action Comics*. But, of course, *after* that story was printed, the real-life Hitler and Tojo would still be walking across Europe and Asia like colossi—and the Superman comics, which depended on a willing suspension of disbelief, would have collapsed from lack of logic.

So the DC editors—Whitney Ellsworth, Jack Schiff, and young assistant Mort Weisinger—made certain that the stories kept Superman on the "Home Front." He could attend war rallies and sell War Bonds, even corral a few spies and saboteurs, or be shown on one cover operating a newspaper printing press as a way to "slap a Jap." But he clearly couldn't

147

be allowed to go on a rampage on any battlefront. On occasion, in both comic books and newspaper strips, he'd explain that the American fighting-man didn't need *his* help to take care of the Axis.

About that "slap a Jap" line above: today, it reads as offensive, if not downright racist. The word "Jap," never anything but a crude slang term for a person of Japanese descent, existed long before Pearl Harbor; but the combination of innate prejudices, combined with memories of the sneak attack in Hawaii, brought it into general parlance for several years.

Such strong sentiments were a side effect of going to war. Even one of the *Superman* animated movie cartoons produced by Paramount carried the title "The Japoteurs"—and the "Japanazis" phrase saw print for the third and perhaps final time when the U.S. government turned the cover art of *Superman* #17 into a war poster.

Thus, although such racially charged expressions were relatively rare in stories associated with Superman and DC Comics, it would've been a whitewashing of history to excise them from this volume. Things were as they were . . . and perhaps

no one who didn't live through those dark days can fully understand *why* they were.

The high-water mark of the war as subject matter in comic books came in 1942. From the the fall of the Philippines and the Japanese conquest of European colonies in the Pacific, the immediate aftermath of the attack on Pearl Harbor; to the turning of the tide in the Pacific with the Battle of Midway; to the Battle of Stalingrad; to the American landings in North Africa in November, to aid the British against the Germans—it was a year when the world's future hung in the balance.

It was also a year when the war with Japan received nearly as much attention in comics as did the Nazis. It had been decided at the highest levels of American and British government that they would pursue a "Germany First" policy. Even while fighting a two-front war, it was deemed best to concentrate on defeating Hitler first, after which the Allies' full power could be turned against the aggressor whose forces were spread across the vast Pacific.

In comic books, Superman was reduced to action around the margins of the war. Even so, his stories were morale-boosters, both for youth at home and for America's men in uniform, who were eager to fend off boredom—while they awaited the inevitable charge into battle.

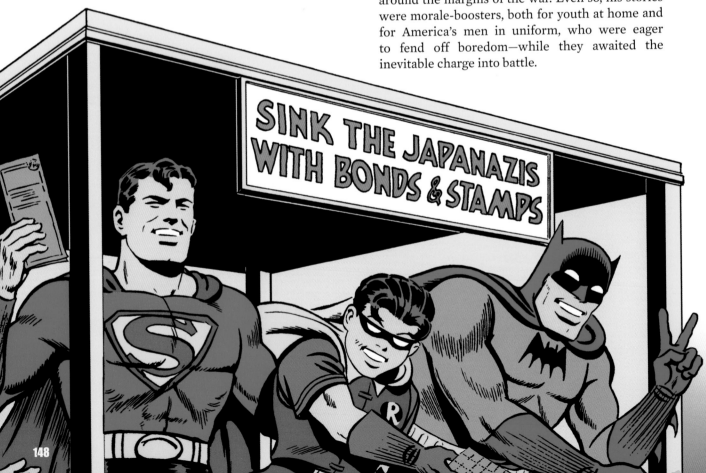

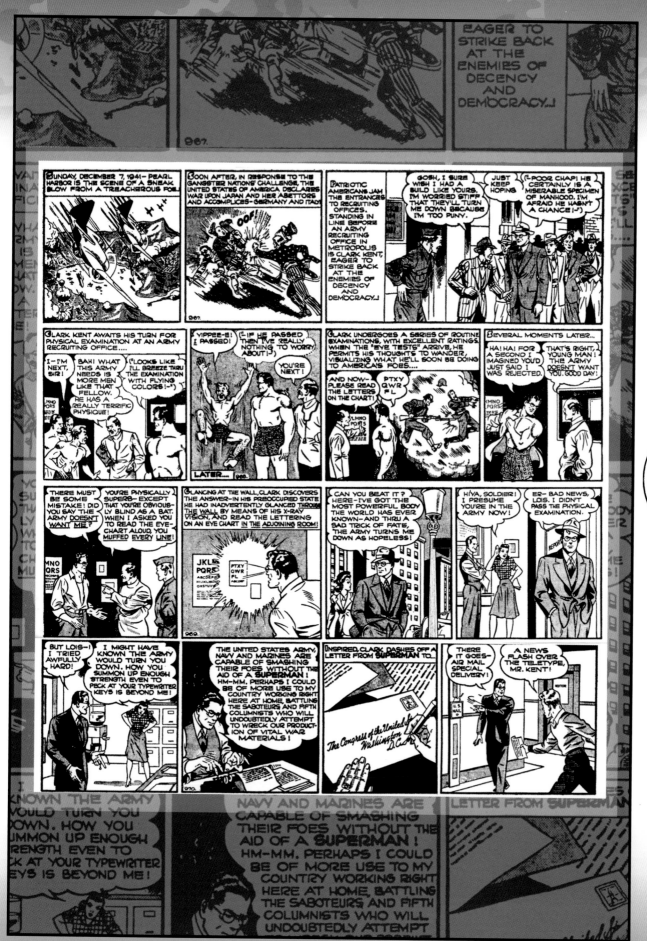

Superman daily newspaper comic strip (Feb. 16–19, 1942) - script: Jerry Siegel - art: Wayne Boring

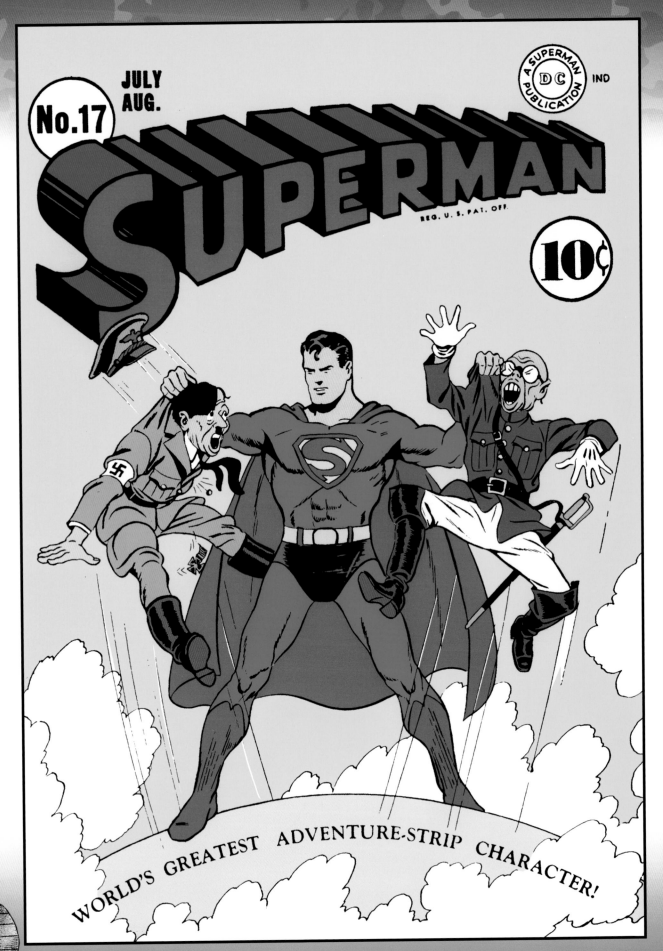

Superman #17 (July–Aug. 1942) - cover art: Fred Ray

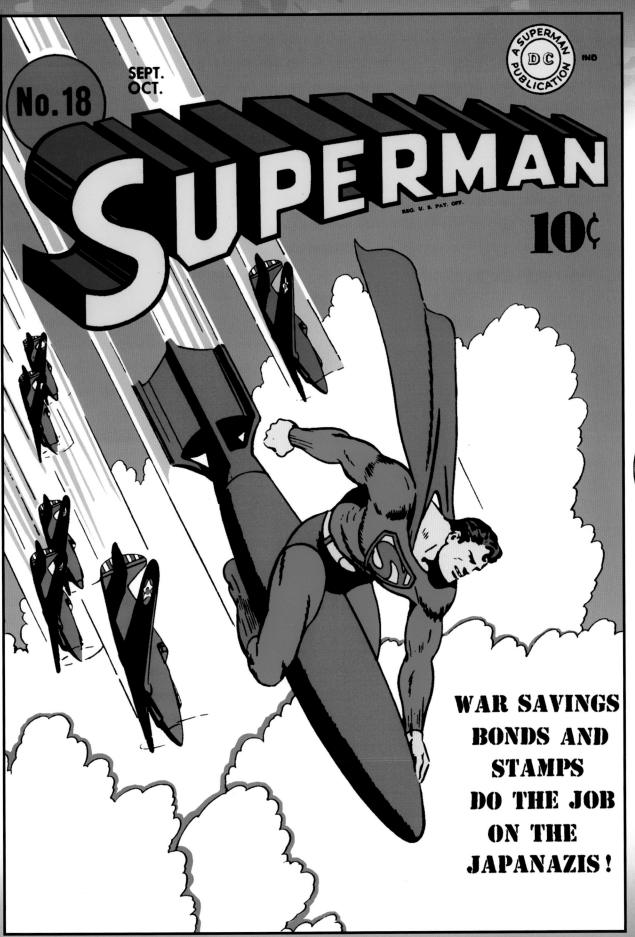

Superman #18 (Sept.–Oct. 1942) - cover art: Fred Ray

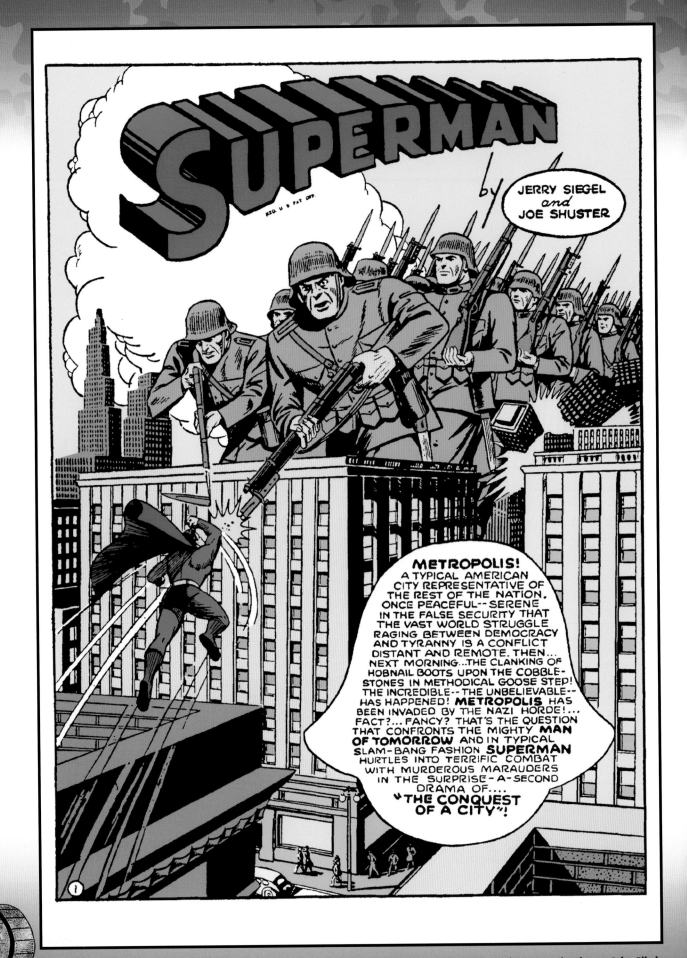

Superman #18 (Sept.–Oct. 1942) - script: Jerry Siegel - art: John Sikela

EN ROUTE TO WORK ONE MORNING, CLARK KENT NOTES...

THAT FACTORY-- NOT IN PRODUCTION--

THE CIVILIAN DEFENSE REQUEST FOR AIR RAID WARDENS... RECEIVING POOR RESPONSE

BE AN AIR-RAID WARDEN

MEN OUT OF WORK-- MEN WHO COULD BE SUPPLYING VALUABLE AID TO THE ARMS PRODUCTION RACE-- UNEMPLOYED BECAUSE OF OLD AGE,--AND YET, THEY'RE ALL LOYAL AMERICANS...

ACME EMPLOYMENT AGENCY

STORES THRONGED-- THEATRES CROWDED--PEOPLE SPENDING--HOARDING--LAUGHING-- WHILE THE FATE OF A WORLD TREMBLES IN THE BALANCE. SOMEBODY SHOULD DO SOMETHING ABOUT IT--AND-- BY GEORGE--I WILL...!

BUY NOW

I TELL YOU, WHITE--THE CITIZENS OF METROPOLIS ARE ASLEEP! IT'S GOT ME WORRIED-- OUR VERY EXISTENCE IS IMPERILED BY FASCISM AND YET WE ARE STILL TROUBLED WITH PETTY PROBLEMS. EVERYWHERE THERE IS A FALSE SENSE OF GAIETY--THE PEOPLE HAVE GOT TO WAKE UP...!!!

YOU'VE MY PERMISSION TO AWAKEN THEM, CLARK-- AND YOU NEEDN'T BE TOO GENTLE ABOUT IT!

153

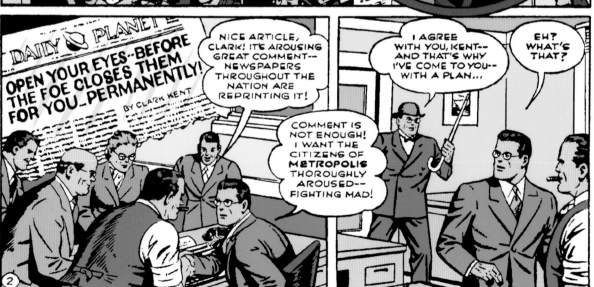

DAILY PLANET

OPEN YOUR EYES--BEFORE THE FOE CLOSES THEM FOR YOU--PERMANENTLY!

BY CLARK KENT

NICE ARTICLE, CLARK! IT'S AROUSING GREAT COMMENT-- NEWSPAPERS THROUGHOUT THE NATION ARE REPRINTING IT!

COMMENT IS NOT ENOUGH! I WANT THE CITIZENS OF METROPOLIS THOROUGHLY AROUSED-- FIGHTING MAD!

I AGREE WITH YOU, KENT-- AND THAT'S WHY I'VE COME TO YOU-- WITH A PLAN...

EH? WHAT'S THAT?

2

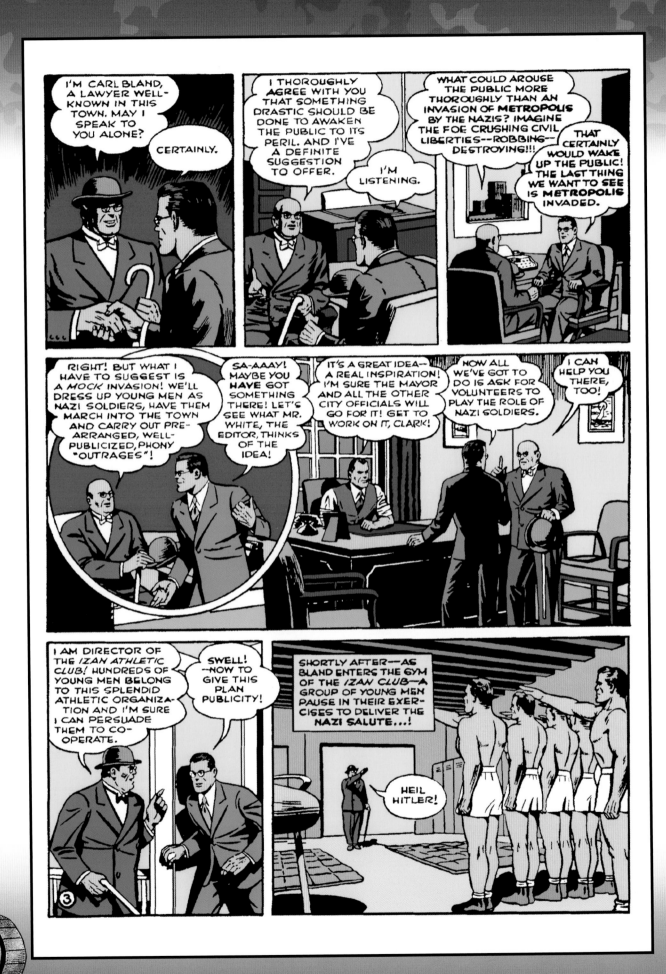

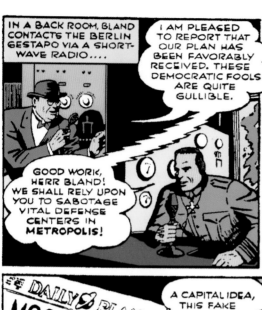

IN A BACK ROOM, BLAND CONTACTS THE BERLIN GESTAPO VIA A SHORT-WAVE RADIO....

I AM PLEASED TO REPORT THAT OUR PLAN HAS BEEN FAVORABLY RECEIVED. THESE DEMOCRATIC FOOLS ARE QUITE GULLIBLE.

GOOD WORK, HERR BLAND! WE SHALL RELY UPON YOU TO SABOTAGE VITAL DEFENSE CENTERS IN METROPOLIS!

FELLOW NAZIS, WE HAVE AN OPPORTUNITY THAT COMES ONCE IN A LIFE-TIME! APPARENTLY PLAYING THE PARTS OF NAZI SOLDIERS, YOU WILL MARCH ON METROPOLIS TOMORROW...BUT INSTEAD OF BLANKS, YOUR GUNS WILL BE LOADED WITH REAL BULLETS!

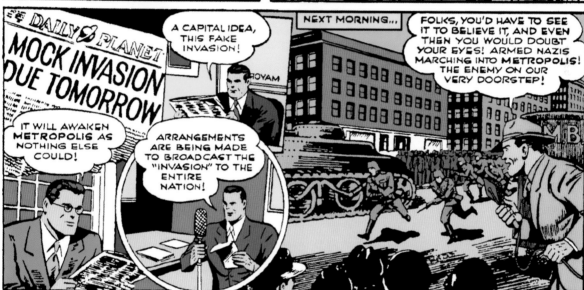

A CAPITAL IDEA, THIS FAKE INVASION!

MOCK INVASION DUE TOMORROW

IT WILL AWAKEN METROPOLIS AS NOTHING ELSE COULD!

ARRANGEMENTS ARE BEING MADE TO BROADCAST THE "INVASION" TO THE ENTIRE NATION!

NEXT MORNING...

FOLKS, YOU'D HAVE TO SEE IT TO BELIEVE IT, AND EVEN THEN YOU WOULD DOUBT YOUR EYES! ARMED NAZIS MARCHING INTO METROPOLIS! THE ENEMY ON OUR VERY DOORSTEP!

155

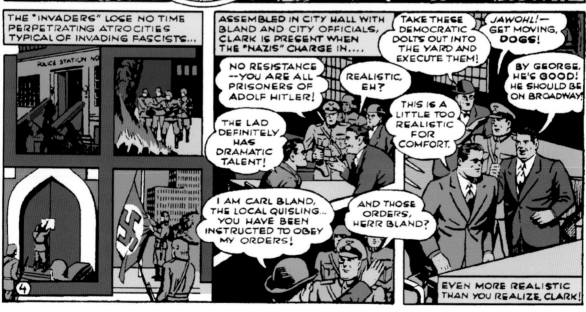

THE "INVADERS" LOSE NO TIME PERPETRATING ATROCITIES TYPICAL OF INVADING FASCISTS...

ASSEMBLED IN CITY HALL WITH BLAND AND CITY OFFICIALS, CLARK IS PRESENT WHEN THE "NAZIS" CHARGE IN....

NO RESISTANCE --YOU ARE ALL PRISONERS OF ADOLF HITLER!

THE LAD DEFINITELY HAS DRAMATIC TALENT!

I AM CARL BLAND, THE LOCAL QUISLING... YOU HAVE BEEN INSTRUCTED TO OBEY MY ORDERS!

TAKE THESE DEMOCRATIC DOLTS OUT INTO THE YARD AND EXECUTE THEM!

REALISTIC, EH?

THIS IS A LITTLE TOO REALISTIC FOR COMFORT.

AND THOSE ORDERS, HERR BLAND?

JAWOHL!— GET MOVING, DOGS!

BY GEORGE, HE'S GOOD! HE SHOULD BE ON BROADWAY!

EVEN MORE REALISTIC THAN YOU REALIZE, CLARK!

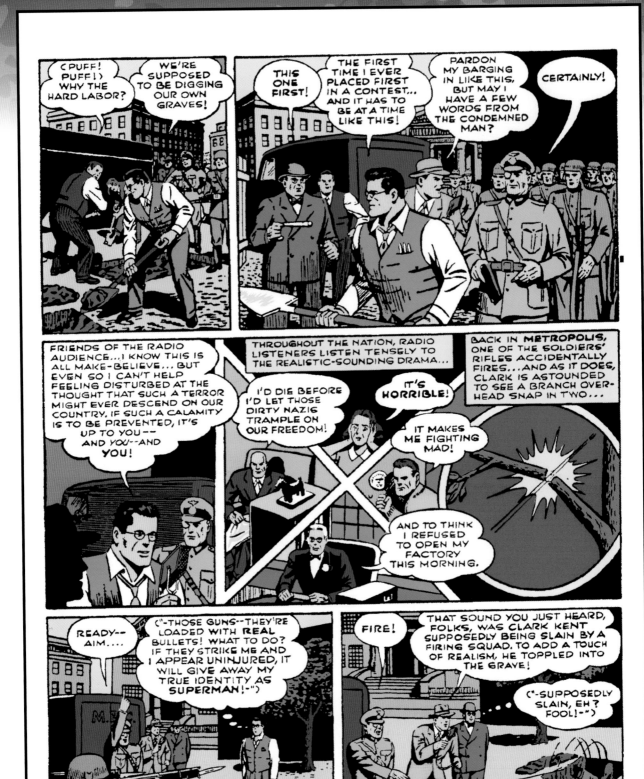

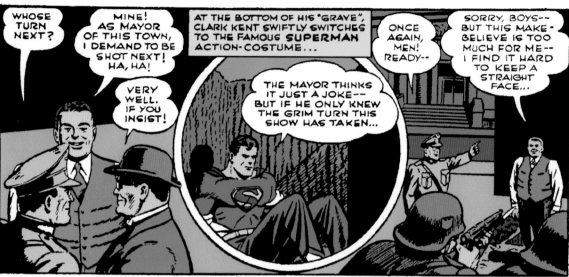

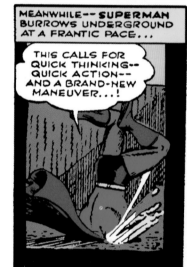

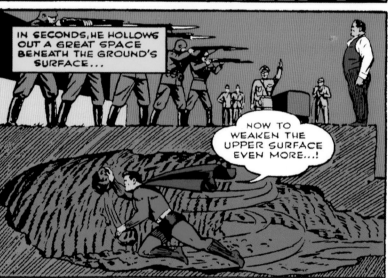

157

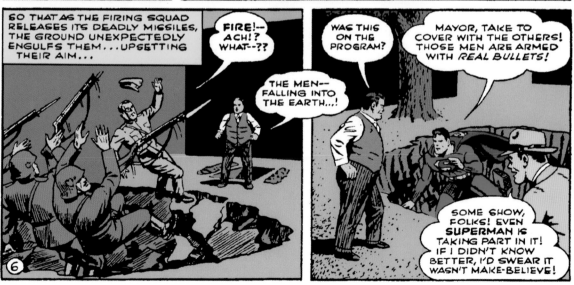

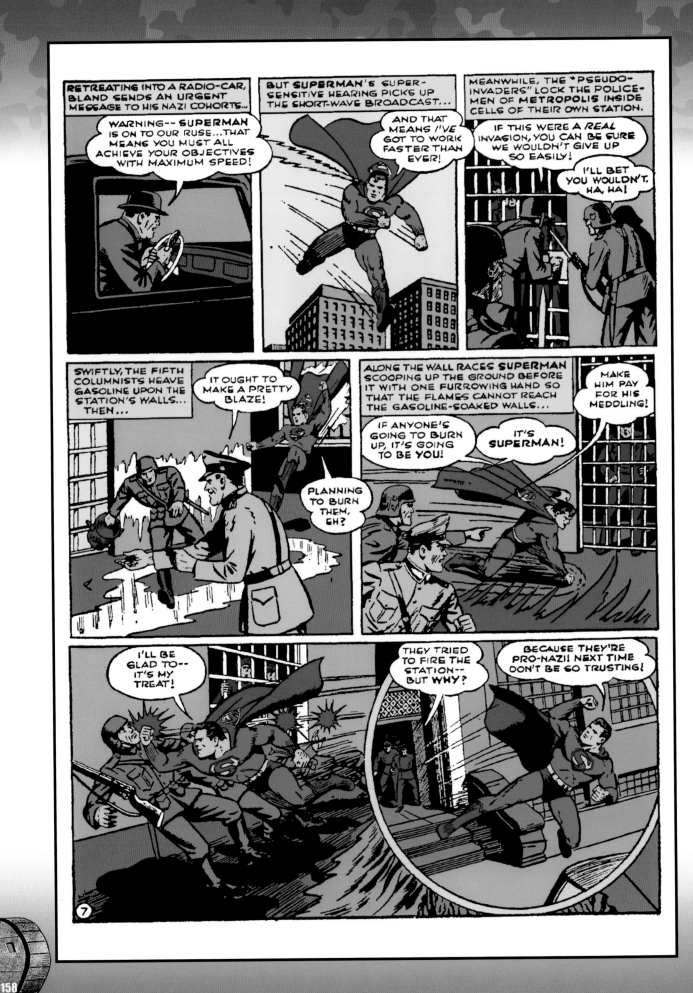

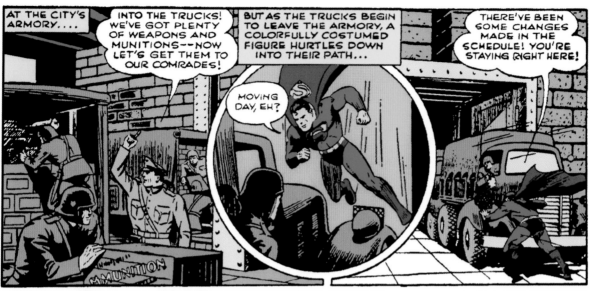

159

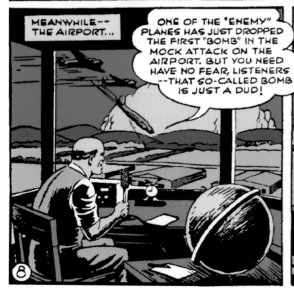

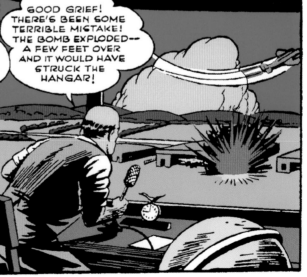

RETURNING TO FORMATION, THE ATTACKING PLANE JOINS THE OTHER WAR-VESSELS IN A PRECIPITATE DIVE...

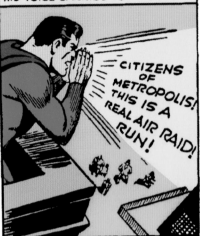

AND AT THAT MOMENT--REACHING THE AIRPORT, **SUPERMAN** SHOUTS A WARNING IN SUCH DYNAMIC TONES HIS VOICE CARRIES FOR MILES...

CITIZENS OF METROPOLIS! THIS IS A REAL AIR RAID RUN!

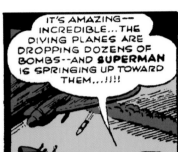

IT'S AMAZING-- INCREDIBLE...THE DIVING PLANES ARE DROPPING DOZENS OF BOMBS--AND **SUPERMAN** IS SPRINGING UP TOWARD THEM...!!!!

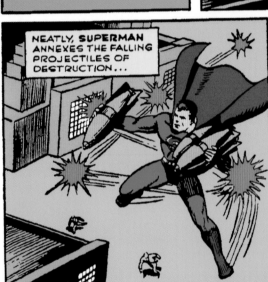

NEATLY, SUPERMAN ANNEXES THE FALLING PROJECTILES OF DESTRUCTION...

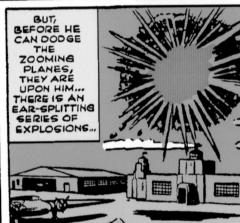

BUT, BEFORE HE CAN DODGE THE ZOOMING PLANES, THEY ARE UPON HIM... THERE IS AN EAR-SPLITTING SERIES OF EXPLOSIONS...

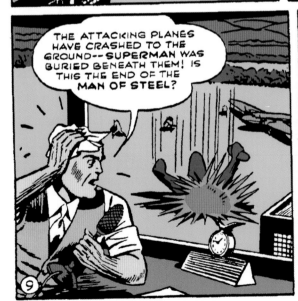

THE ATTACKING PLANES HAVE CRASHED TO THE GROUND--SUPERMAN WAS BURIED BENEATH THEM! IS THIS THE END OF THE MAN OF STEEL?

9

DEFINITELY NOT! IT WOULDN'T BE CRICKET FOR ME TO PERISH UNTIL MY CRUSADE IS CONCLUDED!

NOT DOING BAD AT ALL-- BUT THERE'S STILL PLENTY MORE WORK TO DO! NEXT-- THE CITY RESERVOIR!

I PITY ANY NAZIS WHO WOULD ATTEMPT TO THROW SOMETHING INTO THE RESERVOIR THAT WOULD POISON THE CITY'S WATER!

WE'D HATE TO BE IN THEIR SHOES!

YES-SIR... THEY'D HAVE A TOUGH TIME PUTTING SOMETHING OVER ON YOU!

NAUGHTY! MUSTN'T DO!

THAT UNIFORM-- IT MUST BE SUPERMAN!

JUST TO ERASE THE SLIGHTEST DOUBT AS TO MY IDENTITY!

WHAT GOES ON HERE?

YIPE!

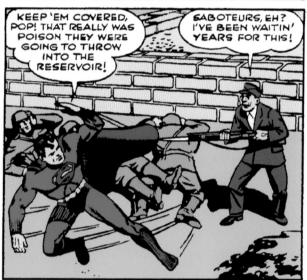

KEEP 'EM COVERED, POP! THAT REALLY WAS POISON THEY WERE GOING TO THROW INTO THE RESERVOIR!

SABOTEURS, EH? I'VE BEEN WAITIN' YEARS FOR THIS!

161

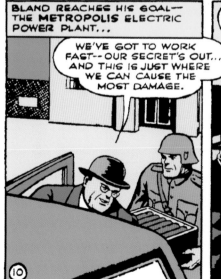

BLAND REACHES HIS GOAL-- THE METROPOLIS ELECTRIC POWER PLANT...

WE'VE GOT TO WORK FAST-- OUR SECRET'S OUT... AND THIS IS JUST WHERE WE CAN CAUSE THE MOST DAMAGE.

⑩

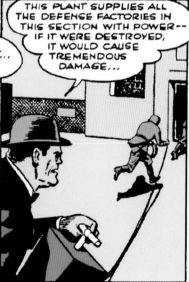

THIS PLANT SUPPLIES ALL THE DEFENSE FACTORIES IN THIS SECTION WITH POWER-- IF IT WERE DESTROYED, IT WOULD CAUSE TREMENDOUS DAMAGE...

AND I'M HERE TO SEE YOU DON'T DESTROY IT!

YOU'RE TOO LATE!!

PAST BLAND WHIZZES SUPER-MAN AT SO SWIFT A PACE NO HUMAN EYE CAN FOLLOW...

ONE OF THE MOST UNUSUAL RACES SINCE THE WORLD BEGAN -- MAN VERSUS ELECTRICITY -- FOR SUPERMAN IS RACING THE CURRENT IN THE WIRE TO ITS DESTINATION...!

THE WINNER!!

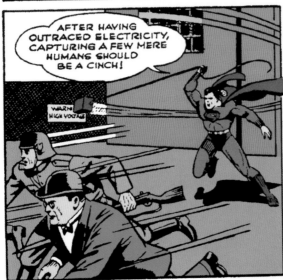

AFTER HAVING OUTRACED ELECTRICITY, CAPTURING A FEW MERE HUMANS SHOULD BE A CINCH!

WARNING HIGH VOLTAGE

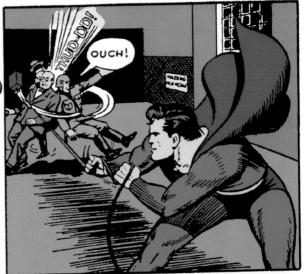

OUCH!

THUD-DD!

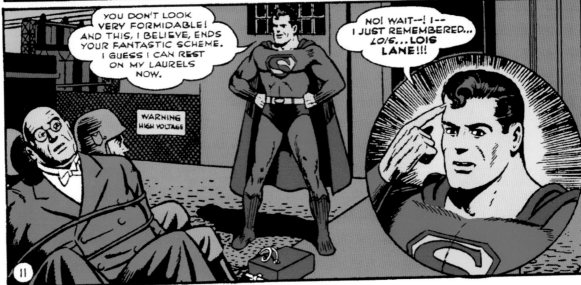

YOU DON'T LOOK VERY FORMIDABLE! AND THIS, I BELIEVE, ENDS YOUR FANTASTIC SCHEME. I GUESS I CAN REST ON MY LAURELS NOW.

WARNING HIGH VOLTAGE

NO! WAIT--! I-- I JUST REMEMBERED... LOIS... LOIS LANE!!!

⑪

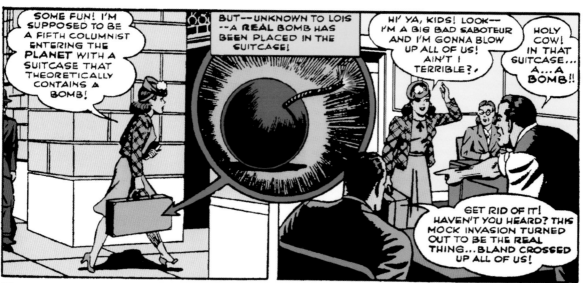

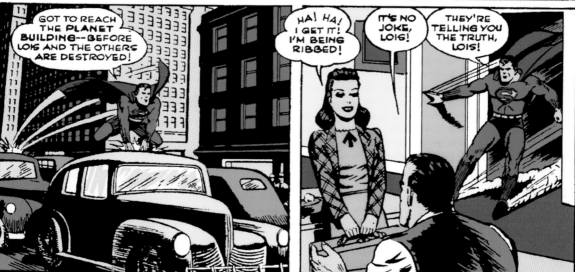

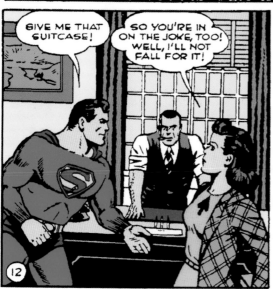

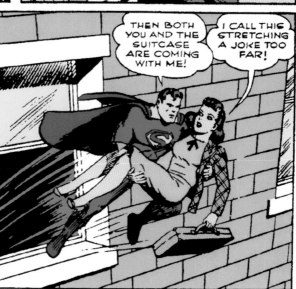

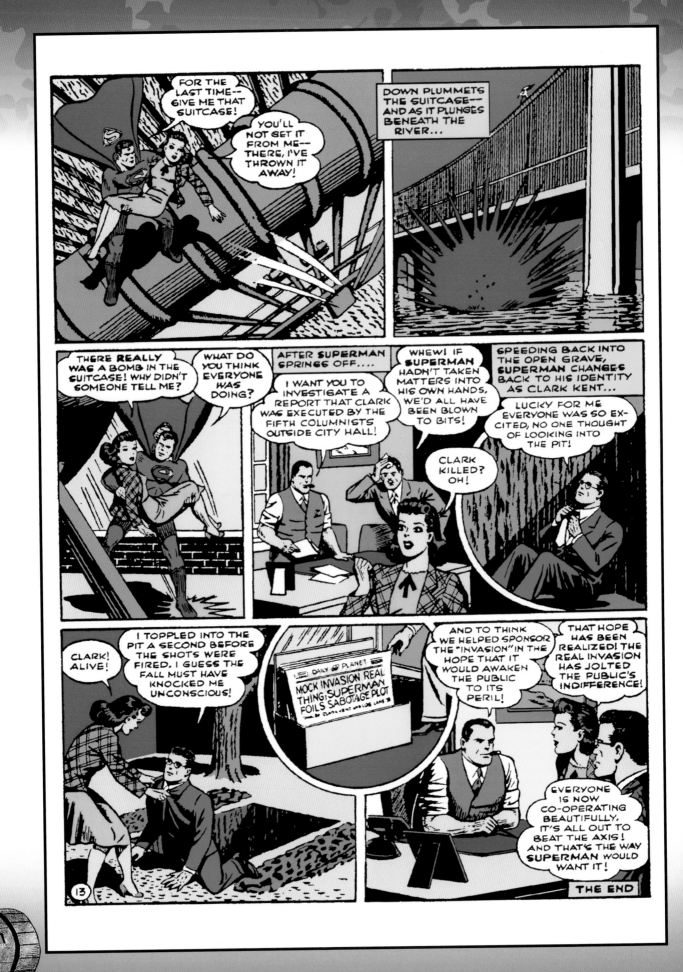

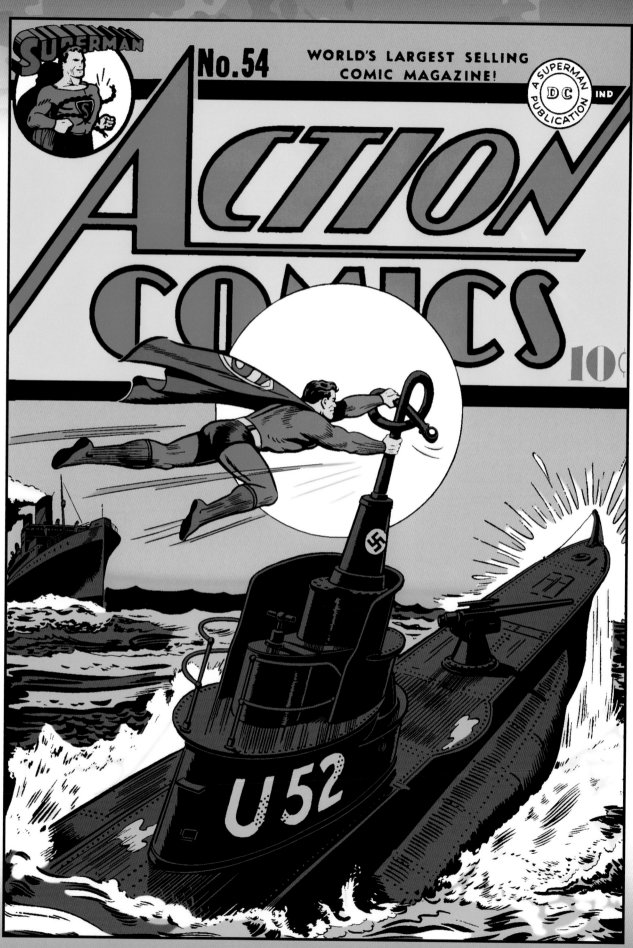

Action Comics #54 (Nov. 1942) - cover art: Jack Burnley

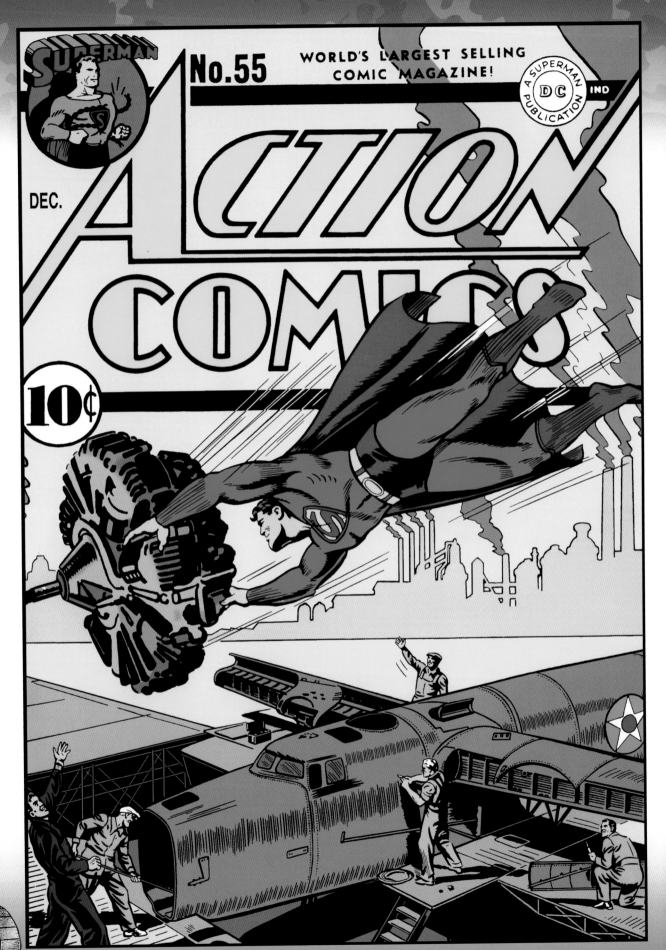

SUPERMAN

No. 55

WORLD'S LARGEST SELLING COMIC MAGAZINE!

A SUPERMAN PUBLICATION

DC

IND

DEC.

ACTION COMICS

10¢

Action Comics #55 (Dec. 1942) - cover art: Jack Burnley

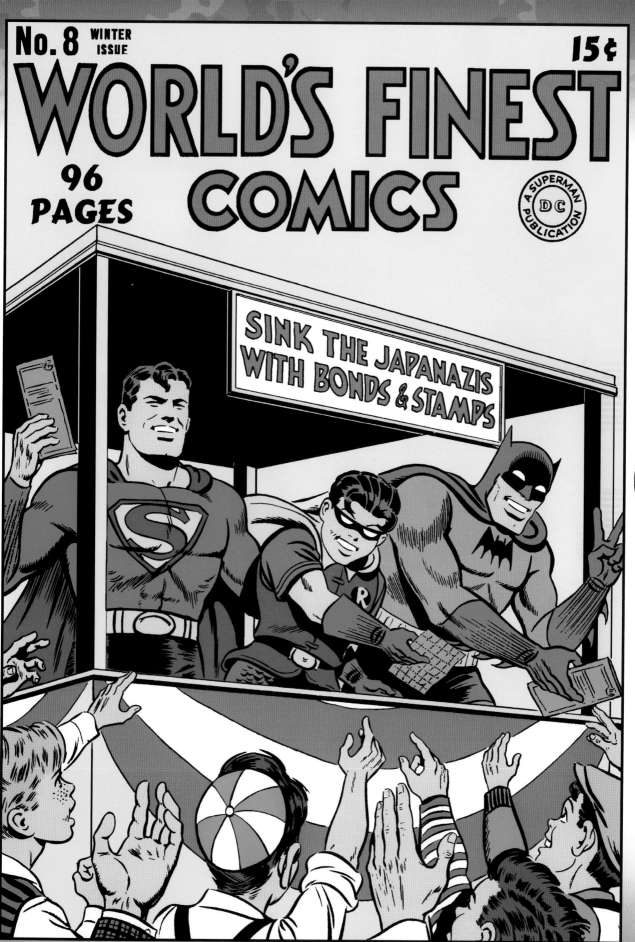

World's Finest Comics #8 (Winter 1942) - cover art: Jack Burnley

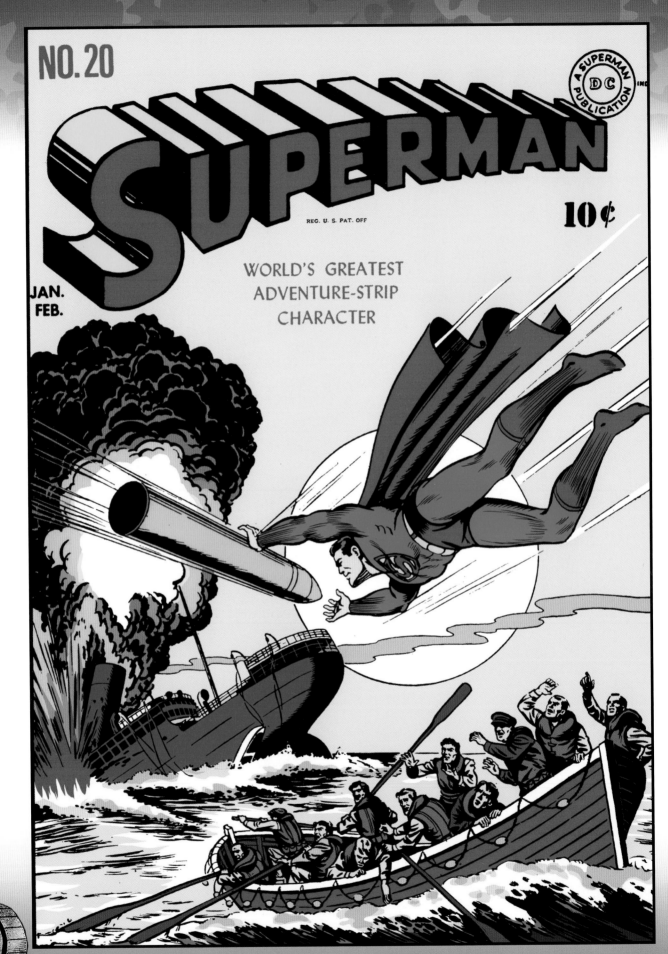

NO. 20

SUPERMAN

REG. U. S. PAT. OFF

10¢

JAN.
FEB.

A SUPERMAN PUBLICATION
DC INC

WORLD'S GREATEST
ADVENTURE-STRIP
CHARACTER

Superman #20 (Jan.–Feb. 1943) - cover art: Jack Burnley

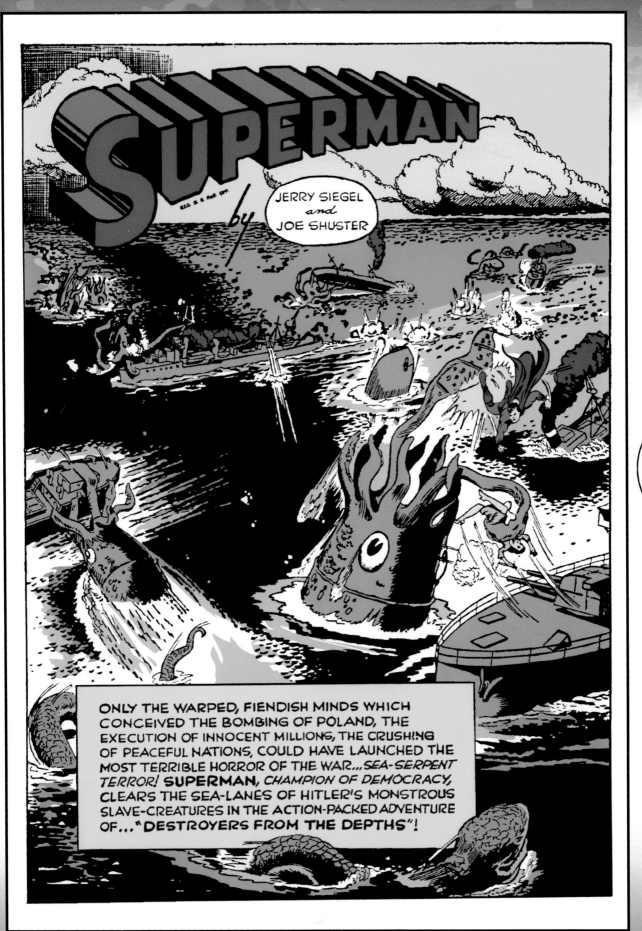

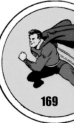

169

ONLY THE WARPED, FIENDISH MINDS WHICH
CONCEIVED THE BOMBING OF POLAND, THE
EXECUTION OF INNOCENT MILLIONS, THE CRUSHING
OF PEACEFUL NATIONS, COULD HAVE LAUNCHED THE
MOST TERRIBLE HORROR OF THE WAR...*SEA-SERPENT
TERROR!* **SUPERMAN,** *CHAMPION OF DEMOCRACY,*
CLEARS THE SEA-LANES OF HITLER'S MONSTROUS
SLAVE-CREATURES IN THE ACTION-PACKED ADVENTURE
OF..."**DESTROYERS FROM THE DEPTHS**"!

Superman #20 (Jan.–Feb. 1943) - script: Jerry Siegel - art: Ed Dobrotka (pencils) & John Sikela (inks)

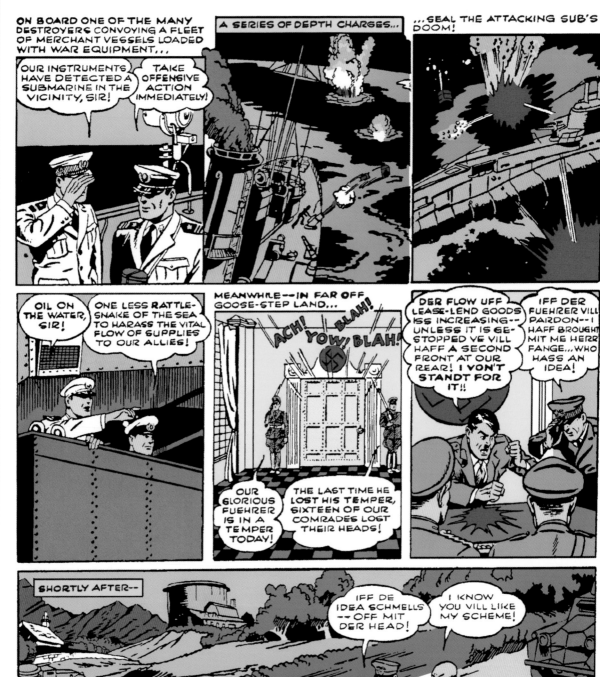

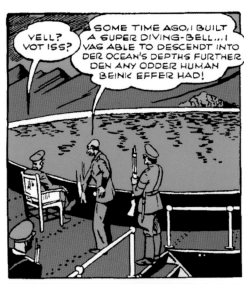

YELL? VOT ISS?

SOME TIME AGO, I BUILT A SUPER DIVING-BELL...I VAG ABLE TO DESCENDT INTO DER OCEAN'S DEPTHS FURTHER DEN ANY ODDER HUMAN BEINK EFFER HAD!

"-DERE, MILES BELOW DER OCEAN'S SURFACE, I DISCOVERED DER DARK HIDDEN LAIR VHERE SEA-SERPENTS HAD HIDDEN SINCE ANTIQUITY!--"

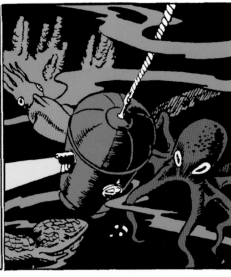

DESE SERPENTS-- DEY ISS DE SOURCE UF ALL DE SERPENT YARNS RIFE SINCE MANKIND'S BEGIN-NINK! VHAT A TRIUMPH!

LOOK! DEY'RE **ATTACKING US!!**

"-IN OUR FRANTIC ESCAPE EFFORTS VE ACCIDENTALLY PULLED A VHISTLE-CORD...!-"

OUDT UFF MY VAY!

OWW-WCH!

"-UNDT VE MADE AN ASTOUNDING DISCOVERY! DER SERPENTS DIDN'T HARM US...DER VHISTLE FASCINATED DEM...!-"

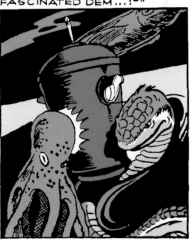

I HAFF LEARNED HOW TO CONTROL DESE MONSTERS UND AM READY TO ATTACK ENEMY CONVOYS IFF YOU BUT GIFF DER VORD!

FOOL! EXPECT-ING ME TO BELIEF SUCH NONSENSE!

HERE'S PROOF!

HERR FANGE, I CONGRATULATE YOU! VE VILL BEAT OUR FOES TO DERE KNEES, VUNCE AGAIN PROOFINK VE ARE A BRAVE MASTER RACE! HEIL HITLER!!

TWEE-EET!

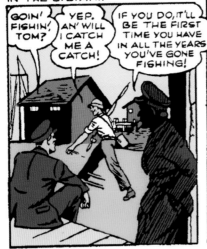

WEEKS LATER...THE SMALL COASTAL TOWN OF WESTON IN THE U.S.A....

GOIN' FISHIN', TOM?

YEP. AN' WILL I CATCH ME A CATCH!

IF YOU DO, IT'LL BE THE FIRST TIME YOU HAVE IN ALL THE YEARS YOU'VE GONE FISHING!

LAUGH AT ME, WILL THEY? HA! I'LL SHOW 'EM! I'LL CATCH SOMETHING SO BIG, IT'LL MAKE THEIR EYES BULGE!

BOY-OH-BOY! I'VE GOT SOMETHING! AN IT'S SO STRONG IT'S PULLING THE BOAT ALONG AFTER IT!! WONDER WHAT IT....

YEE-EEEE!!

AS DESTRUCTION APPEARS IMMINENT FOR TOM, A STRANGE DIVING-VESSEL RISES FROM THE SEA....

HALP! HALP!

DOWN! THE DOLT ISN'T WORTH DESTROYING!

AS BOTH SEA-MONSTER AND ITS MENTOR VANISH BENEATH THE OCEAN'S SURFACE ONCE AGAIN...

I-I-I-I'M G-GETTIN' OUTA HERE!!

HOW LONG WILL IT TAKE YOU TO REPAIR MY MOTOR TROUBLE?

JUST A FEW MINUTES.

WHAT'S ALL THE EXCITEMENT?

GARAGE

RUN! RUN FOR YOUR LIVES!!

HAVE YOU GONE MAD?

WHAT IS IT, TOM?

④

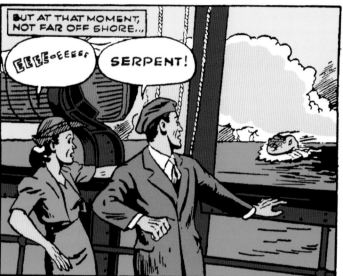

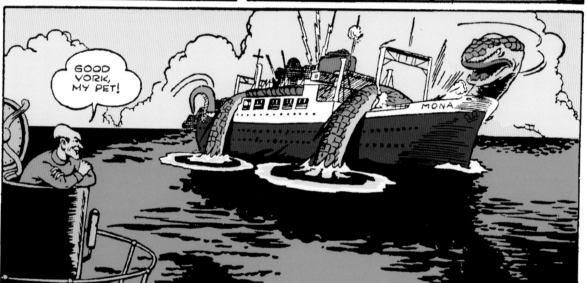

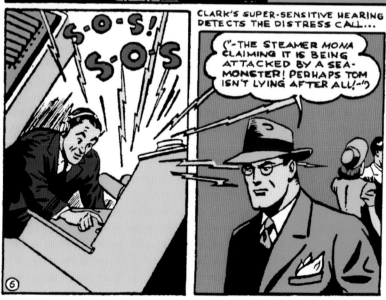

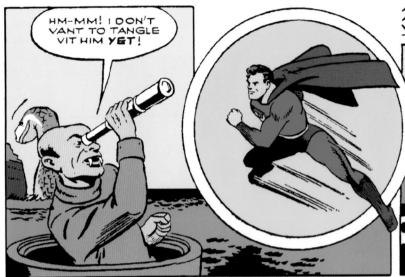

HM-MM! I DON'T VANT TO TANGLE VIT HIM **YET**!

A BLAST FROM FANGE'S WHISTLE AND BOTH MONSTER AND DIVING VESSEL DISAPPEAR BENEATH THE WAVES...!

SEIZING THE SINKING VESSEL, **SUPERMAN** TOWS IT SHOREWARD....

MONA

YOU NEED REPAIRS... AND IN A HURRY!

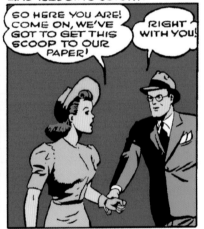

AFTER HE BRINGS THE SHIP TO SHORE, **SUPERMAN** CHANGES BACK TO HIS IDENTITY AS THE **DAILY PLANET** REPORTER AND REJOINS LOIS....

SO HERE YOU ARE! COME ON, WE'VE GOT TO GET THIS SCOOP TO OUR PAPER!

RIGHT WITH YOU!

THE NATION IS BOMBARDED WITH THE AMAZING NEWS...

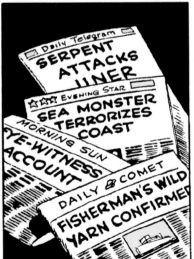

Daily Telegram
SERPENT ATTACKS LINER

Evening Star
SEA MONSTER TERRORIZES COAST

MORNING SUN
EYE-WITNESS ACCOUNT

DAILY COMET
FISHERMAN'S WILD YARN CONFIRMED

OVERNIGHT, THE SMALL TOWN OF WESTON IS INVADED BY A MOB OF REPORTERS, RADIO COMMEN-TATORS, NEWSREEL PHOTOG-RAPHERS...

AND DID YOU REALLY FRIGHTEN OFF THE SEA-BEAST SINGLE-HANDED?

I JUST SHOOK MY FIST, THREATENED TO TWIST ITS TAIL, AND IT SKEEDADDLED!

EACH TIME HE TELLS THE STORY, IT GETS MORE INTERESTING!

--AND EXAGGERATED

⑥

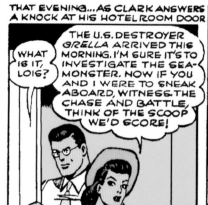

THAT EVENING...AS CLARK ANSWERS A KNOCK AT HIS HOTEL ROOM DOOR

WHAT IS IT, LOIS?

THE U.S. DESTROYER GRELLA ARRIVED THIS MORNING. I'M SURE IT'S TO INVESTIGATE THE SEA-MONSTER. NOW IF YOU AND I WERE TO SNEAK ABOARD, WITNESS THE CHASE AND BATTLE, THINK OF THE SCOOP WE'D SCORE!

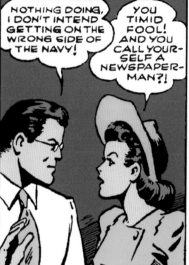

NOTHING DOING. I DON'T INTEND GETTING ON THE WRONG SIDE OF THE NAVY!

YOU TIMID FOOL! AND YOU CALL YOUR-SELF A NEWSPAPER-MAN?!

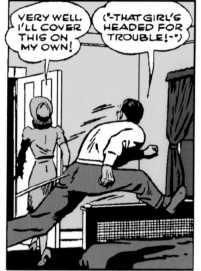

VERY WELL. I'LL COVER THIS ON MY OWN!

("-THAT GIRL'S HEADED FOR TROUBLE!-")

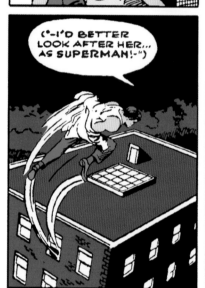

("-I'D BETTER LOOK AFTER HER... AS SUPERMAN!-")

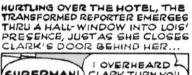

HURTLING OVER THE HOTEL, THE TRANSFORMED REPORTER EMERGES THRU A HALL-WINDOW INTO LOIS' PRESENCE, JUST AS SHE CLOSES CLARK'S DOOR BEHIND HER...

SUPERMAN!

I OVERHEARD CLARK TURN YOU DOWN. BUT I'LL HELP YOU GET ON BOARD THAT DESTROYER!

IF ONLY CLARK KENT HAD SOME OF YOUR NERVE...!

AREN'T YOU HOPING FOR JUST A LITTLE TOO MUCH...?

NEITHER OF THE SENTRIES SEES US!

SCORE ONE FOR SUPER-SPEED!

SECONDS LATER...INSIDE THE DESTROYER....

EVERY-THING'S DARK!

ONE SECOND --I'LL LIGHT A MATCH!

YOU'VE LOCKED ME IN THE BRIG! WHY?

TO KEEP YOU FROM GETTING INTO WORSE MISCHIEF!

7

THE JOKE'S ON YOU! THE DESTROYER'S MOVING!

YOU'RE RIGHT. I'D BETTER LOOK INTO THIS!

OUR SEALED ORDERS WERE TO TRACK DOWN THE SEA-MONSTER AND DESTROY IT!

I STILL SUSPECT A HOAX!

(*-LOIS GUESSED RIGHT!-*)

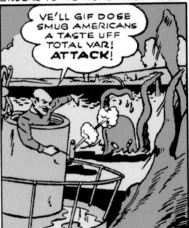

MEANWHILE—A WEIRD DIVING VESSEL EMERGES TO THE SEA'S SURFACE— A CRUEL-FACED HUMAN ISSUES TERRIBLE ORDERS TO HIS MONSTROUS AIDES...

VE'LL GIF DOSE SMUG AMERICANS A TASTE UFF TOTAL VAR! ATTACK!

THE SHORE PATROL IS NO MATCH FOR THE LIGHTNING ATTACK OF THE NAUTICAL MONSTERS...

IN MINUTES THE PREVIOUSLY SERENE TOWN OF *WESTON* IS THE SCENE OF INCREDIBLE HORRORS...!

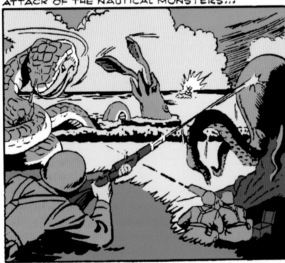

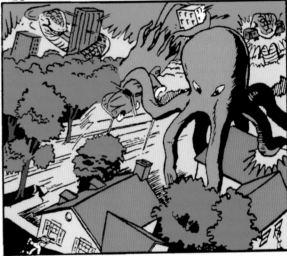

THE MAN OF TOMORROW'S SUPER-ACUTE HEARING BRINGS HIM THE SOUND OF....

SCREAMS— FROM ASHORE!!

LANDWARD WHIZZES THE AMAZING MAN OF STEEL AT ROCKET-SPEED...!

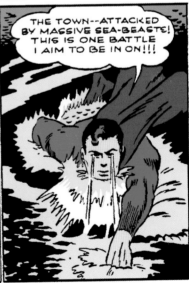

THE TOWN--ATTACKED BY MASSIVE SEA-BEASTS! THIS IS ONE BATTLE I AIM TO BE IN ON!!!

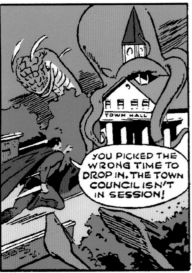

YOU PICKED THE WRONG TIME TO DROP IN. THE TOWN COUNCIL ISN'T IN SESSION!

AND YOU CAN TELL THAT TO YOUR FRIENDS!

BACK, **SUPERMAN** BATTERS THE CREATURES...BACK TOWARD THE SEA...!

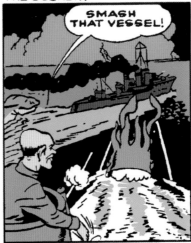

DON'T YOU KNOW WHEN YOU'RE NOT WANTED?

...UNTIL THE MONSTERS THEMSELVES FLEE BACK INTO THE WATERY DEPTHS

YOU'VE DRIVEN THEM OFF!

AND SAVED THE TOWN!

I DON'T THINK THEY'LL BE BACK AFTER THAT RECEPTION!

MEANWHILE...

I FOUND THIS YOUNG LADY LOCKED IN THE BRIG, SIR!

HOW DID YOU GET THERE?

WELL-- THAT'S A LONG STORY...

BUT LOIS IS FORGOTTEN AS WILEY FANGE COMES ONTO THE SCENE...

SMASH THAT VESSEL!

177

DECK-GUNS FIRE FURIOUSLY! BUT THE POWERFUL SERPENTS OF THE DEEP ARE NOT TO BE DENIED THEIR PREY...!

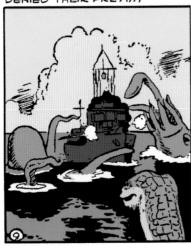

LOIS TAKES REFUGE BELOW DECK --BUT CANNOT ESCAPE THE MURDEROUS MARAUDERS...

THE WIRELESS MAN'S FRANTIC SIGNALS FOR HELP ARE SILENCED BY A SMASHING BLOW!

BUT **SUPERMAN** HAS PICKED UP THE S.O.S. ...

MORE SEA-MONSTERS!

THE *BRELLA*-- BEING DRAGGED TO A WATERY GRAVE!

SUPERMAN VERSUS SEA-MONSTER! A TERRIFIC BATTLE IN WHICH THE *MAN OF STEEL* EMERGES VICTOR!

BUT THE JOY OF VICTORY TURNS TO BITTER SORROW AS HE LEARNS....

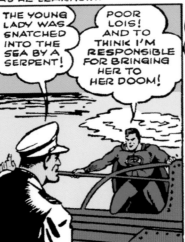

THE YOUNG LADY WAS SNATCHED INTO THE SEA BY A SERPENT!

POOR LOIS! AND TO THINK I'M RESPONSIBLE FOR BRINGING HER TO HER DOOM!

ABOARD ONE OF THE BATTLE-SHIPS ESCORTING A GREAT CONVOY

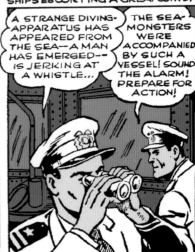

A STRANGE DIVING-APPARATUS HAS APPEARED FROM THE SEA--A MAN HAS EMERGED-- IS JERKING AT A WHISTLE...

THE SEA-MONSTERS WERE ACCOMPANIED BY SUCH A VESSEL! SOUND THE ALARM! PREPARE FOR ACTION!

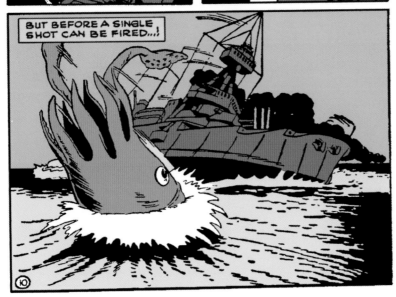

BUT BEFORE A SINGLE SHOT CAN BE FIRED...!

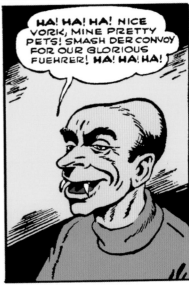

HA! HA! HA! NICE VORK, MINE PRETTY PETS! SMASH DER CONVOY FOR OUR GLORIOUS FUEHRER! HA! HA! HA!

ONCE AGAIN **SUPERMAN'S** SUPER-SENSITIVE HEARING PICKS UP A PERTINENT RADIO BROADCAST

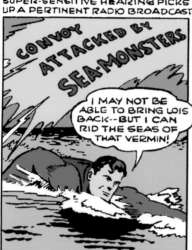

CONVOY ATTACKED BY SEA-MONSTERS

I MAY NOT BE ABLE TO BRING LOIS BACK--BUT I CAN RID THE SEAS OF THAT VERMIN!

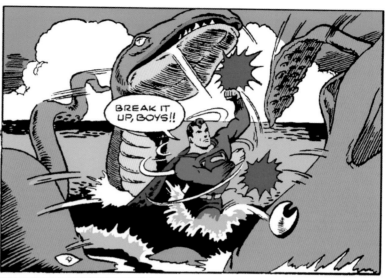

BREAK IT UP, BOYS!!

ALONG THE LINE OF VESSELS STREAKS THE *MAN OF TOMORROW,* YANKING THE MONSTERS OF THE DEEP OFF THE SHIPS...

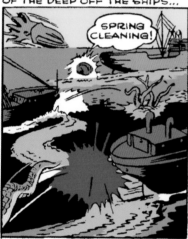

SPRING CLEANING!

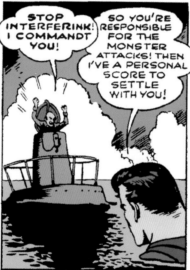

STOP INTERFERINK! I COMMANDT YOU!

SO YOU'RE RESPONSIBLE FOR THE MONSTER ATTACKS! THEN I'VE A PERSONAL SCORE TO SETTLE WITH YOU!

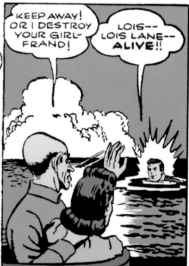

KEEP AWAY! OR I DESTROY YOUR GIRL-FRAND!

LOIS-- LOIS LANE-- ALIVE!!

179

VEN VUN UFF MINE LIDDLE PLAYMATES YANKED HER ALOFT UND VAS GOINK TO KILL HER I ORDERED HER SPARED. YOU SEE, IN CHERMANY, VHILE STUDYINK GESTAPO RECORDS, I LEARNED THIS LADY UND YOU VAS QVITE CHUMMY. UND NOW YOU MUST DO CHUST AS I SAY!

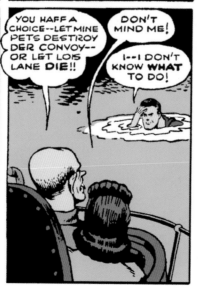

YOU HAFF A CHOICE--LET MINE PETS DESTROY DER CONVOY-- OR LET LOIS LANE DIE!!

DON'T MIND ME!

I--I DON'T KNOW **WHAT** TO DO!

TEARING HERSELF FREE, LOIS DELIBERATELY LEAPS INTO THE MONSTER-INFESTED SEA....

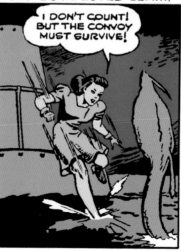

I DON'T COUNT! BUT THE CONVOY MUST SURVIVE!

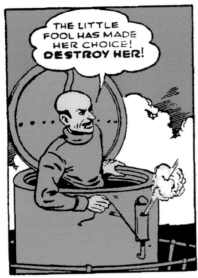

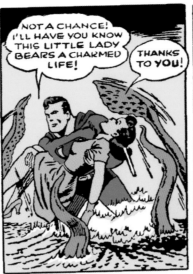

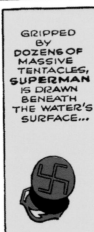

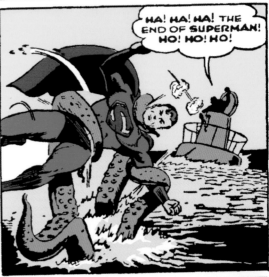

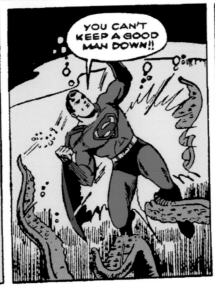

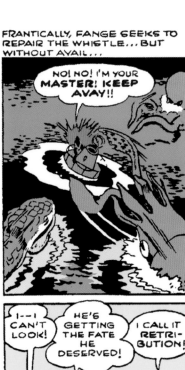
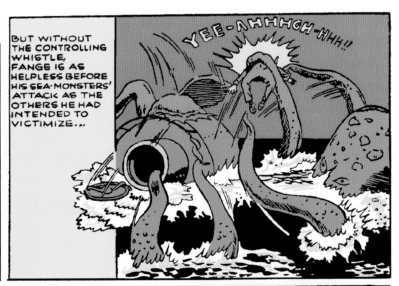
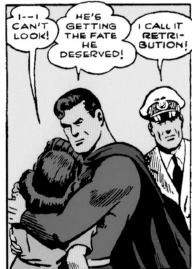

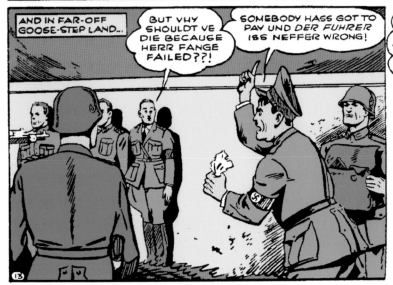

181

Action Comics #58 (March 1943) - cover art: Jack Burnley

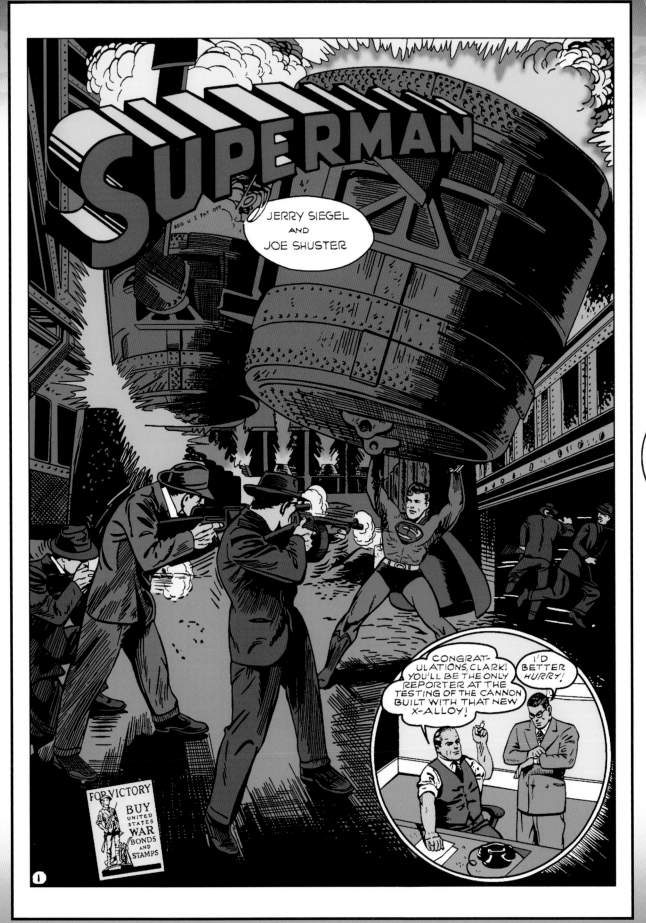

Superman #21 (March–April 1943) - script: Jerry Siegel - art: Ed Dobrotka (pencils) & John Sikela (inks)

BUT AS CLARK KENT SETTLES BACK INTO THE REAR SEAT OF A TAXI HE HAS HAILED, IRON BARS UNEXPECTEDLY SPRING INTO BEING, IMPRISONING HIM...

WHA--? ("-THAT HISSING SOUND! GAS! I'LL PRETEND TO BE OVERCOME!-")

THE TAXI SKIDS INTO A NEARBY GARAGE. RUDE HANDS DRAG THE REPORTER FROM THE TAXI. PEERING THRU HIS EYELIDS WITH THE AID OF HIS AMAZING X-RAY VISION, CLARK IS STARTLED TO SEE....

IT WILL BE A SIMPLE MATTER FOR ME TO ATTEND THAT DEMONSTRATION IN HIS PLACE.

BUT ONCE HE IS IN THE ADJOINING ROOM, CLARK GOES INTO ACTION, AS ONE OF HIS CAPTORS STOOPS TO EXAMINE HIM....

TRY TO KILL ME, WILL YOU?

UH-HH!

KENT RACES OFF WITH THE OTHERS IN PURSUIT ...

WHERE IS HE?

HE MUST BE HIDING SOMEWHERE IN THE SHADOWS! SHOOT TO KILL!

BEHIND ONE OF THE HIGH BOXES, CLARK'S STOOPING FIGURE UNDERGOES AN UNUSUAL TRANSFORMATION...

THIS CALLS FOR-- SUPERMAN!

AS THE MAN OF TOMORROW STANDS ERECT....

WHAT--? I KEEP MISSING HIM!

ON THE CONTRARY --YOU'RE A VERY GOOD SHOT!

MY WORD! THAT'S-- SUPERMAN!

LEAPING INTO THE FACE OF THE FIRE, SUPERMAN CRASHES BOTH OF HIS FOES TO THE GROUND-- BUT HARD..

THE GAS-CAPSULE...IN MY POCKET... IT BROKE!

NO!

A MOMENT LATER-- THE MAN OF TOMORROW TURNS AWAY FROM TWO LIMP, INANIMATE FIGURES...

SLAIN BY THE CYANIDE...VICTIMS OF THEIR OWN PERFIDY!

②

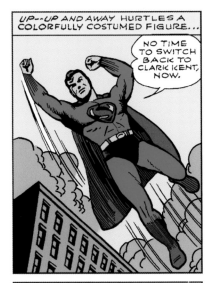

UP--UP AND AWAY HURTLES A COLORFULLY COSTUMED FIGURE...

NO TIME TO SWITCH BACK TO CLARK KENT, NOW.

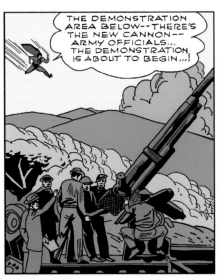

THE DEMONSTRATION AREA BELOW--THERE'S THE NEW CANNON... ARMY OFFICIALS... THE DEMONSTRATION IS ABOUT TO BEGIN...!

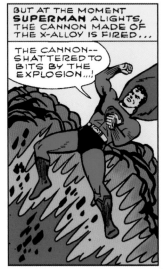

BUT AT THE MOMENT **SUPERMAN** ALIGHTS, THE CANNON MADE OF THE X-ALLOY IS FIRED...

THE CANNON-- SHATTERED TO BITS BY THE EXPLOSION...!

SUPERMAN REMAINS UNHARMED, BUT TO HIS HORROR HE DISCOVERS...

NOT A TRACE OF THE OTHERS! THEY WERE **BLOWN TO BITS!**

BUT HIS KEEN, TELESCOPIC VISION NOTES A SPECK IN THE SKY--AN AUTOGIRO....

SKYWARD, A STALWART FIGURE LAUNCHES ITSELF...

COULD SOMEONE IN THAT AUTOGIRO HAVE DISCHARGED A DEATH-RAY? ONLY ONE WAY TO FIND OUT-- AND THAT'S BY TRAILING IT!

185

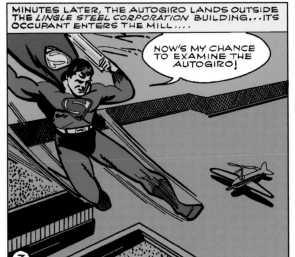

MINUTES LATER, THE AUTOGIRO LANDS OUTSIDE THE *LINGLE STEEL CORPORATION* BUILDING...ITS OCCUPANT ENTERS THE MILL....

NOW'S MY CHANCE TO EXAMINE THE AUTOGIRO!

NO RAY DEVICE ATTACHED! BUT PERHAPS I CAN LEARN BY OBSERVING THE PILOT FURTHER!

3

STEALING INTO THE MILL, FROM CONCEALMENT **SUPERMAN** OBSERVES...

HE'S TALKING TO THE SUPER-INTENDENT! NOW IF I CAN HEAR WHAT THEY'RE SAYING...!

BUT HIGH OVERHEAD, A CRANE OPERATOR SIGHTS THE CONCEALED **SUPERMAN**...

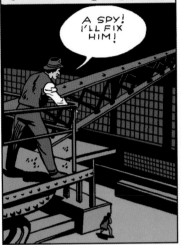

A SPY! I'LL FIX HIM!

AS THE CRANE OPERATOR MANIPULATES HIS CONTROLS, A GREAT VAT TURNS ON ITS SIDE...

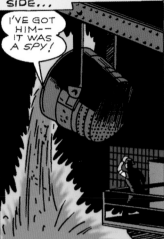

I'VE GOT HIM-- IT WAS A **SPY!**

WORKMEN DASH TOWARD **SUPERMAN** AS THE CONGEALING IRON COOLS....

THERE'S ONE SPY WHO WON'T TALK!

HUH? I COULDA SWORE IT **MOVED!**

A BURST OF THE **MAN OF STEEL'S** INCREDIBLY POWERFUL MUSCLES, AND THE IRON BURSTS OFF IN GREAT LUMPS...

JUST A MUD-PACK!

HE **STILL LIVES!**

STOP HIM!

SUPERMAN RUNS THE GANTLET...

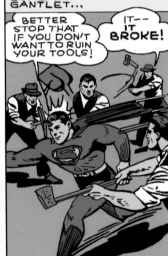

BETTER STOP THAT IF YOU DON'T WANT TO RUIN YOUR TOOLS!

IT-- IT **BROKE!**

SWITCHING TO HIS CIVILIAN GARMENTS, CLARK TELEPHONES HIS STORY TO A **PLANET** REWRITE MAN....

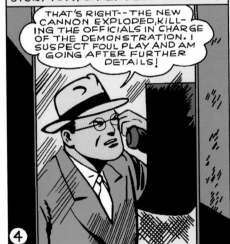

THAT'S RIGHT-- THE NEW CANNON EXPLODED, KILLING THE OFFICIALS IN CHARGE OF THE DEMONSTRATION. I SUSPECT FOUL PLAY AND AM GOING AFTER FURTHER DETAILS!

MINUTES LATER... CLARK IS USHERED INTO THE PRESENCE OF FRANK LINGLE, PRESIDENT OF THE **LINGLE STEEL CORPORATION**...

YOUR SUSPICION THAT MY MILL IS HONEYCOMBED WITH SPIES IS ABSOLUTELY UNFOUNDED!

MIND IF I UNSCREW THE BASE OF YOUR TELEPHONE? JUST A CHECKUP.

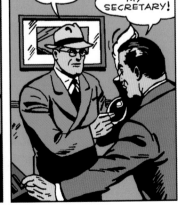

YOU SEE... A CLEVERLY CONCEALED MINIATURE DICTAPHONE! WHAT DO YOU SAY **NOW**?

I'LL CONDUCT A COMPLETE INVESTIGATION, JUST A MOMENT, WHILE I SUMMON MY SECRETARY!

④

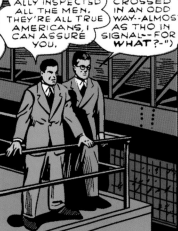

("-MR. LINGLE'S SECRETARY! HE WAS THE AUTOGIRO'S PILOT!-") ER... HOW DO YOU DO?

KENT, I WANT YOU TO MEET MY SECRETARY, CARLTON GRAUL. IF THERE ARE ANY SPIES WORKING IN THIS MILL, HE'LL HELP YOU UNCOVER THEM!

SO THE INQUISITIVE REPORTER SUSPECTS SPIES ARE AMONG OUR EMPLOY. I DISAGREE--BUT WILL AID HIM IN HIS INQUIRY.

CLARK FOLLOWS GRAUL INTO THE MILL....

I'VE PERSONALLY INSPECTED ALL THE MEN. THEY'RE ALL TRUE AMERICANS, I CAN ASSURE YOU.

("-GRAUL'S FINGERS CROSSED IN AN ODD WAY--ALMOST AS THO IN SIGNAL--FOR WHAT?-")

GLANCING AT SOME SHEET METAL, CLARK'S KEEN EYES NOTE THE REFLECTION OF A HEAVY CRANE HOOK SWINGING TOWARD HIS HEAD...

("-A PLOT TO DESTROY ME! IF I SURVIVE THE BLOW, MY IDENTITY AS SUPERMAN WILL BE REVEALED! GOT TO THINK FAST...!-")

TURNING A MOMENT BEFORE THE HOOK CAN STRIKE HIM, CLARK SHRIEKS... THEN DROPS...

EEE-EEE!!

LOOK OUT!

HE'S FAINTED! HELP ME CARRY HIM TO THE FIRST AID STATION!

("-I'LL PRETEND UNCONSCIOUSNESS...BUT NOT MISS A THING!-")

187

HERE... I'LL GIVE THAT STIMULANT TO HIM.

THANK YOU. I'VE A LOT OF OTHER WORK TO DO.

OH-HH... MY HEAD...!

APPARENTLY UNNOTICED, BUT IN REALITY UNDER CLARK'S SHARP SCRUTINY, GRAUL SURREPTITIOUSLY DROPS A POWDER INTO THE DRINK...

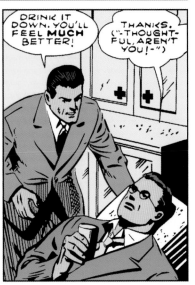

DRINK IT DOWN. YOU'LL FEEL MUCH BETTER!

THANKS. ("-THOUGHTFUL, AREN'T YOU!-")

5

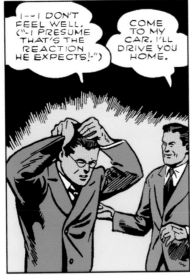

I--I DON'T FEEL WELL. ("--I PRESUME THAT'S THE REACTION HE EXPECTS!--")

COME TO MY CAR. I'LL DRIVE YOU HOME.

BUT AS CLARK ENTERS GRAUL'S CAR, HE PRETENDS TO SLUMP INTO UNCONSCIOUSNESS....

HE'S OUT!

TRAIL ME IN THE OTHER CAR.

THE SECRETARY DRIVES TO A COUNTRY ROAD, THEN HALTS. THE THUGS, WHO HAD FOLLOWED IN ANOTHER CAR, REJOIN HIM...

WHAT NOW?

I'VE TURNED OFF THE EMERGENCY BRAKE. SHOVE THE CAR!

AS THE HOODLUMS OBEY, THE AUTO RUNS WILD DOWN THE CURVING ROAD...

GOOD WORK, MEN!

THAT'S GONNA BE A STRICTLY ONE-WAY TRIP!

...THRU A GUARD-RAIL...

...THEN SINKS OUT OF VIEW BENEATH THE RIVER FAR BELOW!

⑥

BUT WITHIN THE WATER-FLOODED CAR, CLARK KENT CHANGES TO HIS **SUPERMAN** GARMENTS!

SWITCH-EROO!

...THEN BURSTS OUT THRU THE AUTO'S SIDE!

YOU CAN'T KEEP A GOOD MAN DOWN!

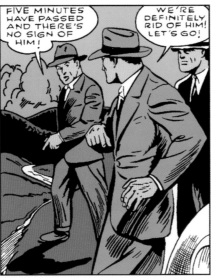

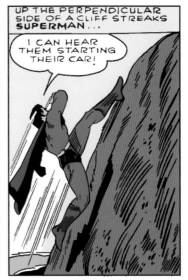

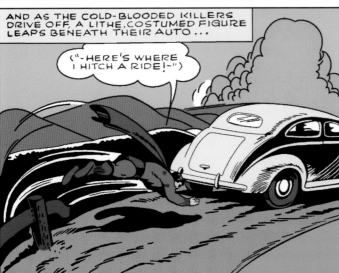

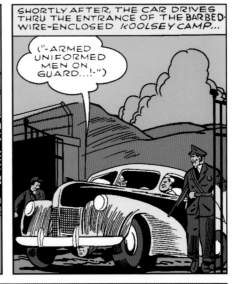

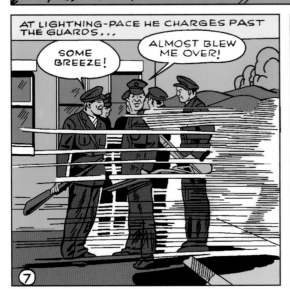

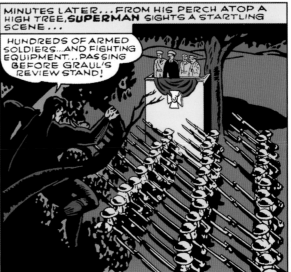

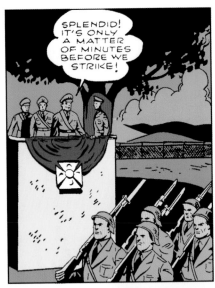

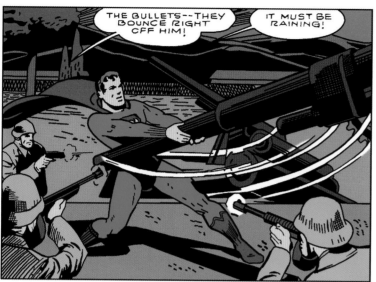

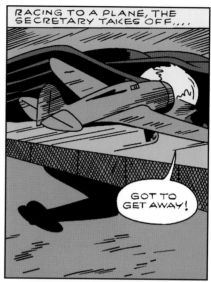

191

THERE! THAT OUGHT TO KEEP YOU PENNED IN --- UNTIL THE POLICE ARRIVE!

YOU CAN'T DO THIS TO US!

BUT HE IS!

NOW TO ATTEND TO A CERTAIN LUG WHO HAS DELUSIONS ABOUT ELUDING ME!

GOT THE LANDING-GEAR!

THE PLANE-- ACTING STRANGELY! ONLY ONE EXPLANATION-- SUPERMAN!

GRAUL STUNTS IN A FRANTIC EFFORT TO DISLODGE THE MAN OF TOMORROW...

WHEE! WISH I HAD TIME TO JUST RELAX AND ENJOY THIS!

BUT I'VE SOMETHING MORE IMPORTANT TO DO!

Y!!!-!!!-!!!

THE TRAITOROUS SECRETARY ABANDONS THE PLANE IN A FRANTIC EFFORT AT ESCAPE...

WANT TO PLAY TAG, EH?

THE CHUTE WON'T OPEN!

10

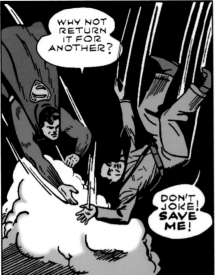

193

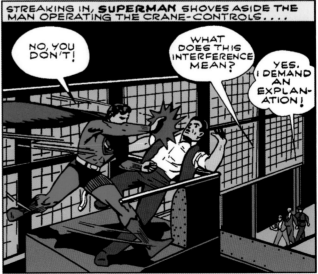

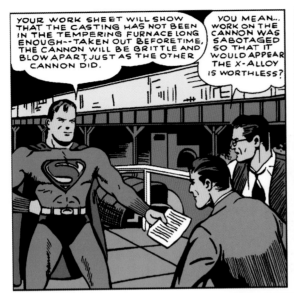

YOUR WORK SHEET WILL SHOW THAT THE CASTING HAS NOT BEEN IN THE TEMPERING FURNACE LONG ENOUGH--TAKEN OUT BEFORETIME, THE CANNON WILL BE BRITTLE AND BLOW APART, JUST AS THE OTHER CANNON DID.

YOU MEAN... WORK ON THE CANNON WAS SABOTAGED SO THAT IT WOULD APPEAR THE X-ALLOY IS WORTHLESS?

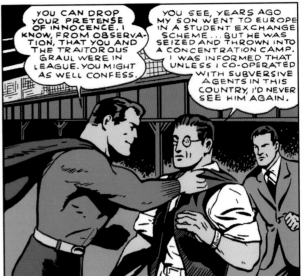

YOU CAN DROP YOUR PRETENSE OF INNOCENCE. I KNOW, FROM OBSERVATION, THAT YOU AND THE TRAITOROUS GRAUL WERE IN LEAGUE. YOU MIGHT AS WELL CONFESS.

YOU SEE, YEARS AGO MY SON WENT TO EUROPE IN A STUDENT EXCHANGE SCHEME... BUT HE WAS SEIZED AND THROWN INTO A CONCENTRATION CAMP. I WAS INFORMED THAT UNLESS I CO-OPERATED WITH SUBVERSIVE AGENTS IN THIS COUNTRY, I'D NEVER SEE HIM AGAIN.

BUT PERHAPS I CAN ATONE SLIGHTLY BY WARNING YOU THAT THE AFOREMENTIONED EUROPEAN NATION IS ABOUT TO LAUNCH STRATO-BOMBS TOWARD AMERICA. THE MOMENT THEY STRIKE MILITARY OBJECTIVES, A SECRET ARMY AT KOOLSEY CAMP IS TO LEAP INTO ACTION.

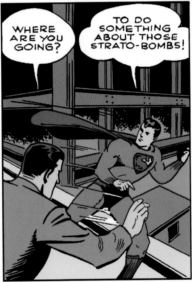

WHERE ARE YOU GOING?

TO DO SOMETHING ABOUT THOSE STRATO-BOMBS!

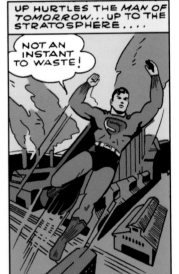

UP HURTLES THE MAN OF TOMORROW... UP TO THE STRATOSPHERE....

NOT AN INSTANT TO WASTE!

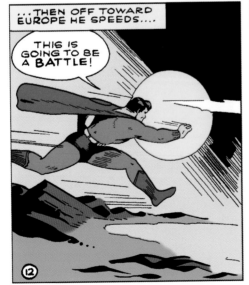

...THEN OFF TOWARD EUROPE HE SPEEDS....

THIS IS GOING TO BE A BATTLE!

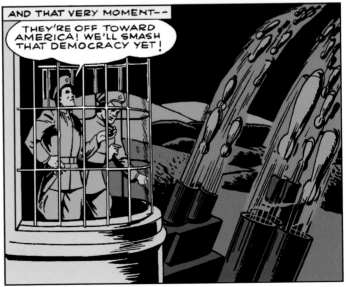

AND THAT VERY MOMENT--

THEY'RE OFF TOWARD AMERICA! WE'LL SMASH THAT DEMOCRACY YET!

12

TOWARD AMERICA WING HUNDREDS OF THE MOST DEADLY, RADIO-DIRECTED BOMBS SCIENCE HAS YET CREATED....

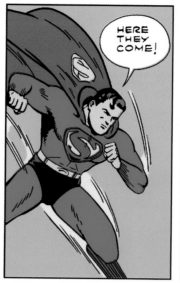
HERE THEY COME!

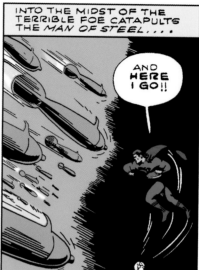
INTO THE MIDST OF THE TERRIBLE FOE CATAPULTS THE MAN OF STEEL....
AND HERE I GO!!

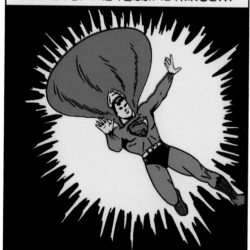
THE VERY HEAVENS SEEM RENT ASUNDER BY THE TERRIFIC HAVOC...

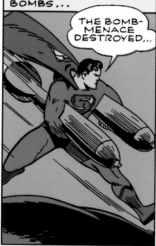
BUT MOVING AT TERRIFIC SPEED, SUPERMAN HAS SALVAGED A FEW OF THE BOMBS...
THE BOMB-MENACE DESTROYED...

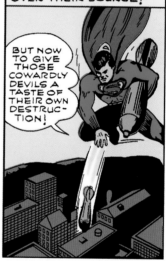
...MINUTES LATER, HE IS OVER THEIR SOURCE!
BUT NOW TO GIVE THOSE COWARDLY DEVILS A TASTE OF THEIR OWN DESTRUCTION!

195

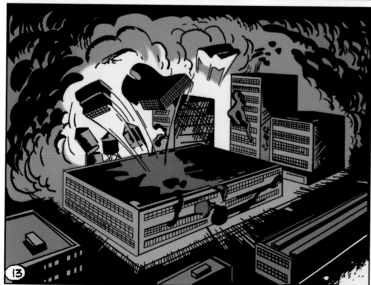
13

LATER--AT THE DAILY PLANET...
CONGRATULATIONS ON YOUR EXCELLENT COVERAGE OF THE X-ALLOY STORY, CLARK.
THANKS, CHIEF. THE GOVERNMENT HAS ISSUED INSTRUCTIONS FOR VIGILANCE AT ALL DEFENSE PRODUCTION PLANTS TO BE REDOUBLED...AND WE'RE MOVING FULL SPEED AHEAD TOWARD VICTORY!
THE END

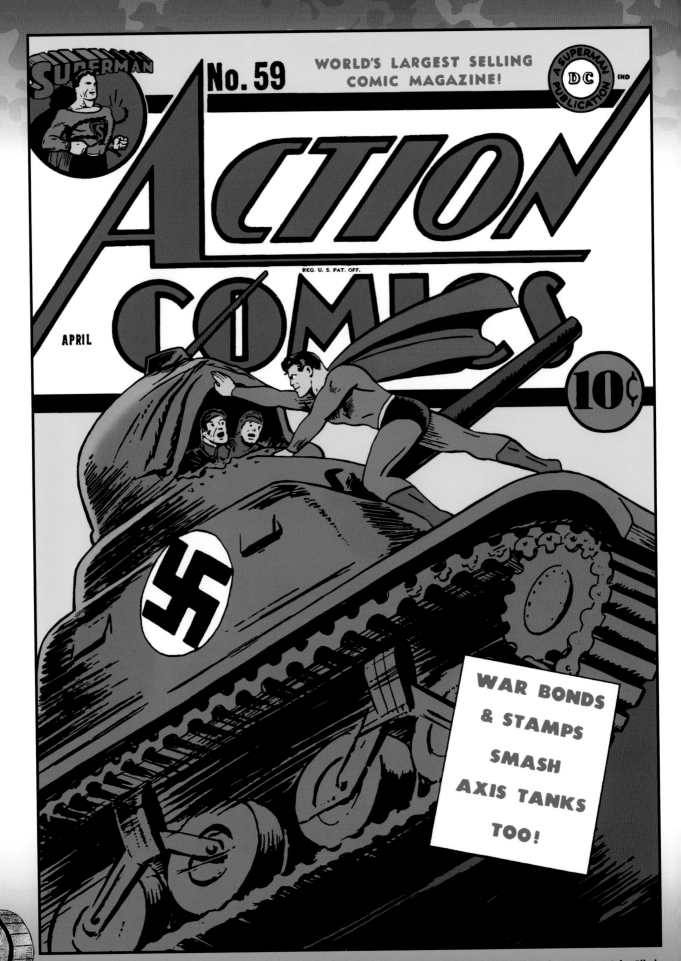

Action Comics #59 (April 1943) - cover art: John Sikela

Part Four

England's war with Nazi Germany had been going on for more than two years before America officially threw its own red-white-and-blue hat into the ring. And even then, the U.S. entrance came largely because of Japanese aggression.

IN FOR THE DURATION

Yet, once Uncle Sam was in, he was in, as they said then, "for the duration." In other words, for as long it took.

From Pearl Harbor until the surrender of Japan took nearly four years. German defeat came three months earlier.

And all that time, Superman had to do what he could for the war effort without ever really doing the thing that every red-blooded American lad (and many lasses) wanted to see—which was wringing the necks of the Axis leaders.

Covers were relatively easier, since readers quickly understood that the action shown on the cover wasn't necessarily going to be reflected inside. For example, on the cover of *Action Comics* #43 (May 1943), Superman flies medical supplies to besieged soldiers manning a machine-gun in a jungle setting. This would have resonated with readers, since, at Guadalcanal in August 1942, America began its "island-hopping" campaign, pushing the Japanese back one strategic island at a time, as U.S. forces drew slowly, inexorably nearer Tokyo.

Superman was also shown, on various covers, protecting soldiers from strafing Japanese aircraft or other enemy fire, occasionally even in battle— for example, astride a Japanese fighter plane with his fist cocked to smash either its engine or its pilot (or both), or scattering Japanese motorcycle troops. Strangely, one of the rare times he ever took the battle to uniformed *Germans* occurred on the beautifully composed cover of *Superman* #23 (July– Aug. 1943), where a terrified U-boat commander

recoils to see, through his periscope, a vengeful Man of Steel plowing through the water straight toward his vessel.

Other war-related covers depicted him yanking the astonished Nazi propaganda minister Joseph Goebbels away from a microphone and being playfully snubbed by Lois Lane in favor of a trio composed of a soldier, a sailor, and a Marine. The cover of *Superman* #24 (Sept–Oct. 1943), while not specifically martial, juxtaposed Superman and the American flag for a powerful patriotic image.

197

One of two *stories* in which the hero gets involved in real combat situations is the oddly fanciful "Meet the Squiffles!" in *Superman* #22 (May–June 1943). Writer Jerry Siegel retooled a popular wartime myth: Gremlins. Many servicemen, both American and British, only half-jokingly blamed any kind of problem with their mechanical equipment—and especially anything having to do with airplanes—on these mischievous elflike creatures. In December 1942, Roald Dahl's short story "The Gremlins"— which Walt Disney was already turning into an animated film—was published in *Cosmopolitan* magazine, which was not then aimed solely at women. It's not unlikely Siegel read the tale and decided to do his own take on the pre-existing "gremlin" legend, rebranding them as "Squiffles" who make a deal with Hitler to sabotage the American aircraft industry.

The other combat-related yarn from this period occurs in *Superman* #24 (Sept.–Oct. 1943), wherein Superman is pitted against a Nazi military expedition in the Arctic. This is one of the first

Superman stories written by anyone other than co-creator Siegel. The reason? In 1943 Siegel, then nearly thirty, was drafted; though he never saw battle, his work on his iconic creation was curtailed until the war's end. One of the first writers to fill his shoes was Don Cameron, the scripter of "Suicide Voyage!" Joe Shuster, whose eyesight was exceptionally poor, was ineligible for the draft.

In other adventures in between fighting civilian criminals, Superman takes part in "war games" to help train American troops; he briefly joins the Army Air Force and goes on a sea voyage with the U.S. Navy (both times as Kent, in search of a *Daily Planet* story). He also battles spies and mops up "black-marketeers" attempting to reap illegal profits from rationed goods. There's even one "public-service" page in which he demonstrates the importance of collecting waste paper for the war effort.

Surprisingly, Superman managed more war-related action in his newspaper strip than in the comic books. One recurring theme in the Sunday strips was "Superman's Service for Servicemen," wherein he fulfilled the requests of men in uniform far from home. And, at Lois Lane's urging, in one color continuity that ran for eight Sundays, he helped a young woman decide between joining the female auxiliary of the Army, Navy, Marines, or Coast Guard—which gave Superman an excuse to interact visually with all four male services.

In one three-week yarn, he even paid a lightning visit to Hitler and the top Nazi brass—Hermann Goering, Joseph Goebbels, and Heinrich Himmler—in the heart of Berlin. Actually, by March 1945, when this oddly light-hearted sequence appeared, the Nazi's armed forces were collapsing both east and west, and the *real* Führer was cowering in an underground bunker, with the end in clear sight for what he had arrogantly proclaimed, only a dozen years earlier, was going to be a "Thousand-Year Reich."

Victory in Europe Day (V-E Day) was May 8, 1945. But, on the far side of the world, the battle was still raging against a weakened but defiant Japanese Empire...

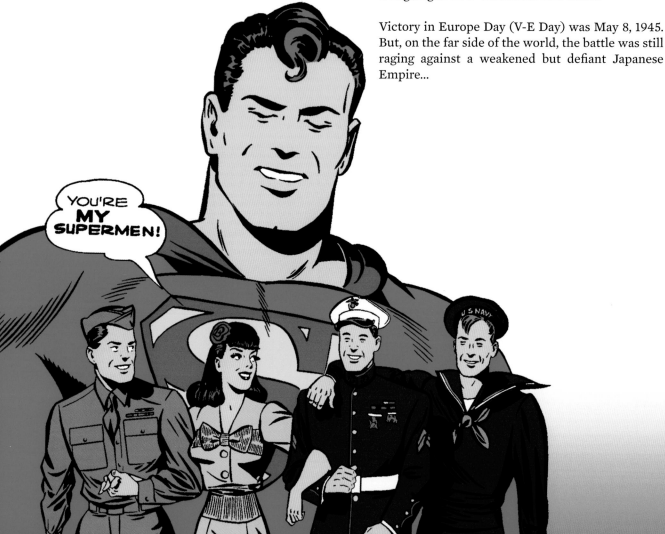

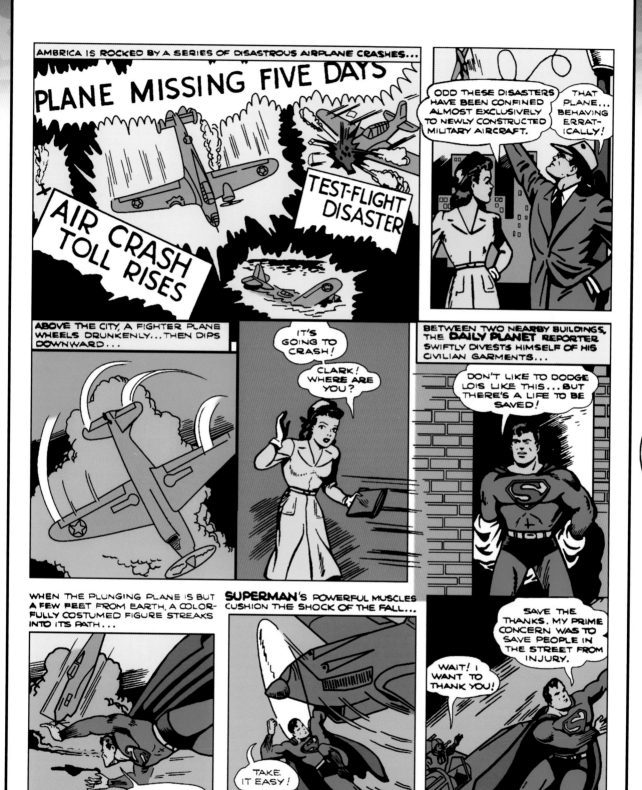

REVERTING TO HIS MORE SUBDUED IDENTITY AS THE **DAILY PLANET** REPORTER, **SUPERMAN** REJOINS LOIS...

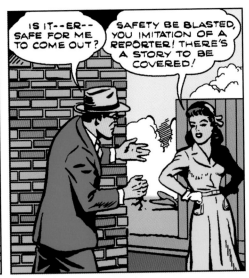

IS IT--ER-- SAFE FOR ME TO COME OUT?

SAFETY BE BLASTED, YOU IMITATION OF A REPORTER! THERE'S A STORY TO BE COVERED!

YOU SMELL OF LIQUOR!

I-- I NEVER TOUCH THE STUFF!

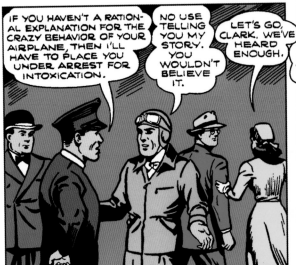

IF YOU HAVEN'T A RATIONAL EXPLANATION FOR THE CRAZY BEHAVIOR OF YOUR AIRPLANE, THEN I'LL HAVE TO PLACE YOU UNDER ARREST FOR INTOXICATION.

NO USE TELLING YOU MY STORY. YOU WOULDN'T BELIEVE IT.

LET'S GO, CLARK. WE'VE HEARD ENOUGH.

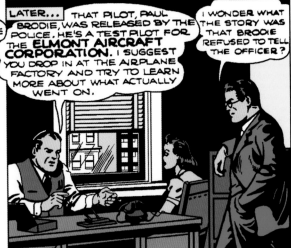

LATER... THAT PILOT, PAUL BRODIE, WAS RELEASED BY THE POLICE. HE'S A TEST PILOT FOR THE **ELMONT AIRCRAFT CORPORATION.** I SUGGEST YOU DROP IN AT THE AIRPLANE FACTORY AND TRY TO LEARN MORE ABOUT WHAT ACTUALLY WENT ON.

I WONDER WHAT THE STORY WAS THAT BRODIE REFUSED TO TELL THE OFFICER?

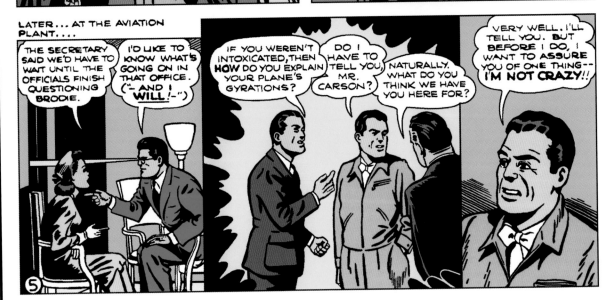

LATER... AT THE AVIATION PLANT....

THE SECRETARY SAID WE'D HAVE TO WAIT UNTIL THE OFFICIALS FINISH QUESTIONING BRODIE.

I'D LIKE TO KNOW WHAT'S GOING ON IN THAT OFFICE. ("-- AND I **WILL**!-")

IF YOU WEREN'T INTOXICATED, THEN **HOW** DO YOU EXPLAIN YOUR PLANE'S GYRATIONS?

DO I HAVE TO TELL YOU, MR. CARSON?

NATURALLY. WHAT DO YOU THINK WE HAVE YOU HERE FOR?

VERY WELL. I'LL TELL YOU. BUT BEFORE I DO, I WANT TO ASSURE YOU OF ONE THING-- **I'M NOT CRAZY!!**

⑤

EVERYTHING WOULD HAVE BEEN OKAY IF IT HADN'T BEEN FOR THOSE BLASTED ELVES!

ELVES?

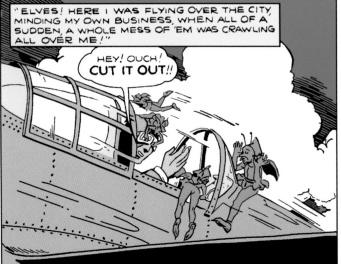

"ELVES! HERE I WAS FLYING OVER THE CITY, MINDING MY OWN BUSINESS, WHEN ALL OF A SUDDEN, A WHOLE MESS OF 'EM WAS CRAWLING ALL OVER ME!"

HEY! OUCH! CUT IT OUT!!

"THEY TORE THE CONTROLS OUT OF MY HANDS, THEY POURED LIQUOR ALL OVER ME. I WAS HALF-BLINDED. IT WAS AWFUL!-"

AND IF SUPERMAN HADN'T CAUGHT THE FALLING PLANE, YOURS TRULY WOULD HAVE BEEN MINCEMEAT!

IT'S BAD ENOUGH THAT YOU PRATTLE ABOUT EVIL ELVES, BUT WHEN YOU DRAG SUPERMAN INTO YOUR FANTASTIC YARN ..,THAT'S TOO MUCH!

I OUGHT TO FIRE YOU, BRODIE, FOR TRYING TO PUT ONE OVER ON US, BUT WE'LL GIVE YOU ANOTHER CHANCE.

AFTER BRODIE DEPARTS...

A NUMBER OF OUR TEST-PILOTS HAVE BEEN FEEDING US THAT SAME YARN ABOUT ELVES...BUT WE'RE TOO SMART TO BE FOOLED BY THEM. AND IF THEY KEEP IT UP THEY'LL COURT DISMISSAL!

THIS OUGHT TO MAKE A REALLY FUNNY FEATURE STORY.

205

LATER... AS CLARK WRITES THE STORY....

"--OVER AT THE ELMONT AIRCRAFT CORPORATION THE TEST-PILOTS HAVE AN ALIBI FOR INEFFICIENCY THAT ESTABLISHES A NEW RECORD FOR INVENTIVENESS. THEY CLAIM THAT MYTHICAL ELVES ANNOY THEM WHILE THEY TRY TO FLY THEIR PLANES...."

"MYTHICAL", EH? LOOK HERE, JUG-HEAD! IN THE FIRST PLACE WE'RE NOT ELVES--WE'RE SQUIFFLES! AND IN THE SECOND PLACE, WE'RE NO MORE MYTHICAL THAN YOU ARE!

AM--AM I SEEING THINGS?!

GONE! NOTHING THERE!! THEN MAYBE I DID IMAGINE IT! HA! HA! OF COURSE I DID!

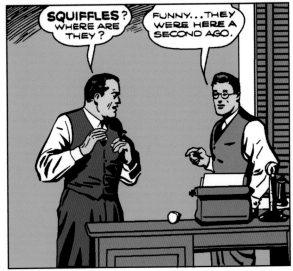

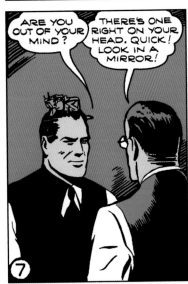

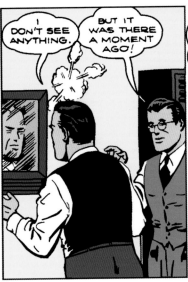

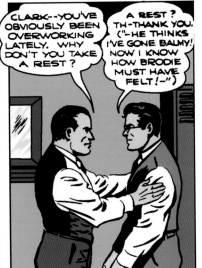

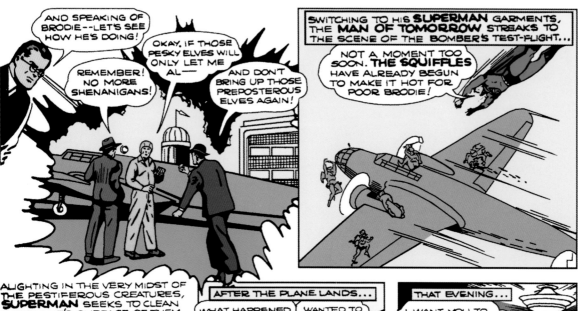

AND SPEAKING OF BRODIE--LET'S SEE HOW HE'S DOING!

REMEMBER! NO MORE SHENANIGANS!

OKAY, IF THOSE PESKY ELVES WILL ONLY LET ME AL--

AND DON'T BRING UP THOSE PREPOSTEROUS ELVES AGAIN!

SWITCHING TO HIS **SUPERMAN** GARMENTS, THE **MAN OF TOMORROW** STREAKS TO THE SCENE OF THE BOMBER'S TEST-FLIGHT...

NOT A MOMENT TOO SOON. **THE SQUIFFLES** HAVE ALREADY BEGUN TO MAKE IT HOT FOR POOR BRODIE!

ALIGHTING IN THE VERY MIDST OF THE PESTIFEROUS CREATURES, **SUPERMAN** SEEKS TO CLEAN THE PLANE'S SURFACE OF THEM...

BLAST THE PESKY LITTLE CREATURES. I SHOULD HAVE BROUGHT ALONG MY FLIT GUN!

AFTER THE PLANE LANDS...

WHAT HAPPENED UP THERE? WAS IT NECESSARY FOR YOU TO PUT THE PLANE THRU ALL THOSE GYRATIONS?

WANTED TO GIVE IT A GOOD WORKOUT!

BRODIE KNOWS THAT IF HE TOLD THE TRUTH, HE'D BE FIRED!

THAT EVENING...

I WANT YOU TO UNDERSTAND THAT MY URGING YOU TO GO TO THIS NIGHT CLUB WITH ME TONIGHT WAS STRICTLY MR. WHITE'S IDEA. HE SAID YOU WERE SUFFERING FROM OVERWORK AND NEEDED SOME RELAXATION. BUT I DOUBT IT.

WHOEVER'S IDEA IT WAS, I THINK IT'S SWELL!

207

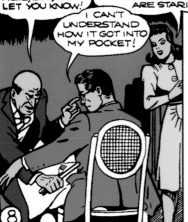

WHEN WE WANT TO GIVE OUR SILVERWARE AWAY FREE, BUD, WE'LL LET YOU KNOW!

DON'T ARGUE WITH HIM, CLARK. PAY HIM AND LET'S GET OUT OF HERE. PEOPLE ARE STARING!

I CAN'T UNDERSTAND HOW IT GOT INTO MY POCKET!

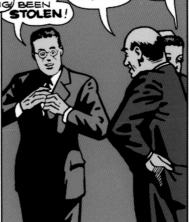

MY POCKET-BOOK-- IT'S BEEN **STOLEN!**

OH-HO! AN' A **WELCHER** TOO, EH?

I'LL PAY FOR THE MEALS!

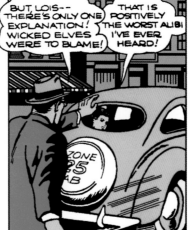

BUT, LOIS-- THERE'S ONLY ONE EXPLANATION! WICKED ELVES WERE TO BLAME!

THAT IS POSITIVELY THE WORST ALIBI I'VE EVER HEARD!

8

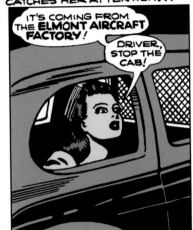

AS LOIS DRIVES HOMEWARD, THE SOUND OF THROBBING AIRCRAFT MOTORS CATCHES HER ATTENTION...

IT'S COMING FROM THE ELMONT AIRCRAFT FACTORY!

DRIVER, STOP THE CAB!

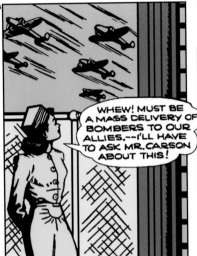

WHEW! MUST BE A MASS DELIVERY OF BOMBERS TO OUR ALLIES.--I'LL HAVE TO ASK MR. CARSON ABOUT THIS!

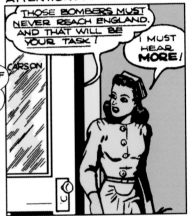

LOIS' REPORTER'S CARD GAINS HER ENTRANCE TO THE FACTORY. BUT AS SHE NEARS THE EXECUTIVE OFFICES, A RAISED VOICE CATCHES HER ATTENTION...

THOSE BOMBERS MUST NEVER REACH ENGLAND. AND THAT WILL BE YOUR TASK!

CARSON

I MUST HEAR MORE!

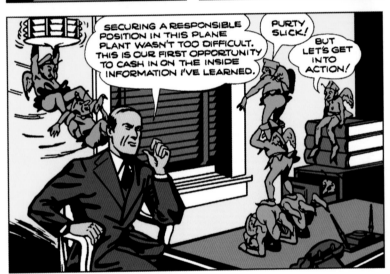

SECURING A RESPONSIBLE POSITION IN THIS PLANE PLANT WASN'T TOO DIFFICULT. THIS IS OUR FIRST OPPORTUNITY TO CASH IN ON THE INSIDE INFORMATION I'VE LEARNED.

PURTY SLICK!

BUT LET'S GET INTO ACTION!

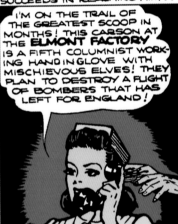

LOIS RISKS CALLING CLARK--AND SUCCEEDS IN REACHING HIM...

I'M ON THE TRAIL OF THE GREATEST SCOOP IN MONTHS! THIS CARSON AT THE ELMONT FACTORY IS A FIFTH COLUMNIST WORKING HAND IN GLOVE WITH MISCHIEVOUS ELVES! THEY PLAN TO DESTROY A FLIGHT OF BOMBERS THAT HAS LEFT FOR ENGLAND!

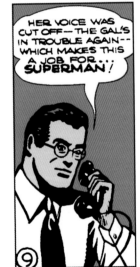

HER VOICE WAS CUT OFF--THE GAL'S IN TROUBLE AGAIN-- WHICH MAKES THIS A JOB FOR...: SUPERMAN!

⑨

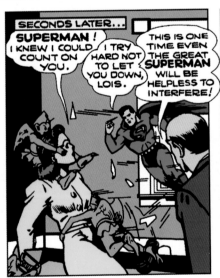

SECONDS LATER...

SUPERMAN! I KNEW I COULD COUNT ON YOU.

I TRY HARD NOT TO LET YOU DOWN, LOIS.

THIS IS ONE TIME EVEN THE GREAT SUPERMAN WILL BE HELPLESS TO INTERFERE!

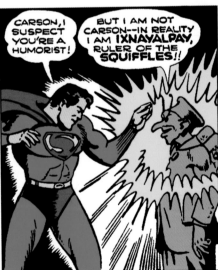

CARSON, I SUSPECT YOU'RE A HUMORIST!

BUT I AM NOT CARSON--IN REALITY I AM IXNAYALPAY, RULER OF THE SQUIFFLES!!

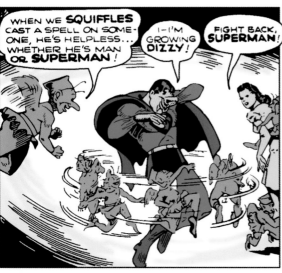

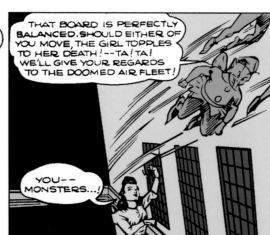

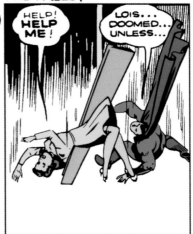

209

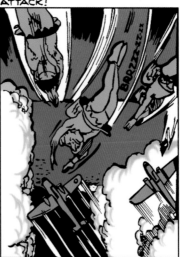

REACHING THE SCENE OF THE UNEVEN AIR BATTLE, **SUPERMAN** HURTLES INTO THE CONFLICT...

NO MATTER HOW MANY I HURL OFF ...THERE ARE ALWAYS MORE!

THIS TIME WE WON'T PUT A SPELL ON YOU. IT'S FUNNY TO WATCH YOUR FRANTIC EFFORTS TO OPPOSE US.

SUPERMAN GAVE UP! HE'S LEAPED AWAY, LEAVING US TO OUR FATE!

I NEVER DREAMED HE WAS A QUITTER!

BUT FAR FROM HAVING ABANDONED THE FLEET OF BOMBERS, **SUPERMAN** PREPARES TO PUT A DESPERATELY CONCEIVED PLAN INTO EXECUTION.

ENGLAND DIRECTLY AHEAD-- IF NO HUMAN AGENCY CAN COPE WITH THOSE **SQUIFFLES** ...THEN THERE ARE OTHER MEANS OF DEALING WITH THEM!

ABOVE AN **RAF** AIRDROME, WHERE **THE GREMLINS**, THOSE HALF-MYTHICAL AERIAL SPRITES OF WORLD WAR II, CONDUCT THEIR HARMLESS PRANKS...

SUPERMAN-- CALLING ALL GREMLINS!!

AND WHAT DO YOU WANT OF US?

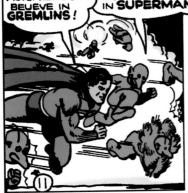

I KNOW YOU **GREMLINS** HAVE PERPETRATED MANY AERIAL JOKES YOURSELVES-- BUT IT WAS ALL IN GOOD FUN. I'M SURE YOU'RE DEFINITELY ON THE SIDE OF THE **UNITED NATIONS**.

VERY TRUE. BUT COME TO THE POINT, **SUPERMAN**.

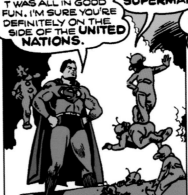

A FLIGHT OF ALLIED BOMBING PLANES HAVE BEEN ATTACKED BY **THE SQUIFFLES**, EVIL ELVES WHO ARE SUBSIDIZED BY THE AXIS. I'M ASKING YOU FOR YOUR AID IN COMBATTING THEM!

WE'VE HEARD OF **THE SQUIFFLES**. A CRUDE LOT... DEFINITELY ON THE BOORISH SIDE. WE'D WELCOME A BATTLE WITH THEM. LEAD ON!

BACK ACROSS THE WAVES HURTLES THE **MAN OF TOMORROW** ACCOMPANIED BY WEIRD REINFORCEMENTS...

HA! HA!--PARDON THE CHUCKLES, BUT WHERE I COME FROM SOME PEOPLE ACTUALLY DON'T BELIEVE IN **GREMLINS**!

HO! HO!--PARDON **MY** CHUCKLES, BUT I'VE HEARD THAT THERE ARE SOME WHO DON'T EVEN BELIEVE IN **SUPERMAN**!

YIPE!! I THOUGHT WE WERE THRU WITH YOU!

FAR FROM IT! GREMLINS-- ATTACK!!!

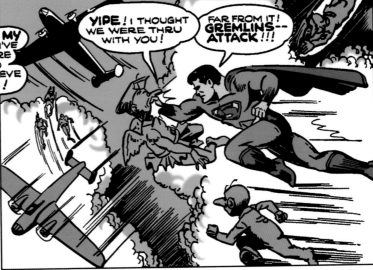

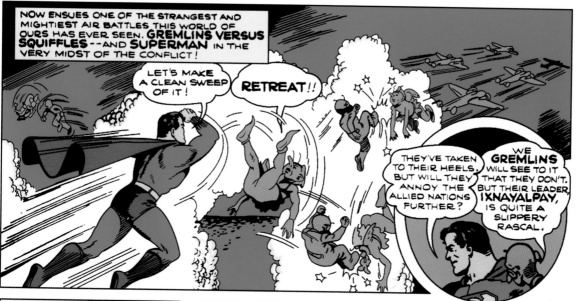

NOW ENSUES ONE OF THE STRANGEST AND MIGHTIEST AIR BATTLES THIS WORLD OF OURS HAS EVER SEEN. GREMLINS VERSUS SQUIFFLES--AND SUPERMAN IN THE VERY MIDST OF THE CONFLICT!

LET'S MAKE A CLEAN SWEEP OF IT!

RETREAT!!

THEY'VE TAKEN TO THEIR HEELS. BUT WILL THEY ANNOY THE ALLIED NATIONS FURTHER?

WE GREMLINS WILL SEE TO IT THAT THEY DON'T. BUT THEIR LEADER IXNAYALPAY, IS QUITE A SLIPPERY RASCAL.

LATER--METROPOLIS...

LOIS, THIS IS ONE SCOOP YOU'LL NEVER BE ABLE TO PRINT. NO ONE WOULD BELIEVE IT.

THAT'S SECONDARY. THE IMPORTANT THING IS THAT SUPERMAN HAS SAVED THE UNITED NATIONS FROM A DEADLY PERIL.

AND STILL LATER--ADOLF HITLER'S HEAVILY GUARDED RETREAT....

BAH! WHERE ARE ALL THE WONDERFUL RESULTS I EXPECTED? PHOEY ON IXNAYALPAY!

ODD COINCIDENCE THAT YOU SHOULD MENTION MY NAME AT THE VERY MOMENT I CHOSE TO CALL ON YOU TO COLLECT THE FAVOR YOU PROMISED ME.

GRANT YOU A FAVOR? BUT YOU HAVEN'T ACHIEVED THE WONDERS YOU PROMISED.

I DIDN'T GUARANTEE THEY WOULD BE SUCCESSFUL--I MERELY EXACTED YOUR PROMISE TO GRANT ME A FAVOR WHEN MY WORK IN YOUR BEHALF WAS DONE. IT IS DONE. AND NOW I WANT MY FAVOR.

211

AND THAT FAVOR? WHAT IS IT YOU WANT?

YOUR BODY!!!

NO! NO! DON'T! PLEASE DON'T--AAAA-AGHHH!

HA-HA-HAAA-AAAAA! CLEVER BARGAIN, WOT?!

AND SO, IXNAYALPAY MERGES WITH ALL THE OTHER DEMONS WHO HAVE TAKEN POSSESSION OF THE SOUL OF ADOLF HITLER SCHICKELGRUBER, THE MAD TYRANT WHO WOULD RULE THE WORLD---BUT WHO WILL BE DESTROYED AS INEVITABLY AS THE SQUIFFLES WERE DESTROYED BY THE GREMLINS AND SUPERMAN!

YOU, TOO, CAN HELP DEFEAT HITLER AND COMPANY BY BUYING WAR BONDS AND STAMPS!

12

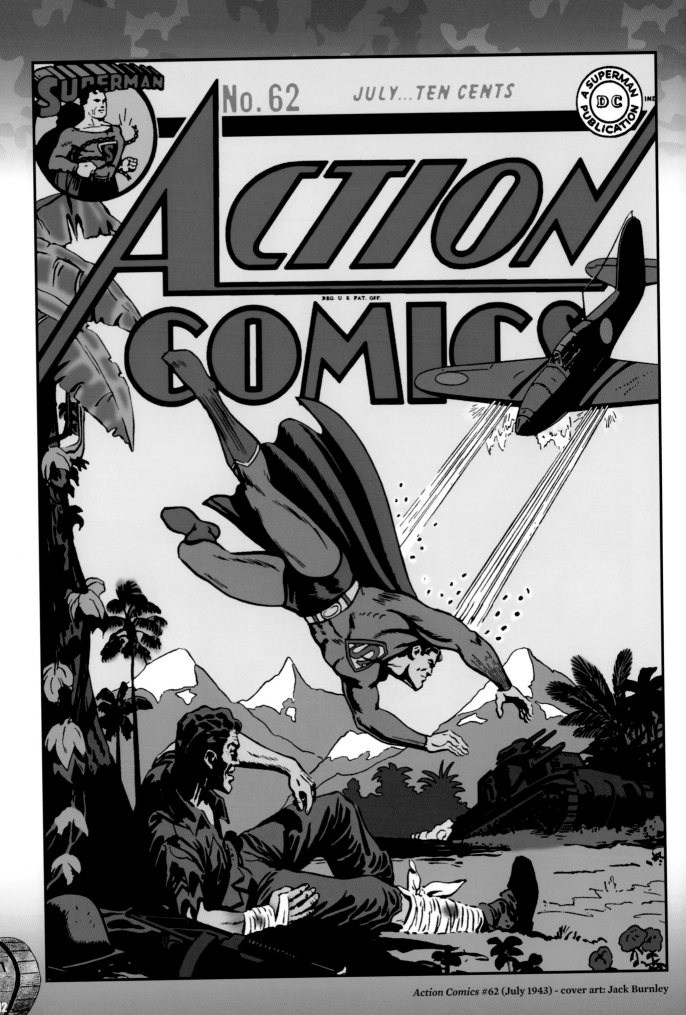

No. 62 JULY...TEN CENTS

SUPERMAN

A SUPERMAN PUBLICATION

REG. U. S. PAT. OFF.

Action Comics #62 (July 1943) - cover art: Jack Burnley

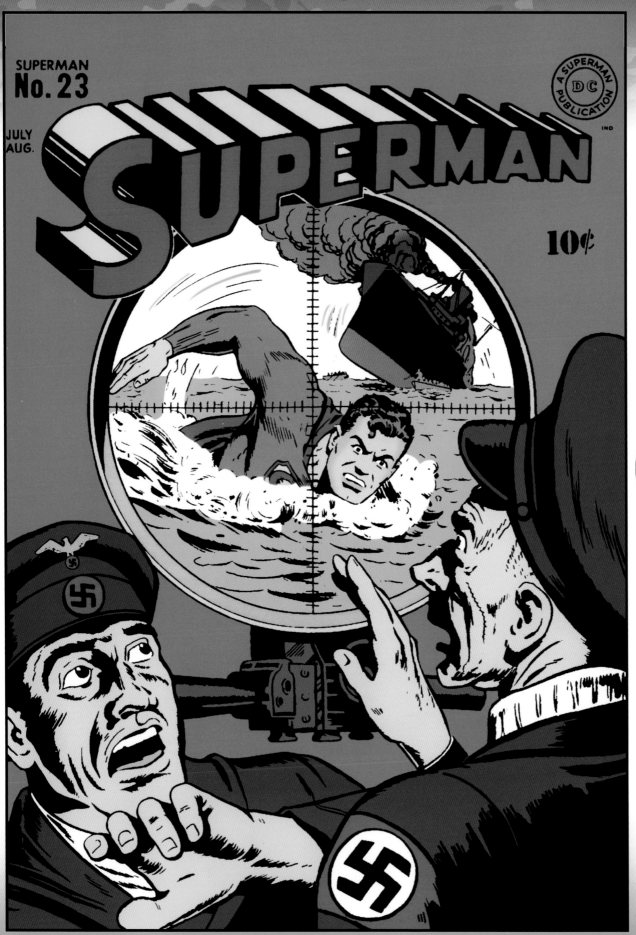

Superman #23 (July–Aug. 1943) - cover art: Jack Burnley

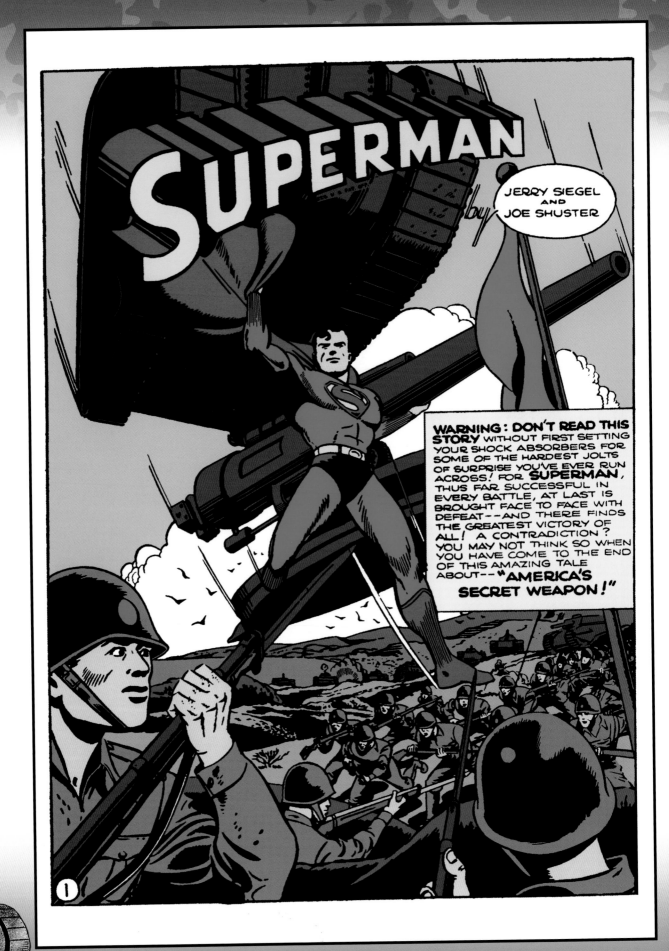

Superman #23 (July–Aug. 1943) - script: Don Cameron - art: Sam Citron (pencils) & Sam Citron & John Sikela (inks)

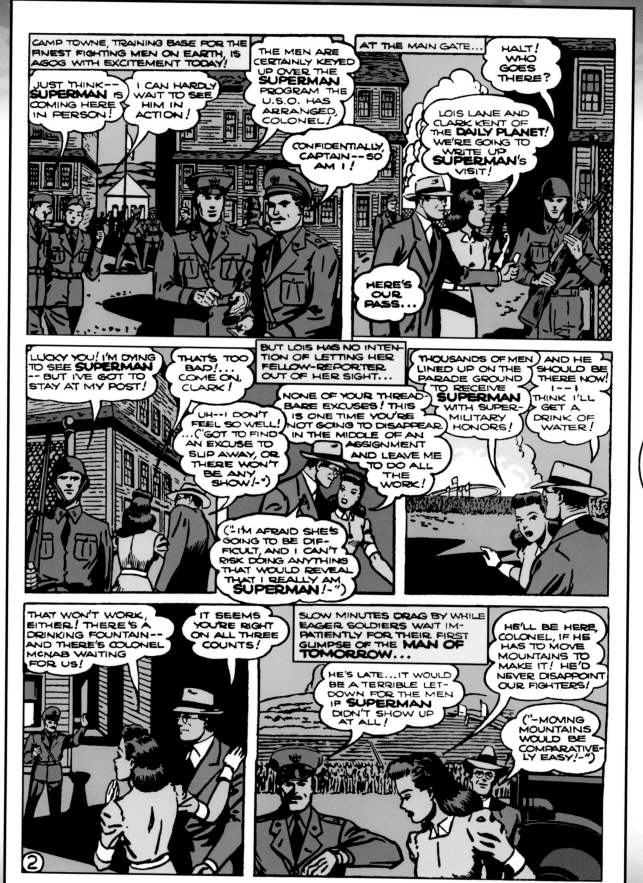

CAMP TOWNE, TRAINING BASE FOR THE FINEST FIGHTING MEN ON EARTH, IS AGOG WITH EXCITEMENT TODAY!

JUST THINK-- SUPERMAN IS COMING HERE IN PERSON!

I CAN HARDLY WAIT TO SEE HIM IN ACTION!

THE MEN ARE CERTAINLY KEYED UP OVER THE SUPERMAN PROGRAM THE U.S.O. HAS ARRANGED, COLONEL!

CONFIDENTIALLY, CAPTAIN-- SO AM I!

AT THE MAIN GATE...

HALT! WHO GOES THERE?

LOIS LANE AND CLARK KENT OF THE DAILY PLANET! WE'RE GOING TO WRITE UP SUPERMAN'S VISIT!

HERE'S OUR PASS...

LUCKY YOU! I'M DYING TO SEE SUPERMAN -- BUT I'VE GOT TO STAY AT MY POST!

THAT'S TOO BAD!... COME ON, CLARK!

BUT LOIS HAS NO INTENTION OF LETTING HER FELLOW-REPORTER OUT OF HER SIGHT...

NONE OF YOUR THREAD-BARE EXCUSES! THIS IS ONE TIME YOU'RE NOT GOING TO DISAPPEAR IN THE MIDDLE OF AN ASSIGNMENT AND LEAVE ME TO DO ALL THE WORK!

UH--I DON'T FEEL SO WELL! ...("GOT TO FIND AN EXCUSE TO SLIP AWAY, OR THERE WON'T BE ANY SHOW!-")

("-I'M AFRAID SHE'S GOING TO BE DIFFICULT, AND I CAN'T RISK DOING ANYTHING THAT WOULD REVEAL THAT I REALLY AM SUPERMAN!-")

THOUSANDS OF MEN LINED UP ON THE PARADE GROUND TO RECEIVE SUPERMAN WITH SUPER-MILITARY HONORS!

AND HE SHOULD BE THERE NOW! I--I THINK I'LL GET A DRINK OF WATER!

215

THAT WON'T WORK, EITHER! THERE'S A DRINKING FOUNTAIN-- AND THERE'S COLONEL MCNAB WAITING FOR US!

IT SEEMS YOU'RE RIGHT ON ALL THREE COUNTS!

SLOW MINUTES DRAG BY WHILE EAGER SOLDIERS WAIT IMPATIENTLY FOR THEIR FIRST GLIMPSE OF THE MAN OF TOMORROW...

HE'S LATE...IT WOULD BE A TERRIBLE LET-DOWN FOR THE MEN IF SUPERMAN DIDN'T SHOW UP AT ALL!

HE'LL BE HERE, COLONEL, IF HE HAS TO MOVE MOUNTAINS TO MAKE IT! HE'D NEVER DISAPPOINT OUR FIGHTERS!

("-MOVING MOUNTAINS WOULD BE COMPARATIVELY EASY!-")

2

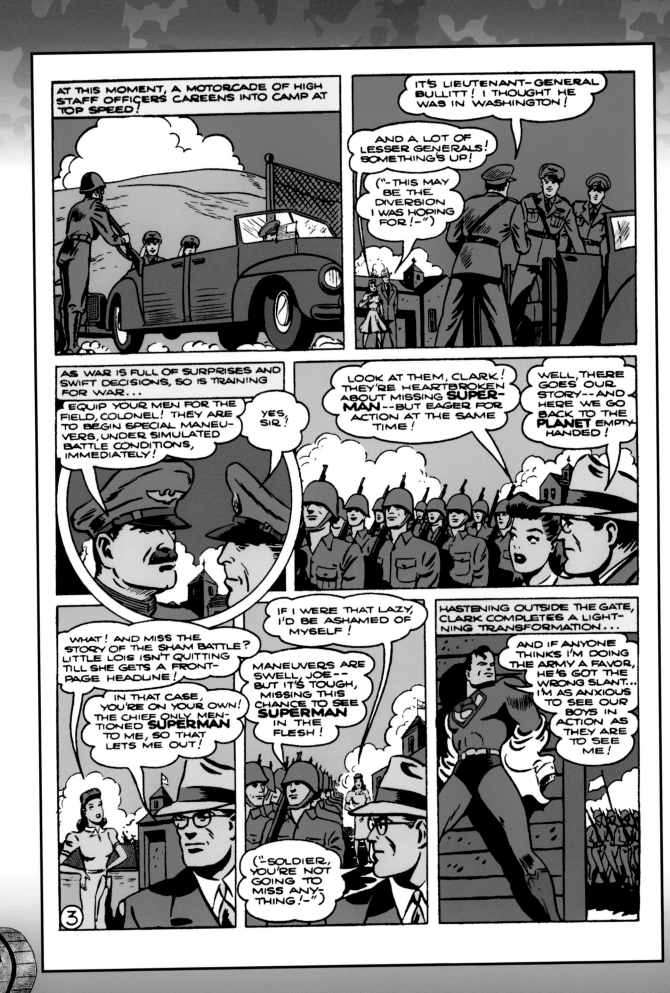

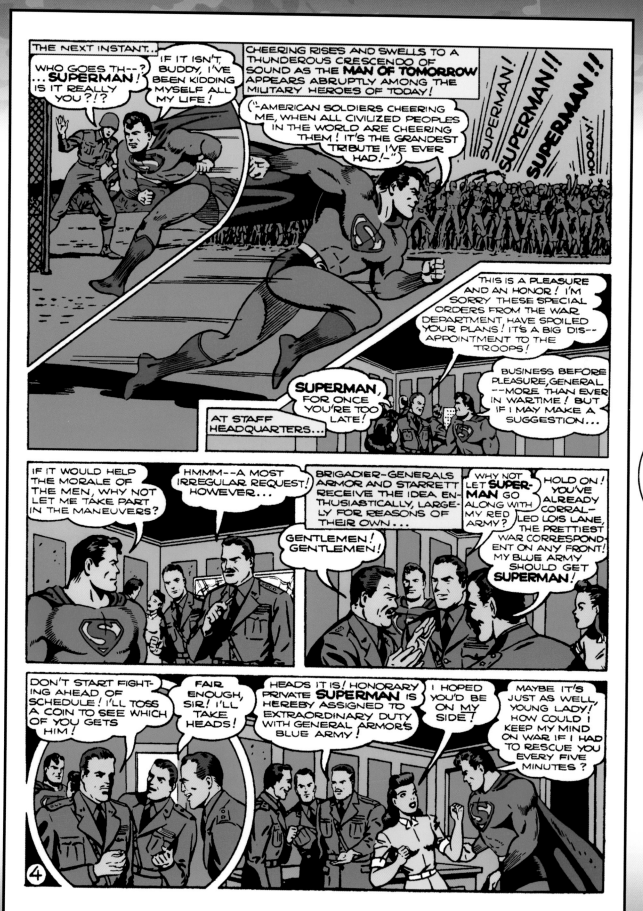

SO WITH ALL THE IMPRESSIVE TRAPPINGS OF REAL WAR BEGINS A VAST, GRIM GAME OF MEN AND MACHINES -- A FULL-DRESS REHEARSAL OF THE TIDAL WAVE OF RETRIBUTION THAT HAS ALREADY BEGUN TO SWEEP OVER HALF THE WORLD, BLOTTING OUT FLAMES OF DESTRUCTION SET BY MAD CRIMINALS AT THE HEAD OF MISLED NATIONS!

YOU SEE, MY STRATEGY IS TO FIND THE REDS' MAIN FORCE AND STRIKE WITH OUR MOBILE WEAPONS BEFORE THEY CAN GET THEIR PLANES AND TANKS INTO LARGE-SCALE ACTION!

GENERAL ARMOR, IT'S DECENT OF YOU TO EXPLAIN THESE THINGS TO ME -- A RAW ROOKIE!

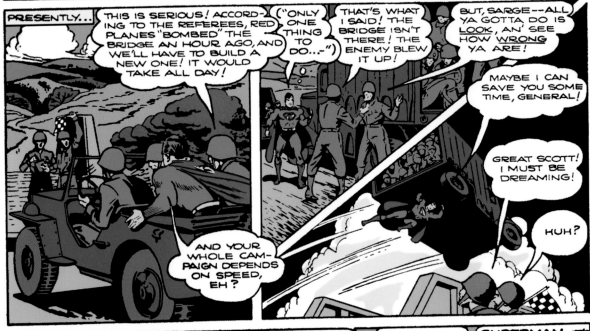

PRESENTLY...

THIS IS SERIOUS! ACCORDING TO THE REFEREES, RED PLANES "BOMBED" THE BRIDGE AN HOUR AGO, AND WE'LL HAVE TO BUILD A NEW ONE! IT WOULD TAKE ALL DAY!

("ONLY ONE THING TO DO...")

THAT'S WHAT I SAID! THE BRIDGE ISN'T THERE! THE ENEMY BLEW IT UP!

BUT, SARGE -- ALL YA GOTTA DO IS LOOK, AN' SEE HOW WRONG YA ARE!

MAYBE I CAN SAVE YOU SOME TIME, GENERAL!

GREAT SCOTT! I MUST BE DREAMING!

HUH?

AND YOUR WHOLE CAMPAIGN DEPENDS ON SPEED, EH?

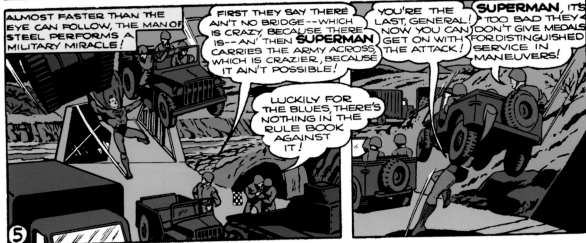

ALMOST FASTER THAN THE EYE CAN FOLLOW, THE MAN OF STEEL PERFORMS A MILITARY MIRACLE!

FIRST THEY SAY THERE AIN'T NO BRIDGE -- WHICH IS CRAZY, BECAUSE THERE IS -- AN' THEN **SUPERMAN** CARRIES THE ARMY ACROSS, WHICH IS CRAZIER, BECAUSE IT AIN'T POSSIBLE!

LUCKILY FOR THE BLUES, THERE'S NOTHING IN THE RULE BOOK AGAINST IT!

YOU'RE THE LAST, GENERAL! NOW YOU CAN GET ON WITH THE ATTACK!

SUPERMAN, IT'S TOO BAD THEY DON'T GIVE MEDALS FOR DISTINGUISHED SERVICE IN MANEUVERS!

⑤

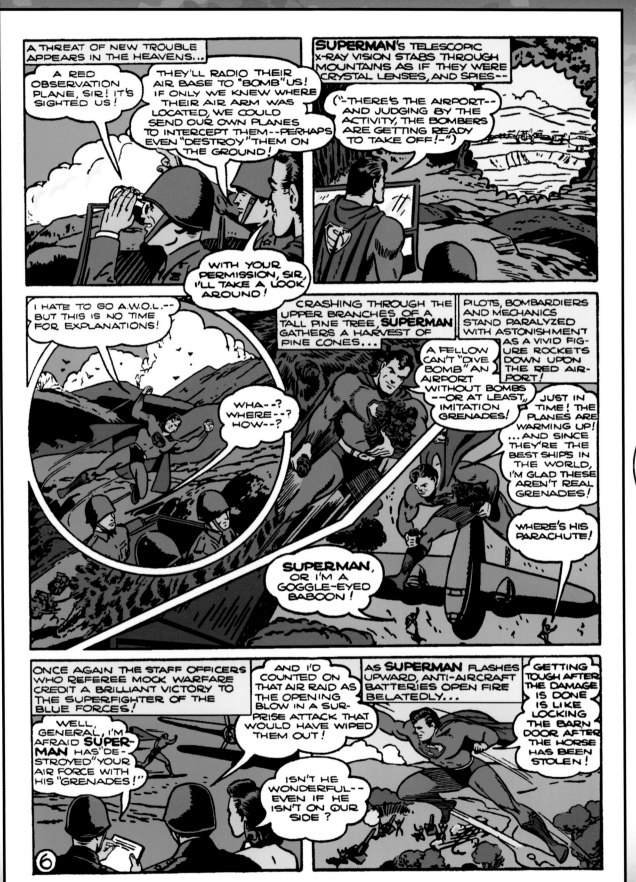

219

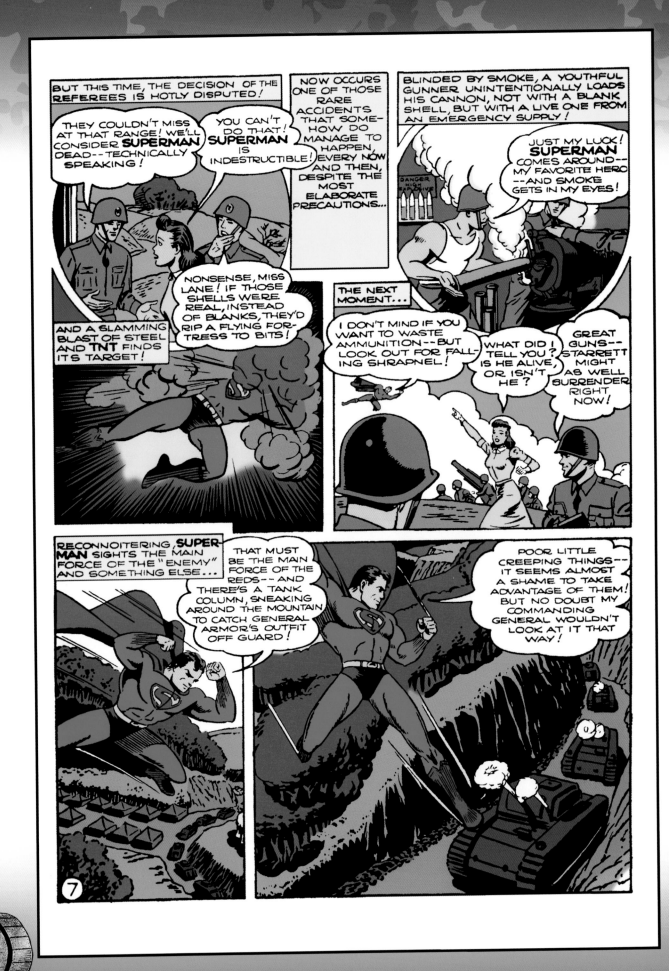

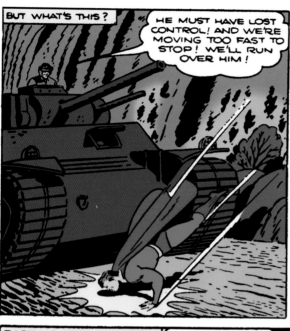

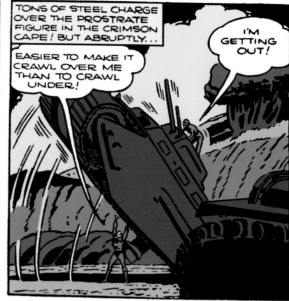

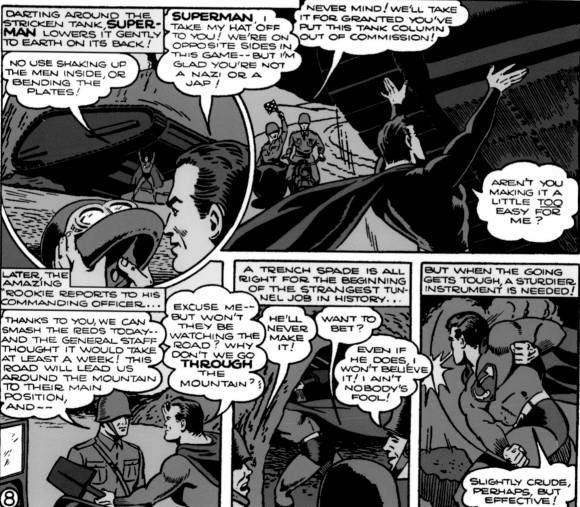

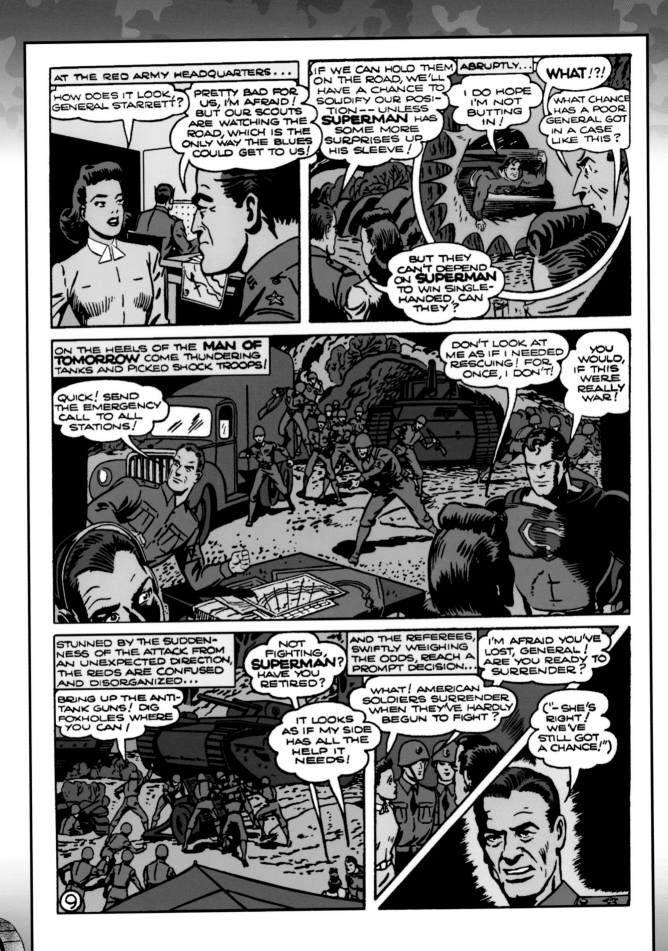

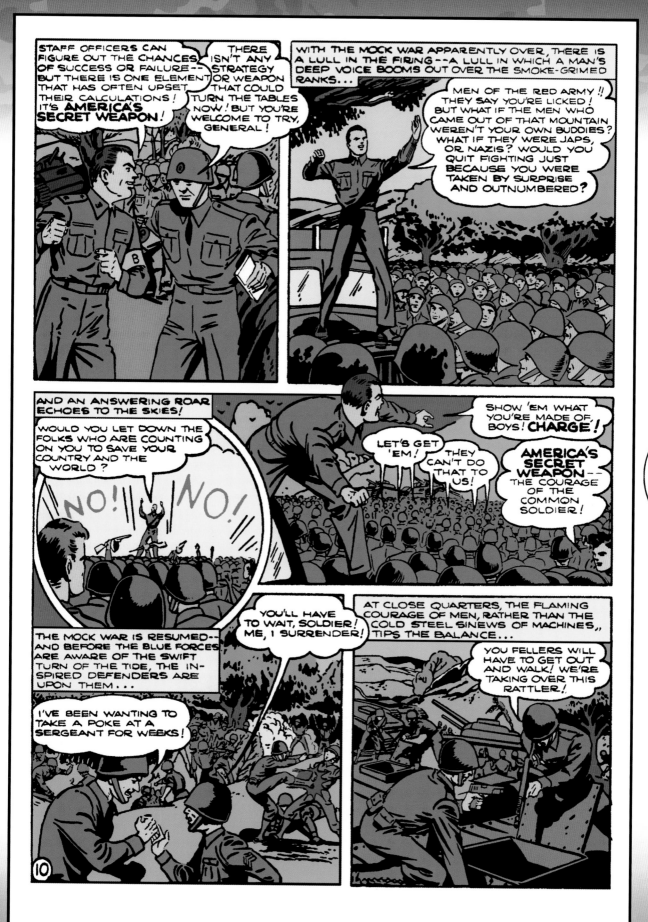

STAFF OFFICERS CAN FIGURE OUT THE CHANCES OF SUCCESS OR FAILURE-- BUT THERE IS ONE ELEMENT THAT HAS OFTEN UPSET THEIR CALCULATIONS! IT'S *AMERICA'S SECRET WEAPON!*

THERE ISN'T ANY STRATEGY OR WEAPON THAT COULD TURN THE TABLES NOW! BUT YOU'RE WELCOME TO TRY, GENERAL!

WITH THE MOCK WAR APPARENTLY OVER, THERE IS A LULL IN THE FIRING--A LULL IN WHICH A MAN'S DEEP VOICE BOOMS OUT OVER THE SMOKE-GRIMED RANKS...

MEN OF THE RED ARMY !! THEY SAY YOU'RE LICKED ! BUT WHAT IF THE MEN WHO CAME OUT OF THAT MOUNTAIN WEREN'T YOUR OWN BUDDIES ? WHAT IF THEY WERE JAPS, OR NAZIS? WOULD YOU QUIT FIGHTING JUST BECAUSE YOU WERE TAKEN BY SURPRISE AND OUTNUMBERED?

AND AN ANSWERING ROAR ECHOES TO THE SKIES!

WOULD YOU LET DOWN THE FOLKS WHO ARE COUNTING ON YOU TO SAVE YOUR COUNTRY AND THE WORLD ?

NO! NO!

SHOW 'EM WHAT YOU'RE MADE OF, BOYS! *CHARGE!*

LET'S GET 'EM !

THEY CAN'T DO THAT TO US !

AMERICA'S SECRET WEAPON-- THE COURAGE OF THE COMMON SOLDIER !

THE MOCK WAR IS RESUMED-- AND BEFORE THE BLUE FORCES ARE AWARE OF THE SWIFT TURN OF THE TIDE, THE IN-SPIRED DEFENDERS ARE UPON THEM...

YOU'LL HAVE TO WAIT, SOLDIER! ME, I SURRENDER!

AT CLOSE QUARTERS, THE FLAMING COURAGE OF MEN, RATHER THAN THE COLD STEEL SINEWS OF MACHINES,, TIPS THE BALANCE...

YOU FELLERS WILL HAVE TO GET OUT AND WALK! WE'RE TAKING OVER THIS RATTLER!

I'VE BEEN WANTING TO TAKE A POKE AT A SERGEANT FOR WEEKS!

⑩

223

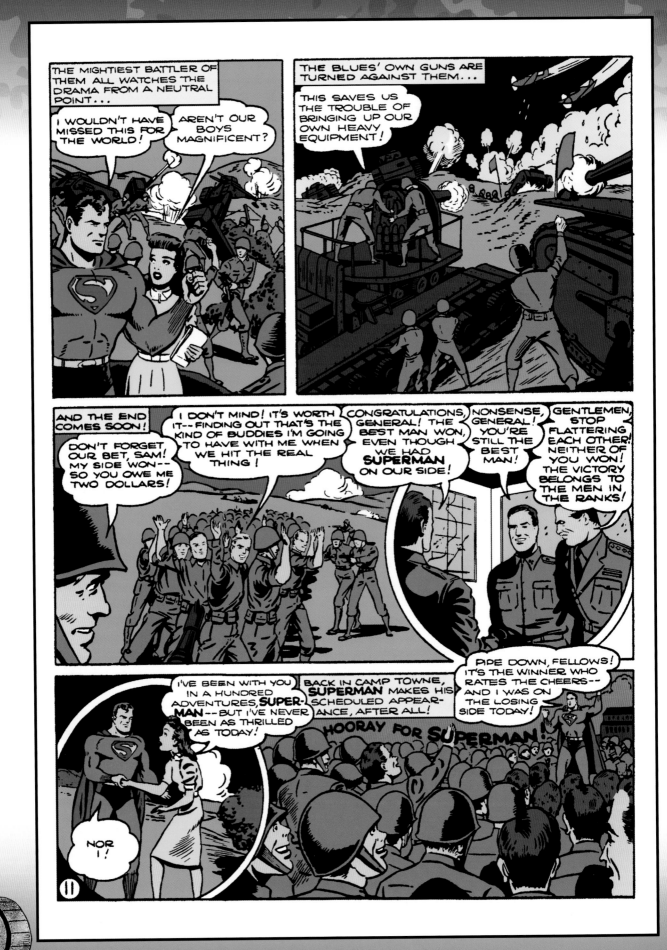

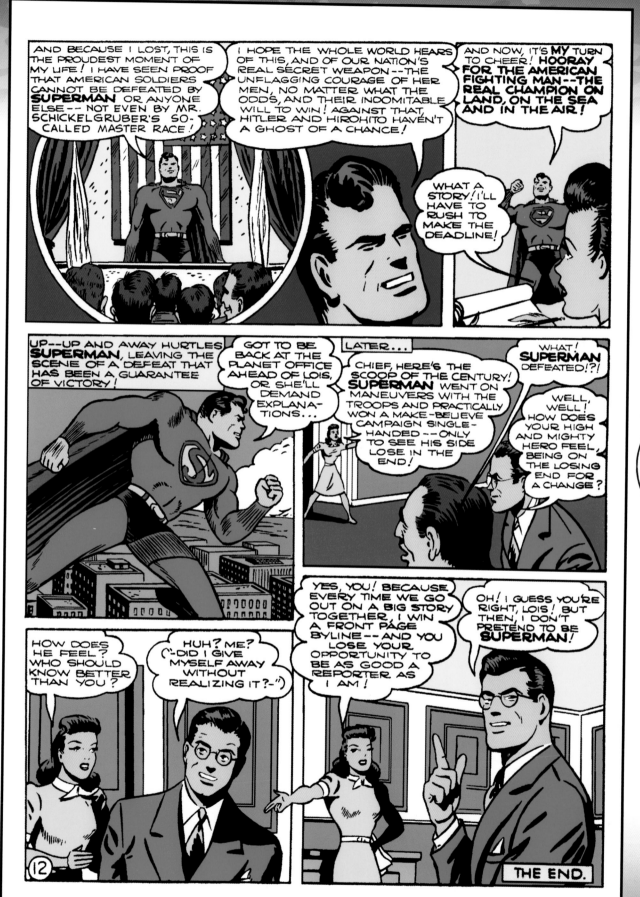

225

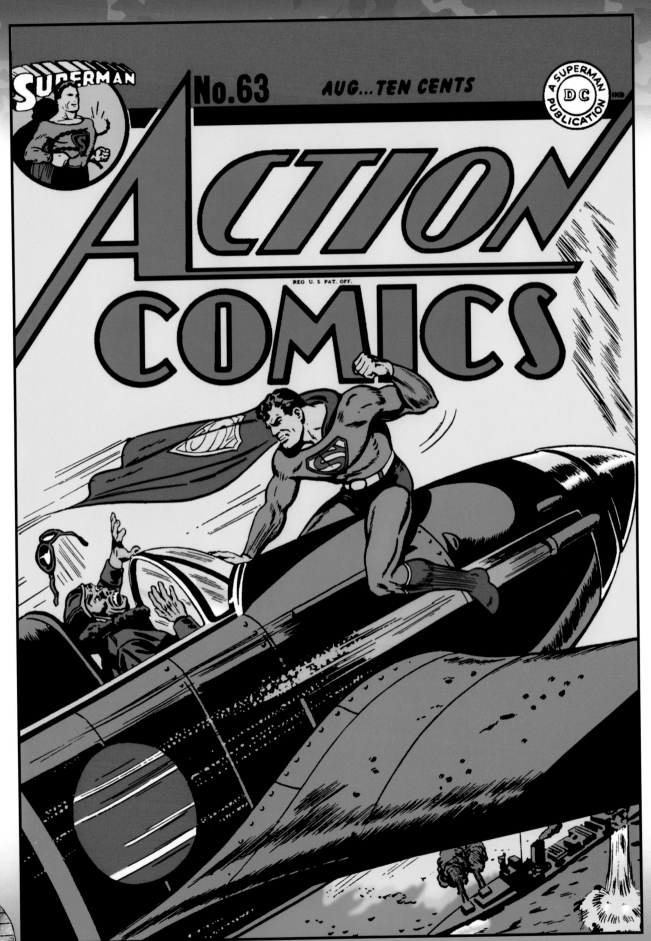

Action Comics #63 (Aug. 1943) - cover art: Jack Burnley

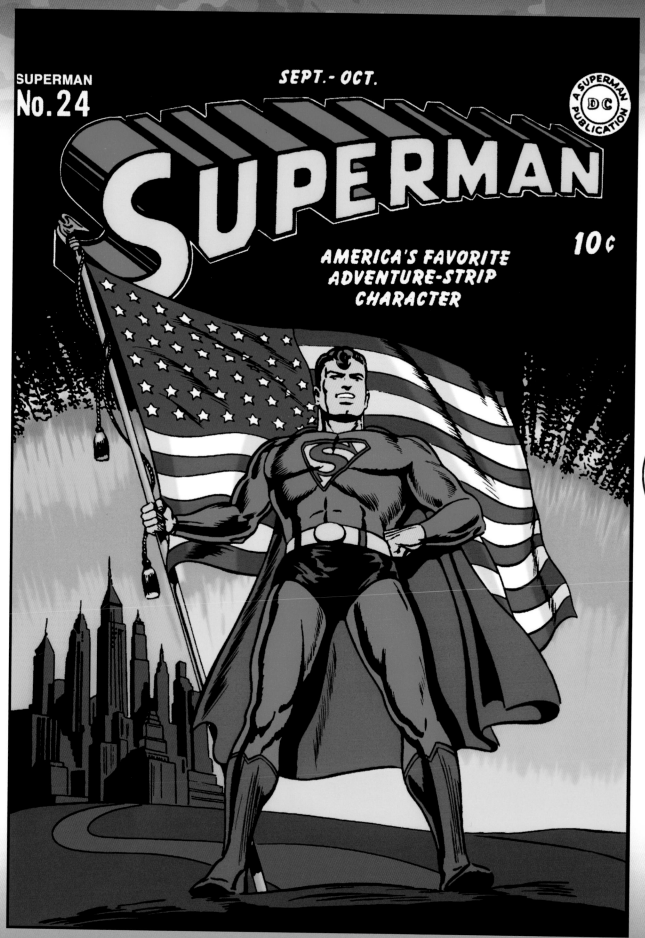

Superman #24 (Sept.–Oct. 1943) - cover art: Jack Burnley

Superman #24 (Sept.–Oct. 1943) - script: Don Cameron - art: Ed Dobrotka (pencils) & George Roussos (inks)

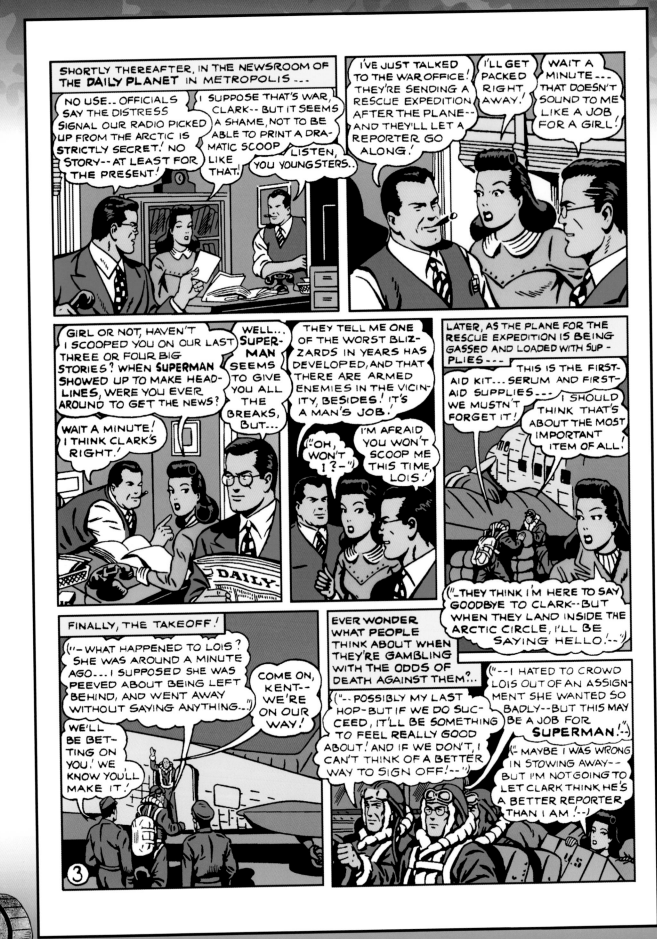

DRONING DUE NORTH, THE SHIP IS CAUGHT HOURS LATER IN THE VIOLENCE OF THE POLAR BLIZZARD...

IT'S GETTING WORSE-- BUT IT WOULD BE SUICIDE TO TRY TO SIT DOWN IN THE OCEAN!

LOTS OF ICE FORMING ON THE WINGS-- BUT I'LL TRY TO CLIMB OUT OF IT.

MEANWHILE, CLARK'S PHENOMENAL X-RAY VISION MAKES A STARTLING DISCOVERY ...

IF THE CARGO SHOULD START SHIFTING, AND UNBALANCE THE SHIP, WE'D BE LOST!

"--CARGO?... WHA--! LOIS! NO WONDER I COULDN'T FIND HER TO SAY GOOD BYE! SHE'S STOWED AWAY-- AND I'M AFRAID IT'S GOING TO COMPLICATE MATTERS!--"

("--AFRAID I'M GOING TO BE AIR-SICK! WHAT A LAUGH FOR CLARK IF HE KNEW-- BUT, THANK GOODNESS, HE DOESN'T!--")

BAD AS THE STORM IS IN THE SKY, IT IS WORSE BELOW-- WHERE A STRICKEN SHIP SENDS OUT AN S-O-S WHICH IS CAUGHT BY THE SUPERSENSITIVE HEARING OF THE SUPPOSED REPORTER...

SCHOONER FLANDINN GOING TO PIECES IN HEAVY SEAS....MAY STRIKE ICEBERG-- MUST HAVE HELP IMMEDIATELY...

("--A FISHING SHIP IN DISTRESS, AND SOMETHING'S GOT TO BE DONE ABOUT HER IMMEDIATELY!--LOOKS LIKE SUPERMAN IS GOING TO HAVE TWO IMPORTANT JOBS ON HIS HANDS AT ONCE.")

WITH EYE-BAFFLING SPEED, CLARK KENT DISCARDS HIS OUTER GARMENTS AND WRENCHES OPEN THE DOOR OF THE PLANE..

YESSIR, MR. KENT-- IF EVER THAT CARGO STARTS GETTING LOOSE..HUH?..HE WAS HERE A SECOND AGO... KENT! WHERE ARE YOU?

("-- RUDE OF ME TO LEAVE SO ABRUPTLY, PERHAPS --BUT WE CAN'T ALWAYS STAND ON CEREMONY.--")

231

--AND DOWNWARD THROUGH THE FURY OF THE ICY GALE DARTS SUPERMAN TO BATTLE WIND AND WATER FOR THE LIVES OF AMERICAN SAILORS!

HE WAS HERE.. AND HE COULDN'T HAVE GONE WITHOUT OPENING THE DOOR-- BUT IT'S CLOSED TIGHT..

"--THE SCHOONER'S PLANKING IS RIPPING LOOSE -- SHE'S TRYING TO AVOID THAT ICEBERG-- BUT IT MAY BE HER ONLY HOPE--"

④

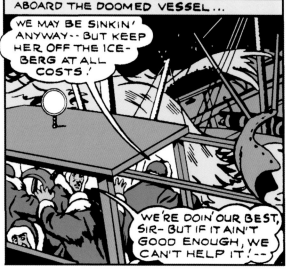

ABOARD THE DOOMED VESSEL...

WE MAY BE SINKIN' ANYWAY-- BUT KEEP HER OFF THE ICEBERG AT ALL COSTS!

WE'RE DOIN' OUR BEST, SIR-- BUT IF IT AIN'T GOOD ENOUGH, WE CAN'T HELP IT!--

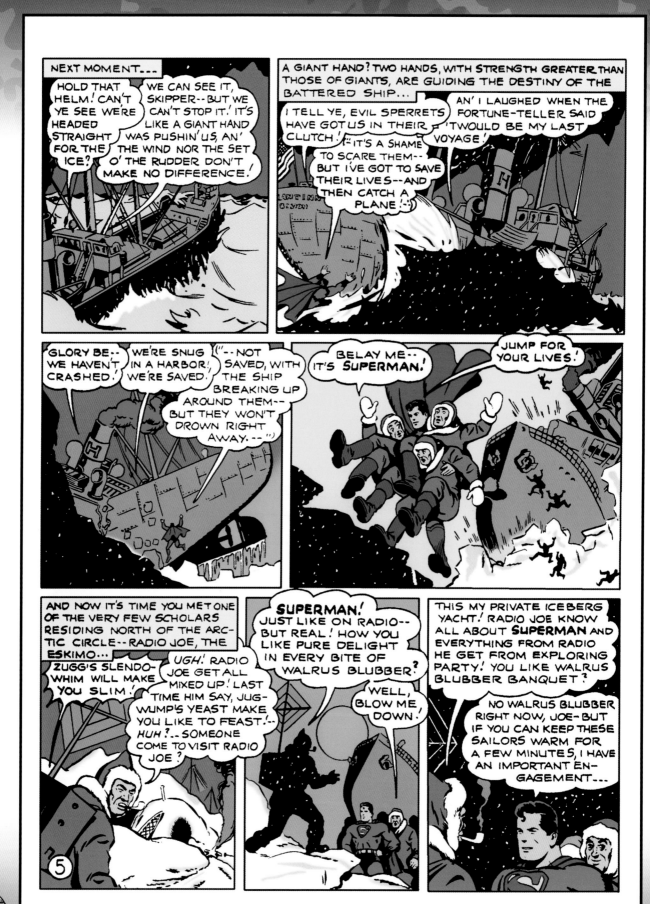

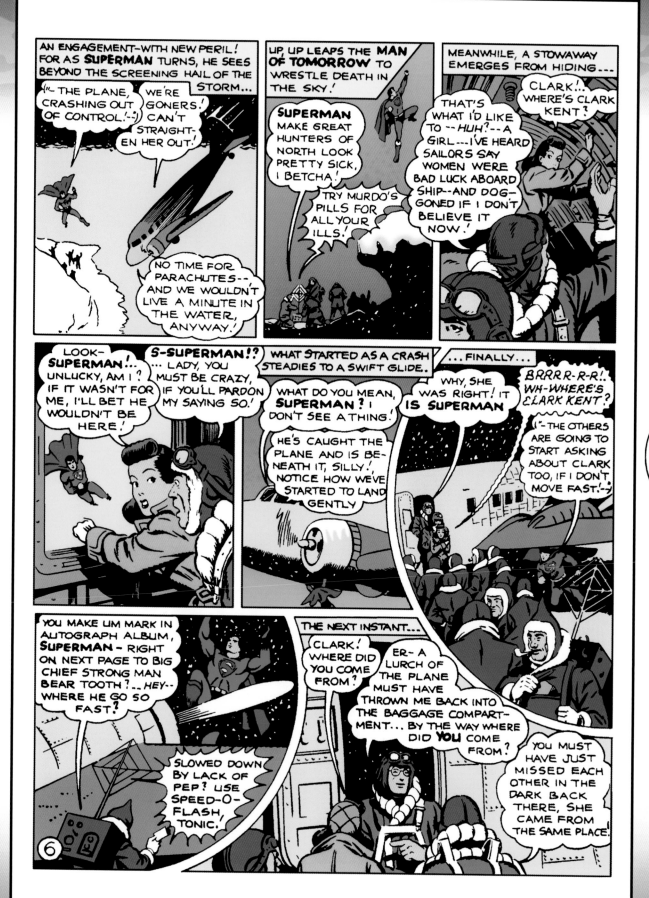

233

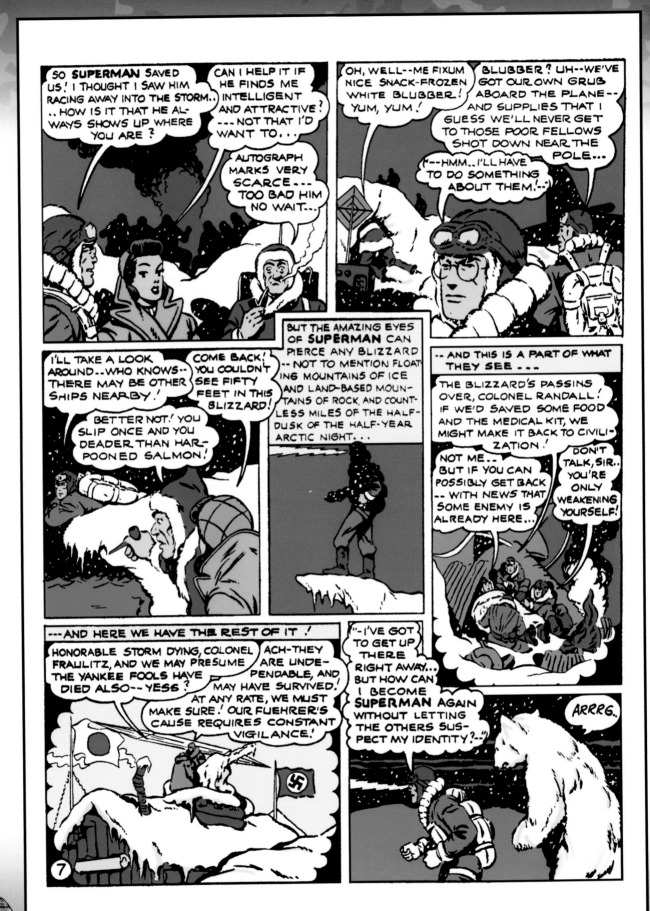

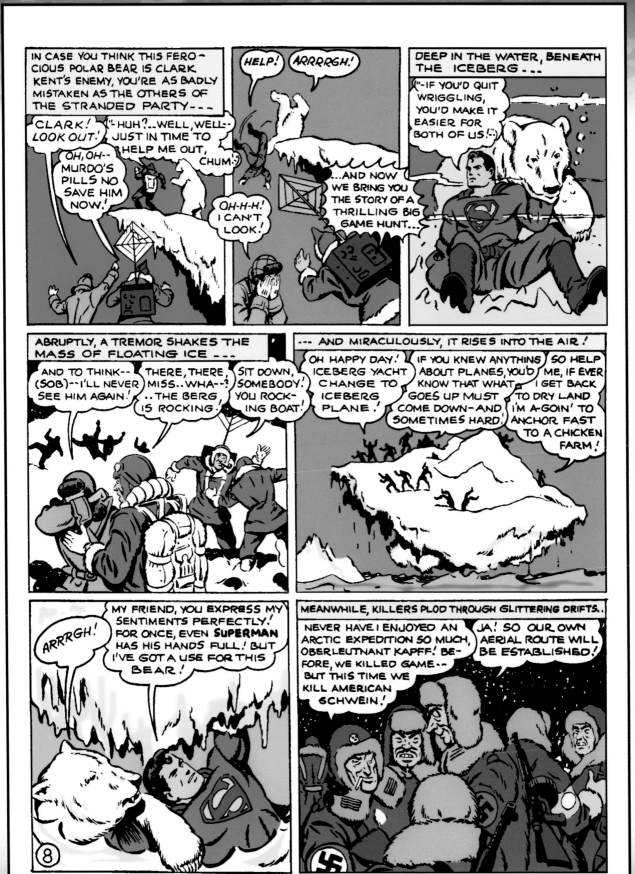

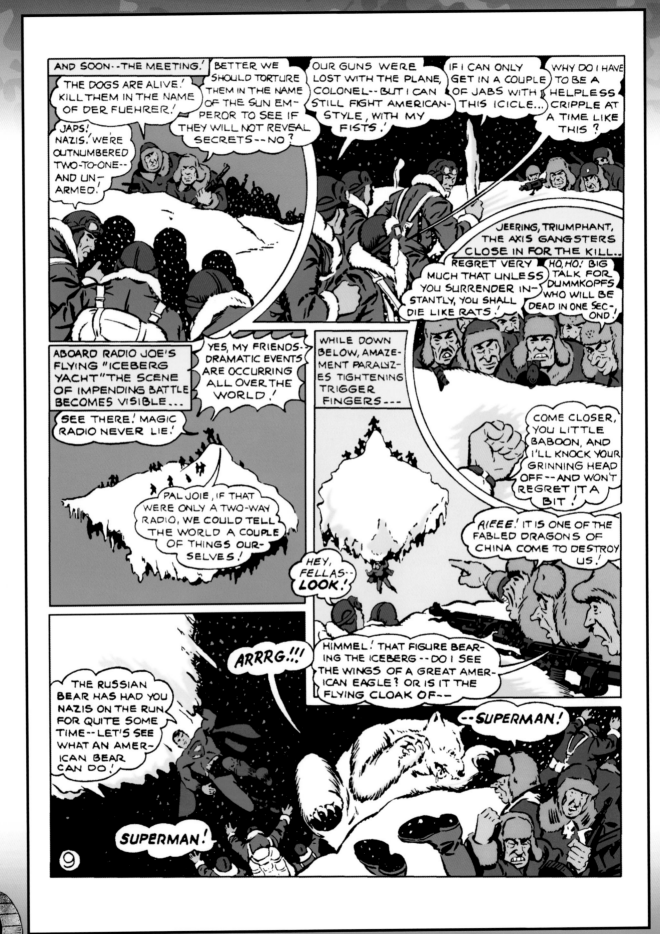

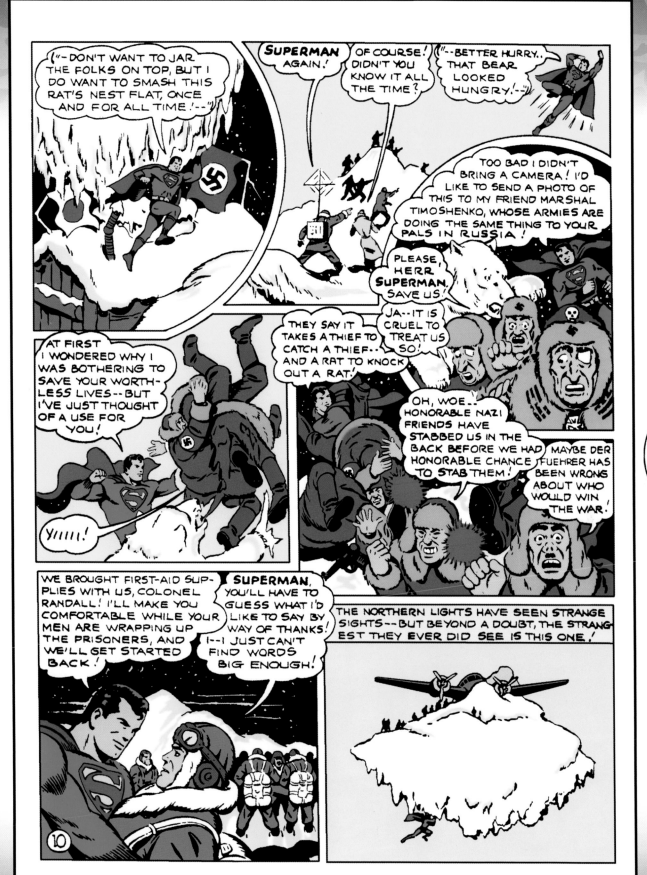

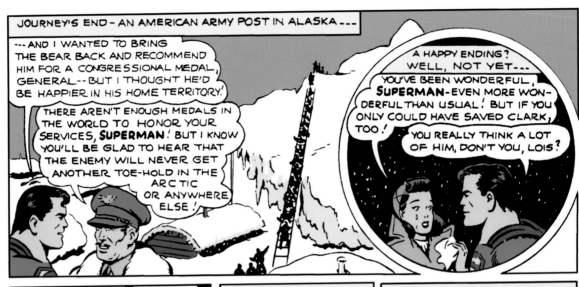

JOURNEY'S END - AN AMERICAN ARMY POST IN ALASKA ---

--- AND I WANTED TO BRING THE BEAR BACK AND RECOMMEND HIM FOR A CONGRESSIONAL MEDAL, GENERAL -- BUT I THOUGHT HE'D BE HAPPIER IN HIS HOME TERRITORY!

THERE AREN'T ENOUGH MEDALS IN THE WORLD TO HONOR YOUR SERVICES, **SUPERMAN**! BUT I KNOW YOU'LL BE GLAD TO HEAR THAT THE ENEMY WILL NEVER GET ANOTHER TOE-HOLD IN THE ARCTIC OR ANYWHERE ELSE!

A HAPPY ENDING? WELL, NOT YET---

YOU'VE BEEN WONDERFUL, **SUPERMAN**-EVEN MORE WON-DERFUL THAN USUAL! BUT IF YOU ONLY COULD HAVE SAVED CLARK, TOO!

YOU REALLY THINK A LOT OF HIM, DON'T YOU, LOIS?

I'D NEVER LET HIM GUESS IT, BUT-- BUT NEXT TO YOU, HE'S THE GRANDEST PERSON I'VE EVER KNOWN!

DO I SEE SOMETHING MOVING IN THAT DEEP CREVASSE IN THE ICE-BERG!

EXCUSE PLEASE, **SUPERMAN**, BUT--

FAR MORE SWIFTLY THAN ANY HUMAN EYE CAN FO-CUS, **SUPERMAN** DARTS AWAY.

WHERE? OH, DO YOU THINK IT COULD BE..?

--IF YOU WOULD KINDLY MAKE MARK.. HEY!..! WHA--!

A SPLIT SECOND LATER...

CLARK! OH, CLARK! YOU'RE ALIVE!

WH-WHERE ARE WE? WH-WHAT HAPPENED? I REMEMBER A BEAR JUMPED AT ME, AND--

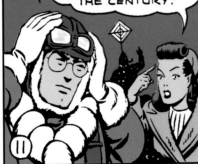

MY HEAD... MUST HAVE BUMPED IT...

I'M NOT SURPRISED, YOU IDIOT! I TOLD YOU NOT TO GO CLIMBING AROUND THAT ICEBERG! WHY, IF IT HADN'T BEEN FOR ME, THE **PLANET** WOULD HAVE MISSED THE STORY OF THE CENTURY!

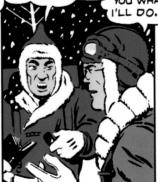

EXCUSE, BUT DID **SUPERMAN** COME THIS WAY? ME LIKE HIS AUTO-GRAPH MARK, BUT NO CAN FIND HIM!

SUPERMAN? HE DOESN'T SEEM TO BE IN SIGHT, BUT I'LL TELL YOU WHAT I'LL DO...

I'LL GIVE YOU MY AUTOGRAPH IN-STEAD! YOU KNOW, I'M QUITE A RE-MARKABLE PERSON, MYSELF!

WELL, OF ALL THE NERVE.

DON'T LET FALSE MODESTY HOLD YOU BACK! ASSERT YOUR INDIVIDU-ALITY! READ PROFESSOR PLUNKER'S AMAZING VOL-UME, "*BE YOURSELF!*"

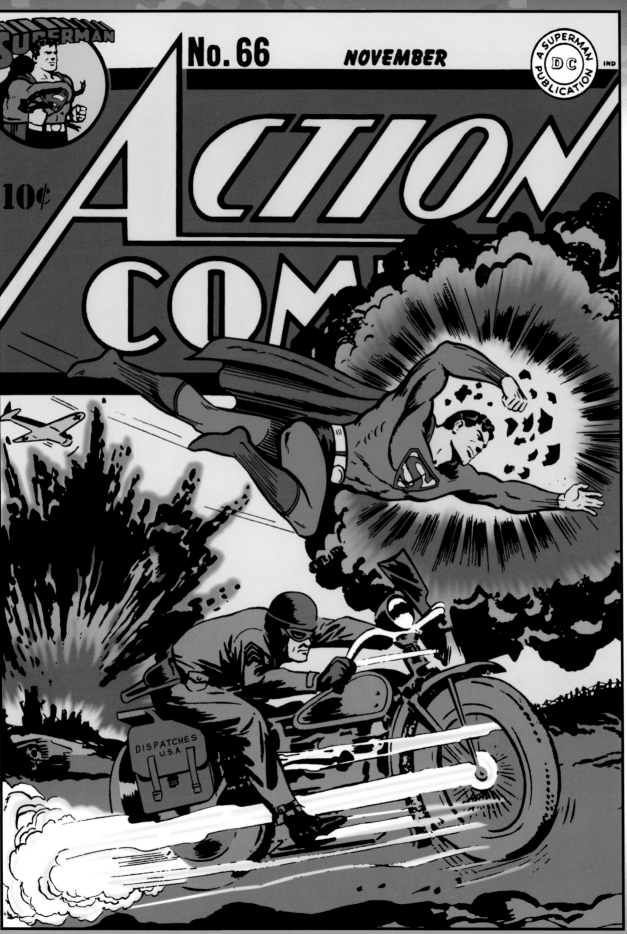

Action Comics #66 (Nov. 1943) - cover art: Jack Burnely (pencils) & Stan Kaye (inks)

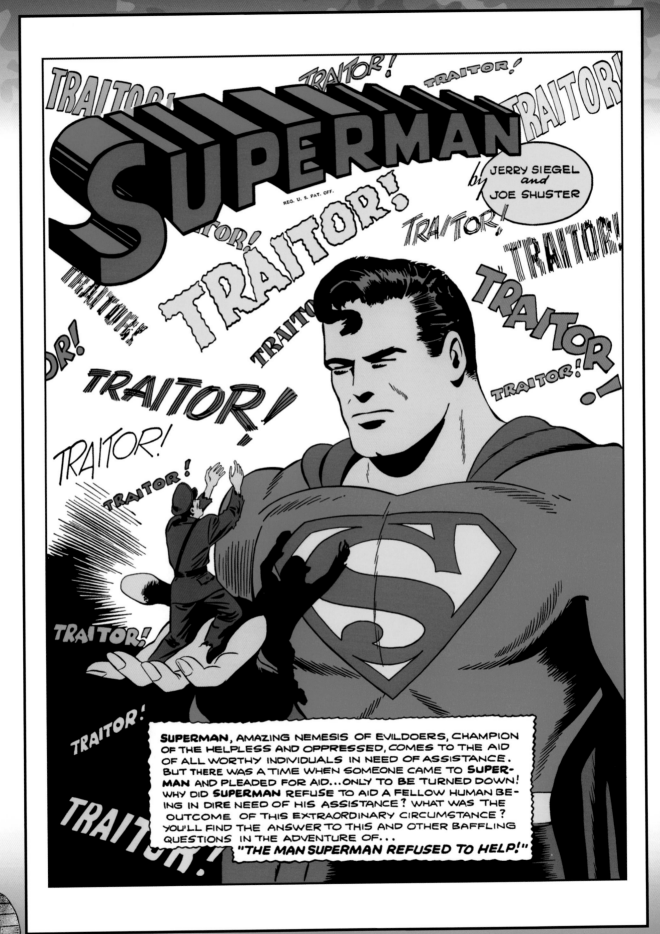

Superman #25 (Nov.–Dec. 1943) - script: Jerry Siegel - art: Ira Yarbrough (pencils) & unknown (inks)

DEMOCRACY IS DOOMED! THE AXIS SHALL TRIUMPH! AND WE SHALL CONTINUE OUR VIGOROUS EFFORTS TO UNDERMINE THE ALLIED WAR EFFORT UNTIL THIS GOAL IS ACHIEVED!!

A LOUD CHORUS OF "HEILS" RESOUNDS THRU LIBERTY HALL AS THE ASSEMBLED MEMBERS OF THE "101% AMERICANISM SOCIETY" SHOUT THEIR UNANIMOUS APPROVAL OF SPEAKER HENKEL'S SUBVERSIVE MOUTHINGS...

HEIL HITLER!

HURRAY!

HURRAY

HEIL HITLER

HEIL HITLER!

IN A BUILDING ADJOINING THE HALL, AGENTS OF THE FEDERAL BUREAU OF INVESTIGATION PREPARE FOR ACTION...

WE'VE ENOUGH EVIDENCE RECORDED TO PUT THEM AWAY FOR A LONG, LONG TIME!

THE RAID IS DUE IN ANOTHER FEW MINUTES

STATIONED AT PREVIOUSLY AGREED POSITIONS ABOUT THE HALL, F.B.I. MEN IMPATIENTLY AWAIT THE GO-SIGNAL...

WHEN DO WE GET THE GREEN LIGHT?

ANY MOMENT NOW!

241

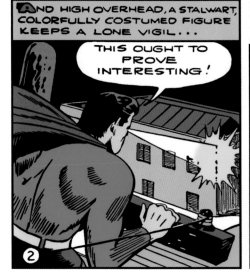

AND HIGH OVERHEAD, A STALWART, COLORFULLY COSTUMED FIGURE KEEPS A LONE VIGIL...

THIS OUGHT TO PROVE INTERESTING!

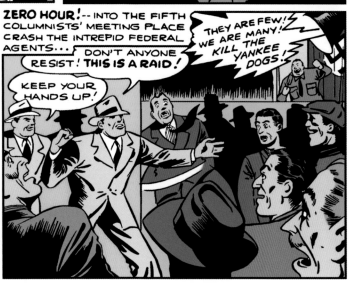

ZERO HOUR!-- INTO THE FIFTH COLUMNISTS' MEETING PLACE CRASH THE INTREPID FEDERAL AGENTS...

DON'T ANYONE RESIST! THIS IS A RAID!

KEEP YOUR HANDS UP!

THEY ARE FEW! WE ARE MANY! KILL THE YANKEE DOGS!

2

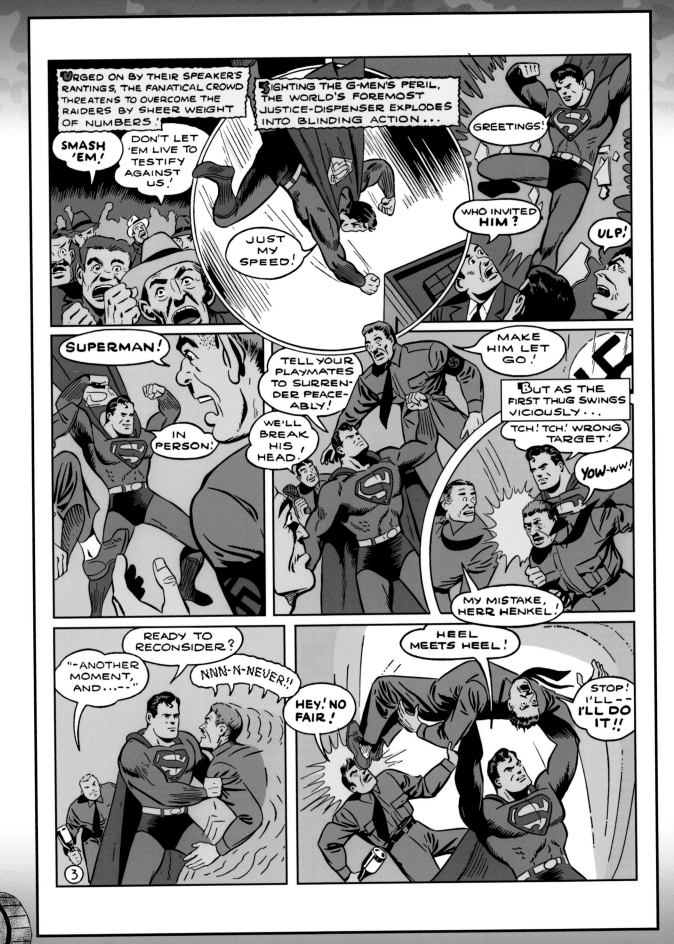

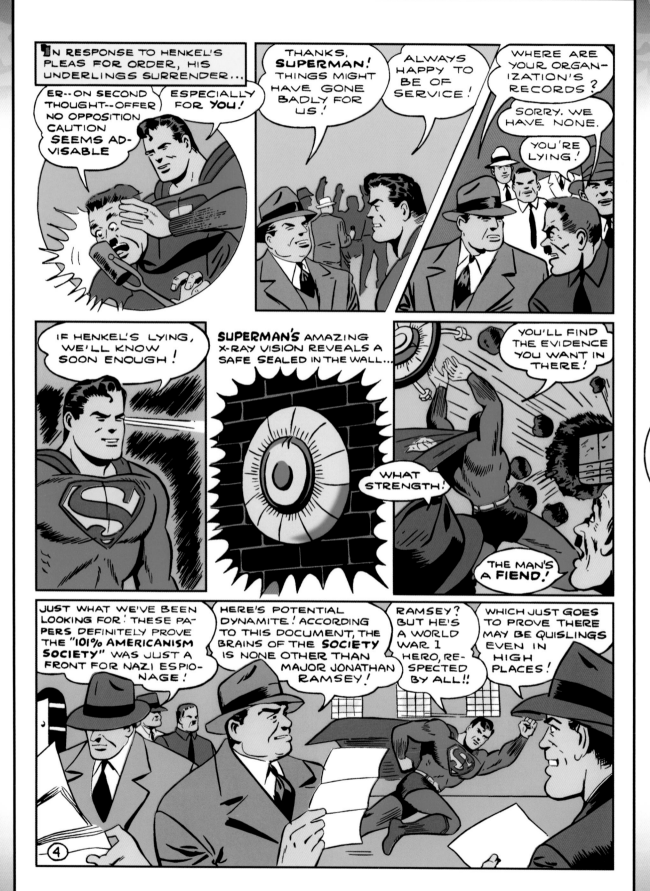

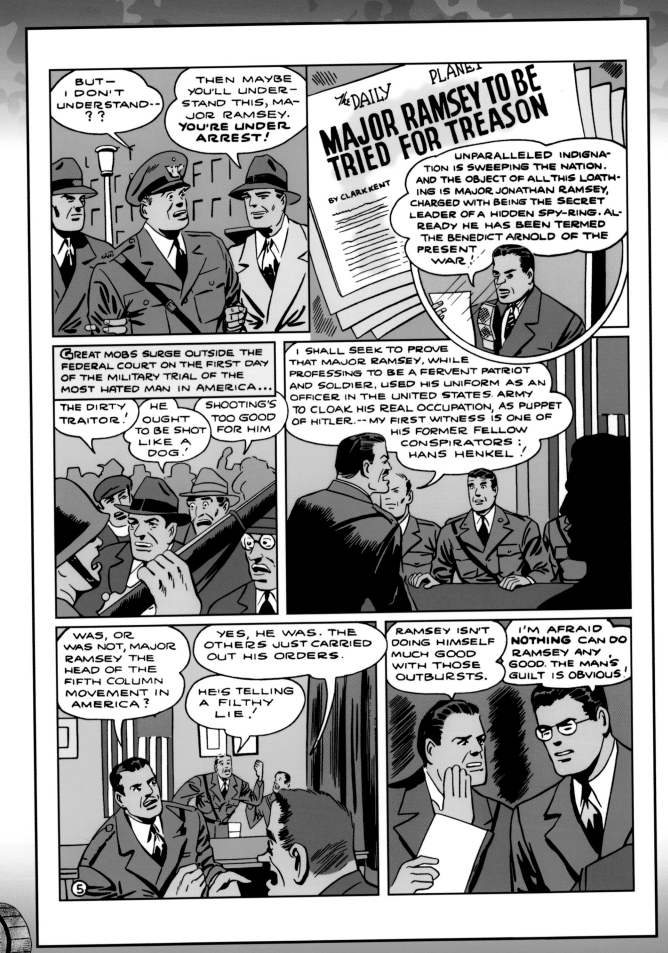

SO YOU STILL MAINTAIN YOUR FLIMSY PRETENSE OF INNOCENCE!

BUT I **AM** INNOCENT! I'LL ADMIT I MADE A SMALL FINANCIAL CONTRIBUTION TO THE **SOCIETY**--BUT IT WAS BECAUSE I SUSPECTED ITS SUBVERSIVE NATURE...AND WAS SECRETLY INVESTIGATING THE ORGANIZATION.

CONSIDER MY MILITARY RECORD-COMPLETELY UN-BLEMISHED! IN ALL THE YEARS I'VE FAITHFULLY SERVED MY COUNTRY, NOT ONCE HAVE I PERPETRATED AN ACT UNWORTHY OF MY UNIFORM. GENTLEMEN, I BEG YOU TO CLEAR MY GOOD NAME. **I AM NOT A TRAITOR!**

THIS DOCUMENTARY EVIDENCE PROVES HE **LIES!**-OTHER NATIONS WERE TAKEN UNAWARES BY THE AXIS' TREACHEROUS FIFTH COLUMN TECHNIQUE, AND CONQUERED. THE ONLY WAY WE CAN EFFECTIVELY STEM FURTHER TREACH-ERY, SUCH AS MAJOR RAMSEY HAS EXHIBITED, IS BY MAKING A GRIM EXAMPLE OF HIM.

I DEMAND THAT THIS FOUL TRAITOR RECEIVE THE GUILTY VERDICT HE MERITS --!

NO! NOT THE FIRING SQUAD!

245

THE VERDICT OF THIS COURT-- **GUILTY!**

⑥

AREN'T YOU IN A HURRY TO PHONE IN THE VERDICT?

NOT AT ALL. I WAS SO CERTAIN OF THE TRIAL'S OUTCOME, I HAD MY STORY WRITTEN WELL IN AD-VANCE, AND IT'S ALREADY SET UP IN TYPE!

LOCAL AND LONG

LOCAL

LOCAL

CLARK LEISURELY AMBLES BACK TO THE NEWSPAPER OFFICE. BUT AS HE ENTERS, HE NOTES A CERTAIN TENSENESS IN THE ATMOSPHERE...

?

BOSS WANTS TO SEE YOU, MR. KENT

POOR CLARK!

AND HE WAS SUCH A NICE CHAP TO HAVE AROUND!

ER-- YOU MEAN YOU DIDN'T LIKE MY STORY?

YOU'VE MERELY MADE A LAUGHING STOCK OF OUR NEWSPAPER. AFTER YOU LEFT THE TRIAL, MAJOR RAMSEY MANAGED TO ESCAPE HIS GUARDS. WHILE WE'RE RUNNING THAT STORY YOU WROTE YESTERDAY, OUR COMPETITORS HAVE THE MOST STARTLING DEVELOPMENT IN THE CASE ON THE STREET. **YOU'RE FIRED !!!**

WHY, LOIS, YOU ACTUALLY SEEM **SORRY** TO SEE ME GO.

A PERSON CAN GET ACCUSTOMED TO ANYTHING (SNIFF!) EVEN **YOU!**

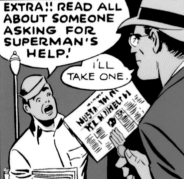

NEXT DAY- SEEKING EMPLOYMENT, CLARK FINDS EDITORIAL DOORS CLOSED TO HIM.- AS HE LEAVES THE **MORNING PICTORIAL,** DISCOURAGED, A NEWSBOY'S CRY CATCHES HIS ATTENTION...

EXTRA!! READ ALL ABOUT SOMEONE ASKING FOR SUPERMAN'S HELP!

I'LL TAKE ONE.

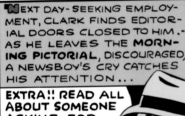

WHAT SORT OF A RACKET IS THIS? I DON'T SEE ANY SUCH ARTICLE.

IT'S ON THE CLASSIFIED AD PAGE. SEE FOR YOURSELF!

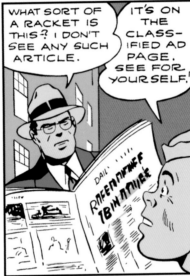

IT'S A DATE!

CALLING SUPERMAN! I URGENTLY REQUIRE AID. MIDNIGHT- TERMINAL YARD... DON'T FAIL ME! "IN TROUBLE"

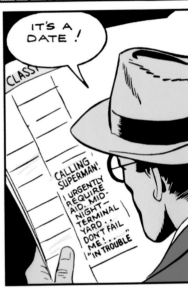

LATE THAT NIGHT...

I'VE PLENTY TROUBLES OF MY OWN AT THE PRESENT TIME - BUT NOTHING CAN STAND IN THE WAY OF MY HELPING SOMEONE ELSE IN NEED OF AID!

SEEMS TO BE NO ONE ABOUT! THIS COULD BE ANYTHING FROM A PRACTICAL JOKE TO A DEATH TRAP!

7

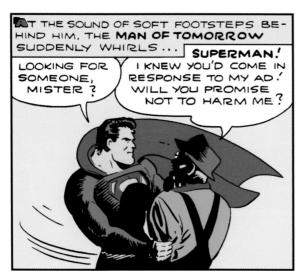

AT THE SOUND OF SOFT FOOTSTEPS BEHIND HIM, THE MAN OF TOMORROW SUDDENLY WHIRLS ...

LOOKING FOR SOMEONE, MISTER?

SUPERMAN! I KNEW YOU'D COME IN RESPONSE TO MY AD! WILL YOU PROMISE NOT TO HARM ME?

IF IT'LL MAKE YOU FEEL ANY BETTER, YOU HAVE MY WORD. NOW WHAT'S YOUR TROUBLE? AND HOW CAN I HELP?

YOU'LL KNOW IN A MOMENT-- WHEN I FINISH RE-MOVING THIS DISGUISE ...

MAJOR RAMSEY!

YOU'VE GOT TO BELIEVE ME! I'M AN INNOCENT MAN!

INNOCENT, EH? THEN HOW DO YOU EXPLAIN AWAY HENKEL'S TESTIMONY-- AND THE DOCUMENTARY EVIDENCE?

I CAN'T EXPLAIN IT, OR I WOULDN'T BE THE MOST HUNTED AND HATED MAN IN THE NATION. YOU'VE GOT TO BELIEVE IN ME! YOU'VE GOT TO HELP!!

"--NOW HERE'S A DILEMMA! I'VE NEVER TURNED DOWN A LEGITIMATE PLEA FOR AID --YET HERE STANDS A MAN I'M CERTAIN IS A FOUL TRAITOR, BEGGING FOR HELP! AND I'VE GIVEN MY SOLEMN WORD NOT TO HARM HIM. WHAT CAN I DO ??!--"

247

I'M CONVINCED OF YOUR GUILT. AND IF I HADN'T PROMISED NOT TO HARM YOU, I'D GIVE YOU PLENTY PROOF OF MY FEELINGS TOWARD YOU.

SUPERMAN- TURNING DOWN AN APPEAL FOR HELP! I--I'D NEVER HAVE BELIEVED IT!

8

HIDDEN WITHIN THE NEARBY STEAM SHOVEL, A HARD-EYED MAN REACHES FOR THE BARELY VISIBLE CONTROLS ...

NOW!!

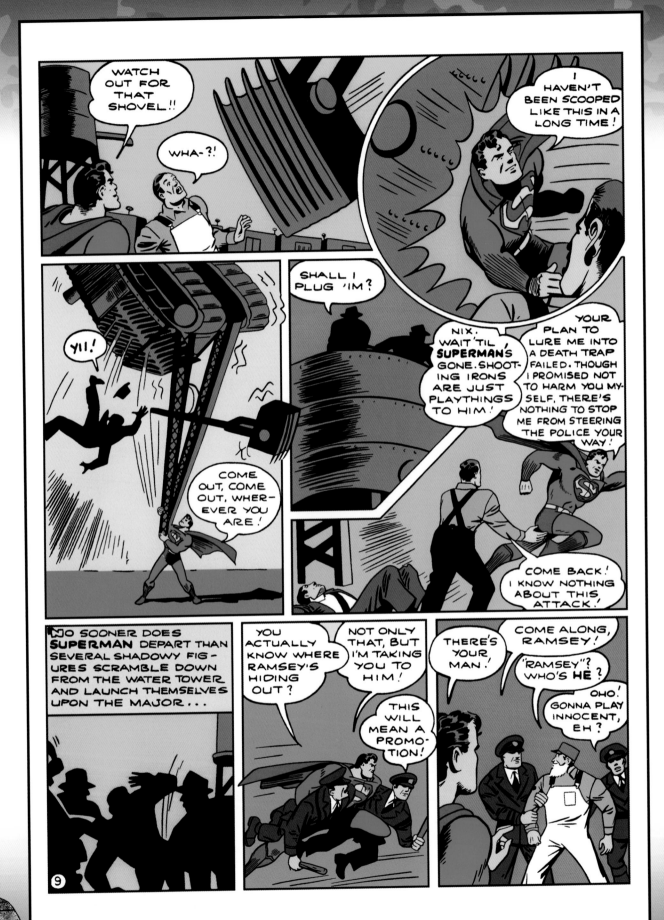

THE WHISKERS DON'T COME OFF! THEY'RE **REAL!**

WE'LL SOON KNOW IF YOU'RE A PHONEY OR NOT! OFF WITH THOSE FAKE WHISKERS!

OWW-WW!

WHAT SORT OF RUNAROUND ARE YOU GIVING US? THIS MAN IS NO MORE MAJOR RAMSEY THAN **YOU** ARE!

I-I CAN'T QUITE UNDERSTAND IT MYSELF. COME WITH ME. I'LL SHOW YOU WHERE I LEFT AN UNCONSCIOUS THUG!

LEAD ON!

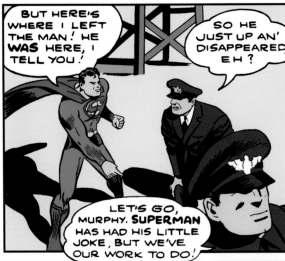

BUT HERE'S WHERE I LEFT THE MAN! HE **WAS** HERE, I TELL YOU!

SO HE JUST UP AN' DISAPPEARED, EH?

LET'S GO, MURPHY. SUPERMAN HAS HAD HIS LITTLE JOKE, BUT WE'VE OUR WORK TO DO!

 AS THE IRATE POLICEMEN DEPART, SUPERMAN KEEPS THE WATCHMAN IN SIGHT..

 I CAN'T HAVE LOST MY SENSES. THERE'S A RATIONAL EXPLANATION BEHIND THESE BEWILDERING GOINGS-ON, AND I'M DETERMINED TO FIND OUT WHAT IT IS!

249

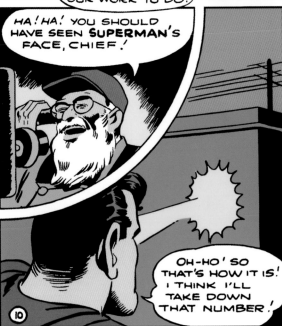

HA! HA! YOU SHOULD HAVE SEEN SUPERMAN'S FACE, CHIEF!

OH-HO! SO THAT'S HOW IT IS! I THINK I'LL TAKE DOWN THAT NUMBER!

SWIFTER THAN THE EYE CAN FOLLOW, SUPERMAN SPEEDS TO THE TELEPHONE EXCHANGE BUILDING...

A JOKE, EH? SOMEHOW, I BELIEVE I'M GOING TO HAVE THE LAST LAUGH! FIRST, TO TRACE THAT CALL!

⑩

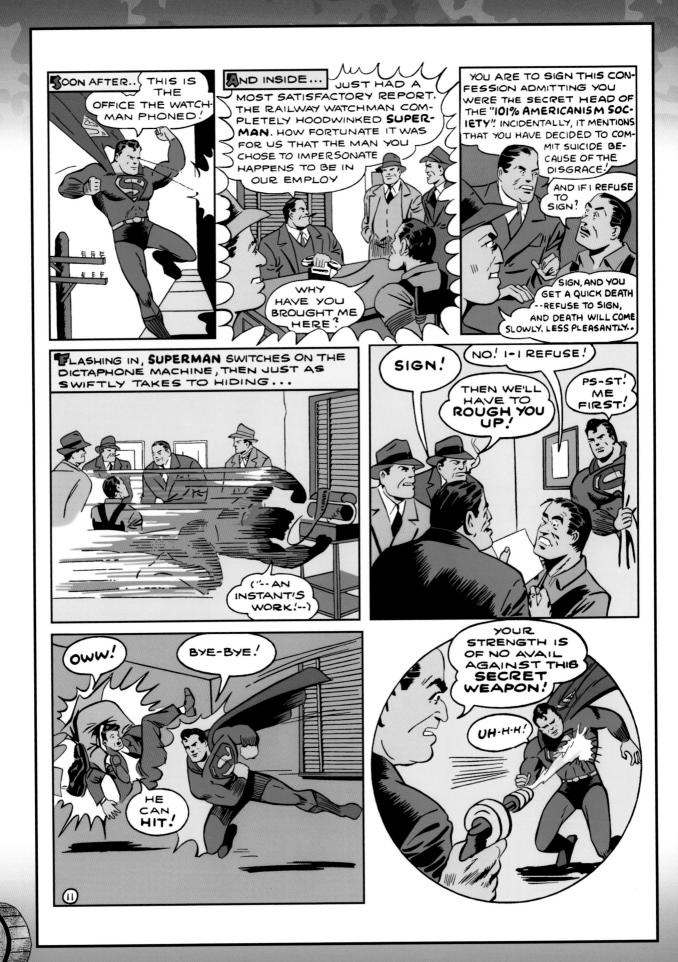

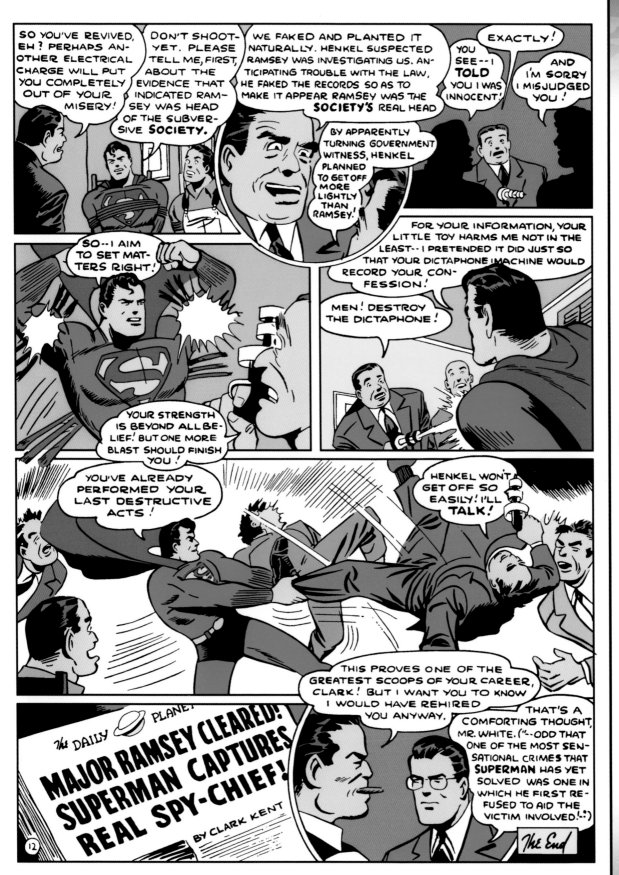

251

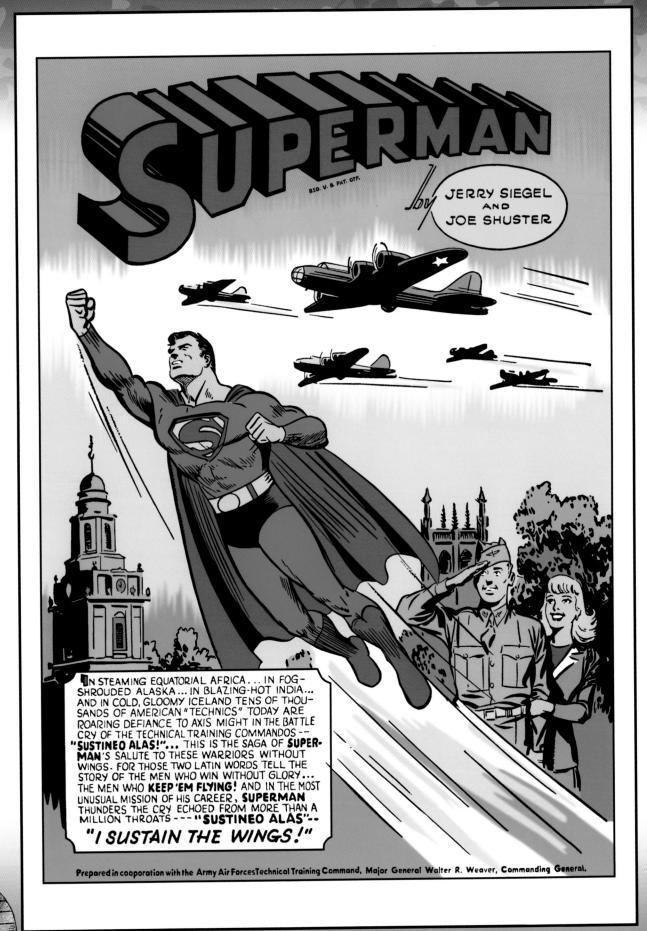

Superman #25 (Nov.–Dec. 1943) - script: Mort Weisinger - art: Fred Ray

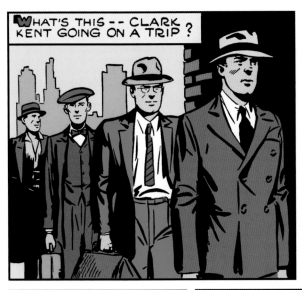

WHAT'S THIS -- CLARK KENT GOING ON A TRIP?

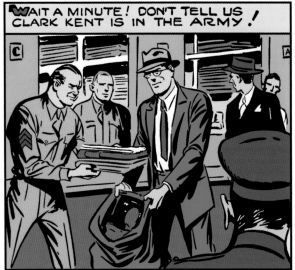

WAIT A MINUTE! DON'T TELL US CLARK KENT IS IN THE ARMY!

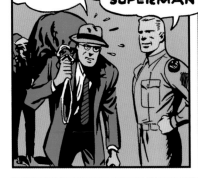

AND NOW CLARK KENT HIDES HIS IDENTITY BY APPEARING TO STAGGER UNDER THE WEIGHT OF HIS BARRACKS BAG...

WHEW! WHAT A LOAD!

A MONTH IN THE ARMY SOLDIER, AND YOU'LL BE AS STRONG AS SUPERMAN!

A FEW HOURS LATER ON A TROOP TRAIN SPEEDING EASTWARD...

AND FINALLY... HISTORIC YALE UNIVERSITY!

253

MEN, WELCOME TO YALE UNIVERSITY... HERE YOU WILL RECEIVE THE FINEST TRAINING THE AAFTTC* CAN GIVE YOU AND IN A FEW MONTHS YOU WILL GRADUATE AS WELL DISCIPLINED AND EXPERTLY TRAINED OFFICERS... A CREDIT TO YOUR COUNTRY.

② AAFTTC*-ARMY AIR FORCES TECHNICAL TRAINING COMMAND.

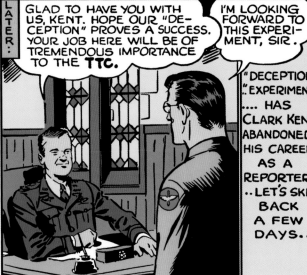

LATER:

GLAD TO HAVE YOU WITH US, KENT. HOPE OUR "DECEPTION" PROVES A SUCCESS. YOUR JOB HERE WILL BE OF TREMENDOUS IMPORTANCE TO THE TTC.

I'M LOOKING FORWARD TO THIS EXPERIMENT, SIR.

"DECEPTION"? "EXPERIMENT"?.... HAS CLARK KENT ABANDONED HIS CAREER AS A REPORTER?...LET'S SKIP BACK A FEW DAYS...

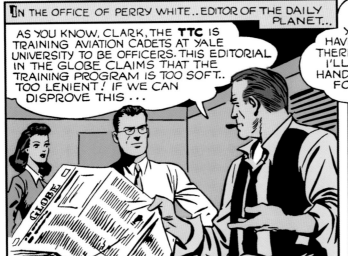

IN THE OFFICE OF PERRY WHITE.. EDITOR OF THE DAILY PLANET...

AS YOU KNOW, CLARK, THE **TTC** IS TRAINING AVIATION CADETS AT YALE UNIVERSITY TO BE OFFICERS. THIS EDITORIAL IN THE GLOBE CLAIMS THAT THE TRAINING PROGRAM IS TOO SOFT.. TOO LENIENT! IF WE CAN DISPROVE THIS ...

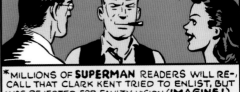

WAIT A MINUTE, CHIEF. WHY DON'T YOU ARRANGE TO HAVE ME SENT UP THERE AS A CADET? I'LL GET A FIRST-HAND REPORT FOR YOU!

HMMM.. NOT A BAD IDEA, CLARK.

WELL, YOU WERE RE-JECTED FOR THE ARMY ON ACCOUNT OF YOUR EYES.. IT **WOULD** BE SOMETHING TO SEE CLARK KENT IN UNIFORM!*

*MILLIONS OF **SUPERMAN** READERS WILL RE-CALL THAT CLARK KENT TRIED TO ENLIST, BUT WAS REJECTED FOR FAULTY VISION (**IMAGINE!**) WHEN HIS X-RAY VISION PENETRATED THE EYE-CHART AND READ A DIFFERENT CHART IN THE NEXT ROOM. SINCE THEN, HE HAS LEARNED THAT **SUPERMAN** COULD BE OF MORE VALUE ON THE HOME FRONT OPERATING AS A FREE AGENT.

("--YOU'VE SEEN ME IN UNIFORM BEFORE, LOIS... ONE WITH A RED CAPE !--")

LITTLE DOES CLARK REALIZE THAT HE SOON WILL BE EXCHANGING HIS NEW-WON KHAKIS FOR THE GARB OF THE **MAN OF TOMORROW!**

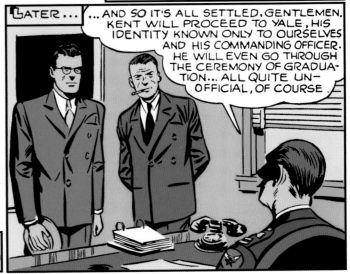

LATER ...

... AND SO IT'S ALL SETTLED, GENTLEMEN. KENT WILL PROCEED TO YALE, HIS IDENTITY KNOWN ONLY TO OURSELVES AND HIS COMMANDING OFFICER. HE WILL EVEN GO THROUGH THE CEREMONY OF GRADUA-TION... ALL QUITE UN-OFFICIAL, OF COURSE.

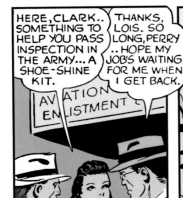

HERE, CLARK.. SOMETHING TO HELP YOU PASS INSPECTION IN THE ARMY.... A SHOE-SHINE KIT.

THANKS, LOIS. SO LONG, PERRY .. HOPE MY JOB'S WAITING FOR ME WHEN I GET BACK.

AVIATION ENLISTMENT

③

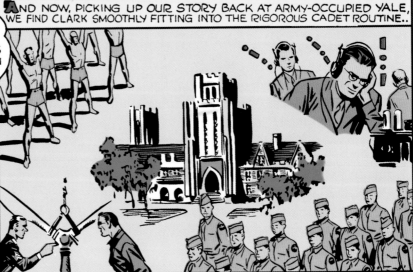

AND NOW, PICKING UP OUR STORY BACK AT ARMY-OCCUPIED YALE, WE FIND CLARK SMOOTHLY FITTING INTO THE RIGOROUS CADET ROUTINE..

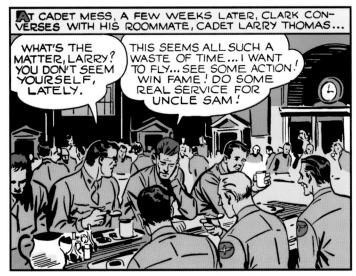

AT CADET MESS, A FEW WEEKS LATER, CLARK CONVERSES WITH HIS ROOMMATE, CADET LARRY THOMAS...

WHAT'S THE MATTER, LARRY? YOU DON'T SEEM YOURSELF, LATELY.

THIS SEEMS ALL SUCH A WASTE OF TIME... I WANT TO FLY... SEE SOME ACTION! WIN FAME! DO SOME REAL SERVICE FOR UNCLE SAM!

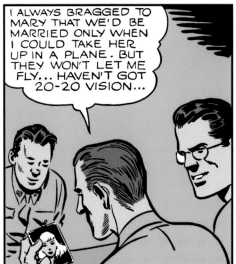

I ALWAYS BRAGGED TO MARY THAT WE'D BE MARRIED ONLY WHEN I COULD TAKE HER UP IN A PLANE. BUT THEY WON'T LET ME FLY... HAVEN'T GOT 20-20 VISION...

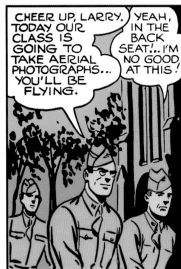

CHEER UP, LARRY. TODAY OUR CLASS IS GOING TO TAKE AERIAL PHOTOGRAPHS... YOU'LL BE FLYING.

YEAH, IN THE BACK SEAT!... I'M NO GOOD AT THIS!

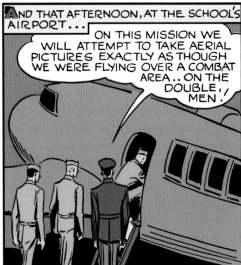

AND THAT AFTERNOON, AT THE SCHOOL'S AIRPORT...

ON THIS MISSION WE WILL ATTEMPT TO TAKE AERIAL PICTURES EXACTLY AS THOUGH WE WERE FLYING OVER A COMBAT AREA.. ON THE DOUBLE, MEN!

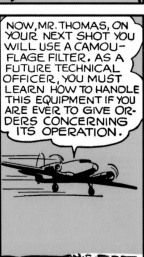

NOW, MR. THOMAS, ON YOUR NEXT SHOT YOU WILL USE A CAMOUFLAGE FILTER. AS A FUTURE TECHNICAL OFFICER, YOU MUST LEARN HOW TO HANDLE THIS EQUIPMENT IF YOU ARE EVER TO GIVE ORDERS CONCERNING ITS OPERATION.

255

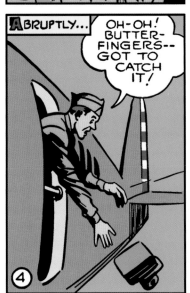

ABRUPTLY...

OH-OH! BUTTERFINGERS-- GOT TO CATCH IT!

④

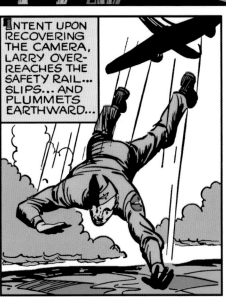

INTENT UPON RECOVERING THE CAMERA, LARRY OVERREACHES THE SAFETY RAIL... SLIPS... AND PLUMMETS EARTHWARD...

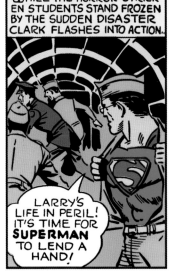

WHILE THE HORROR-STRICKEN STUDENTS STAND FROZEN BY THE SUDDEN DISASTER CLARK FLASHES INTO ACTION..

LARRY'S LIFE IN PERIL! IT'S TIME FOR SUPERMAN TO LEND A HAND!

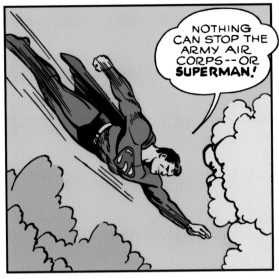

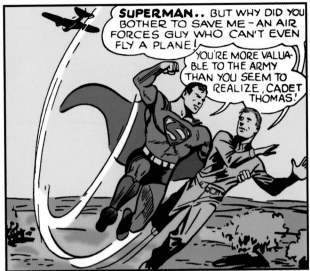

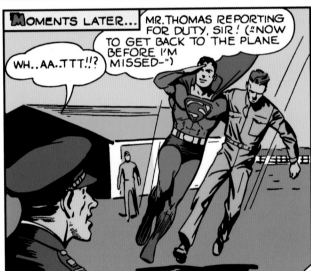

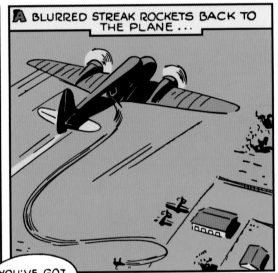

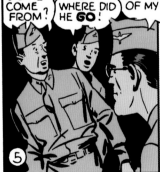

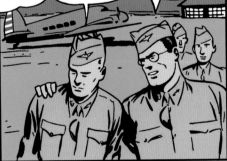

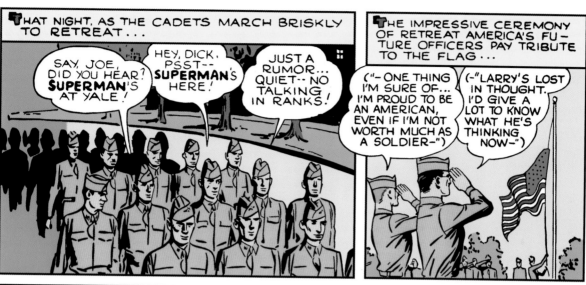

THAT NIGHT, AS THE CADETS MARCH BRISKLY TO RETREAT...

SAY, JOE, DID YOU HEAR? **SUPERMAN**'S AT YALE!

HEY, DICK, PSST-- **SUPERMAN**'S HERE!

JUST A RUMOR... QUIET-- NO TALKING IN RANKS!

THE IMPRESSIVE CEREMONY OF RETREAT AMERICA'S FUTURE OFFICERS PAY TRIBUTE TO THE FLAG...

("-- ONE THING I'M SURE OF... I'M PROUD TO BE AN AMERICAN, EVEN IF I'M NOT WORTH MUCH AS A SOLDIER--")

(-"LARRY'S LOST IN THOUGHT. I'D GIVE A LOT TO KNOW WHAT HE'S THINKING NOW--")

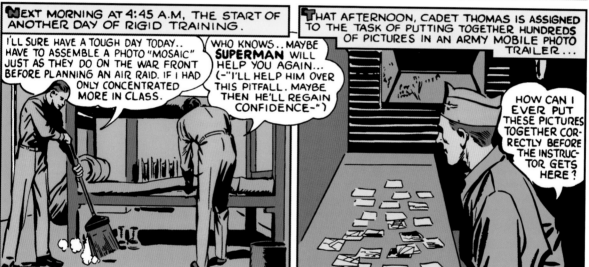

NEXT MORNING AT 4:45 A.M, THE START OF ANOTHER DAY OF RIGID TRAINING.

I'LL SURE HAVE A TOUGH DAY TODAY.. HAVE TO ASSEMBLE A PHOTO "MOSAIC" JUST AS THEY DO ON THE WAR FRONT BEFORE PLANNING AN AIR RAID. IF I HAD ONLY CONCENTRATED MORE IN CLASS.

WHO KNOWS.. MAYBE **SUPERMAN** WILL HELP YOU AGAIN... (-"I'LL HELP HIM OVER THIS PITFALL. MAYBE THEN HE'LL REGAIN CONFIDENCE-")

THAT AFTERNOON, CADET THOMAS IS ASSIGNED TO THE TASK OF PUTTING TOGETHER HUNDREDS OF PICTURES IN AN ARMY MOBILE PHOTO TRAILER...

HOW CAN I EVER PUT THESE PICTURES TOGETHER CORRECTLY BEFORE THE INSTRUCTOR GETS HERE?

257

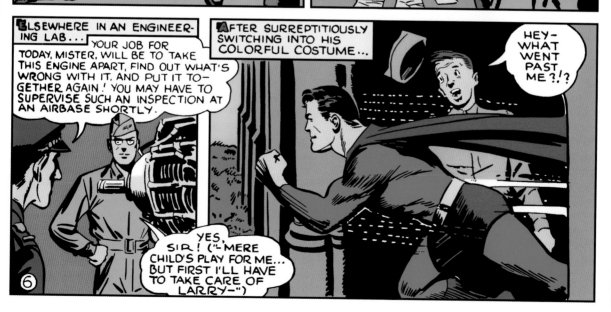

ELSEWHERE IN AN ENGINEERING LAB...

YOUR JOB FOR TODAY, MISTER, WILL BE TO TAKE THIS ENGINE APART, FIND OUT WHAT'S WRONG WITH IT, AND PUT IT TOGETHER AGAIN! YOU MAY HAVE TO SUPERVISE SUCH AN INSPECTION AT AN AIRBASE SHORTLY.

AFTER SURREPTITIOUSLY SWITCHING INTO HIS COLORFUL COSTUME...

HEY-- WHAT WENT PAST ME?!?

YES, SIR! ("-MERE CHILD'S PLAY FOR ME... BUT FIRST I'LL HAVE TO TAKE CARE OF LARRY-")

6

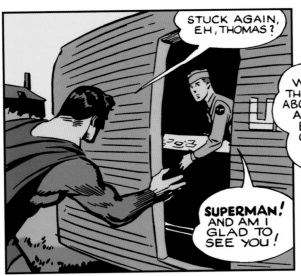

STUCK AGAIN, EH, THOMAS?

SUPERMAN! AND AM I GLAD TO SEE YOU!

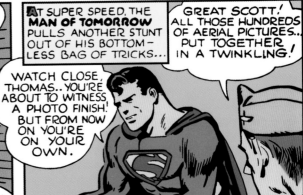

AT SUPER SPEED, THE **MAN OF TOMORROW** PULLS ANOTHER STUNT OUT OF HIS BOTTOM-LESS BAG OF TRICKS...

WATCH CLOSE, THOMAS.. YOU'RE ABOUT TO WITNESS A PHOTO FINISH! BUT FROM NOW ON YOU'RE ON YOUR OWN.

GREAT SCOTT! ALL THOSE HUNDREDS OF AERIAL PICTURES.. PUT TOGETHER IN A TWINKLING!

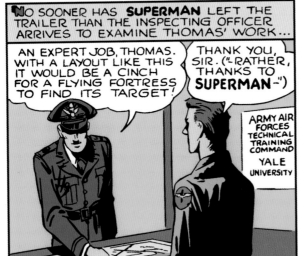

NO SOONER HAS **SUPERMAN** LEFT THE TRAILER THAN THE INSPECTING OFFICER ARRIVES TO EXAMINE THOMAS' WORK...

AN EXPERT JOB, THOMAS. WITH A LAYOUT LIKE THIS IT WOULD BE A CINCH FOR A FLYING FORTRESS TO FIND ITS TARGET!

THANK YOU, SIR. ("RATHER, THANKS TO **SUPERMAN**-")

ARMY AIR FORCES TECHNICAL TRAINING COMMAND YALE UNIVERSITY

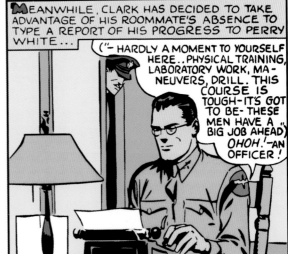

MEANWHILE, CLARK HAS DECIDED TO TAKE ADVANTAGE OF HIS ROOMMATE'S ABSENCE TO TYPE A REPORT OF HIS PROGRESS TO PERRY WHITE...

("– HARDLY A MOMENT TO YOURSELF HERE.. PHYSICAL TRAINING, LABORATORY WORK, MA-NEUVERS, DRILL. THIS COURSE IS TOUGH–IT'S GOT TO BE– THESE MEN HAVE A BIG JOB AHEAD") OHOH!–AN OFFICER!

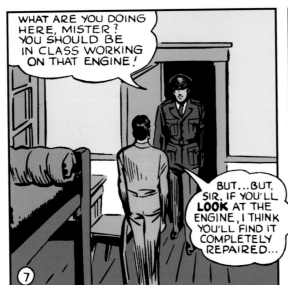

WHAT ARE YOU DOING HERE, MISTER? YOU SHOULD BE IN CLASS WORKING ON THAT ENGINE!

BUT...BUT, SIR, IF YOU'LL **LOOK** AT THE ENGINE, I THINK YOU'LL FIND IT COMPLETELY REPAIRED...

⑦

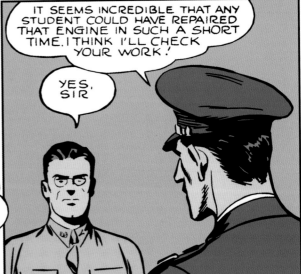

IT SEEMS INCREDIBLE THAT ANY STUDENT COULD HAVE REPAIRED THAT ENGINE IN SUCH A SHORT TIME. I THINK I'LL CHECK YOUR WORK!

YES, SIR

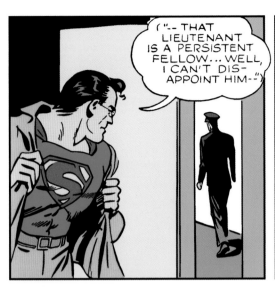

("-- THAT LIEUTENANT IS A PERSISTENT FELLOW... WELL, I CAN'T DISAPPOINT HIM--")

LIKE A HUMAN COMET, **SUPERMAN** STREAKS DOWN THE CORRIDOR... A MERE GUST OF WIND TO THE LIEUTENANT, WHO IS STRIDING TOWARD THE ENGINE LAB...

I MUST SAY THEY KEEP THIS HALL RATHER WELL VENTILATED.

WOOSH!

SPEED IS ESSENTIAL... LET'S SEE... THIS PIECE GOES THERE... THIS ONE UNDER THE GENERATOR ... THERE, IT'S FIXED NOW... ONE SECOND FLAT.

OOPS! THE LIEUTENANT'S ENTERING THE OTHER DOOR! GOTTA MAKE MYSELF SCARCE IN A HURRY!

INCREDIBLE! EVERY PIECE PERFECTLY FITTED. THAT CADET IS A WIZARD! THEY'RE **ALL** WIZARDS. THESE CADETS MUST BE SUPERMEN!

FLASHING BACK TO HIS QUARTERS, **SUPERMAN** PAUSES TO EAVESDROP ON A PAIR OF WORRIED CADETS...

HOW ARE WE EVER GOING TO SWEEP THIS ROOM AND MOP THE FLOOR IN TIME FOR INSPECTION?

THE TROUBLE IS WE SPENT TOO MUCH TIME STUDYING!

WHAT WITH THE MAID SITUATION AS IT IS, IT'S TIME FOR **SUPERMAN** TO DO A LITTLE HOUSECLEANING

I'VE BEEN **DREAMING** OF A DAY LIKE THIS!

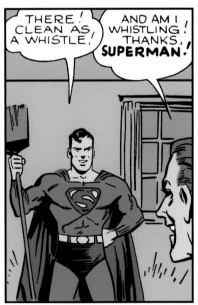

THERE! CLEAN AS A WHISTLE!

AND AM I WHISTLING! THANKS, **SUPERMAN!**

⑧

MEANWHILE, ON A TRAIN STREAKING ACROSS CONNECTICUT AND NEARING YALE UNIVERSITY...

LOOK AT THIS-- **SUPERMAN** DROPPING FROM THE CLOUDS AGAIN. I ALWAYS SEEM TO BE CROSSING HIS PATH, EVEN WHEN I'M PAYING CLARK A SURPRISE VISIT!

WHAT A COINCIDENCE! I'M ALSO MAKING A SURPRISE VISIT--TO MY FIANCE. IN FACT, HE'S THE SAME CADET SAVED BY **SUPERMAN!**-- LARRY THOMAS!

LARRY AND I ARE ENGAGED. BUT HE VOWED HE WOULDN'T MARRY ME UNTIL HE'S TAKEN ME UP IN A PLANE. YOU SEE, HE KNOWS I'M A FLYING ENTHU- SIAST. EVEN THOUGH HE KNOWS HE CAN NEVER FLY, HE INSISTS UPON MAKING GOOD HIS BARGAIN. IT SEEMS HOPELESS.

LATER

LUCKILY I WAS ABLE TO BORROW THIS CAR FOR THE AFTERNOON. THEY TOLD ME CADET KENT WOULD BE OUT ON THE ARMAMENT TESTING RANGE TODAY. (WISH I COULD SEE **SUPERMAN** HERE...BUT HE ONLY SHOWS UP WHEN TROUBLE OCCURS!)

A PROPHETIC THOUGHT, LOIS! THOUGH YOU ARE UN- AWARE OF IT, YOUR REAR TIRE HAS LESS THAN HALF A MILE OF LIFE LEFT...SUDDENLY...

POW!

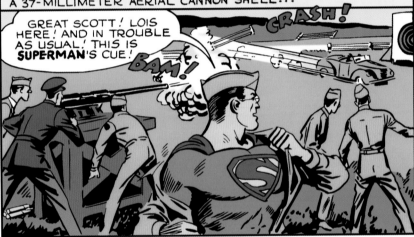

THE TIRE BLOWS OUT! OUT OF CONTROL, THE CAR VEERS CRAZILY, CRASHES THRU THE GUARD RAIL. DIRECTLY INTO THE LINE OF FIRE OF A 37-MILLIMETER AERIAL CANNON SHELL...

GREAT SCOTT! LOIS HERE! AND IN TROUBLE AS USUAL! THIS IS **SUPERMAN**'S CUE!

BAM!

CRASH!

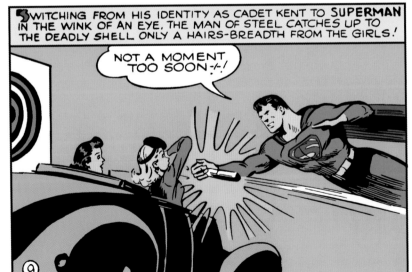

SWITCHING FROM HIS IDENTITY AS CADET KENT TO **SUPERMAN** IN THE WINK OF AN EYE, THE MAN OF STEEL CATCHES UP TO THE DEADLY SHELL ONLY A HAIRS-BREADTH FROM THE GIRLS!

NOT A MOMENT TOO SOON-+!

⑨

IF YOU HAD TO VISIT A COLLEGE, WHY DIDN'T YOU PICK ON HARVARD?

SUPERMAN!... STILL, I'M NOT SURPRISED!

LATER

THAT WAS A CLOSE SHAVE YOU HAD TODAY, LOIS...YOU CERTAINLY HAVE A NOSE FOR TROUBLE...

WASN'T IT SIMPLY THRILLING, CLARK? BUT HOW ARE YOU PROGRESSING WITH YOUR STORY?

BUT WHY DON'T WE GET MARRIED RIGHT AFTER GRADUATION, LARRY? WHY ARE YOU SO STUBBORN, JUST BECAUSE OF A CHANCE STATEMENT YOU ONCE MADE...

WHEN I MAKE A PROMISE, I'VE GOT TO STICK TO IT, MARY. NOT UNTIL I TAKE YOU UP IN A PLANE WILL I GO THROUGH WITH OUR WEDDING PLANS. THAT'S THE WAY IT IS...SORRY...

DON'T FORGET, GIRLS. TOMORROW WE'LL SHOW YOU THE INSIDE OF A FLYING FORTRESS OUT AT THE AIRFIELD. NOW WE'LL HAVE TO RUN...10 O'CLOCK BED CHECK, YOU KNOW.

RESTRICTED ARMY AIR FORCES

NEXT MORNING THE CADETS ARE SHOWN A TRAINING FILM IN THE AUDITORIUM...CLARK NOTICES THAT LARRY IS TAKING PARTICULAR INTEREST IN THE PICTURE.

IN THE GREAT ALLIED RAID ON COLOGNE, 1,000 BOMBERS TOOK PART...FOR EVERY PLANE IN THE AIR IT TOOK 60 MEN ON THE GROUND! SIXTY THOUSAND MEN MADE THAT RAID POSSIBLE. THE IMPORTANCE OF THE GROUND CREW, THE **MECHANIC**, CANNOT BE OVEREMPHASIZED. THE **TTC** KEEPS 'EM FLYING!

("— HMMM.. MAYBE **I AM** AN IMPORTANT PART OF THE WAR AFTER ALL!--")

261

YES, THE UNSUNG HERO OF THIS WAR IS THE MAN ON THE GROUND...NO, HE DOESN'T GET HIS NAME IN THE PAPERS, HE'S NOT AN ACE, BUT WITHOUT HIM OUR AIR FORCE WOULD BE USELESS...

HOW ABOUT IT, LARRY? ARE YOU BEGINNING TO REALIZE YOUR IMPORTANCE?

("--HMMM...THERE WILL HAVE TO BE A CHANGE OF PLANS...I THINK CADET KENT WILL FIND HIMSELF TOO BUSY TO TAKE IN THAT TOUR OF THE AIRFIELD TO-MORROW. BUT UNLESS I'M MISTAKEN, **SUPERMAN WILL** BE THERE!--")

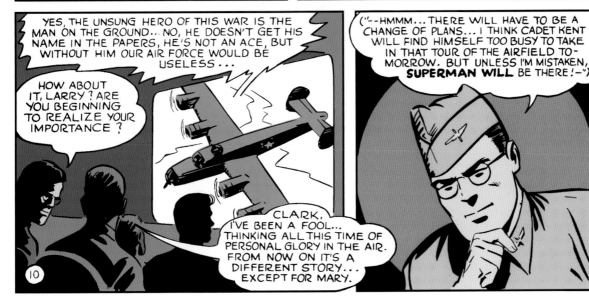

CLARK, I'VE BEEN A FOOL...THINKING ALL THIS TIME OF PERSONAL GLORY IN THE AIR. FROM NOW ON IT'S A DIFFERENT STORY...EXCEPT FOR MARY.

⑩

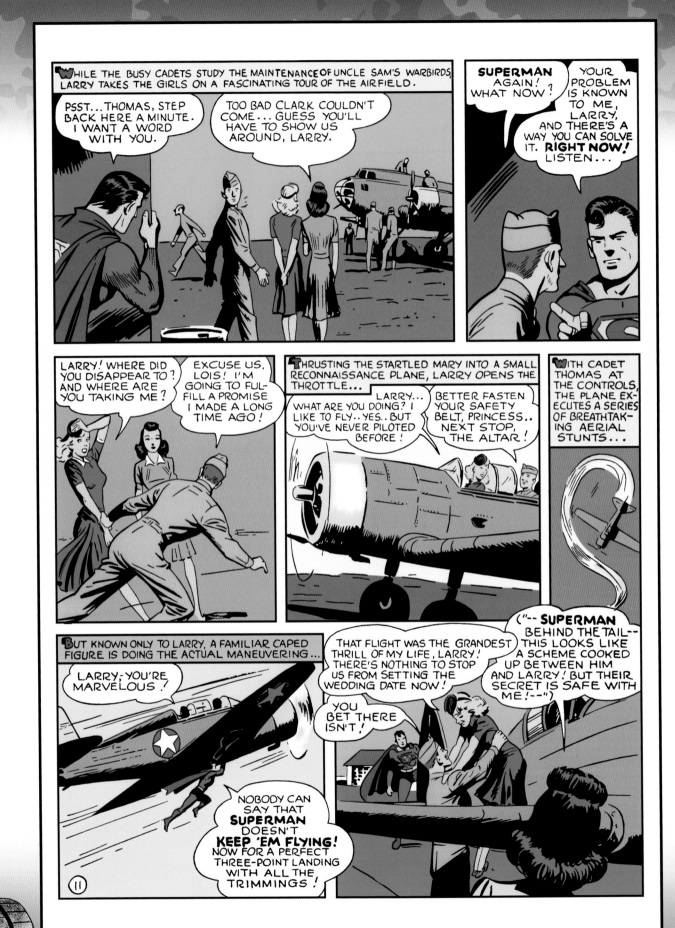

WELL, THAT WAS ADDING SOMETHING NEW-- **SUPERMAN** PLAYING CUPID FOR THE ARMY!

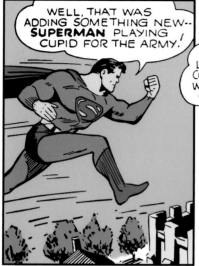

THE FINAL WEEK OF TRAINING.. AND THE HONOR ROLL OF STUDENTS IS POSTED...

CONGRATULATIONS, LARRY! YOU'VE COME THROUGH WITH FLYING COLORS!

YES, CLARK, EVERYTHING IS PERFECT... BUT IF IT HADN'T BEEN FOR **SUPERMAN**..

HONOR ROLL
2 LARRY THOMAS
3 CLARK K
4 WILL
5 HEN
6 STC
7 DA
8 JIM
9 LE

GRADUATION DAY! IN A THRILLINGLY MOVING CEREMONY, THE CLASS OF CADETS WHO HAVE WON THEIR WELL-EARNED COMMISSIONS TAKE THE SACRED OATH OF APPOINTMENT AS OFFICERS IN THE ARMY OF THE UNITED STATES!

"HAVING BEEN APPOINTED SECOND LIEUTENANT, I DO SOLEMNLY SWEAR THAT I WILL DEFEND THE CONSTITUTION OF THE UNITED STATES AGAINST ALL ENEMIES, FOREIGN AND DOMESTIC, AND THAT I WILL WELL AND FAITHFULLY DISCHARGE THE DUTIES OF THE OFFICE UPON WHICH I AM ABOUT TO ENTER, SO HELP ME GOD."

MR. THOMAS, MR. KENT.. MR. STEVENS...

WELL, "LIEUTENANT" KENT, YOU'VE ACCOMPLISHED YOUR MISSION AT YALE. NOW LET ME PIN YOUR BARS ON.

AND, I HAVE ENOUGH EVIDENCE OF THE THOROUGHNESS OF THE **TTC** TRAINING PROGRAM TO BLAST THAT CRITICAL EDITORIAL WIDE OPEN...AND **SUPERMAN'S** APPEARANCE HERE WILL GIVE MY STORY ALL THE PUNCH IT NEEDS.

LIEUT. THOMAS-- YOU'RE WONDERFUL!

HERE'S YOUR DOLLAR, CORPORAL...FIRST COME, FIRST SERVED. IT'S AN OLD TRADITION, LOIS. TO GIVE A DOLLAR TO THE FIRST MAN WHO SALUTES YOU AFTER GRADUATION...

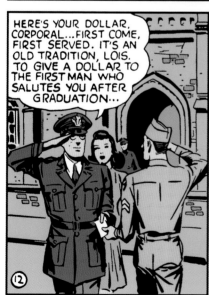

⑫

LATER:

YOU KNOW, LOIS, THAT WAS ONE OF THE GREATEST ASSIGNMENTS I HAVE EVER HAD. I LEARNED A LOT ABOUT THE **TTC** AND THE WORK IT IS DOING, THOUGH I DO WISH I HAD CAUGHT JUST ONE GLIMPSE OF **SUPERMAN.**

LOOSE LIPS SINK SHIPS!

A YANK AT YALE

WELL, CLARK, YOU EARNED A LIEUTENANT'S COMMISSION-- EVEN IF IT WAS UNOFFICIAL. I THINK THIS INSIGNIA THE **TTC** GAVE YOU WILL MAKE UP FOR HAVING TO RETURN THOSE GOLD BARS!

THE END

SUSTINEO ALAS

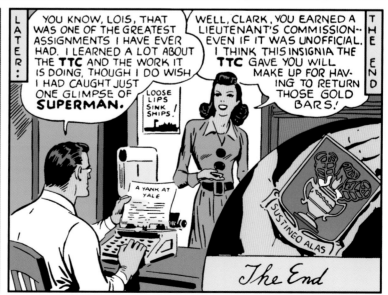

The End

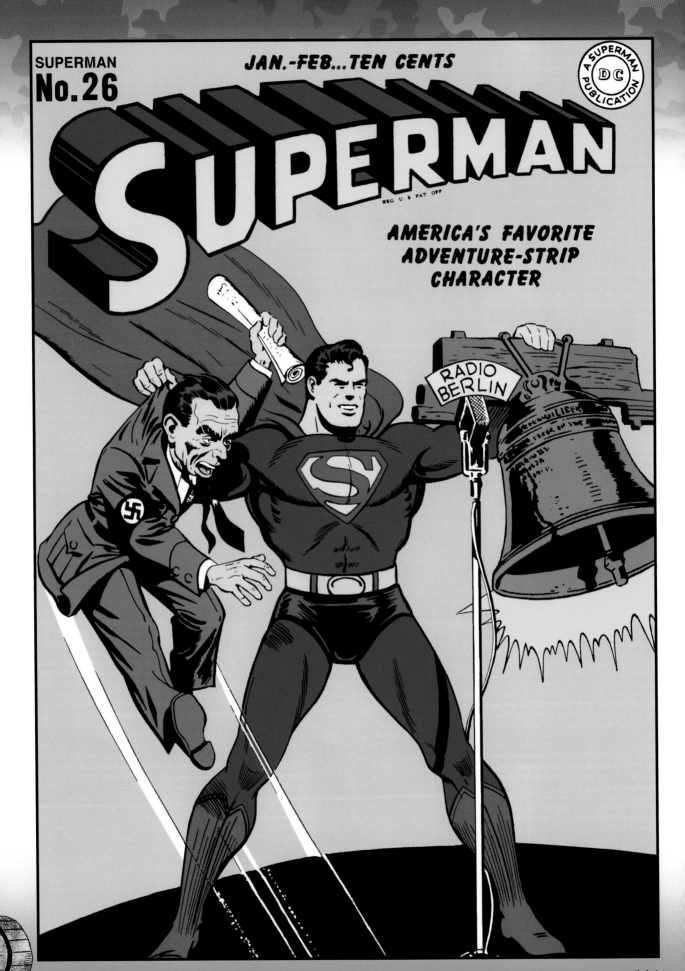

Superman #26 (Jan.–Feb. 1943) - cover art: Wayne Boring (pencils) & George Roussos (inks)

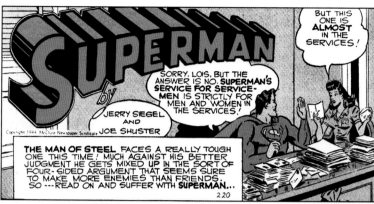

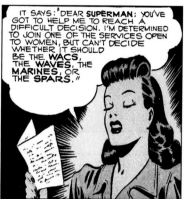

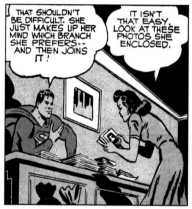

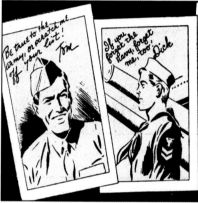

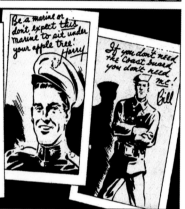

265

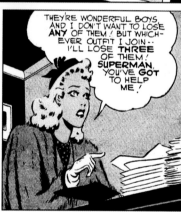

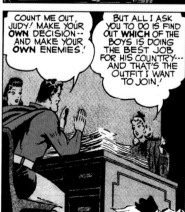

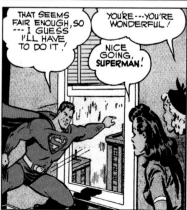

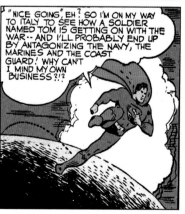

Superman Sunday newspaper comic strip #220–227 (Jan. 16–March 5, 1944)
script: unknown - art: Wayne Boring - (pencils) & unknown (inks)

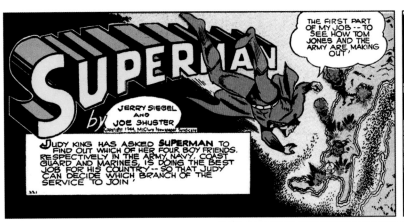

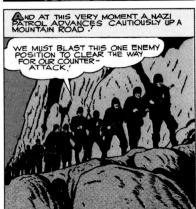

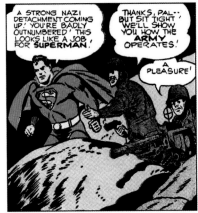

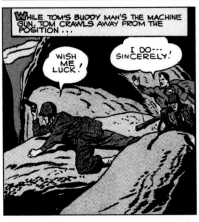

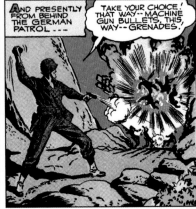

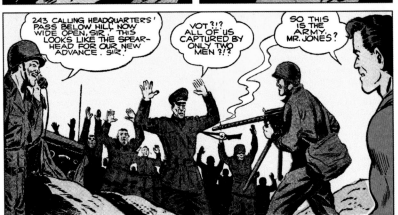

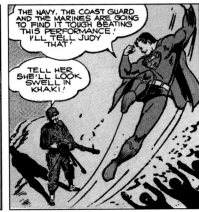

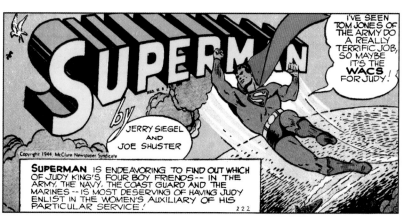

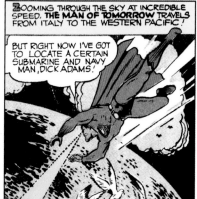

 I'VE SEEN TOM JONES OF THE ARMY DO A REALLY TERRIFIC JOB, SO MAYBE IT'S THE **WACS** FOR JUDY!

ZOOMING THROUGH THE SKY AT INCREDIBLE SPEED, **THE MAN OF TOMORROW** TRAVELS FROM ITALY TO THE WESTERN PACIFIC!

BUT RIGHT NOW I'VE GOT TO LOCATE A CERTAIN SUBMARINE AND NAVY MAN, DICK ADAMS!

SUPERMAN by JERRY SIEGEL AND JOE SHUSTER

Copyright 1944, McClure Newspaper Syndicate

SUPERMAN IS ENDEAVORING TO FIND OUT WHICH OF JUDY KING'S FOUR BOY FRIENDS-- IN THE ARMY, THE NAVY, THE COAST GUARD AND THE MARINES -- IS MOST DESERVING OF HAVING JUDY ENLIST IN THE WOMEN'S AUXILIARY OF HIS PARTICULAR SERVICE! 222

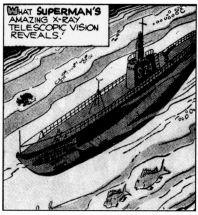

WHAT SUPERMAN'S AMAZING X-RAY TELESCOPIC VISION REVEALS!

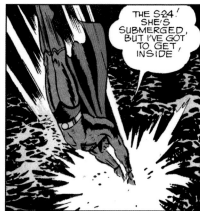

THE S-24! SHE'S SUBMERGED, BUT I'VE GOT TO GET INSIDE!

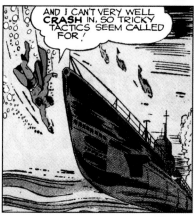

AND I CAN'T VERY WELL **CRASH** IN, SO TRICKY TACTICS SEEM CALLED FOR!

267

MEANWHILE, WITHIN THE FORWARD TORPEDO COMPARTMENT OF THE YANK SUB...

AM I NUTS? SOMETHIN'S TAPPIN' "OPEN UP" IN MORSE ON THAT TORPEDO TUBE!

BLOW THE WATER OUT, AND LET'S TAKE A LOOK-SEE!

SUPERMAN!

MR. DICK ADAMS, I PRESUME?

JUDY **WROTE** ME SHE WAS ASKING YOU TO HELP HER MAKE UP HER MIND-- BUT I STILL SAY IT'S GOTTA BE THE **WAVES** OR SHE CAN FORGET **ME**!

SERIOUS ABOUT THAT, AREN'T YOU!

MEANWHILE, IN THE CONTROL ROOM OF THE SUB...

SHIP BEARING DOWN ON US, SIR--PROBABLY A NIP DESTROYER! SHE MUST HAVE PICKED UP OUR MOTORS!

OFF MOTORS, MR. RAINES! WE'LL HAVE TO LIE DOGGO AND TAKE OUR CHANCES!

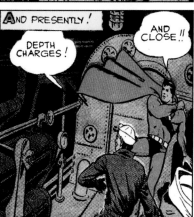

AND PRESENTLY!

DEPTH CHARGES!

AND CLOSE!!

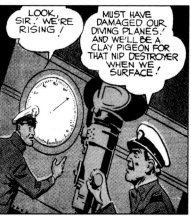

LOOK, SIR! WE'RE RISING!

MUST HAVE DAMAGED OUR DIVING PLANES! AND WE'LL BE A CLAY PIGEON FOR THAT NIP DESTROYER WHEN WE SURFACE!

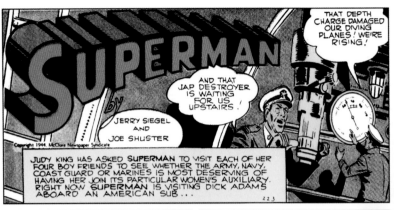

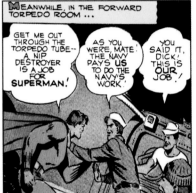

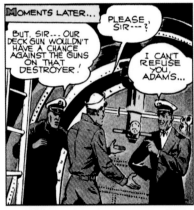

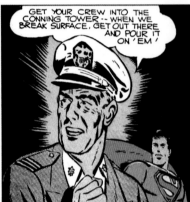

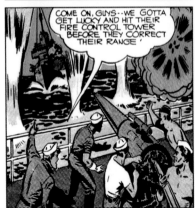

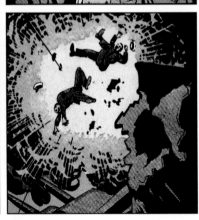

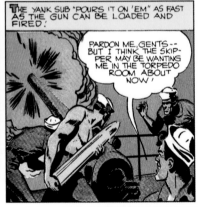

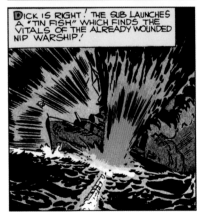

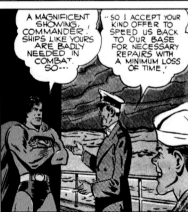

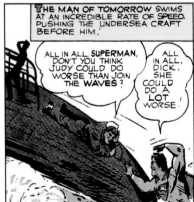

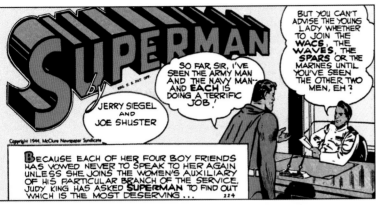

SO FAR, SIR, I'VE SEEN THE ARMY MAN AND THE NAVY MAN-- AND EACH IS DOING A TERRIFIC JOB!

BUT YOU CAN'T ADVISE THE YOUNG LADY WHETHER TO JOIN THE WACS, THE WAVES, THE SPARS OR THE MARINES UNTIL YOU'VE SEEN THE OTHER TWO MEN, EH?

BECAUSE EACH OF HER FOUR BOY FRIENDS HAS VOWED NEVER TO SPEAK TO HER AGAIN UNLESS SHE JOINS THE WOMEN'S AUXILIARY OF HIS PARTICULAR BRANCH OF THE SERVICE, JUDY KING HAS ASKED SUPERMAN TO FIND OUT WHICH IS THE MOST DESERVING ... 224

BUT THAT SHOULDN'T BE DIFFICULT, SUPERMAN. STRANGELY ENOUGH, HARRY MONTGOMERY OF THE MARINES, AND BILL CONKLIN OF THE COAST GUARD, ARE BOTH AT THIS BASE. COME, I'LL TAKE YOU TO THEM...

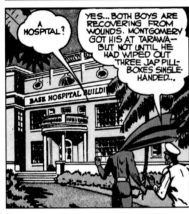

A HOSPITAL?

YES... BOTH BOYS ARE RECOVERING FROM WOUNDS. MONTGOMERY GOT HIS AT TARAWA-- BUT NOT UNTIL HE HAD WIPED OUT THREE JAP PILL-BOXES SINGLE-HANDED...

BASE HOSPITAL BUILDI

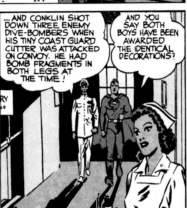

...AND CONKLIN SHOT DOWN THREE ENEMY DIVE-BOMBERS WHEN HIS TINY COAST GUARD CUTTER WAS ATTACKED ON CONVOY. HE HAD BOMB FRAGMENTS IN BOTH LEGS AT THE TIME!

AND YOU SAY BOTH BOYS HAVE BEEN AWARDED THE IDENTICAL DECORATIONS?

HEY! LOOK WHO'S COMIN'!

PIPE DOWN, LEATHER-NECK! JUST 'CAUSE YOU CAN'T WRITE TO JUDY, DON'T BOTHER A GUY WHO CAN!

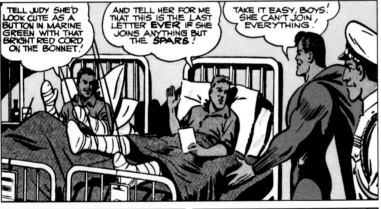

TELL JUDY SHE'D LOOK CUTE AS A BUTTON IN MARINE GREEN WITH THAT BRIGHT RED CORD ON THE BONNET!

AND TELL HER FOR ME THAT THIS IS THE LAST LETTER EVER IF SHE JOINS ANYTHING BUT THE SPARS!

TAKE IT EASY, BOYS! SHE CAN'T JOIN EVERYTHING.

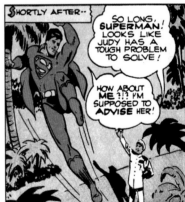

SHORTLY AFTER--

SO LONG, SUPERMAN! LOOKS LIKE JUDY HAS A TOUGH PROBLEM TO SOLVE!

HOW ABOUT ME ?!? I'M SUPPOSED TO ADVISE HER!

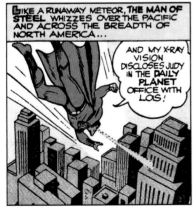

LIKE A RUNAWAY METEOR, THE MAN OF STEEL WHIZZES OVER THE PACIFIC AND ACROSS THE BREADTH OF NORTH AMERICA...

AND MY X-RAY VISION DISCLOSES JUDY IN THE DAILY PLANET OFFICE WITH LOIS!

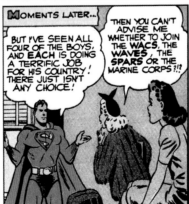

MOMENTS LATER...

BUT I'VE SEEN ALL FOUR OF THE BOYS, AND EACH IS DOING A TERRIFIC JOB FOR HIS COUNTRY! THERE JUST ISN'T ANY CHOICE!

THEN YOU CAN'T ADVISE ME WHETHER TO JOIN THE WACS, THE WAVES, THE SPARS OR THE MARINE CORPS ?!?

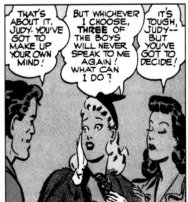

THAT'S ABOUT IT, JUDY. YOU'VE GOT TO MAKE UP YOUR OWN MIND!

BUT WHICHEVER I CHOOSE, THREE OF THE BOYS WILL NEVER SPEAK TO ME AGAIN! WHAT CAN I DO?

IT'S TOUGH, JUDY-- BUT YOU'VE GOT TO DECIDE!

269

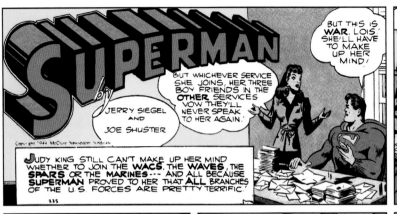

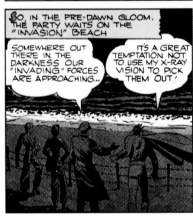
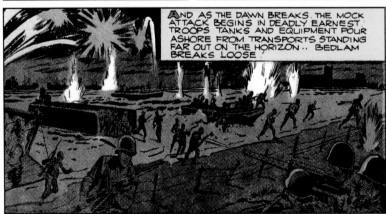
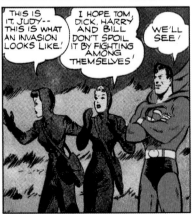

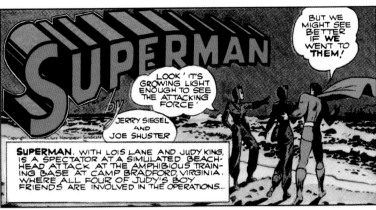

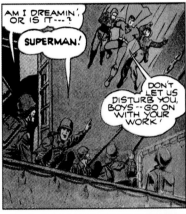

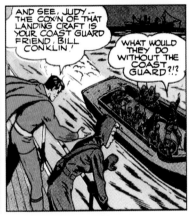

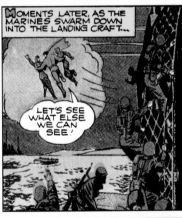

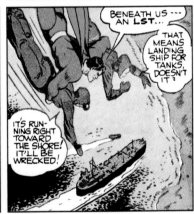

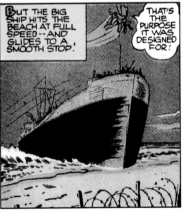

271

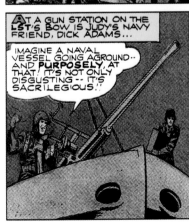

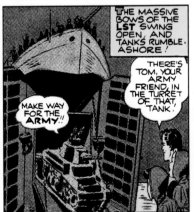

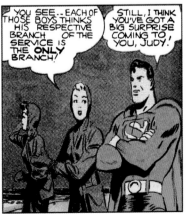

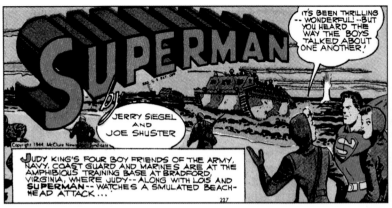

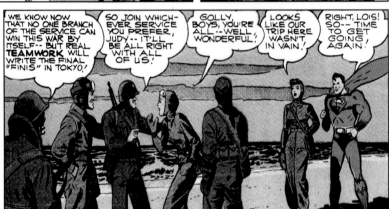

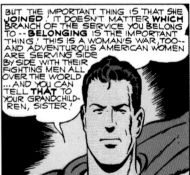

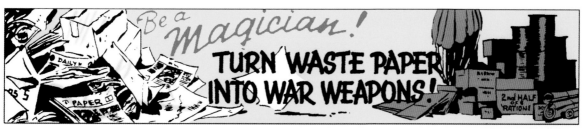

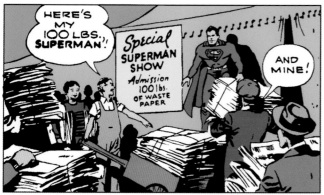

273

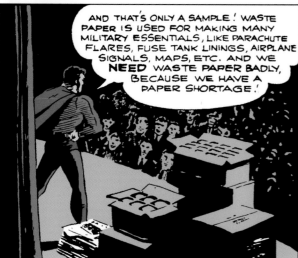

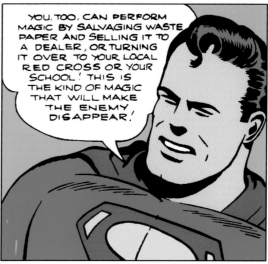

Public service ad, *Superman* #28 (May–June 1944) - script: unknown - art: George Roussos

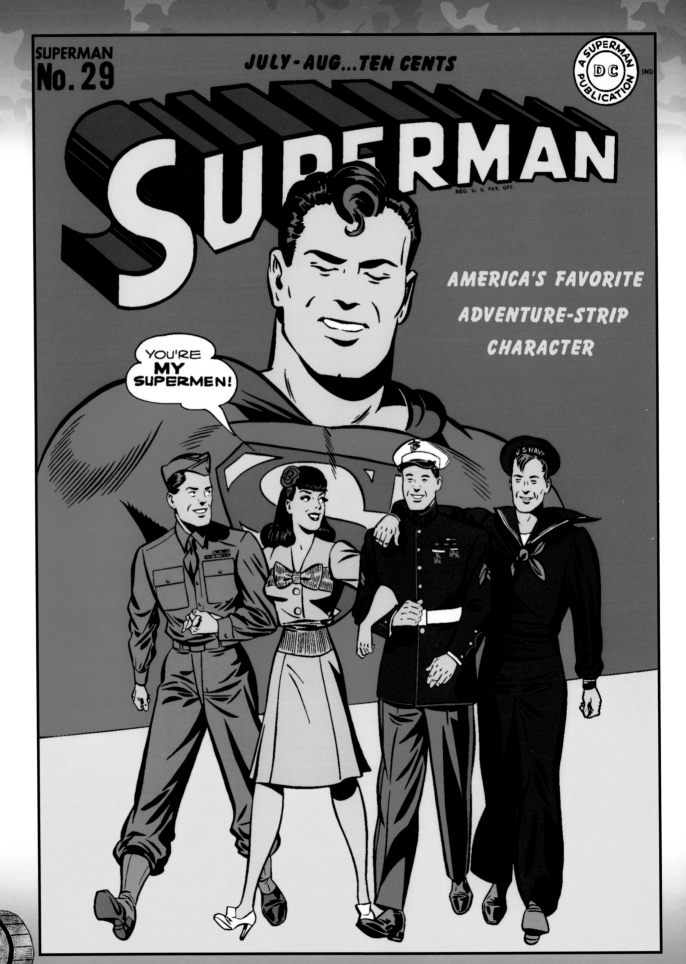

Superman #29 (July–Aug. 1944) - cover art: Wayne Boring (pencils) & unknown (inks)

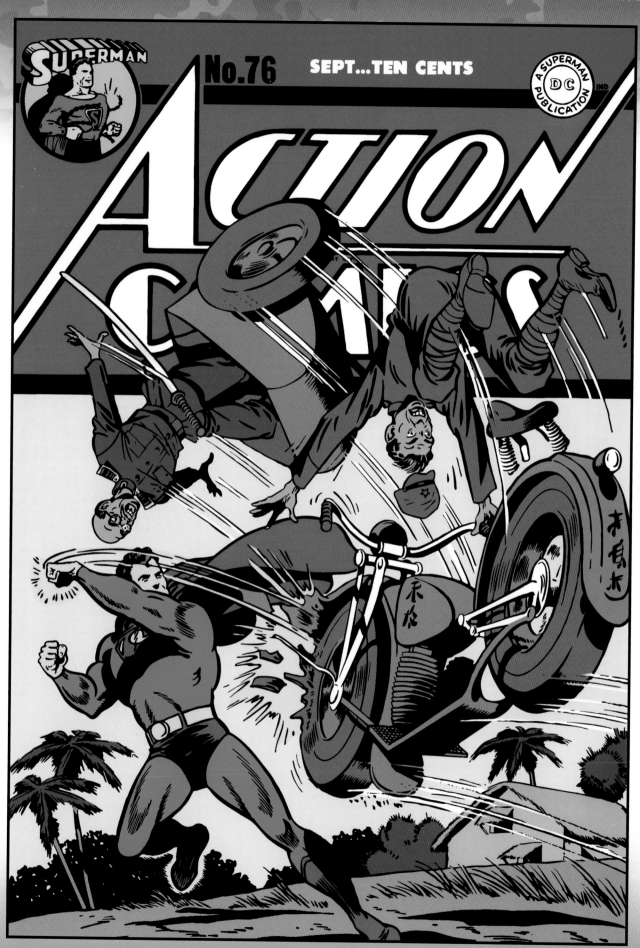

Action Comics #76 (Sept. 1944) - cover art: Wayne Boring (pencils) & Stan Kaye (inks)

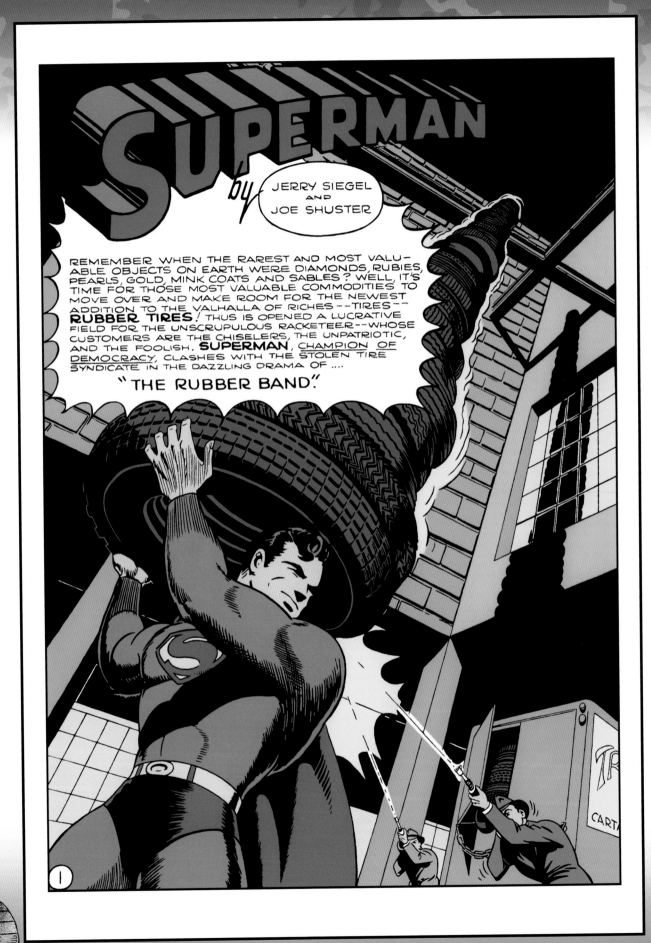

World's Finest Comics #15 (Fall 1944) - script: unknown - art: unknown

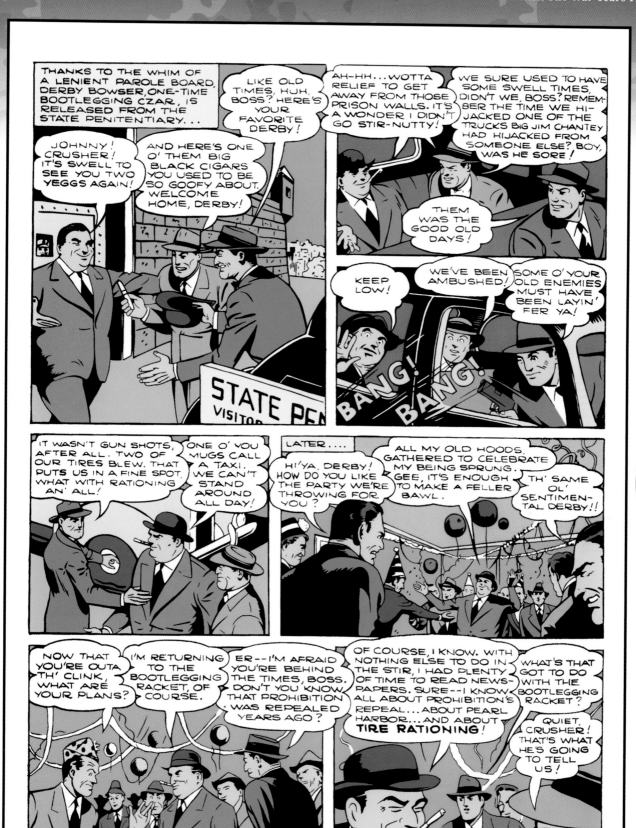

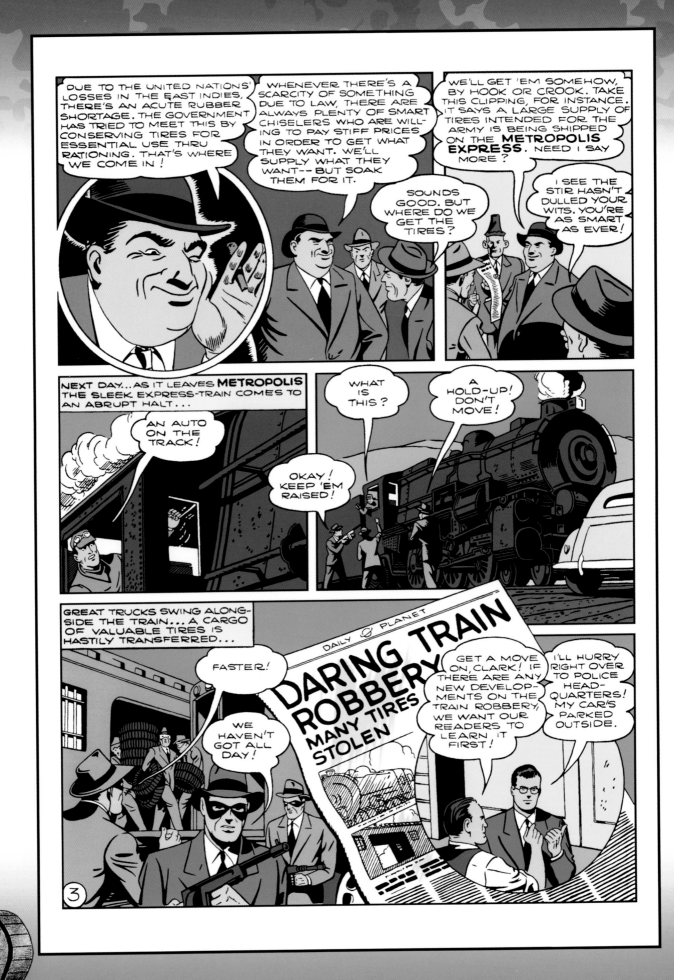

278

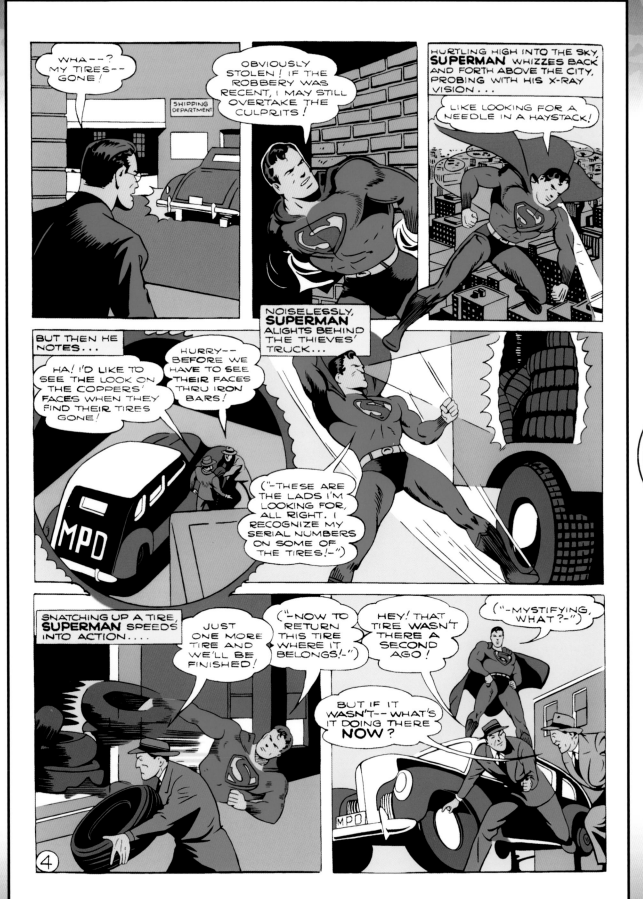

279

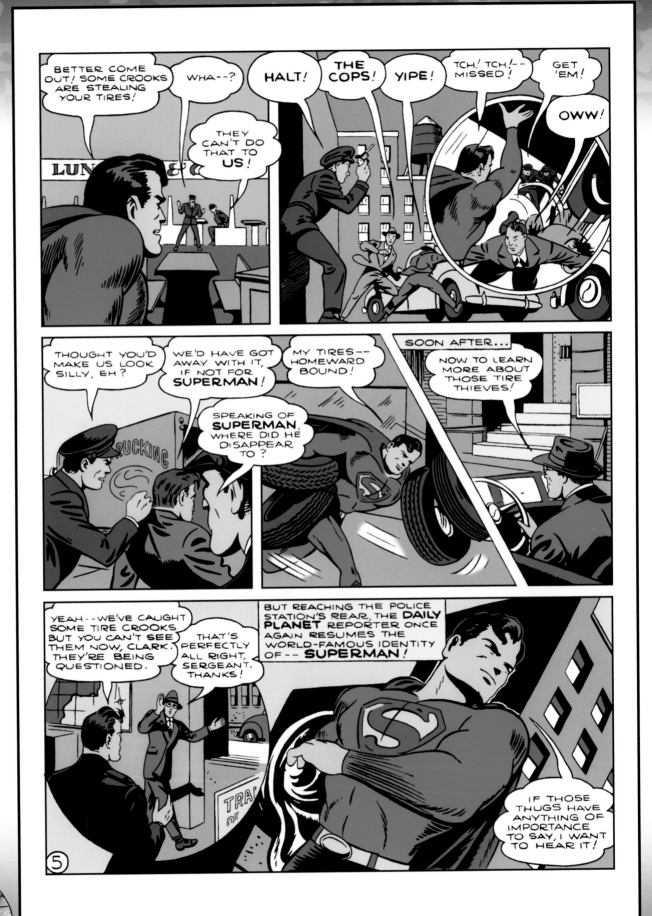

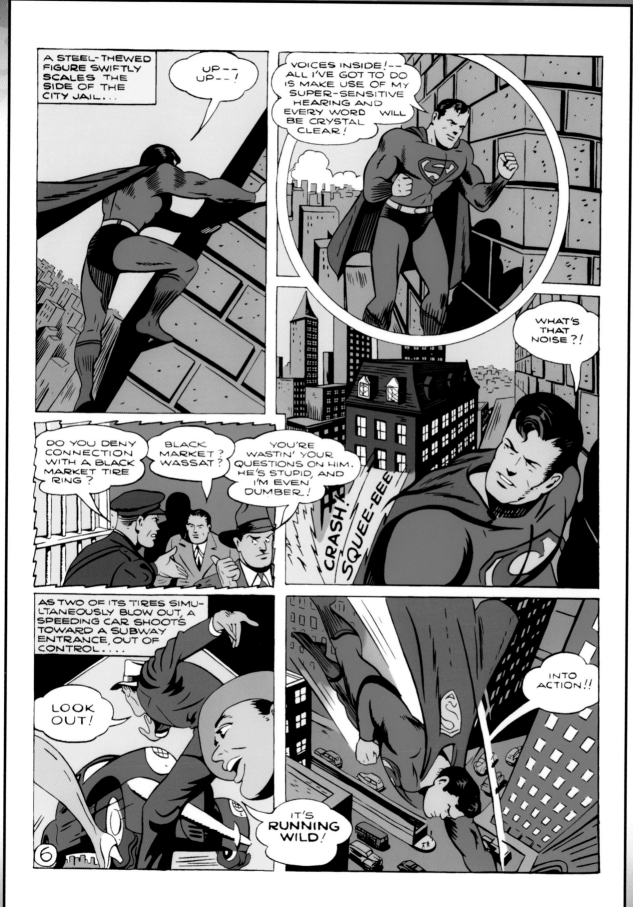

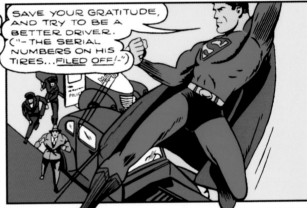

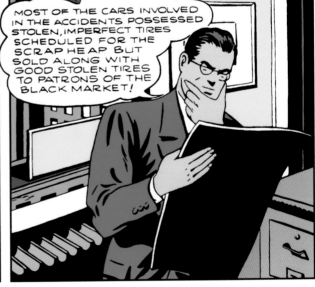

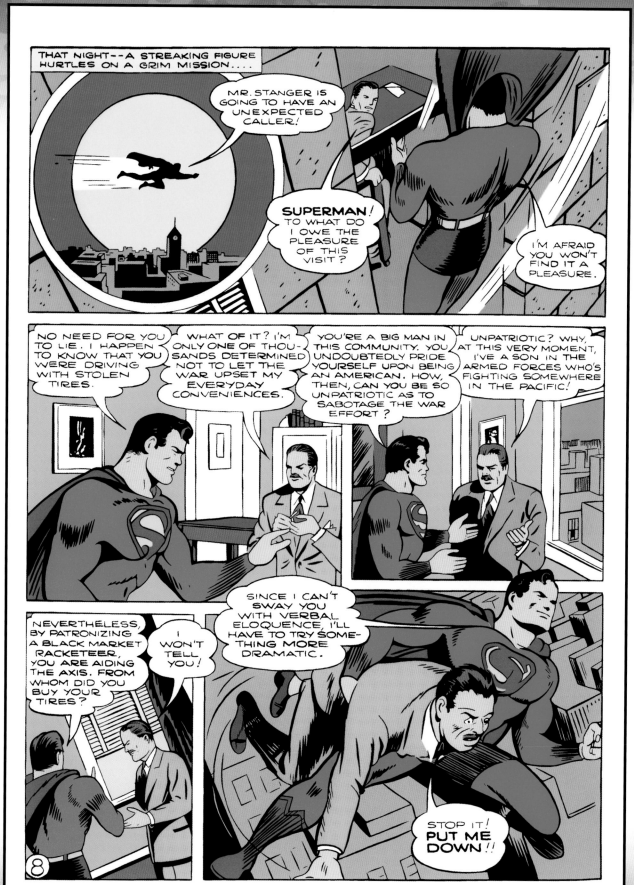

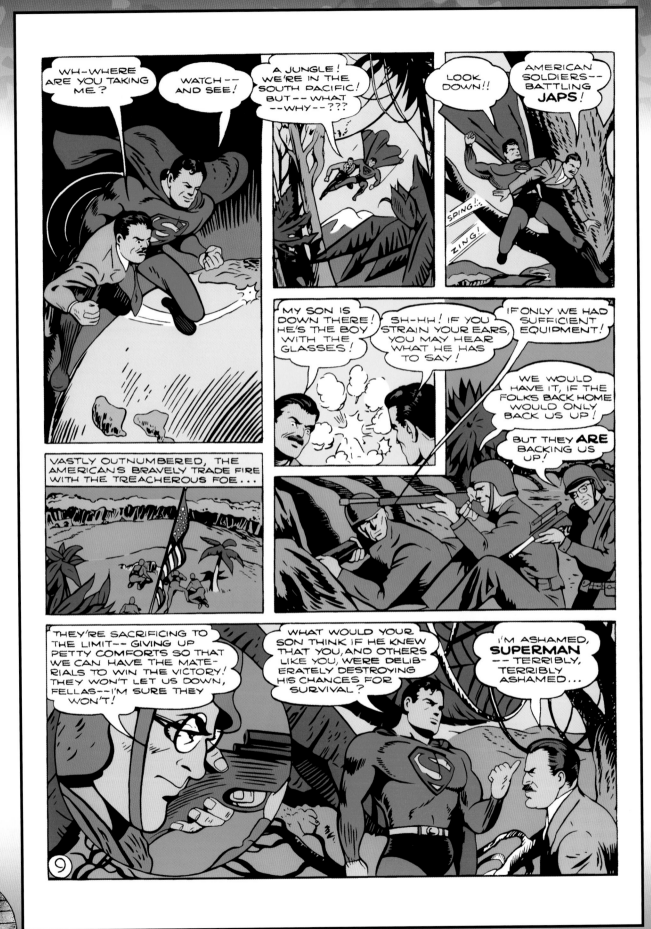

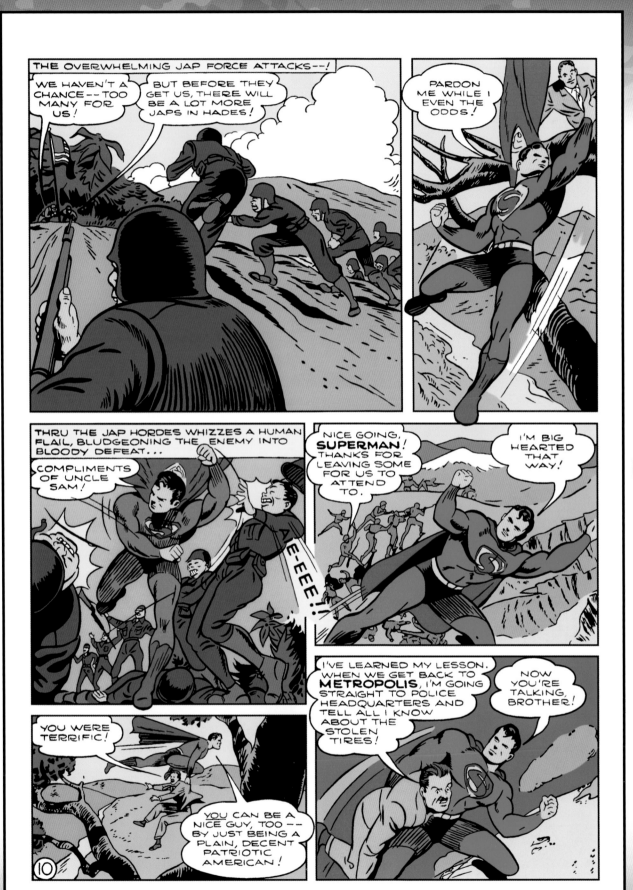

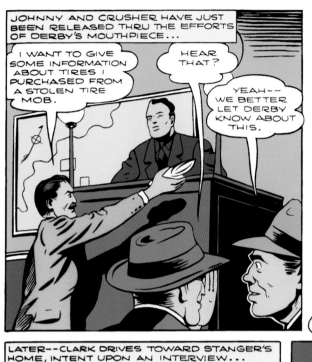

JOHNNY AND CRUSHER HAVE JUST BEEN RELEASED THRU THE EFFORTS OF DERBY'S MOUTHPIECE...

I WANT TO GIVE SOME INFORMATION ABOUT TIRES I PURCHASED FROM A STOLEN TIRE MOB.

HEAR THAT?

YEAH-- WE BETTER LET DERBY KNOW ABOUT THIS.

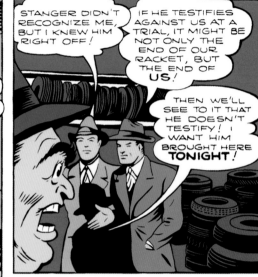

STANGER DIDN'T RECOGNIZE ME, BUT I KNEW HIM RIGHT OFF!

IF HE TESTIFIES AGAINST US AT A TRIAL, IT MIGHT BE NOT ONLY THE END OF OUR RACKET, BUT THE END OF US!

THEN WE'LL SEE TO IT THAT HE DOESN'T TESTIFY! I WANT HIM BROUGHT HERE TONIGHT!

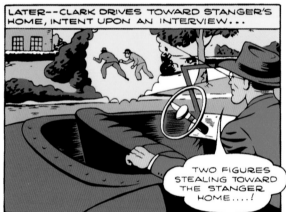

LATER--CLARK DRIVES TOWARD STANGER'S HOME, INTENT UPON AN INTERVIEW...

TWO FIGURES STEALING TOWARD THE STANGER HOME....!

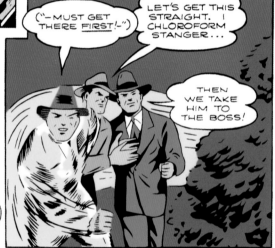

("-MUST GET THERE FIRST!-")

LET'S GET THIS STRAIGHT. I CHLOROFORM STANGER...

THEN WE TAKE HIM TO THE BOSS!

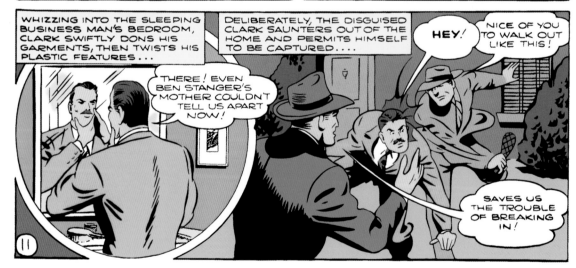

WHIZZING INTO THE SLEEPING BUSINESS MAN'S BEDROOM, CLARK SWIFTLY DONS HIS GARMENTS, THEN TWISTS HIS PLASTIC FEATURES...

THERE! EVEN BEN STANGER'S MOTHER COULDN'T TELL US APART NOW!

DELIBERATELY, THE DISGUISED CLARK SAUNTERS OUT OF THE HOME AND PERMITS HIMSELF TO BE CAPTURED....

HEY!

NICE OF YOU TO WALK OUT LIKE THIS!

SAVES US THE TROUBLE OF BREAKING IN!

11

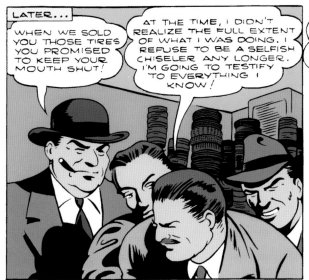

LATER...

WHEN WE SOLD YOU THOSE TIRES YOU PROMISED TO KEEP YOUR MOUTH SHUT!

AT THE TIME, I DIDN'T REALIZE THE FULL EXTENT OF WHAT I WAS DOING. I REFUSE TO BE A SELFISH CHISELER ANY LONGER. I'M GOING TO TESTIFY TO EVERYTHING I KNOW!

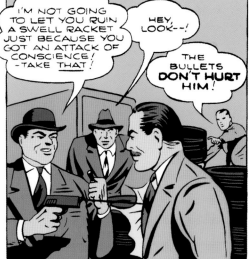

I'M NOT GOING TO LET YOU RUIN A SWELL RACKET JUST BECAUSE YOU GOT AN ATTACK OF CONSCIENCE! --TAKE THAT!

HEY, LOOK--!

THE BULLETS DON'T HURT HIM!

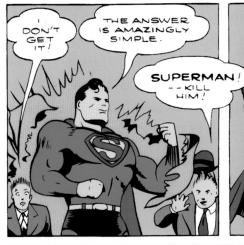

I DON'T GET IT!

THE ANSWER IS AMAZINGLY SIMPLE.

SUPERMAN! --KILL HIM!

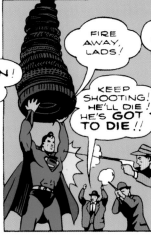

FIRE AWAY, LADS!

KEEP SHOOTING! HE'LL DIE! HE'S GOT TO DIE!!

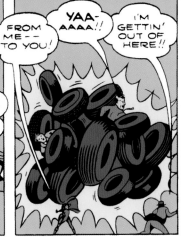

FROM ME -- TO YOU!

YAA-AAAA!!

I'M GETTIN' OUT OF HERE!!

287

LEAPING INTO A PARKED CAR, DERBY SPEEDS DESPERATELY INTO THE NIGHT...

GOT TO GET AWAY--HIDE FROM THE AVENGING CREATURE...!

SUPERMAN RACES IN PURSUIT...TO DISCOVER...

ONE OF THE TIRES EXPLODED...AND SO... IRONICALLY... DERBY BOWSER MEETS THE SAME TERRIBLE DEATH THAT OVER-TOOK HIS INNOCENT VICTIMS! THUS PERISHES...THE RUBBER BAND!

BY A STRANGE QUIRK OF FATE, THE CAR IS OUTFITTED WITH ONE OF DERBY'S OWN STOLEN IMPERFECT TIRES...

⑫

THE END.

DON'T PATRONIZE THE BLACK MARKET! IF YOU CAN'T BATTLE THE ENEMY IN THE FRONT LINES, THE LEAST YOU CAN DO IS FULL-HEARTEDLY SUPPORT THE GOVERN-MENT IN EVERY MEASURE NECESSARY TO THE WIN-NING OF THE WAR!

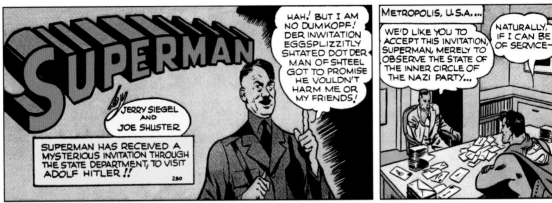

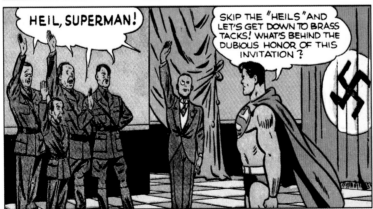

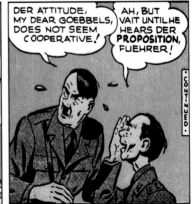

Superman Sunday newspaper comic strip #280–282 (March 11–25, 1945
script: unknown - art: Wayne Boring (pencils) & unknown (inks)

288

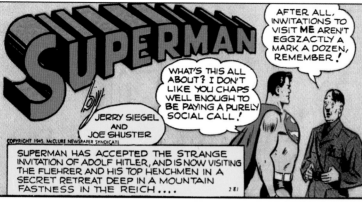

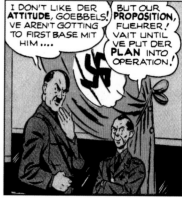

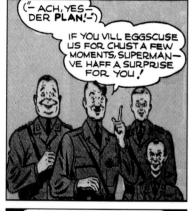

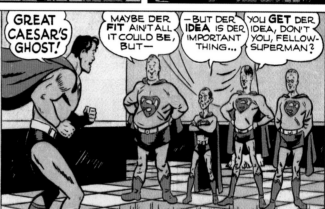

289

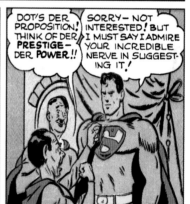

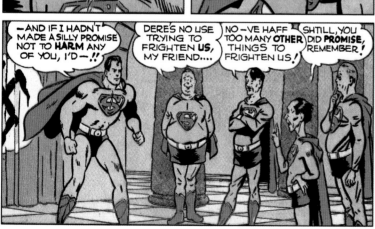

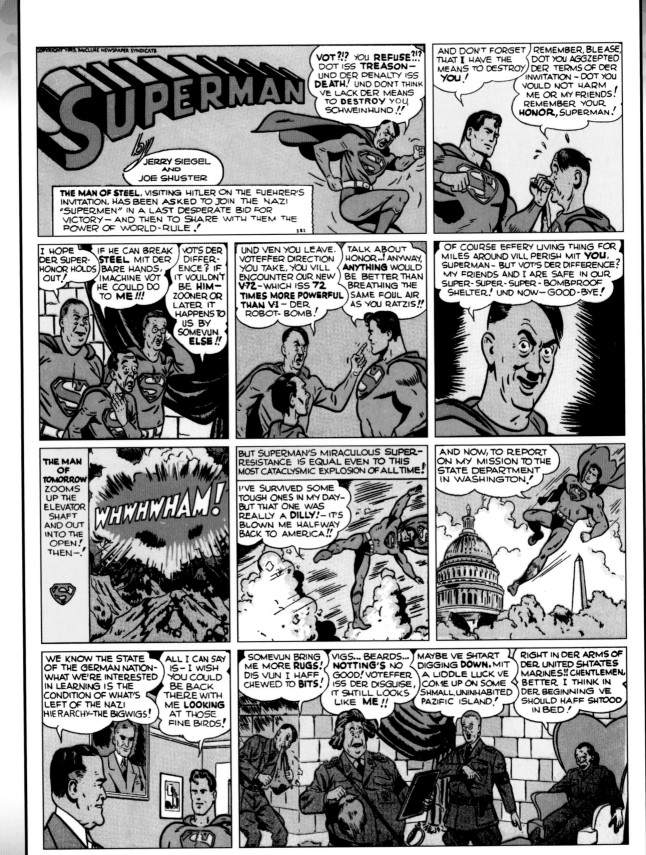

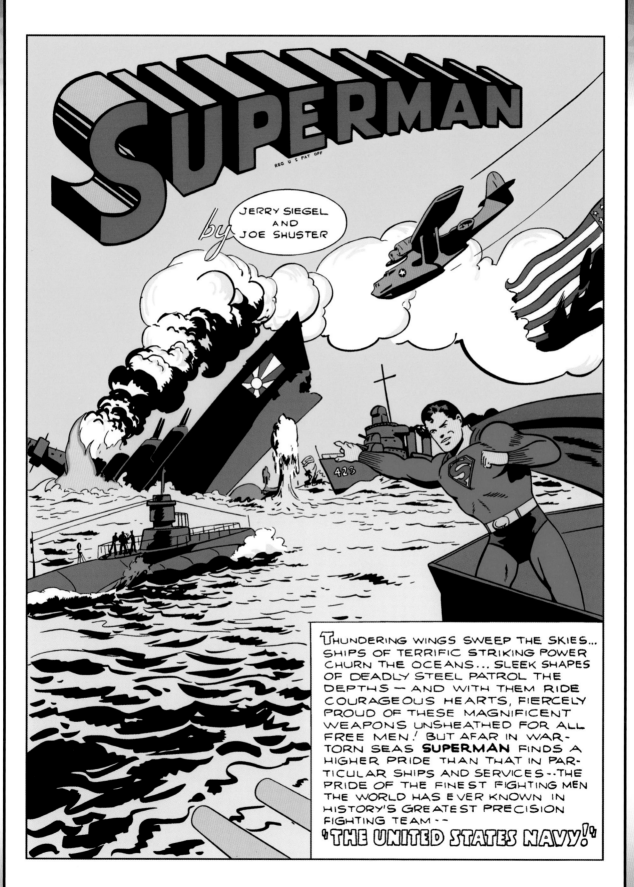

Superman #34 (May–June 1945) - script: Don Cameron - art: Pete Riss (pencils) & George Roussos (inks)

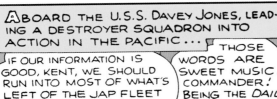

ABOARD THE U.S.S. DAVEY JONES, LEADING A DESTROYER SQUADRON INTO ACTION IN THE PACIFIC...

IF OUR INFORMATION IS GOOD, KENT, WE SHOULD RUN INTO MOST OF WHAT'S LEFT OF THE JAP FLEET WITHIN THE NEXT FEW HOURS! THE REST OF OUR TASK FORCE IS COMING UP!

THOSE WORDS ARE SWEET MUSIC, COMMANDER! BEING THE *DAILY PLANET'S* CORRESPONDENT WITH YOUR OUTFIT TOPS ANY ASSIGNMENT I EVER DREW!

WITH YOUR PERMISSION, I THINK I'LL TAKE A WALK! I UNDERSTAND THAT YOUR SHIP HAS SOME METROPOLIS BOYS ABOARD!

CRUISE AROUND ALL YOU LIKE! MAYBE YOU'LL SIGHT SOME FAMILIAR FACES!

CLARK KENT, THE DEMON REPORTER — BIG AS LIFE AND TWICE AS SASSY!

SHEP SHEPPARD, OR I'M A RINGTAILED MONKEY! THE BIGGEST GUN OF METROPOLIS U'S THREE MUSKETEERS HAS GONE UP IN THE WORLD!

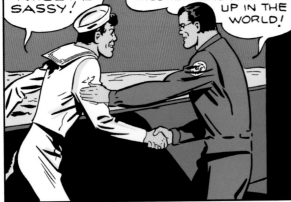

I GOT A KICK OUT OF WRITING THE STORY OF THE TERRIBLE TRIO JOINING THE NAVY — YOU AND DAN RYAN AND AL WADE!

WE GOT A KICK OUT OF READING IT! TOO BAD AL AND DAN DIDN'T PICK THE NUMBER ONE BRANCH OF THE GERVICE, LIKE I DID — SAILING WITH A REAL FIGHTING SHIP!

② IMAGINE — DAN THINKS FLYING IN A PBY IS THE WORLD'S BEST JOB, AND AL IS STARRY-EYED ABOUT HIS BERTH AS A TORPEDOMAN ON A SUBMARINE! THOSE GUYS ARE ALL WET! THEY DON'T KNOW WHAT THE REAL NAVY IS!

I'VE HEARD THAT TUNE BEFORE, WITH DIFFERENT WORDS! EACH OF YOU FELLOWS WAS ALWAYS TRYING TO OUTRANK THE OTHERS!

THE ARGUMENT WAS HOT WHEN YOU WERE THE TRIPLE-THREAT KIDS OF THE FOOTBALL SQUAD — AL AS HALFBACK, DAN AS QUARTERBACK AND —

AND OLD SHEP AS FULLBACK! YOU'LL HAVE TO ADMIT MY TACKLING WAS INSPIRATIONAL, AND WHEN I HIT THAT LINE, SOMETHING ALWAYS GAVE!

EACH OF YOU THOUGHT HIS JOB WAS THE BIGGEST! BUT REMEMBER WHEN YOU WON EVERY GAME OF THE SEASON EXCEPT THE EASIEST — A PRACTICE GAME WITH YOUR OWN FRESHMAN SQUAD?

NO FAIR! THAT WAS ALL THE DOING OF **SUPERMAN!**

JUST TO CLARIFY CLARK'S POINT, LET'S TAKE A BRIEF BACKWARD LOOK AT THAT PRE-WAR FOOTBALL GAME, BEGINNING WITH THE FRIENDLY ARGUMENT THAT PRECEDED IT ...

MY PASSING OUGHT TO RUN UP A 100-TO-0 SCORE AGAINST THESE FROSHIES!

WHAT DO YOU MEAN YOUR PASSING? THE QUARTERBACK'S BRAINS DECIDES THE SCORE-- AND THAT'S ME!

BUT WHERE'D ANY OF YOU BE WITHOUT A FULL-BACK LIKE ME TO SCATTER THAT LINE?

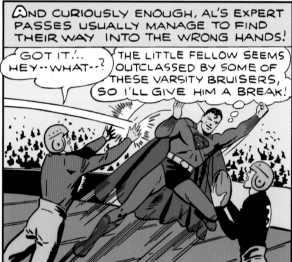

HMMM... EVEN THOUGH THOSE PIGSKIN WARRIORS ARE ONLY KIDDING, A LITTLE LESSON WOULDN'T HURT THEM — AND I THINK SUPERMAN CAN PROVIDE IT!

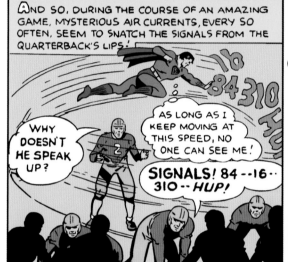

AND SO, DURING THE COURSE OF AN AMAZING GAME, MYSTERIOUS AIR CURRENTS, EVERY SO OFTEN, SEEM TO SNATCH THE SIGNALS FROM THE QUARTERBACK'S LIPS!

AS LONG AS I KEEP MOVING AT THIS SPEED, NO ONE CAN SEE ME!

WHY DOESN'T HE SPEAK UP?

SIGNALS! 84--16-- 310-- HUP!

AND CURIOUSLY ENOUGH, AL'S EXPERT PASSES USUALLY MANAGE TO FIND THEIR WAY INTO THE WRONG HANDS!

GOT IT!... HEY--WHAT--?

THE LITTLE FELLOW SEEMS OUTCLASSED BY SOME OF THESE VARSITY BRUISERS, SO I'LL GIVE HIM A BREAK!

293

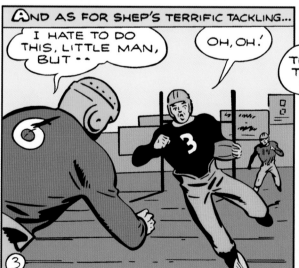

AND AS FOR SHEP'S TERRIFIC TACKLING...

I HATE TO DO THIS, LITTLE MAN, BUT --

OH, OH!

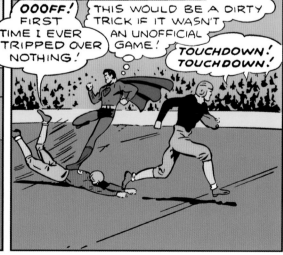

THERE'S MANY A SLIP!

OOOFF! FIRST TIME I EVER TRIPPED OVER NOTHING!

THIS WOULD BE A DIRTY TRICK IF IT WASN'T AN UNOFFICIAL GAME!

TOUCHDOWN! TOUCHDOWN!

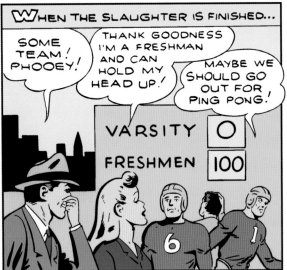

WHEN THE SLAUGHTER IS FINISHED...

SOME TEAM! PHOOEY!

THANK GOODNESS I'M A FRESHMAN AND CAN HOLD MY HEAD UP!

MAYBE WE SHOULD GO OUT FOR PING PONG!

VARSITY 0
FRESHMEN 100

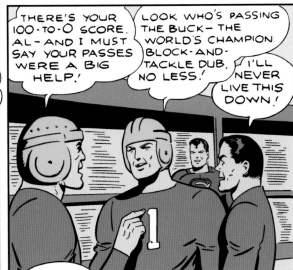

THERE'S YOUR 100-TO-0 SCORE, AL—AND I MUST SAY YOUR PASSES WERE A BIG HELP!

LOOK WHO'S PASSING THE BUCK—THE WORLD'S CHAMPION BLOCK-AND-TACKLE DUB, NO LESS!

I'LL NEVER LIVE THIS DOWN!

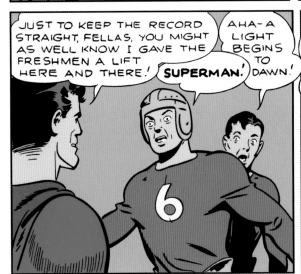

JUST TO KEEP THE RECORD STRAIGHT, FELLAS, YOU MIGHT AS WELL KNOW I GAVE THE FRESHMEN A LIFT HERE AND THERE!

AHA—A LIGHT BEGINS TO DAWN!

SUPERMAN!

YOU SEE, I OVERHEARD YOU CLAIMING CREDIT FOR A VICTORY YOU HADN'T WON, JUST AS NOW YOU'RE TRYING TO PASS OFF THE BLAME FOR AN UNDESERVED DEFEAT!

HE'S RIGHT, GUYS! AFTER ALL, IT TAKES 11 MEN TO PLAY THE GAME!

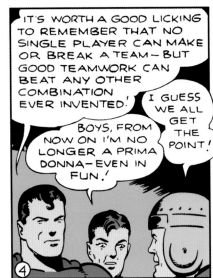

IT'S WORTH A GOOD LICKING TO REMEMBER THAT NO SINGLE PLAYER CAN MAKE OR BREAK A TEAM—BUT GOOD TEAMWORK CAN BEAT ANY OTHER COMBINATION EVER INVENTED!

I GUESS WE ALL GET THE POINT!

BOYS, FROM NOW ON I'M NO LONGER A PRIMA DONNA—EVEN IN FUN!

4

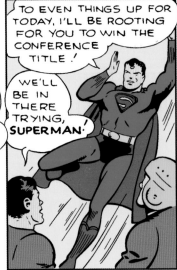

TO EVEN THINGS UP FOR TODAY, I'LL BE ROOTING FOR YOU TO WIN THE CONFERENCE TITLE!

WE'LL BE IN THERE TRYING, SUPERMAN!

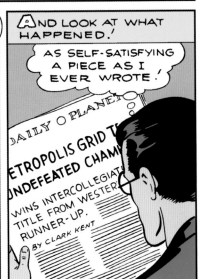

AND LOOK AT WHAT HAPPENED!

AS SELF-SATISFYING A PIECE AS I EVER WROTE!

DAILY PLANET
METROPOLIS GRID
UNDEFEATED CHAMP
WINS INTERCOLLEGIAT
TITLE FROM WESTER
RUNNER-UP.
BY CLARK KENT

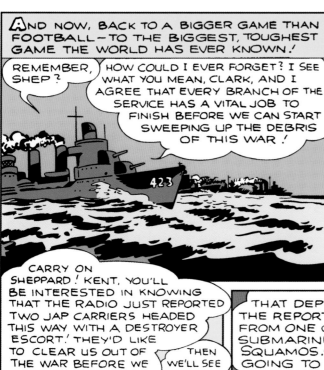

AND NOW, BACK TO A BIGGER GAME THAN FOOTBALL—TO THE BIGGEST, TOUGHEST GAME THE WORLD HAS EVER KNOWN!

REMEMBER, SHEP?

HOW COULD I EVER FORGET? I SEE WHAT YOU MEAN, CLARK, AND I AGREE THAT EVERY BRANCH OF THE SERVICE HAS A VITAL JOB TO FINISH BEFORE WE CAN START SWEEPING UP THE DEBRIS OF THIS WAR!

BUT DOGGONE IT, THE SHIPS OF THE LINE STILL PACK THE HEAVIEST PUNCH! YOU'LL SEE WHEN WE TACKLE THE NIPS!

STILL THE TOP TACKLER, EH? GOOD THING **SUPERMAN** ISNT AROUND TO HEAR YOU LOW-RATE THE SUBS AND THE CLOUD-SWEEPERS!

CARRY ON SHEPPARD! KENT, YOU'LL BE INTERESTED IN KNOWING THAT THE RADIO JUST REPORTED TWO JAP CARRIERS HEADED THIS WAY WITH A DESTROYER ESCORT! THEY'D LIKE TO CLEAR US OUT OF THE WAR BEFORE WE MAKE CONTACT WITH THEIR FLEET!

THEN WE'LL SEE ACTION SOONER THAN WE EXPECTED?

THAT DEPENDS! THE REPORT CAME FROM ONE OF OUR SUBMARINES, THE SQUAMOS! SHE'S GOING TO ATTACK--

EXCUSE ME, SIR— DID YOU SAY THE **SQUAMOS**?

WHY, YES! KNOW HER?

ONE OF MY BUDDIES IS A TORPEDO-MAN ABOARD HER—AL WADE!

ANOTHER METROPOLIS MAN, COMMANDER!

295

IT'S SUICIDE FOR A LONE SUB— BUT IF SHE SINKS OR CRIPPLES THE CARRIERS, WE'LL BE SPARED A NASTY FEW HOURS!

LEAVE IT TO AL WADE, SIR!

SO AL'S OUTFIT IS RUNNING INTER-FERENCE FOR YOU! IF ONLY HE CAN TOSS A TORPEDO AS STRAIGHT AS HE USED TO TOSS A FOOTBALL!

HE'LL DO IT! YOU'LL SEE! BUT—BUT GOSH, I HOPE THE **SQUAMOS** LIVES THROUGH IT!

⑤

ENTER THE ENEMY—AND EXIT A LONE PERISCOPE, THE ONLY VISIBLE SIGN OF AMERICAN FIGHTING STRENGTH IN ALL THAT VAST EXPANSE OF OCEAN!

INSIDE THE SQUAMOS' DOUBLE HULL....

ONE-- THREE-- FOUR-- THREE-- FIVE--

MORE EXCITING THAN FOOTBALL, EH, AL?

I'LL SAY!

IF MY PALS HAD LISTENED TO ME, THEY'D ALL BE IN ON THIS PARTY! BUT ONE OF THE IDIOTS WANTED TO FLY, AND ONE HAD THE SILLY IDEA THAT IF YOU AREN'T ON A DESTROYER OR A CRUISER, YOU AREN'T IN THE NAVY!

"FIRE ONE!" "FIRE TWO!" "FIRE THREE!" "FIRE FOUR!"

AND NOW, FIREWORKS TO DIM THE RISING SUN — BUT REALLY!

BOOM! BOOM!

⑥

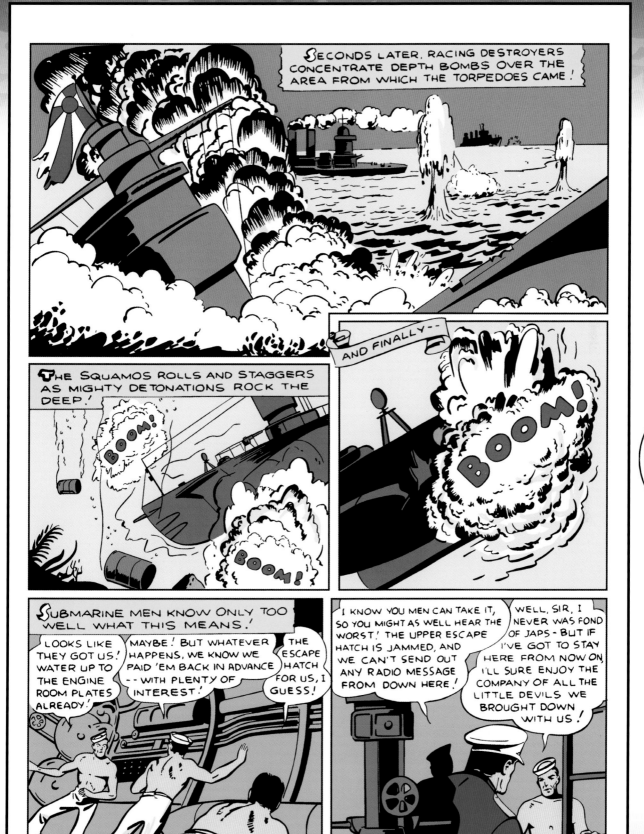

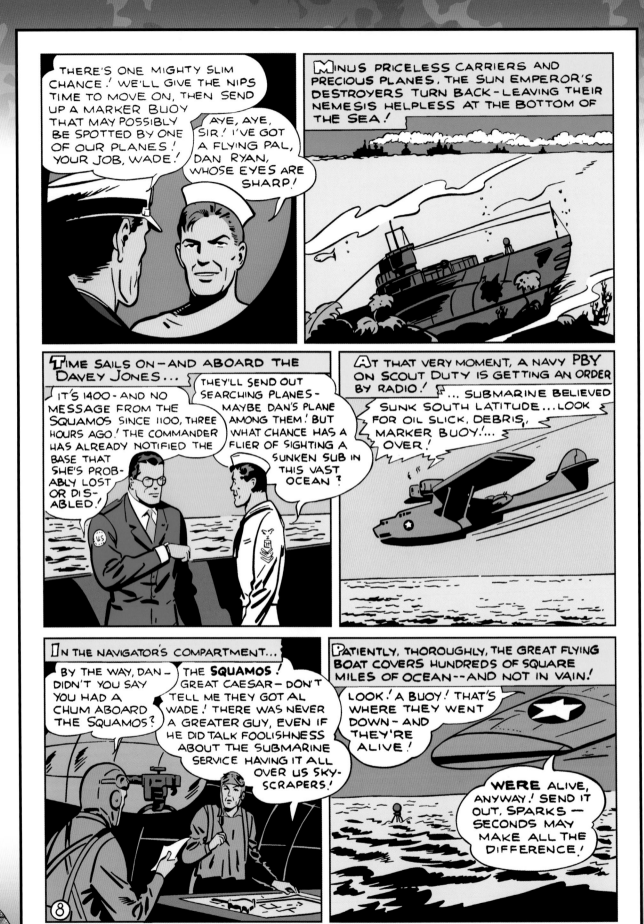

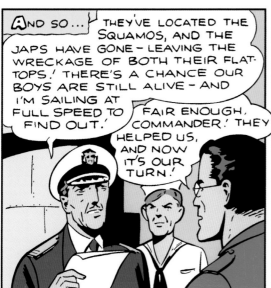

AND SO... THEY'VE LOCATED THE SQUAMOS, AND THE JAPS HAVE GONE – LEAVING THE WRECKAGE OF BOTH THEIR FLAT-TOPS.! THERE'S A CHANCE OUR BOYS ARE STILL ALIVE – AND I'M SAILING AT FULL SPEED TO FIND OUT.!

FAIR ENOUGH, COMMANDER.! THEY HELPED US, AND NOW IT'S OUR TURN.!

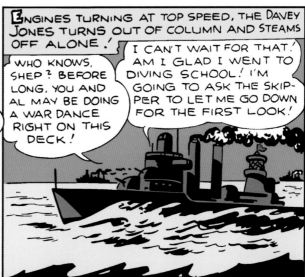

ENGINES TURNING AT TOP SPEED, THE DAVEY JONES TURNS OUT OF COLUMN AND STEAMS OFF ALONE.!

WHO KNOWS, SHEP? BEFORE LONG, YOU AND AL MAY BE DOING A WAR DANCE RIGHT ON THIS DECK!

I CAN'T WAIT FOR THAT.! AM I GLAD I WENT TO DIVING SCHOOL.! I'M GOING TO ASK THE SKIP-PER TO LET ME GO DOWN FOR THE FIRST LOOK!

PRESENTLY... WE'LL SEND SALVAGE SHIPS TO RAISE HER LATER! THE MAIN THING IS TO GET THE CREW OFF IF THEY'RE STILL ALIVE!

YES, SIR!

GOOD FISHING, SHEP!

THE HULL'S INTACT.! AL'S ALIVE – I FEEL IT IN MY BONES – AND SO ARE THE OTHERS.! THEY'VE **GOT** TO BE!

299

ALIVE, YES – AND KICKING.!

WOULDN'T YOU KNOW IT? MY RUN OF LUCK STARTS NOW.!

WHY DIDN'T SOMEBODY TELL ME SOONER THAT THE NAVY DOESN'T EQUIP PIGBOATS WITH SUNLIGHT AND BALMY BREEZES?

LISTEN! IF MY EARS ARE KIDDING ME, I'LL BITE 'EM OFF MYSELF!

TAP-TAP-TAP-A TAP!

⑨

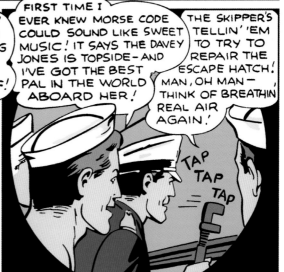

FIRST TIME I EVER KNEW MORSE CODE COULD SOUND LIKE SWEET MUSIC! IT SAYS THE DAVEY JONES IS TOPSIDE – AND I'VE GOT THE BEST PAL IN THE WORLD ABOARD HER!

THE SKIPPER'S TELLIN' 'EM TO TRY TO REPAIR THE ESCAPE HATCH! MAN, OH MAN – THINK OF BREATHIN' REAL AIR AGAIN!

TAP TAP TAP

SHEPPARD PHONES THAT A JAMMED HINGE ON THE ESCAPE HATCH CAN BE FIXED IN AN HOUR OR SO! IF THE NIPS LEAVE US ALONE THAT LONG, KENT, YOU'LL SEE AN UNUSUAL RESCUE!

FROM NOW ON, I'LL BE SPOILED FOR HANDLING ORDINARY RUN-OF-THE-MILL NEWS STORIES!

BUT THE NEXT INSTANT...

RADIO MESSAGE FROM THE PBY THAT LOCATED THE SUB, SIR! BIG ENEMY TASK FORCE COMING UP FAST FROM THE NORTHWEST!

THAT MAY PUT A STOP TO THE RESCUE FOR A WHILE — PERHAPS FOR GOOD!

HUH?...SOMETHING TELLS ME SUPERMAN HAS STAYED IN THE BACKGROUND LONG ENOUGH!

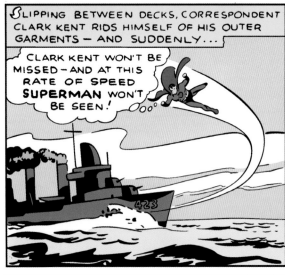

SLIPPING BETWEEN DECKS, CORRESPONDENT CLARK KENT RIDS HIMSELF OF HIS OUTER GARMENTS — AND SUDDENLY...

CLARK KENT WON'T BE MISSED — AND AT THIS RATE OF SPEED SUPERMAN WON'T BE SEEN!

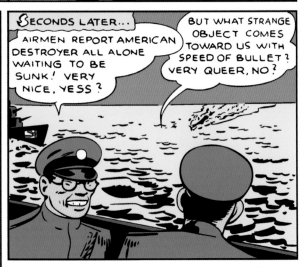

SECONDS LATER...

AIRMEN REPORT AMERICAN DESTROYER ALL ALONE WAITING TO BE SUNK! VERY NICE, YESS?

BUT WHAT STRANGE OBJECT COMES TOWARD US WITH SPEED OF BULLET? VERY QUEER, NO?

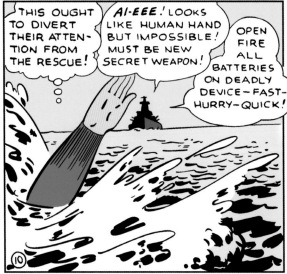

⑩

THIS OUGHT TO DIVERT THEIR ATTENTION FROM THE RESCUE!

AI-EEE! LOOKS LIKE HUMAN HAND BUT IMPOSSIBLE! MUST BE NEW SECRET WEAPON!

OPEN FIRE ALL BATTERIES ON DEADLY DEVICE — FAST — HURRY — QUICK!

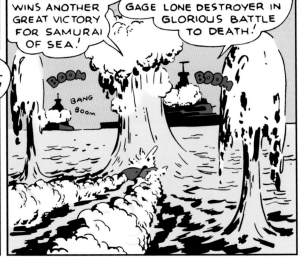

SO! RADIO TOKYO THAT DIRECT HIT WINS ANOTHER GREAT VICTORY FOR SAMURAI OF SEA!

NOW TO PROCEED WITH INVINCIBLE FLEET TO ENGAGE LONE DESTROYER IN GLORIOUS BATTLE TO DEATH!

BOOM

BANG BOOM

BOOM

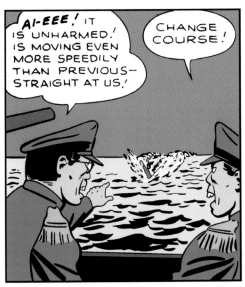

AI-EEE! IT IS UNHARMED! IS MOVING EVEN MORE SPEEDILY THAN PREVIOUS— STRAIGHT AT US!

CHANGE COURSE!

AS THE SUPER-MANEUVER IS REPEATED AGAIN AND AGAIN...

SEA SPIRITS GIVE AID TO INCOMPETENT AMERICANS!

HONORABLE ANCESTORS HAVE FORSAKEN US! BOLD ADVANCE TO REAR IS INDICATED!

IT'LL TAKE THEM QUITE A WHILE TO UNTANGLE THAT SNARL— AND BY THEN, THE REST OF OUR TASK FORCE SHOULD BE CATCHING UP!

THE REST OF THE TASK FORCE — HERE THEY COME! BUT WILL THEY ARRIVE IN TIME?

301

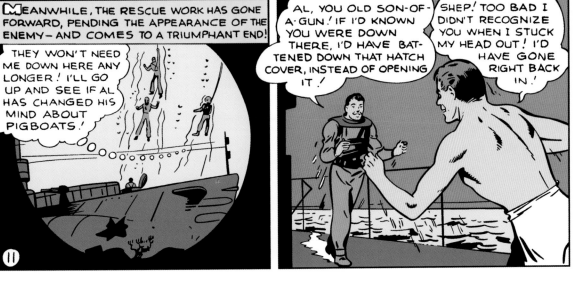

MEANWHILE, THE RESCUE WORK HAS GONE FORWARD, PENDING THE APPEARANCE OF THE ENEMY— AND COMES TO A TRIUMPHANT END!

THEY WON'T NEED ME DOWN HERE ANY LONGER! I'LL GO UP AND SEE IF AL HAS CHANGED HIS MIND ABOUT PIGBOATS!

AL, YOU OLD SON-OF-A-GUN! IF I'D KNOWN YOU WERE DOWN THERE, I'D HAVE BATTENED DOWN THAT HATCH COVER, INSTEAD OF OPENING IT!

SHEP! TOO BAD I DIDN'T RECOGNIZE YOU WHEN I STUCK MY HEAD OUT! I'D HAVE GONE RIGHT BACK IN!

11

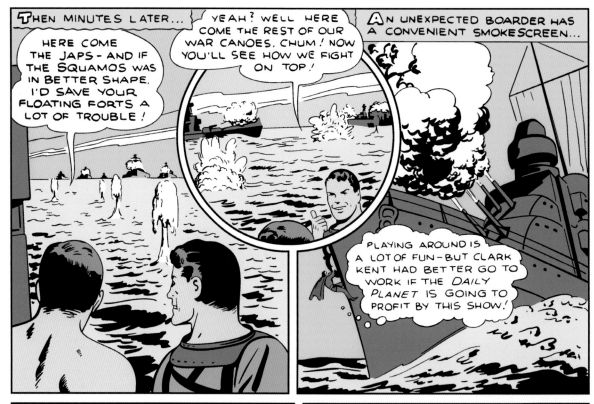

THEN MINUTES LATER...

HERE COME THE JAPS - AND IF THE SQUAMOS WAS IN BETTER SHAPE, I'D SAVE YOUR FLOATING FORTS A LOT OF TROUBLE!

YEAH? WELL HERE COME THE REST OF OUR WAR CANOES, CHUM! NOW YOU'LL SEE HOW WE FIGHT ON TOP!

AN UNEXPECTED BOARDER HAS A CONVENIENT SMOKE SCREEN...

PLAYING AROUND IS A LOT OF FUN - BUT CLARK KENT HAD BETTER GO TO WORK IF THE *DAILY PLANET* IS GOING TO PROFIT BY THIS SHOW!

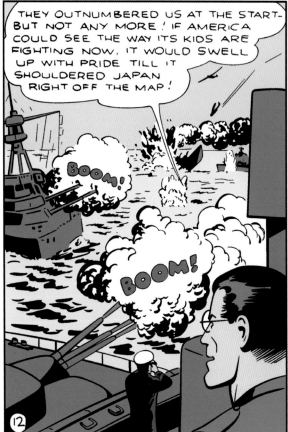

THEY OUTNUMBERED US AT THE START - BUT NOT ANY MORE! IF AMERICA COULD SEE THE WAY ITS KIDS ARE FIGHTING NOW, IT WOULD SWELL UP WITH PRIDE TILL IT SHOULDERED JAPAN RIGHT OFF THE MAP!

BOOM!

BOOM!

⑫

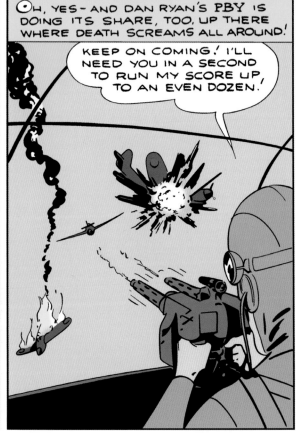

OH, YES - AND DAN RYAN'S PBY IS DOING ITS SHARE, TOO, UP THERE WHERE DEATH SCREAMS ALL AROUND!

KEEP ON COMING! I'LL NEED YOU IN A SECOND TO RUN MY SCORE UP, TO AN EVEN DOZEN!

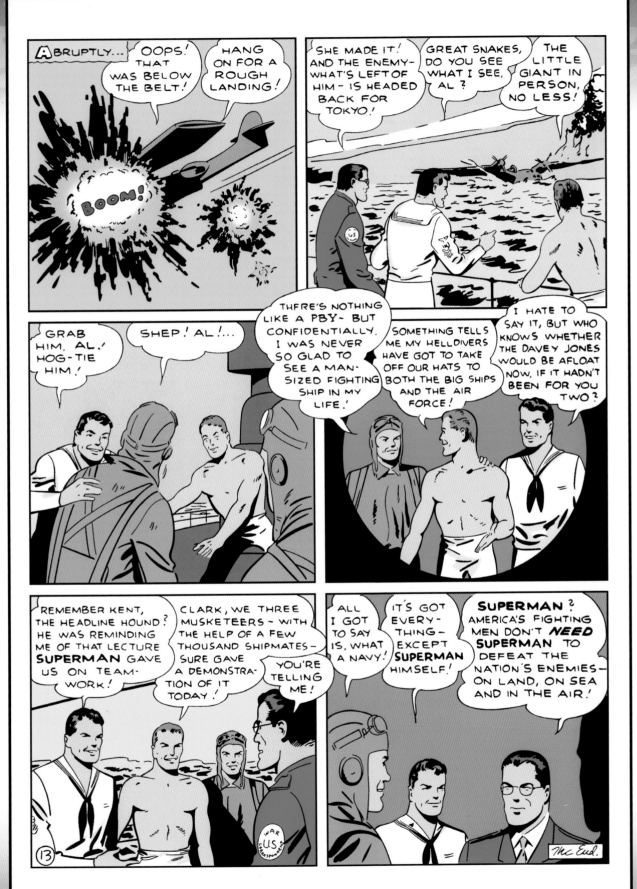

303

Part Five

America and her Allies had grim plans to establish a beachhead on the Japanese Home Islands sometime in 1946, and feared it might take a year or two after that to bring the war to a conclusion.

Heavy casualties were expected on both sides.

ATOMS FOR PEACE?

On August 6, 1945, a nightmarish mushroom-shaped cloud blossomed above the city of Hiroshima. Three days afterward, a second atomic bomb exploded over Nagasaki. On September 2, Japanese emissaries signed the Instrument of Surrender in Tokyo Bay aboard the battleship Missouri... and the Second World War, at last, came to an end.

The end came so suddenly that there was no good way to handle it in a comic book, whose stories had to be readied months in advance of appearing on the newsstand. One month, the war was a background presence in many stories; the next, it didn't exist. In DC's comics, the transition to stories of peacetime was quick and total.

Yet, when they read about the A-bomb blasts, certain members of DC's editorial staff must've shaken their heads and muttered, "So that's why they were here!"

For, one day the previous April, several G-men appeared at the DC offices with queries about the currently-running comic strip story arc in which Superman was being bombarded by a cyclotron (aka "atom-smasher") to see if he'd survive the experience. He did, of course. In all, the printed atom-smasher sequence was composed of only eight strips, written by Alvin Schwartz and penciled by Wayne Boring. Whether the G-men persuaded DC to replace the strips that would've followed (naturally without mentioning the top-secret Manhattan Project in Los Alamos, New Mexico), or whether those eight dailies were all that were ever planned, is unclear. Rumors abound that it was meant to go on much longer, and that Alvin Schwartz refused to do the rewrites and so was replaced as the scripter on that sequence. No atomic secrets

were compromised by the newspaper episode, but the government wasn't taking any chances.

Even so, that very November, only three months after America bombed Hiroshima, Superman #38 (cover-dated Jan.–Feb. 1946) featured the story "The Battle of the Atoms!" It bears no resemblance to the newspaper sequence. It was a comic book story either shelved after the G-Men's visit, or else one written, drawn, and rushed into print in record time after August 6th! That yarn had even less to do with anything nuclear than the newspaper strips, but that didn't stop the words "Now it can be told!" from being splashed on its first page. (Hey, maybe that's why they call it a splash page!) Both the newspaper and comic stories were somewhat outside the province of this book, however.

With the war over, Superman breathed a sigh of relief. He'd been proved right, all those times he'd said that the American fighting man would win this man's war without needing his help. Now the Man of Steel could go back to fighting evil super-scientists like Luthor, and protecting his precious secret identity from that ultimate investigative reporter, Lois Lane!

Since the end of the World War II era in which he was produced, the world famous creation of Jerry Siegel and Joe Shuster—the Last Son of Krypton, who's more powerful than a locomotive (or apparently even an atom-smasher!)—has continued from strength to strength. Fifteen years into the 21st century, he remains one of the best-known fictional concepts of all time.

Up, up, and awaaaay!